THE RARER KINDS OF STONE MENTIONED BY VASARI.

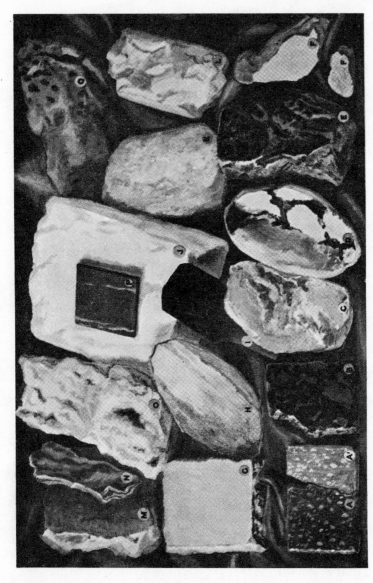

A, Egyptian Porphyry. A¹, Portion of the same piece that has passed through the fire. B, Dark green porphyritic stone, incorrectly called "Serpentine." C, D, Two specimens of Breccias of Seravezza (Stazzema) E, "Verde di Prato," a true Serpentine. F, F, Red Marble or Limestone from Monsummano, near Pistoja, as used on the Duomo and Campanile, Florence. G, Pietra Serena. H, Cipollino. I, True Touchstone or Basanite. J, White Statuary Marble from Monte Altissimo. K, Bardiglio, or Grey Marble, from La Cappella, near Seravezza. L, Istrian Stone. M, Pietra Forte. N, Do. from Fortezza, Florence. O, Travertine. P, So-called "Paragone," a grey marble with lighter veins. Q, Peperino, from Rome.

VASARI ON TECHNIQUE

BEING THE INTRODUCTION TO THE THREE
ARTS OF DESIGN, ARCHITECTURE, SCULPTURE
AND PAINTING, PREFIXED TO THE LIVES OF
THE MOST EXCELLENT PAINTERS, SCULPTORS
AND ARCHITECTS

By GIORGIO VASARI

PAINTER & ARCHITECT OF AREZZO

NOW FOR THE FIRST TIME
TRANSLATED INTO ENGLISH BY

LOUISA S. MACLEHOSE

EDITED WITH INTRODUCTION & NOTES BY

PROFESSOR G. BALDWIN BROWN

DOVER PUBLICATIONS, INC.
NEW YORK

This new Dover edition, first published in 1960,
is an unabridged and unaltered republication of the
work first published by J. M. Dent & Company in
1907, except that the frontispiece, Plate XII, which
appeared in color in the original edition, are here
reproduced in black and white.

International Standard Book Number: 0-486-20717-X
Library of Congress Catalog Card Number: 61-460

Manufactured in the United States of America

Dover Publications, Inc.
180 Varick Street
New York, N. Y. 10014

PREFATORY NOTE

THE title page indicates the general responsibility for the different parts of the work now offered to the reader. It should be said however that the editor has revised the translation especially in those portions which deal with technical matters, while the translator has contributed to the matter incorporated in the Notes. The translation was in great part written during a sojourn near Florence, and opportunity was taken to elucidate some of the author's expressions by conversation with Italian artificers and with scholars conversant with the Tuscan idiom.

The text has been translated without omissions, and the rendering has been made as literal as is consistent with clearness and with a reasonable regard for the English tongue. In the two editions issued in Vasari's lifetime the chapters are numbered continuously from one to thirty-five through the three divisions of the work, but in more modern editions each division has its chapters separately numbered. The latter arrangement has been followed, but the continuous numbers of the chapters have been added in brackets. With the view of assisting the reader the text has also been broken up into numbered sections, each with its heading, though there is no arrangement of the kind in the original.

The shorter notes at the foot of the pages are intended to explain the author's meaning, which is not always very clear, and to help to identify and localize buildings and objects mentioned in the text. A certain number of the notes, the longer of which have been placed at the ends

of the three divisions, afford an opportunity for discussing more general questions of historical or aesthetic interest raised by Vasari.

A number of plates and figures in the text have been added, some of which are illustrative of Vasari's descriptions, while others give representations of unpublished objects, and examples of the different kinds of artistic work included in the scope of the treatise. Our acknowledgements for permission to reproduce are due to the authorities of the Print Room, British Museum, and the National Art Library; to Signor Giacomo Brogi at Florence; and to others to whom we have expressed our thanks in the text.

Vasari's unit of measurement is the 'braccio,' and this term has been retained in place of the more familiar English equivalent 'cubit.' Vasari's braccio seems to be equal to about twenty-three inches or fifty-eight centimetres. This equation is given by Aurelio Gotti, and agrees with various dimensions Vasari ascribes to monuments that can now be measured. A smaller unit is the 'palmo,' and this is not, as might be supposed, the breadth of a hand, but what we should rather call a 'span,' that is the space that can be covered by a hand trying to stretch an octave, and may be reckoned at about nine inches.

In the matter of proper names, Vasari's own forms have in most cases been followed in the text, but not necessarily in the commentary.

There are some passages in which we suspect that the printed text does not exactly correspond with what Vasari originally wrote (see Index s.v. 'Text'), but no help is to be obtained here from any known MS. sources. Vasari gives us to understand that the original edition of the *Lives* was printed, not from his own autograph, but from a transcript made for him by a monastic calligraphist, placed at his disposal by a friendly abbot who also corrected to some extent the text. Neither this transcript, nor any MS. of the additions made for the second edition of the work, is known to exist, and textual criticism has to be

confined to a comparison of the printed texts of the two editions published in Vasari's own lifetime.

The character of the subject matter and the multiplicity of the processes and materials passed in review have rendered it needful to invoke the aid of many Italian scholars and experts in historical and technical matters, who have met our applications with a courteous readiness to help for which we desire to express our sincere gratitude. Our obligations to each of these are expressed in the notes, but we cannot close this preface without a special word of thanks to Signor Agnoletti, of the University of Glasgow, and to the Rev. Don Vittorio Rossi, Priore of Settignano. Our acknowledgements are also due to Mr G. K. Fortescue, Keeper of Printed Books at the British Museum; Mr G. H. Palmer, of the National Art Library; Comm. Conte D. Gnoli, Biblioteca Vittorio Emanuele, Rome; Comm. Dottore Guido Biagi, Biblioteca Medicea Laurenziana, Florence; Dr Thomas Ashby, Director of the British School at Rome; and Mr John Kinross, R.S.A. To many artists and connoisseurs in this country whom we have consulted on technical points we are indebted for information not easily to be found in books, and to Mr W. Brindley a special tribute is due for the kindness with which he has opened to us his unique stores of practical knowledge of stones and quarries.

TABLE OF CONTENTS

CHAPTER I.

CONTENTS

CHAPTER I. (VIII.)

What Sculpture is ; how good works of Sculpture are made, and
what qualities they must possess to be esteemed perfect, -

§ 36. *The Nature of Sculpture* (143). § 37. *Qualities necessary
for Work in the Round* (143). § 38. *Works of Sculpture should
be treated with a view to their destined position* (145). § 39. *The
Proportions of the Human Figure* (146). § 40. *Artists must
depend on their Judgement rather than on the Measuring
Rule* (146).

CHAPTER II. (IX.)

Of the manner of making Models in Wax and in Clay ; how
they are draped, and how they are afterwards enlarged in

CONTENTS

CONTENTS

CHAPTER XXI. (XXXV.)

Of Wood Engraving and the method of executing it and con
cerning its first Inventor : how Sheets which appear to be drawn
by hand and exhibit Lights and Half-tones and Shades, are
produced with three Blocks of Wood, - - - - - 281

LIST OF ILLUSTRATIONS

INSERTED PLATES

FIGURES IN THE TEXT

PORTRAIT OF VASARI, FROM THE EDITION OF 1568,
probably by a German artist, called in Italy 'Cristoforo Coriolano'.

INTRODUCTORY ESSAY

INTRODUCTORY ESSAY

WHEN Vasari published in 1550 his famous *Lives of the Artists,* he prefixed to the work an Introduction, divided into three parts headed respectively Architecture, Sculpture, and Painting. In the text of the *Lives* he refers more than once to this preliminary matter under the terms 'parte teorica' and 'capitoli delle teoriche,' but as a fact it only consists to a small extent in 'theory,' that is in aesthetic discussions on the general character of the arts and the principles that underlie them. The chief interest of the chapters is technical. They contain practical directions about materials and processes, intended in the first place to enlighten the general reader on subjects about which he is usually but little informed; and in the second, to assist those actually engaged in the operations of the arts.

To some of the readers of the original issue of Vasari's work these technical chapters proved of special interest, for we find a Flemish correspondent writing to him to say that on the strength of the information therein contained he had made practical essays in art, not wholly without success. This same correspondent, as Vasari tells us in the chapter on Flemish artists at the end of the *Lives,* hearing that the work was to be reprinted, wrote in the name of many of his compatriots to urge Vasari to prefix to the new edition a more extended disquisition on sculpture, painting, and architecture, with illustrative designs, so as to enforce the rules of art after the fashion of Alberti, Albrecht Dürer, and other artists. This seemed however to Vasari to involve too great an alteration in the scheme of his work, and in the edition of 1568 he preserved the original form of the Introduction, though he incorporated with it considerable additions. It is worth

noting that the increase is chiefly in the earlier part, as if Vasari began his revision with the intention of carrying out the suggestion of his correspondents, but gave up the idea of substantial enlargement as he went on. For example the first chapter in the ' Introduction ' to Architecture is half as long again in the second as in the first edition, and Architecture generally is increased by a third part, while in Sculpture the additions are trifling. The total additions amount to nearly one seventh of the whole. The matter thus added is in general illustrative of the previous text, and adduces further examples of work under review. It is this extended Introduction of the second, or 1568, edition, which is now completely translated and issued with the needful commentary.

The reputation of the writer and the value of his world-renowned biographies naturally give importance to matter which he has deliberately prefixed to these, and it is somewhat surprising that though the text has been constantly printed it has not been annotated, and that it has never yet been rendered as a whole into English, nor, as far as can be ascertained, into any other European language.

Ernst Berger, in his learned and valuable *Beiträge zur Ent-wicklungs-Geschichte der Maltechnik,* vierte Folge, München, 1901, does justice to Vasari's Treatise, of which, as he says, ' the thirty-five chapters contain a complete survey of the manual activities of the time, in connection with which Vasari gives us very important information on the condition of technique in the sixteenth century,' and he translates the chapters relating to painting with one or two useful notes. There was apparently an intention of editing Vasari's Introduction in the Vienna series of Technical Treatises (Quellenschriften) but the project was not carried out. Anglo-Saxon readers will note that the chapters do not appear in the classic English translation by Mrs Jonathan Foster, nor in the American reprint of selected Lives lately edited with annotations by Blashfield and Hopkins; they are omitted also from the French translation by Leclanché, and from that into German by Ludwig Schorn. Mrs Foster explains that she only meant to translate the *Lives* and not Vasari's ' other works '; while the German editor, though he admits the value of the technical

chapters to the artist, thinks that the latter 'would have in any case to go to the original because many of the technical terms would not be intelligible in translation.'

On this it may be remarked that the chapters in question are not 'other works' in the sense in which we should use the term in connection with Vasari's *Letters,* and the 'Ragionamenti,' or description of his own performances in the Palazzo Vecchio at Florence, that are all printed by Milanesi in the Sansoni edition of Vasari's works. The chapters are distinctly a part, and a valuable part, of the main work of the author, and it is difficult to see any valid reason why they should ever have been dissociated from it. With regard to the reason for omission given by the German editor, surely the resources of the translator's art are not so limited as he supposed! It may be claimed, at any rate, that in what follows a conscientious effort has been made to find technical terms in English equivalent to Vasari's, and yet intelligible to the reader. Where such terms do not seem to be clear, a footnote has been added in explanation.

It is probable that the real reason of the neglect of Vasari's Introduction by his translators has been the fact that when these translations were made, more than half-a-century ago, not much interest was taken by the reading public in the technical processes of the arts, and this part of Vasari's work was passed over in order not to delay the reader anxious for the biographical details the author presents in so lively a fashion. At the present time, largely as a result of the inspiring influence of William Morris alike upon the craftsmen and the artistic public, people have been generally awakened to the interest and importance of these questions of technique, and a new translator of Vasari would certainly not be betrayed into this omission. The present translation and commentary may therefore claim to fill a gap that ought never to have been suffered to exist, and on this ground to need no explanation nor apology. Some English writers on the technique of the arts, such as Mrs Merrifield and the late G. T. Robinson, have made considerable use of the material that Vasari has placed before students in these Introductory Chapters, and the practical service that they have thus rendered is an

additional reason why they should be brought as a whole in convenient form before English readers.

Readers familiar with Vasari's *Lives* will miss in the technical Introduction much of the charm and liveliness of style in which they have been wont to delight. Vasari indeed had a natural gift for biographical writing. He had a sense of light and shade and of contrast in colouring that animates his literary pictures, and is the secret of the fascination of his work, while it explains at the same time some of its acknowledged defects. Above all things he will have variety. If one artist have been presented to the reader of the *Lives* as a man of the world in constant touch with his fellows, the next artist who comes forward on the stage is a recluse. If one be open and free, another is secretive and brooding; the artist jealous of his brother's fame and envious of his secrets is contrasted with the genial companion ready to impart all he knows to his less fortunate compeer. In bringing out these picturesque comparisons, the writer sometimes forces the note, and is a little more regardful of effect than of strict biographical accuracy,[1] and this accounts for some of the censure which in the modern critical age has fallen to the lot of the Aretine.

The technical disquisitions in the Introduction afford little opportunity for picturesque writing of this kind, and they must be judged from another standpoint. They have certain obvious defects that are however counterbalanced by qualities of much value. Vasari's treatment in many parts lacks system and completeness, his statement is wanting in clearness, his aesthetic comments are often *banal*. On the other hand there are sections or chapters of great, even enthralling, interest, as when he discourses with all a Florentine's enthusiasm on the virile and decided handling of a master in fresco painting; or lets us follow step by step from the small sketch to the finished casting the whole process of making a great bronze statue. Throughout the treatise moreover, we

[1] Berenson, *The Drawings of the Florentine Painters*, London, 1903, I, p. 18, says that Vasari 'was an indifferent connoisseur and a poor historian; but he was a great appreciator . . . and a passionate anecdote-monger. Now the Anecdote must have sharp contrasts'

have the advantage of hearing a practical craftsman speaking about the processes and materials with which he is himself familiar, for Vasari, though he did not put his own hand to nearly all the kinds of work he describes, yet was all his life a professional, in intimate touch with craftsmen in every branch of artistic production. If he did not make painted glass windows, he at any rate designed for them. His mural work involved modelled and stamped plaster enrichment and wood carving, while his sections on different processes of decoration for temporary purposes derive a personal interest from the fact that the writer was a famous expert in the construction and adornment of showy fabrics for pageants and state entries, of which his own letters give us many details. If he be unavoidably tedious in his description of the Orders of Architecture, he enlivens this by a digression on his own devices in the masonry of the Uffizi palace. The august figure of Michelangelo sometimes crosses the page, and in the midst of the rather copious eulogies of which Vasari is lavish, we find here and there some record of a word or work of Buonarroti which reminds us of the author's intimate personal relation to the master whom he calls in a letter ' il mio rarissimo e divinissimo Vecchio.'

Vasari's general intention in this Introduction he explains at the close of the ' Proemio ' to the whole work that precedes the technical chapters. The Introduction is primarily to instruct ' every gracious spirit in the most noble matters that appertain to the artistic professions '; and next in order, ' for his delight and service, to give him to know in what qualities the various masters differed among themselves, and how they adorned and how they benefitted each in his own way their country '; and finally to enable any one that wills to gain advantage from the labour and cunning of those who in times past have excelled in the arts. Architecture will be shown to be the most universal, the most necessary, and the most useful of human arts, for whose service and adornment the other two arts exist; the different qualities of stones will be demonstrated, with the styles of building and their proper proportions, and the characteristics of good designs and good construction. Next in order comes Sculpture, and here will be shown the

manner of working statues, in their correct forms and pro-
portions, and the qualities that make sculpture good, ' with
all the directions for work that are most secret and most
precious.' Lastly, the treatment of Painting will include
design ; the methods of colouring and of carrying out a
picture ; the characteristics of painting and its subordinate
branches, with mosaics of every sort, niello work, enamels,
damascening, and finally engravings after pictures.

Vasari's treatise does not stand alone but is only one among
many technical and theoretical essays which have come down
to us from various epochs both of the middle ages and of the
Renaissance. The nature and the value of it will be best
understood if we compare it with one or two representative
publications of a similar kind, contemporary with it or of
earlier date. The comparison will serve to show the spirit
in which Vasari writes, and to exhibit the strong and the
weak points in his work.

About the middle of the last century, a number of technical
treatises and collections of recipes, from MSS. of the twelfth
to the eighteenth centuries, were edited and published by
Mrs Merrifield, and the acumen and accuracy with which she
fulfilled her laborious task are warmly eulogized by Dr Albert
Ilg, the learned editor of Theophilus and Cennini in the Vienna
Quellenschriften. The most important of existing treatises
of the kind are however not included in Mrs Merrifield's
work, though they have been translated and edited separately
both by her and by other scholars. The recent publication
by Ernst Berger noticed above gives the most complete account
of all this technical literature. Those of the early treatises
or tracts that consist in little more than collections of recipes
need not detain us, and the only works of which we need
here take account are the following : (1) The *Schedula
Diversarum Artium* of Theophilus, a compendium of the
decorative arts as they were practised in the mediaeval
monastery, drawn up by a German monk of the eleventh or
twelfth century ; (2) *Il Libro dell' Arte, o Trattato della Pittura*
of the Florentine painter Cennino Cennini, written in the early
part of the fifteenth century ; (3) The *De Re Aedificatoria* and
the tracts *Della Pittura* and *Della Scultura,* written rather later

and in quite a different vein, by the famous Florentine humanist and artist Leon Battista Alberti; (4) Benvenuto Cellini's treatises, *Sopra l' Oreficeria e la Scultura,* that belong to the same period as Vasari's own Introduction, and partly cover the same ground. There are later treatises, such as Borghini's *Il Riposo,* 1584; Armenini's *Dei veri Precetti della Pittura,* 1587; Pacheco's *Arte de la Pintura,* 1649; Palomino's *El Museo Pictorico,* etc., 1715-24, which all contain matter of interest, but need not be specially noticed in this place. Some of these later writers depend very largely on Vasari.

The fact just stated about the treatises of Cellini and Vasari suggests the question whether the two are independent, or, if borrowing existed, which treatise owes most to this adventitious aid. The dates of Vasari's two editions have already been given. Cellini's two *Trattati* first appeared in 1568 the same year as Vasari's second edition, and there exists a second recension of his text which formed the basis of Milanesi's edition of 1857, republished in 1893. It is worth noting that Vasari's account of bronze casting, in which we should expect reliance on Cellini, appears in full in the first edition of 1550, and the same applies to the account of die-sinking. On the other hand Celini's notice of the Tuscan building stones, pietra serena, etc., seems like a clearer statement of what we find in Vasari's edition of 1550. On the whole it was Cellini who used Vasari rather than Vasari Cellini, though the tracts can be regarded as practically independent. The *Trattati* of Cellini are really complementary to Vasari's ' Introductions.'

Vasari, as he says of himself, was painter and architect, while Cellini was sculptor and worker in metal. In matters like die-sinking, niello work, enamelling, and the making of medals, Cellini gives the fuller and more practical information, for these were not exactly in the province of the Aretine, while Vasari on his side gives us much information, especially on the processes of painting and on architectural subjects, for which we look in vain to Cellini.

Allowing for these differences, the two treatises agree in the general picture that they give of the artistic activity of their times, and they faithfully reflect the spirit of the High

Renaissance, when the arts were made the instruments of a dazzling, even ostentatious, parade, in which decadence was unmistakeably prefigured. From this point of view, the point of view, that is, of the general artistic tone of an age, it is interesting to draw a comparison between the spirit of the treatises of Vasari and Cellini on the one side, and on the other the spirit of the earlier writings already referred to. If the former bring us into contact with the Renaissance in the heyday of its pride, the artistic tractates of Alberti, of a century before, show us the Renaissance movement in its strenuous youth, already self-conscious, but militant and disposed to work rather than to enjoy. Cennini's *Book of Art,* though certainly written in the lifetime of Alberti, belongs in spirit to the previous, that is to the fourteenth, century. It reflects the life of the mediaeval guilds, when artist and craftsman were still one, and the practice of the arts proceeded on traditional lines in urban workshops where master and apprentices worked side by side on any commissions that their fellow citizens chose to bring. Lastly the *Schedula* of the monk Theophilus introduces us into quite a different atmosphere of art. Carrying us back for two hundred years, it shows us art cultivated in an ascetic community in independence of patrons or guilds or civic surroundings ; on purely religious lines for the glory of the Almighty and the fitting adornment of His house.

This treatise by Theophilus is by far the most interesting and valuable of all those that have been named. No literary product of the middle ages is more precious, for it reflects a side of mediaeval life of which we should otherwise be imperfectly informed. Can it be possible, we ask ourselves, that men vowed to religion in its most ascetic form, who had turned their backs on the world's vain shows and whose inward eye was to see only the mystic light of vision, could devote time and care to the minutiae of the craftsman's technique? Such however was the fact. We cannot read the first few pages of Theophilus without recognizing that the religion of the writer was both sincere and fervent, and that such religion seemed to him to find a natural outcome in art. Art moreover with the German monk was essentially a matter

of technique. From end to end of the treatise there is comparatively l'ttle about art as representative. Sculpture and
painting indeed in the monastic period were not capable of
embodying the ideal, so as to produce on the spectator the
religious impression of a Madonna by Angelico or Raphael.
The art of the eleventh and twelfth centuries was decorative,
and aimed at an effect of beauty with an under suggestion
of symbolism. Theophilus troubles himself little about symbolism but bases everything on a knowledge of materials and
processes; and in the workshop, whose homely construction
and fittings he describes, we are invited to see the gold and
silver and bronze, the coloured earths, the glass stained with
metallic oxides, all taking shape in dainty and beautiful forms,
and coming together in discreet but opulent display, till, as
he phrases it, the Abbey Church which they bedeck and furnish
' shall shine like the garden of Paradise.' For to the mind
of the pious craftsman this church is a microcosm. Creative
skill has made it all beautiful within, and this is the skill of
man, but it is only his in so far as man shares the nature of
the Divine Artist that fashioned the vast macrocosm of the
universe. Artistic knowledge and craftsmanship are a part
of the original heritage of man as he was made in the image
of God the creator, and to win back this heritage by patient
labour and contriving is a religious duty, in the fulfilment of
which the Holy Spirit will Himself give constant aid.
Theophilus enumerates from St Paul the seven gifts of the
Spirit, and shows how the knowledge, the wisdom, the counsel,
and the might, thus imparted to men, all find a field of exercise
in the monastic workshop.

Cennino Cennini da Colle di Val d' Elsa was not a devotee
nor a man of religion, but a city tradesman and employer of
labour. Art in his time had taken up its abode in the towns
that were the seat of the artistic activity of the Gothic period
in France and the neighbouring countries. It was there
practised by laymen in secular surroundings, but as the French
Cathedrals and the work of Giotto and Simone Martini testify,
on religious subjects and in a spirit of piety. Some gleams
of the visionary light that irradiates the workshop of Theophilus
fall across the panels which Cennini and his apprentices smooth

and clamp, and prime with gesso, and paint with forms of
the Madonna or the Crucified. In one of his chapters he
demands for the artist a chaste and almost ascetic life, as of
one who studies theology or philosophy, and again he bids
him clothe himself for his art with love and obedience, with
patience and godly fear. When beginning a delicate piece
of manipulation Cennini bids the worker ' Invoke the name
of God,' and it is characteristic too that he tells him that
such work must not be executed in haste, but ' with great
affection and care.' In the main however, Cennini's treatise
is occupied with a description of the processes of painting
traditional in the school of Florence, that was dominated
throughout the fourteenth century by the commanding figure
of Giotto. We learn from the *Trattato* how walls were
plastered and prepared for the mural painter, and can measure
how far the technical practice of fresco had at the time been
carried. Fresco painting, on which the reader will find a Note
at the close of the ' Introduction ' to Painting, was only the
revival of an art familiar to the ancients, but the best form
of the technique, called by the Italians ' buon fresco,' was
only completely recovered in the course of the fifteenth century.
In the school of Giotto, represented by Cennini, the practice
was as yet imperfect, but his account of it is full of interest.
Painting on panels and on the vellum of books he thoroughly
understands, and his notices of pigments and media convey
much valuable information. Amongst other things he seems
quite *au fait* in the practice of oil-painting, which Vasari has
made many generations believe was an invention of the Flemish
van Eyck.

The chief importance however of Cennini for the present
purpose is to be found in his implicit reliance on authority and
tradition, in which he contrasts most markedly, as we shall
see, with his fellow-countryman and successor, Leon Battista
Alberti. Cennini had himself worked for twelve years with
Agnolo Gaddi the son of Taddeo Gaddi, for twenty-four years
the pupil and assistant of Giotto, and he warns the student
against changing his teacher, and so becoming, as he calls it,
a ' phantasist.' To quote his own words, ' do thou direct
thy course by this rule according to which I will instruct thee

in the painter's art, for Giotto the great master himself
followed it. Four and twenty years was Taddeo Gaddi, the
Florentine, his scholar; Taddeo's son was Agnolo; Agnolo
kept me by him twelve years, during which he taught me to
paint in this manner,' and he points the moral from his own
experience, ' At the earliest moment you can, put yourself under
the best master you can find, and stay with him as long as
you are able.'

Cennini, who seems to have been born about 1372, probably
wrote his *Trattato* towards the close of his life, and there is
MS. authority for dating the tract *Della Pittura* of Leon
Battista Alberti about 1435, so that the two works may have
been composed within the same generation. The contrast
between them is however most striking. Cennini's ideas are
wholly those of the fourteenth century, when guild traditions
were supreme over artistic practice; whereas Alberti is possessed
by the spirit of the Early Renaissance, of which he is indeed
one of the most representative figures. In his view the artist
should base his life and his work on the new humanistic
culture of the age, and build up his art on science and the
study of nature and on the example of the masters of antiquity.
With regard to the last, the reader, who hears Alberti invoking
the legendary shades of Pheidias and Zeuxis and Apelles, may
suspect that a new authority is being set up in place of the
old and that the promised freedom for the arts is to be only
in the name. It is of course true that the reliance on classical
models, which came into fashion with the Revival of Learning,
was destined in future times to lie like an incubus on the arts,
and to give an occasion for many famous revolts; but these
times were not yet, and with Alberti the appeal to antiquity
is little more than a fashion of speech. At other epochs, when
men have suddenly broken loose from some old-established
authoritative system, they have turned to the classical world
for the support which its sane and rationally based intellectual
and political systems seemed to offer. It was so at the time
of the French Revolution, and so it was earlier when the men
of the fifteenth century were passing out from under the shadow
of mediaeval authority. Alberti seems to find satisfaction in
the thought of the existence of unquestionable models of per-

fection in those classical masters whose names were current in humanistic circles, but he makes but little practical use of them. It is remarkable indeed how little direct influence in the essentials of art was exercised over the Italian painting and sculpture of the fifteenth century by the models of the past. Classical subjects come in by the side of the more familiar religious themes, and accessories in pictures are drawn largely from antique remains, but the influence does not penetrate very deep. How little there is that is classical in the spirit and even the form of the art of Donatello! How closely we have to scan the work or the utterances of Leonardo to find a trace of the study of Roman or Hellenic antiquity!

With Alberti, as with the humanists in art in general, the watchword was ' Nature.' As if with direct reference to what Cennini had said about adhering to a chosen master, Alberti in the third book of his *Della Pittura,* derides those who follow their predecessors so closely as to copy all their errors. Equally at fault are those who work out of their own head without proper models before them. The real mistress is nature. Now ever since the beginning of the Italian revival the study of nature had been set before the artist, and Cennini bids the craftsman never to pass a day without making some drawing from a natural object. The study of nature however, with Alberti and the masters of the Early Renaissance, meant something more. The outward aspect of things was to be narrowly observed, and he instances the effect of wind on the drapery of figures, but underneath this outward aspect the artist was to explore the inner structure upon which the external appearance depends. The nude figure must be understood under the drapery, the skeleton and muscular system beneath the integument. Then nature as a whole, that is to say, figures and objects in their mutual relations, must be investigated, and this on a basis of mathematical science. Alberti has a passion for geometry, and begins his treatise with a study from this point of view of visible surfaces. The relation of the eye to visual objects, and especially the changes which these are seen to undergo in their sizes and relations according as the eye is moved, lead on to the study of perspective, on which science, as is well known, depended so

much of the advance in painting in the fifteenth century. Everything in a picture is to be studied from actual persons or objects. It will add life and actuality to a historical composition if some of the heads are copied from living people who are generally known, but at the same time a common sort of realism is to be avoided, for the aim of the artist should not be mere truth to nature but beauty and dignity.

It is in his conception of the artist's character and life that Alberti is least mediaeval. Here, in the third book of *Della Pittura,* we see emerging for the first time the familiar modern figure of the artist, who, as scholar and gentleman, holds a place apart from and above the artizan. The same conception inspires the interesting chapter, the tenth in the ninth book, of Alberti's more important treatise *De Re Aedificatoria,* where he draws out the character of the ideal architect, who should be ' a man of fine genius, of a great application, of the best education, of thorough experience and especially of sound sense and firm judgement.' The Renaissance artist was indeed to fulfil the idea of a perfectible human nature, the conception of which is the best gift of humanism to the modern world. As sketched in *Della Pittura,* he was to be learned in all the liberal arts, familiar with the creations of the poets, accustomed to converse with rhetoricians, ' a man and a good man and versed in all good pursuits.' He was to attract the admiring regard of his fellows by his character and bearing, and to be marked among all for grace and courtesy, for ' it is the aim and end of the painter to seek to win for himself through his works praise and favour and good-will, rather than riches.' Such a one, labouring with all diligence and penetration on the study of nature and of science, would win his way to the mastery possessed by the ancient painters, and would secure to himself that fame so dear to the Italian heart !

In the hundred years that intervened between the life-courses of Alberti and of Vasari, the Renaissance artist, whom the former describes in the making, had become a finished product, and the practice of the arts was a matter of easy routine. The artistic problems at which the men of the fifteenth century had laboured so earnestly were solved; the materials had become plastic to the craftsman's will; the forms of nature

were known so well that they ceased to excite the curiosity
which had set Leonardo's keenly sensitive nature on edge.
At the time Vasari wrote, with the exception of the Venetians
and of Michelangelo, all the men of genius who had created
the art of the Renaissance had passed away, and the busy
workers whose multitudinous operations he watched and
chronicled were, like himself, only epigoni—successors of the
great. We have only to read Vasari's eulogy of Michel-
angelo's frescoes on the vault of the Sistine, in his Life of
that master, to see how far the tone of the age in regard to
art had changed from the time when Alberti was exhorting
the student to work out his own artistic salvation with fear
and trembling. ' No one,' exclaims Vasari, ' who is a painter
cares now any more to look out for novelty in inventions or
attitudes or drapery, for new modes of expression, and for
sublimity in all the varied effects of art; seeing that all the
perfection which it is possible to give in work done in this
fashion has been imparted to these figures by Michelangelo.'
The cultivation of the Michelangelesque, instead of the severe
and patient study of nature, that Leonardo had called ' the
mistress of all masters,' marks the spirit of the Florentine and
Roman schools after the middle of the sixteenth century, and
Vasari's own works in fresco and oil, hastily executed and
on a vast scale, but devoid alike of originality and of charm,
are the most effective exponents of the ideas of his time and
school. At this epoch the artist himself was no longer the
dominant figure in the world of art, nor was his struggle for
self-perfection in the forefront of interest for the spectator.
The stage was rather commanded by the patron, the Pope
Leo, the Duke Cosimo or the Cardinal Farnese of the day,
at whose bidding the artist must run hither and thither, and
leave one task for another, till a delicate nature like Raphael's
or Perino del Vaga's fails under the strain, and the sublime
genius of Michelangelo is thwarted in its free expression.
With the exception of the Venetians, most of the more
accomplished Italian masters of the period were at work on
commissions set them by these wealthy patrons, who lorded
it over their kind and made the arts subservient to their
temporal glory. For such Vasari himself was always con-

tentedly busy on buildings or frescoes or pageants, and for work of the kind demanded nature had exactly equipped him. He was evidently embarrassed neither by ideals nor by nerves, but was essentially business-like. Galluzzi in his History of the Grand Dukes says of him that ' to the qualities of his profession he united a certain sagacity and alertness of spirit which gave to Duke Cosimo considerable pleasure from his company.' He was distinguished above his fellows for the characteristic, not too common among artists, of always working to time. He might scamp his work, but he would by one method or another get it finished in accordance with his contract. His powers of application must have been of a high order, for we should remember that his literary output was by no means inconsiderable, and with his busy life the wonder is not that he wrote rather carelessly but that he was able to do any serious literary work at all.

A favourable specimen of Vasari's decorative painting is the fresco in the Palazzo Vecchio at Florence, given on Plate I. It represents Leo X surrounded by his Cardinals, and introduces portraits of famous men of the day. For instance, on the left above the balustrade in the upper part of the fresco against the opening, will be observed four heads of personages outside the conclave. That on the right is of Leonardo da Vinci and the one on the left Michelangelo's, while the two men with covered heads who intervene are Giuliano de' Medici, Duc de Nemours, and his nephew Lorenzo de' Medici, Duca d' Urbino, the originals of Michelangelo's world-famous statues on the Medici tombs, that are of course treated in a wholly ideal fashion. It will be observed that among the foreground figures the heads of the second from the left and the second from the right are rendered with much more force and character than the rest. They are of Cardinal Giulio de' Medici afterwards Clement VII, and Cardinal de' Rossi, and Vasari has saved himself trouble by boldly annexing them, and with them the bust of the Pope, from Raphael's Portrait of Leo X, of which, as he tells us elsewhere, he had at one time made a copy.

It has been well said of him by the continuators of his autobiography that ' to our Giorgio nature was very bountiful

in her gifts; study and good will had largely improved his natural disposition, but the taste of the times, and the artistic education he received, corrupted the gifts of nature, and the fruit of his unwearied studies.' Vasari was not an inspired artist, and he had neither the informing mind of a master nor the judgement of a discriminating critic, but he was, as we have already pointed out, above all things a thoroughly practical craftsman in intimate touch with all the manifold artistic life of the Italy of his time. He possessed moreover a most genial personality with which it is a pleasure to come into contact, and his good temper (which only fails him when he talks about Gothic art), though it may at times slightly provoke us, accounts for not a little of the deserved popularity of his writings.[1]

Vasari has no doubt at all about the arts being in the most healthy condition in the best of all possible artistic worlds, but it is easy for us to see that this art of the High Renaissance was not of the very best; that the spirit had died out of it almost as soon as the form had attained to outward perfection. We cannot share the facile optimism of Vasari who will admire any work, or any at least in his own school and style, in which there is initiative and force and technical mastery, and in whose eyes to paint feigned architecture on a stucco façade, provided it be deftly done, is as much a ' cosa bellissima ' as to carve the Marsuppini sarcophagus in S. Croce. We cannot however withhold our admiration when we consider the copious artistic output of the age, the manifold forms of aesthetic expression, the easy surrender of the most intractable materials to the artist's will. As we read Vasari's descriptions and recipes the air all about us seems full of the noise of the mason's hammer, the splash of plaster on the wall, the tinkle of the carver's chisel against the marble, the grating of the chaser's rasp upon the bronze. We feel ourselves spectators of an organized activity on a vast scale, where

[1] The materials for our knowledge of Vasari and his works are derived from his own Autobiography and his notes on himself in the Lives of other artists, as well as from the *Ragionamenti* and from the *Letters*, printed by Milanesi in the eighth volume of the Sansoni edition of Vasari's writings, or previously printed by Gaye in the third volume of the *Carteggio*.

PLATE I

LEO X WITH HIS CARDINALS

Mural Painting by Vasari, in
the Palazzo Vecchio, Florence

processes are so well understood that they go on almost of themselves. In the present day, in so much that is written about art, the personal or biographical interest is uppermost, and the lives of Italian artists, with their troubles and triumphs, absorb so much attention that one wonders whether any is left for Italian art. Hence one of the chief values of Vasari's Technical Introduction is its insistence on artistic practice in general, as distinct from the doings of individual artists, and in this it may serve as a useful supplement or corrective to the biographical writing now in vogue. In Vasari on Technique there are no attractive personal legends, like that of Giotto's shepherding or Donatello's adventure with the eggs, but we learn in exchange to follow step by step the building and plastering and painting of Giotto's chapel at Padua, and can watch Donatello's helpers as they anxiously adjust the mould and core for casting the statue of Gattamelata.

It may assist the reader if there be here subjoined a succinct resumé of the subjects treated by Vasari in the three ' Introductions.'

The first of these, on Architecture, opens with a long chapter on stones used in building and decoration, which is important as the fullest notice of the subject that has come down to us from the Renaissance period. Into his somewhat loose disquisitions on porphyry, marbles, travertine, and other materials, Vasari introduces so many incidental notices of monuments and personages of interest, that a somewhat extended commentary has in this part been necessary. Next follows the inevitable chapter on the five Orders, at the close of which comes the notable passage in which Vasari adopts for late mediaeval architecture the term ' Gothic ' that has ever since adhered to it. With Vasari the word ' Gothic ' means ' barbarian,' and he holds that the style was invented by the Goths, after they had conquered the Romans and destroyed all the good antique structures. His description of what he terms the ' abominations ' of slender shafts and niches and corbels and finials and doors that touch the roof is quite spirited, and might be learned by heart as a lesson in humility by some of our mediaeval enthusiasts. On the question whether Vasari

was the first to use the term ' Gothic ' in this sense a word
will be said in the Note on the passage in Vasari's text.

Next come chapters on the architectural use of enriched
plaster; on the rustic fountains and grottoes, the taste for
which was coming in in Vasari's time, and which at a later
period generated the so-called ' rocaille ' or ' rococo ' style in
ornamentation; and on mosaic pavements. This ' Introduction '
ends with a chapter on an interesting subject to which it
does not quite do justice, the subject of ideal architecture,
on which in that and the succeeding age a good deal was
written.

Though Sculpture was not Vasari's *métier* his account of
the processes of that art is full and practical, though we miss
the personal note that runs through the descriptions of the
same procedure in the *Trattato* of Cellini. After an intro-
ductory chapter we have one on the technique of sculpture
in marble, with an account first of the small, and then of the
full-sized, model in clay or wax, the mechanical transfer of
the general form of this to the marble block, and the com-
pletion of the statue by the use of tools and processes which
he describes. Chapter three introduces the subject of reliefs,
and there is here of course a good deal about the picturesque
reliefs in which perspective effects are sought, that Ghiberti
and Donatello had brought into vogue. The account of bronze
casting in chapter four is one of the most interesting in the
whole treatise, and the descriptions are in the main clear and
consistent. Illustrations have been introduced here from the
article on the subject in the French *Encyclopédie* of the
eighteenth century, where is an account of the processes used
in 1699 for casting in one piece Girardon's colossal equestrian
statue of Louis XIV for the Place Vendôme in Paris. A
chapter on die-sinking for medals is followed by one on
modelled plaster work, for this material is dealt with in all
the three sections of the Introduction; while sculpture in wood
forms the subject of the concluding chapter, in which there
is a curious notice of an otherwise unknown French artist,
who executed at Florence a statue of S. Rocco which may
still be seen in the church of the Annunziata. In various
places of this ' Introduction ' to Sculpture questions of general

aesthetic interest are brought forward, and some of these are discussed in the commentary at its close.

Of the three ' Introductions ' that on Painting is the longest and deals with the greatest variety of topics. After a preliminary chapter in which Vasari shows that he regards the art with the eyes of a Florentine frescoist, he gives a practical account of different methods of executing drawings and cartoons, and of transferring the lines of the cartoon to the fresh plaster of the wall, on which the fresco painter is to work. A chapter on colouring in mural pictures leads on to the account of the fresco process. As Vasari was in this an expert, his description and appreciation of the process form one of the most valuable parts of the treatise. He is enthusiastic in his praise of the method, which he calls the most masterly and most beautiful of all, on account of its directness and rapidity. Tempera painting on panel or on dry plaster is next discussed, and then follows a notice of oil painting on panel or canvas. The statement here made by Vasari that oil painting was invented by van Eyck is the earliest enunciation of a dogma that has given rise in recent times to a large amount of controversial writing. He goes on next to treat of the right method of mural painting in the oil medium, and in this last connection Vasari gives us the recipe he had finally adopted after years of experiment, and employed for preparing walls for the application of oil paint in the Palazzo Vecchio at Florence. The use of oil paint on a ground of slate or other kinds of stone furnishes matter for another chapter.

With chapter eleven begins what we may regard as a second division of this ' Introduction,' in which various processes of the decorative arts are grouped together under the head of Painting, on the ground of the pictorial effects produced by their means. Decorative painting, in the usual sense, is first described as executed in monochrome for permanence on the façades of buildings, or for temporary purposes on triumphal arches and similar structures ; and then follows a chapter on what is known as ' Sgraffito ' work, or decoration in plaster of two colours, especially valuable as the first statement of the method and aim of this process, which had been evolved

from *pâte-sur-pâte* pottery not long before Vasari's time. 'Grotesques' in modelled and stamped plaster are next described, and the uses of colour in various ways in connection with them are noticed, though with tantalizing brevity. Recipes for gilding follow, and then with a treatment of glass mosaic we pass on to a discussion of eight different kinds of decorative work, which interest Vasari chiefly because of their pictorial possibilities. Of glass mosaic, while he gives very good advice about the sort of design suitable for it, he says that it must be so executed as to look like painting and not like inlaid work. Some, he says, are so clever that they make it resemble fresco. Floor mosaics in coloured marbles are to appear exactly like a flat picture; works in tarsia, or wood inlays, are dismissed because they cannot do more than counterfeit painting without equalling it; stained glass windows, on the other hand, are lauded because they can be carried to the same perfection as fine pictures on panel. Enamel is noticed because it is of the nature of picture-work, and even damascening on metal 'partakes of the nature both of sculpture and of painting.' Lastly wood-engraving is only described under the form of the Chiaroscuri, or shaded prints, introduced early in the sixteenth century, though W. J. Linton in his work *The Masters of Wood Engraving* regards these as merely aping drawings, and hardly coming under the engraver's art at all!

To return for a moment in concluding to a comparison already drawn, the contrast is very significant between Vasari's attitude towards these decorative processes and that of the mediaeval writer Theophilus. Throughout his treatise Theophilus hardly says anything about design, or what is to be represented in the various materials. It is the materials themselves that are his concern, and the end before his eyes is the effect of beauty and sumptuousness in colour and texture that their skilful manipulation will secure. To Vasari these materials are chiefly of importance as producing something of the effect of painting, and though he deals with them and their manipu-lation from the technical point of view, the vision of the completed result as a picture hovers always before his eyes. In this Vasari was only following in his theoretical treatment

the actual facts of artistic development in his times. Since the beginning of the Renaissance period all the forms of industrial art which he describes had been gradually losing the purely decorative character which belonged to them in the mediaeval epoch, and were being hurried along at the chariot wheels of the triumphant art of painting. This is one of the two dangers to which these forms of art are always subject. The naturalism in design, which is encouraged by the popularity of the painter's art on its representative side, is as much opposed to their true genius as is the modern system of mechanical production, which deprives them of the charm they owe to the touch of the craftsman's personality. History brought it about that in the century after Vasari these arts were in a measure rescued from the too great predominance of the pictorial element, though they were subjected at the same time to the other unfavourable influence just hinted at. Italy, from which the artistic Renaissance had spread to other lands, ceased in the seventeenth century to be the main centre of production or of inspiration for the decorative arts, which rather found their home in Paris, where they were organized and encouraged as part of the state system. The *Manufacture des Meubles de la Couronne,* a creation of Louis XIV's minister Colbert, which had its headquarters at the Hotel des Gobelins and the Savonnerie, was a manufactory of decorative work of almost every kind and in the most varied materials. That this work, judged on an aesthetic standard, was cold and formal, and wanting in the breath of life which plays about all the productions of the mediaeval workshop, was an inevitable consequence of its systematized official character and of its environment. The lover of art will take more real pleasure in the output of the old-fashioned and more personal English craftsmanship of the seventeenth and eighteenth centuries, than in the artistic glories of the French state factories under the *Ancien Régime.* This native British craftsmanship was however struck into inanition a century ago by the apparition of machinery; and the result of half-a-century of the new industrial era was the Great Exhibition of 1851, wherein was displayed what was probably the greatest collection of artistic failures that the world has

ever beheld. In consequence agencies were then set on foot, and engineered by the Science and Art Department, to improve the artistic quality of industrial products, but unfortunately these were based on principles not wholly sound. The shibboleths ' Historic Ornament ' and ' Applied Ornament ' covered the desponding view that the decorative arts were dead, and that enrichment must henceforth not be a living thing, the concomitant and even the product of the work itself, but a dead or ' historic ' thing, that might be procured from books or museums and then ' applied ' as an afterthought to whatever was to be made a ' work of art.' The results of this system were not encouraging, and led to the revival of mediaeval ideas, which, embodied in the magnetic personality of William Morris, have done much to effect a real, though as yet not far-reaching artistic revival.

The first principle here is to discourage undue naturalism in ornamental design by withdrawing the decorative arts from the influence of painting, and attaching them rather to the arts of construction, under the beneficent control of which they did so well in the middle ages. The next principle, which is equally important, is to foster the personal element in decorative work, but at the same time to prevent individuality from becoming self-assertive and running into vagaries, by insisting on the vital connection of ornament with material and technique. For the worker to ornament a thing properly he must either have made it or at any rate be in intimate touch with the processes of fabrication, out of which the decorative treatment should grow. The fact that the more advanced Schools of Art in our own country, such as that at Birmingham, regard as essential parts of their equipment the range of workshops where technical processes are explained and studied, is an encouraging sign, and this return from the drawing-board and the book to the bench and the tool gives an additional practical value to the older treatises on the technique of the arts, of which Vasari's Introduction is one.

OF ARCHITECTURE

OF ARCHITECTURE

CHAPTER I.

Of the different kinds of Stone which are used by Architects for ornamental details, and in Sculpture for Statues; that is, Of Porphyry, Serpentine, Cipollaccio, Breccia, Granites, Paragon or Test-stone, Transparent Marbles, White Marbles and Veined Marbles, Cipollini, Saligni, Campanini, Travertine, Slate, Peperigno, Ischia Stone, Pietra Serena and Pietra Forte.

§ 1. *The author's object in the Discussion of Architecture.*

How great is the utility of Architecture it does not fall to me to tell, since the subject has been treated at length and most carefully by many writers. For this reason, leaving on one side the limes, sands, wood, iron armatures, mode of preparing the foundations, as well as everything else that is used in a building; disregarding also the questions of water and localities and sites, already enlarged on by Vitruvius[1] and by our own Leon Battista Alberti,[2]

[1] Before Vasari published his *Lives*, at least eight editions of Vitruvius had appeared. The Editio Princeps, 'curante Jo. Sulpitio Verulano,' is believed to have been issued at Rome about 1486, and in 1496 and 1497 reprints were published at Florence and at Venice. In 1511 appeared the important edition, with emendations and illustrations, by the famous architect Fra Giocondo of Verona, and this was reprinted in the Giunta edition at Florence in 1513. Other editions saw the light in 1522, 1523, 1543, and 1550. An Italian translation was published in 1521, a French one in 1547, and in 1548 one in German. The reverence of the architects of the Renaissance for Vitruvius was unbounded, and Michelangelo is said to have remarked that if a man could draw he would be able by the help of Vitruvius to become a good architect.

[2] Leon-Battista Alberti shares with Brunelleschi the distinction of representing in its highest form the artistic culture of the early age of Humanism. His principal

I shall only discuss, for the use of our artificers and for whoever likes to know, the essential qualities of buildings, and in what proportions they should be put together and of what parts composed in order to obtain that graceful beauty that is desired. In short, I shall collect all that seems to me necessary for the purpose in view.

§ 2. *Of the working of hard stones, and first of Porphyry.*

In order that the great difficulty of working very hard and compact stones may be clearly understood, we shall treat distinctly but briefly of every variety which our workmen handle, and first of porphyry.[3] This is a red stone, with minute white specks, brought into Italy from Egypt, where it is generally believed that the stone when quarried is softer than it is after it has been exposed to rain, frost and sunshine; because all these influences make it harder and more difficult to work.[4] Of this stone numberless works are to be seen, some of them shaped with the chisel, some sawn into shape, and some again

work *De Re Aedificatoria*, or, as it is also called, *De Architectura*, was published after his death, in 1485. It is divided, like the work of Vitruvius, into ten books, and is an exceedingly comprehensive treatise on the architectural art both in theory and practice, and on the position of architecture in relation to civilization and to society at large. It is written in a noble and elevated style, and, as the title implies, in Latin. It was translated into Italian by Bartoli and into English by J. Leoni (three volumes, folio, 1726). Alberti also wrote shorter tracts on Sculpture and Painting, as well as other works of a less specially artistic order.

[3] See Note on 'Porphyry and Porphyry Quarries' at the close of the 'Introduction' to Architecture, postea, p. 101, and A on the Frontispiece, which gives representations in colour of the stones Vasari mentions in these sections, omitting those familiarly known.

[4] If a stone be comparatively soft when quarried and become harder after exposure to the air, this is due to the elimination in the air of moisture that it held when in the earth. In a dry climate like that of Egypt there is little or no moisture for stones to hold, and the Egyptian porphyry, Mr. W. Brindley reports, is quite as hard when freshly quarried as after exposure. Vasari repeats this remark when he is dealing with granite in § 6, postea, p. 41. He has derived it from Alberti, who in *De Architectura*, bk. ii, ch. vii, notices perfectly correctly that the question is one of the comparative amount of moisture in the stone.

gradually worked up by means of wheels and emery.
There are many different examples in divers places; for
instance, square, round, and other pieces smoothed for
pavements, statues for edifices, a great number of columns
large and small, and fountains with various masks, all
carved with the greatest care. There are also sarcophagi
still extant, with figures in low and half relief, laboriously
wrought, as at the temple of Bacchus,[5] outside Rome, by
Sant' Agnese, where is said to be the sarcophagus of Santa
Costanza, daughter of the Emperor Constantine, on which
are carved many figures of children with grapes and vine-
leaves, that testify how great was his labour who worked
them in a stone so hard. There is another example in
an urn, near to the door known as the Porta Santa in
San Giovanni in Laterano, which is decorated with scenes
containing a great number of figures.[6] There is also in
the piazza della Ritonda a very beautiful urn made for
sepulchral purposes [7] that is worked with great care and

[5] 'Temple of Bacchus' was the name given at the Renaissance to the memorial
chapel containing the tomb of Constantia, daughter of Constantine the Great,
on the Via Nomentana close to S. Agnese, and now known as S. Costanza.
The name was suggested by the mosaics with vintage scenes on the barrel vault
of the aisle, which are of great interest and beauty. In Vasari's time this still
contained the porphyry sarcophagus where Constantia was laid, and of this he
goes on to speak. In 1788 Pius VI transferred it to his new Sala a Croce Greca
in the Vatican, where it now stands.

[6] This is the second of the two vast cubical porphyry sarcophagi in the Croce
Greca, and it is believed that it served once to contain the mortal remains
of Helena, mother of Constantine. It is much finer in execution than the
other, and exhibits a large number of figures in high relief, though incoherently
composed. The subject may be the victories of Constantine. It was originally in
the monument called 'Torre Pignattara,' the supposed mausoleum of Helena
on the Via Labicana, and was transported in the twelfth century by
Anastatius IV to the Lateran, whence Pius VI had it transferred to the Vatican.
The restoration of these huge sarcophagi cost an immense amount in money and
time. Massi (*Museo Pio-Clementino*, Roma, 1846, p. 157) states that the second
one absorbed the labour of twenty-five artificers, who worked at it day and night
for the space of nine years. Strzygowski, *Orient oder Rom*, 1901, notices the
sarcophagi.

[7] Urns, or, as the Italians called them, 'conche,' of porphyry, basalt, granite
and marble existed in great abundance in the Roman Thermae where they were

diligence. It is of extremely graceful and beautiful form, and is very different from the others. In the house of Egizio and of Fabio Sasso [8] there used to be a seated figure, measuring three and a half braccia, preserved to our days with the remains of the other statues in the Casa Farnese.[9] In the courtyard also of the Casa la Valle,[10] over a window, is a she-wolf most excellently sculptured,[11] and, in the garden of the same house, the

used for bathing purposes. From the seventh century onwards the Christians adopted these for sepulchral use and placed them in the churches, where many of them are still to be seen (Lanciani, *Storia degli Scavi*, Roma, 1902, I, 3, and Marangoni, *Delle Cose Gentilesche*, etc., Roma, 1744). Hence Vasari speaks of the porphyry urn of the Piazza della Rotonda (the Pantheon) as of sepulchral origin, and it was indeed rumoured to have held the ashes of Agrippa, and to have stood once on the apex of the pediment of the Pantheon portico. It was however an ancient bath vessel, and was found when Eugenius IV, 1431-39, first excavated and paved the piazza in front of the Pantheon. It was placed with two Egyptian lions in front of the portico, where it may be seen in the view of the Piazza della Rotonda in G. F. Falda's *Vedute delle Fabbriche*, etc., of 1665. Clement XII, 1730-40, who was a Corsini, had it transported for his own sepulchre to the Corsini chapel in the Lateran, where it now stands, with a modern cover. Vasari evidently admired this urn, and he mentions it again in the life of Antonio Rossellino, where he says of the sarcophagus of the monument of the Cardinal of Portugal in S. Miniato, ' La cassa tiene il garbo di quella di porfido che è in Roma sulla piazza della Ritonda.' (*Opere*, ed. Milanesi, III, 95.) See Lanciani, *Il Pantheon*, etc., Prima Relazione, Roma, 1882, p. 15, where the older authorities are quoted. Of all the bath vases of this kind now visible in Rome, the finest known to the writers is the urn of green porphyry, a rare and beautiful stone, behind the high altar of S. Nicola in Carcere. It is nearly six ft. long, and on each side has two Medusa heads in relief worked in the same piece, with the usual lion's head on one side at the bottom for egress of water. The workmanship is superb. It may be noted that the existing baptismal font in St. Peter's, in the first chapel on the left on entering, is the cover of the porphyry sarcophagus of Hadrian turned upside down. It measures 13 ft. in length by 6 ft. in width.

[8] In chapter VI of the ' Introduction ' to Architecture, postea, p. 93, Vasari writes of the ' casa di Messer Egidio et Fabio Sasso ' as being ' in Parione.' See Note at the end of the ' Introduction ' to Architecture on ' The Sassi, della Valle, and other Collections of Antiques of the early part of the sixteenth century,' postea, p. 102 f.

[9] This is the ' Apollo ' at Naples, No. 6281. See Note as above.

[10] See Note above mentioned.

[11] Now lost.

two prisoners bound, each four braccia in height,[12] executed in this same porphyry by the ancients with extraordinary skill. These works are lavishly praised to-day by all skilled persons, knowing, as they do, the difficulty the workers had in executing them owing to the hardness of the stone.

In our day stone of this sort is never wrought to perfection,[13] because our artificers have lost the art of tempering the chisels and other instruments for working them. It is true that they can still, with the help of emery, saw drums of columns into slices, and cut other pieces to be arranged in patterns for floors, and make various other ornaments for buildings. The porphyry is reduced little by little by means of a copper saw, without teeth, drawn backwards and forwards between two men, which, with the aid of emery reduced to powder, and kept constantly wet with water, finally cuts its way through the stone.[14] Although at different times many ingenious attempts have been made to find out the method of working porphyry used by the ancients,[15] all have been in vain, and Leon Battista

[12] Now in the Boboli Gardens at Florence. See Note on the Sassi, etc., Collections.

[13] See Note on 'The Revival of Sculpture in Porphyry,' postea, p. 110 f.

[14] Reciprocating saws of the kind Vasari mentions, mostly of soft steel or iron, and also circular saws, are in use at the present day, the abrasives being emery, or a new material called 'carborundum.' This consists in minute crystals of intense hardness gained by fusing by an electric current a mixture of clay and similar substances. See *The Times*, Engineering Supplement, Oct. 31, 1906.

[15] It needs hardly to be said that the ancients had no 'secrets' such as Vasari hints at. Mr. W. Brindley believes that the antique methods of quarrying and working hard stones were 'precisely the same as our own were until a few years ago,' that is to say that the blocks were detached from the quarry and split with metal wedges, dressed roughly to shape with large and small picks, and 'rubbed down with flat stone rubbers and sand, then polished with bronze or copper rubbers with emery powder' (*Transactions*, R.I.B.A., 1888, p. 25). At a very early date in Egyptian history, even before the dynastic period, the hardest stones (not excepting porphyry) were successfully manipulated, and vases and bowls of these materials cut with exquisite precision. Professor Flinders Petrie found evidence that at the epoch of the great pyramids tubular drills and bronze saws set with gem-stones (corundum) were employed by the Egyptians in hollowing basalt sarcophagi and cutting the harder stones (*The Pyramids and Temples of Ghizeh*, London, 1883, p. 173 f.). There is however no evidence of the use of these

Alberti, the first to make experiments therein not how-
ever in things of great moment, did not find, among the
many tempering-baths that he put to the test, any that
answered better than goats' blood; because, though in
the working it removed but little of that hardest of stones
and was always striking sparks of fire, it served him
nevertheless so far as to enable him to have carved, in
the threshold of the principal door of Santa Maria Novella
in Florence, the eighteen antique letters, very large and
well proportioned, which are seen on the front of the step,
in a piece of porphyry. These letters form the words
BERNARDO ORICELLARIO.[16] And because the edge of the
chisel did not suit for squaring the corners, or giving

advanced appliances by the Greeks or Romans. It must not be forgotten that
even before the age of metals the neolithic artificers of western Europe could not
only cut and bore, but also ornament with patterns, stone hammer-heads of the
most intractable materials, with the aid only of pieces of wood twirled or rubbed
on the place and plentifully fed with sand and water. The stone axe- and hammer-
heads so common in pre-historic collections were bored with tubular drills, made
probably from reeds, which cut out a solid core. Such cores can still be seen in
partly-pierced hammer-heads in the Museum at Stockholm, and elsewhere.

[16] Fig. 1 shows the inscription of which Vasari writes and the situation of it on
the riser of the step is seen on Plate II. The porphyry slab is 3 ft. 5 in. long and
5½ in. high. The tongues at the ends are in separate pieces. The letters,
nineteen not eighteen in number, are close upon 2 in. in height and are cleanly
cut with V-shaped incisions. The illustration shows the form of the letters which
Vasari justly praises. The name 'Oricellario' or -us was derived by the dis-
tinguished Florentine family that bore it from the plant Oricello, orchil, which
was employed for making a beautiful purple dye, from the importation of which
from the Levant the family gained wealth and importance. The shortened
popular form of the name 'Rucellai' is that by which the family is familiarly
known. Giovanni Rucellai gave a commission to Alberti to complete the façade
of S. Maria Novella, which was carried out by 1470. The Bernardo Rucellai of
the inscription, the son of Giovanni, was known as a historian, and owned the
gardens where the Platonic Academy had at one time its place of meeting.
Fineschi, in his *Forestiero Istruito in S. Maria Novella*, Firenze, 1790, says that
Bernardo desired to be buried in front of the church and had the inscription cut
for sepulchral purposes. The existence of sepulchral 'avelli' of distinguished
Florentine families at the front of the church makes this seem likely, and in this
case the lettering would be after Alberti's time, though as Fineschi believes, the
earliest existing work of the kind in hard stone at Florence. See Rev. J. Wood
Brown, *S. Maria Novella*, Edinburgh, 1902, p. 114.

the necessary polish and finish, he had a little revolving drill made, with a handle like a spit, which was easily worked by placing the said handle against the chest, and putting the hands into the crank in order to turn it.[17] At the working end, instead of a chisel or bit, he fixed copper discs, larger or smaller according to need, and these, well sprinkled with emery, gradually reduced and smoothed the stone, producing a fine surface and finishing the corners, the drill all the while being dexterously twirled by the hand. But all this effort cost so much time, that Leon Battista lost heart, and did not put his hand to anything else, either in the way of statues, or vases, or other delicate work. Others, afterwards, who set them-selves to smoothing stones and restoring columns by the

FIG. 1.—Inscribed Porphyry Tablet at Santa Maria Novella, Florence.

same special process, have done it in this way. They make for the purpose large and heavy hammers, with the points of steel, keenly tempered with goats' blood, and worked in the manner of diamond points; with these they carefully tap on the porphyry, and 'scabbling' it, or working it down, little by little the best way they can, finally reduce it, with much time and trouble, to the round or the flat, as the workman chooses,—not however to the form of statues, because of this we have lost the art—and they polish it with emery and leather, scouring it till there comes a lustre very clear and well finished.

Now although every day refinements are being made on human inventions, and new things enquired into, yet even the moderns, who from time to time have tried fresh methods of carving porphyry, various tempering-baths, and very carefully refined steels, have, as was said above, up till recent years laboured in vain. Thus in

[17] After the fashion of an ordinary carpenter's 'brace.'

the year 1553 Pope Julius III, having been presented by Signor Ascanio Colonna [18] with a very handsome antique porphyry basin, measuring seven braccia across, ordered it to be restored, for some pieces were missing, that it might adorn his vineyard : the work was undertaken, and many things tried by the advice of Michelagnolo Buonarroti and of other excellent masters, but after a great length of time the enterprise was despaired of, chiefly because it was found impossible to preserve some of the arrises, a matter essential to the undertaking : Michel-agnolo, moreover, even though accustomed to the hardness of stones, gave up the attempt, as did all the others, and nothing more was done.

At last, since no other thing in our days was lacking to the perfection of our arts, except the method of satisfactorily working porphyry, that not even this should still be to seek, it was rediscovered in the following manner. In the year 1555, Duke Cosimo, wishing to erect a fountain of remarkable beauty in the court of his principal palace in Florence, had excellent water led there from the Pitti Palace and Garden, and ordered a basin with its pedestal to be made for the said fountain from some large pieces of porphyry found among broken fragments. To make the working of it more easy to the master, he caused an extract to be distilled from an herb, the name of which is unknown to me, and this extract had such virtue, that red-hot tools when plunged into it acquired the hardest possible temper. With the aid of this process then, Francesco del Tadda, the carver of Fiesole, [19] executed after my design the basin of the said fountain, which is two and a half braccia in diameter, [20] together with its pedestal, just as it may be

[18] See Note on 'The Porphyry Tazza of the Sala Rotonda of the Vatican,' at the close of the ' Introduction ' to Architecture, postea, p. 108.

[19] See Note at the end of the ' Introduction ' to Architecture, postea, p. 110 f., on ' Francesco del Tadda and, the Revival of Sculpture in Porphyry.'

[20] About 4 ft. 9 in. In a letter of May 1557 in Gaye, *Carteggio*, II, 419, Vasari mentions the work as nearly finished.

PLATE II

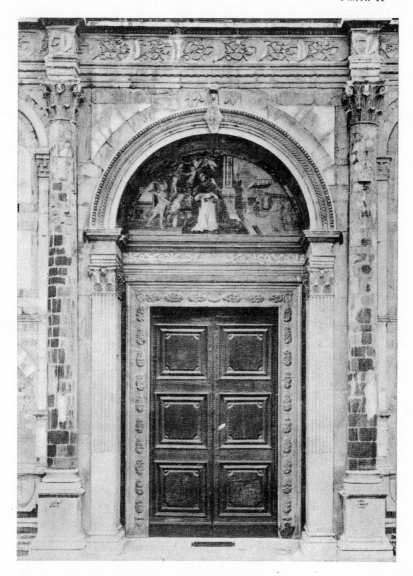

PRINCIPAL DOORWAY AT S. MARIA NOVELLA, FLORENCE

Showing the position of the inscribed porphyry tablet on the riser of the step

seen to-day in the above-named palace.[21] Tadda, judging that the secret imparted to him by the duke was very precious, set himself to put it to the test by carving something, and he has succeeded so well that in a short time he has made, in three ovals, life-size portraits in half-relief of Duke Cosimo and of the duchess Leonora, and a head of Christ, executed so perfectly that the hair and beard, most difficult to reproduce in carving, are finished in a manner equal to that of the ancients. The Duke was talking one day of these works with Michelagnolo [22] when his Excellency was in Rome, and Buonarroti would not believe in them; therefore, by the Duke's order, I sent the head of Christ to Rome where it was seen by Michelagnolo with great wonder, who praised it highly and rejoiced greatly to see the sculpture of our time enriched by this rare gift, which until our day had been searched for in vain. Tadda has recently finished the head of the elder Cosimo de' Medici [23] in an oval, like those mentioned above, and he has executed and continues to execute many other similar works.

All that remains to be said of porphyry is that, because the quarries are now lost to knowledge,[24] it is necessary to make use of what is left of it in the form of ancient fragments, drums of columns and other pieces; and that

[21] The palace in question is the well-known Palazzo Vecchio at Florence, which was adapted for the Grand-ducal residence largely by Vasari himself under the Grand Dukes Cosimo and his successor Francesco. The fountain is the one at present in the courtyard of the palace, carrying the beautiful bronze figure of a boy with a dolphin, by Verrocchio. This 'putto' was brought in from the famous Medicean Villa at Careggi, the seat of the Platonic Academy, for the purpose of completing the fountain of which Vasari here gives an account. The porphyry work, both in design and execution, is worthy of the beautiful bronze that surmounts it. The basin rests on a well-turned dwarf pillar of porphyry and this on a square base of the same material. The surfaces are true and the arrises sharp, and the whole is carried out in a workmanlike manner, and by no means betrays a 'prentice hand.'

[22] See Vasari's Life of Michelangelo, *Opere*, ed. Milanesi, VII, 260.

[23] That is Cosimo 'Pater Patriae,' who died at Careggi in 1464. The portrait in question is shown on Plate III. For what is known about this and other works by Francesco del Tadda, see postea, p. 113 f.

[24] See Note on 'Porphyry and Porphyry Quarries,' postea, p. 101.

in consequence he who works in porphyry must ascertain whether or not it has been subjected to the action of fire, because if it have, although it does not completely lose its colour, nor crumble away, it lacks much of its natural vividness and never takes so good a polish as when it has not been so subjected; and, what is worse, it easily fractures in the working. It is also worth knowing, as regards the nature of porphyry, that, if put into the furnace, it does not burn away (non si cuoce),[25] nor allow other stones round it to be thoroughly burnt; indeed, as to itself, it grows raw (incrudelisce) as is shown in the two columns the men of Pisa gave to the Florentines in the year 1117 after the acquisition of Majorca. These columns now stand at the principal door of the church of San Giovanni; they are colourless and not very well polished in consequence of having passed through fire, as Giovanni Villani relates in his history.[26]

[25] This remark is evidently derived by Vasari from Leon Battista Alberti, who writes as follows in *De Re Aedificatoria*, Lib. II, 'At nos de porphirite lapide compertum habemus non modo flammis non excoqui, verum et contigua quaeque circumhereant saxa intra fornacem reddere ut ignibus ne quidquam satis exquoquantur.' The sense of 'excoqui' in this passage, and of Vasari's 'cuocer,' is somewhat obscure, but can be interpreted by reference to old writings on stones, in which great importance is given to their comparative power of resistance to fire. See Pliny, *Hist. Nat.*, XXXVI, 22, etc., etc. Theophrastus, Περὶ Λίθων, §4, has the following: 'Stones have many special properties . . . for some are consumed by fire and others resist it . . . and in respect of the action of the fire and the burning they show many differences . . .' The 'excoqui' of Alberti probably refers to the resistance of porphyry to the fire as compared with the submission to it of stones like limestone, which are 'burnt out' or calcined by the heat. Vasari's 'non si cuoce' is not an adequate translation of Alberti's word 'excoqui.' With a blast heat porphyry fuses to a sort of obsidian or slag, but a moderate heat only causes it to lose its fine purple hue and become grey. This is the 'rawness' implied in Vasari's word 'incrudelisce.' To us rawness suggests raw meat which is redder in colour than cooked, but the Italians, who are not great meat eaters, would have in their minds the action of fire on cakes and similar comestibles that darken when baked, and an Italian artist would think too of the action of fire on clay, 'che viene rossa quando ella è cotta' as he says in chapter XXV of the 'Introduction' to Painting. See Frontispiece, where AI, compared with A, shows the effect of fire on the stone.

[26] The two porphyry columns, that stand one on each side of Ghiberti's Old Testament gates at the eastern door of the Baptistry of Florence, serve to point

PLATE III

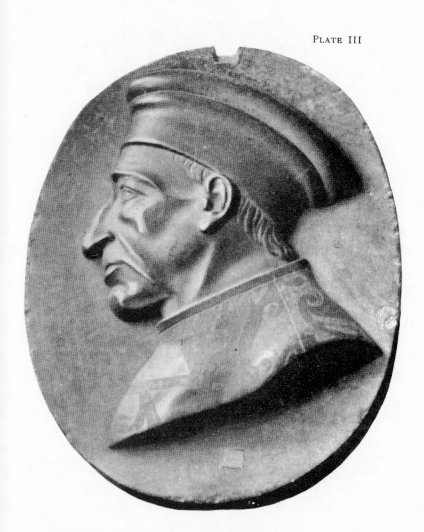

PORTRAIT IN PORPHYRY OF COSIMO 'PATER PATRIAE'
BY FRANCESCO DEL TADDA

§ 3. Of Serpentine.

After porphyry we come to serpentine,[27] which is a green stone, rather dark, with little crosses long and yellowish all through its texture. The artificers busy themselves with making columns and slabs for pavements in edifices from it, in the same way as from porphyry. It is never seen carved into figures, although it is very

a moral about the untrustworthiness of popular sayings. When these apply to monuments it usually happens that the monument itself hopelessly discredits the saying. The porphyry columns in question are perfectly normal in colour and show no recognizable trace of the action of fire. Villani (*Chronicle*, bk. IV, ch. 31) says of these columns 'The Pisani sent them to Florence covered with scarlet cloth, and some said that before they sent them they put them in the fire for envy.' If we rationalize a little we can imagine that the scarlet cloth, the use of which by the Pisans in connection with porphyry shows a most lamentable absence of taste in colour, would at first sight seem to take the colour out of the porphyry and make it look grey through contrast. Hence may have arisen the impression which gave rise to the saying. Boccaccio, in his commentary on the passage in Dante (*Inferno*, XV, 67), in which the 'blindness' of the Florentines is referred to, notices this affair of the columns as one explanation of this accusation against his countrymen.

[27] On the subject of serpentine some misapprehension exists. Mineralogists apply the term to a soft stone of a green hue with long curling markings through it, which in their form suggest lacertine creatures and account for the name of the stone. It derives its colour from the presence of a large percentage of manganese in union with silica, and contains twelve or so per cent. of water. A penknife scores it easily. The 'Verde di Prato,' a dark stone used in bands on Tuscan buildings, of which there is question in a subsequent section, postea, p. 43, is a species of true serpentine.

On the other hand the word 'serpentine' is in common use for a dark green stone of quite a different kind, that occurs very commonly in ancient Roman tesselated pavements, and it is this false serpentine that Vasari has in view. It is very hard indeed, and a penknife does not mark it. Professor Bonney describes it as 'a somewhat altered porphyritic basalt,' and it is full of scattered crystals of a paler green composed of plagioclasic felspar. These crystals average about the size of grains of maize and they sometimes cross each other, thus justifying Vasari's description of them. A specimen is B, on the Frontispiece. This stone was found in Egypt, and it is probably the 'Augustan' and 'Tiberian' stone mentioned by Pliny, *Hist. Nat.*, XXXVI, 7. See *Transactions*, R.I.B.A., 1888, p. 9. The chief quarry of it however was in the Peloponnesus to the south of Sparta, and the produce of this is called by Pliny, loc. cit., 'Lacedaemonium viride.' It should be noted that 'Verde Antico,' a green marble of which the chief quarries are in Thessaly, is distinct from both the true and the false 'serpentine.'

often used for the bases of columns, the pedestals of tables, and other works of a ruder kind. Though this sort of stone is liable to fracture, and is harder than porphyry, it is sweeter to work and involves less labour. Serpentine is quarried in Egypt and Greece and the sound pieces are not very large; consequently no work of greater dimensions than three braccia in any direction is ever seen of serpentine, and such works as exist are slabs and pieces of pavement. A few columns are found also but not very massive nor thick, as well as some masks and sculptured brackets, but figures never. This stone is worked in the same manner as porphyry.

§ 4. Of Cipollaccio.

Softer than serpentine is cipollaccio,[28] a stone quarried in various places; it is of a crude yellowish green colour and has within it some square black marks, large and small, and also biggish white marks. Of this material one may see in various places columns both massive and slender, as well as doors and other ornaments, but not figures. There is a fountain of this stone in Rome in the Belvedere, that is to say a niche in a corner of the garden where are the statues of the Nile and of the Tiber;[29] Pope Clement VII had this niche made, after a design by Michelagnolo,[30] to adorn the statue of a river god that

[28] Cipollaccio. It is not clear what is the difference, if any exist, between the stone thus called and the 'Cipollino' which Vasari discusses in a later section, postea, p. 49. The latter is a name in universal employment, but the term 'Cipollaccio' is not known to Cavaliere Marchionni, the courteous Director of the Florentine State Manufactory of Mosaics, nor is it recognized at Carrara. On the other hand it is given as the name of a marble in Tomaseo's *Dizionario* (though probably only on the strength of this mention in Vasari) and a stone worker at Settignano claimed to know and use the word. On the material see the Note on 'Cipollino,' postea, p. 49. The terminations '-accio' and '-ino' are dear to the Florentines—Mas*accio* and Maso*lino* will occur to everyone.

[29] This is the 'Cortile di Belvedere' where the Laocoon and Apollo Belvedere are located. See Note 30.

[30] On Michelangelo's niche and fountain see the Note on 'The Cortile of the Belvedere in the Vatican in the sixteenth century,' at the end of the 'Introduction' to Architecture, postea, p. 115. The 'river god' is the 'Tigris' of the Vatican.

it might look very beautiful in this setting made in imitation of natural rocks, as indeed it actually does. Cipollaccio is also sawn into panels, round and oval, and into similar pieces which, when arranged with other stones in pavements and other flat surfaces, make lovely compositions. It takes a polish like porphyry and serpentine and is sawn in the same manner. Numberless pieces of it are found in Rome, buried under the ruins; these come to light daily and thus of ancient things modern works are made, such as doors and other ornamental details, which, wherever placed, are decorative and very beautiful.

§ 5. *Of Breccia (' Mischio,' Conglomerate).*

Here is now another stone, called ' mischio ' (breccia),[31] from the mixture of various stones coagulated together and made one by time and by the mordant action of water. It is found in abundance in several places, as in the mountains of Verona, in those of Carrara, and of Prato in Tuscany, and in the hills of the Impruneta in the neighbourhood of Florence.[32] But the best and choicest breccias have been found, not long ago, at San Giusto at Monte Rantoli, five miles distant from Florence.[33] In this material Duke Cosimo has commissioned me to decorate all the new rooms of the palace with doors and chimney pieces, and

[31] Vasari's description of the variegated stones called breccias is clear and good. Corsi, *Delle Pietre Antiche*, Roma, 1845, p. 139, defines breccias as ' marbles formed of numerous fragments of other marbles either of one colour or of different colours, embedded in a calcareous cement.' The mineralogist distinguishes breccias from conglomerates by the fact that in the former the fragments embedded are angular, in the latter round like pebbles. The fragments need not be of marble. These breccias were greatly used at the Renaissance, as Vasari indicates, for the framing of doorways and for chimney pieces, but it may be questioned whether they are really suitable for such architectural use. For door jambs and similar constructive members a self-coloured stone, with its greater severity of effect, would be preferable. On the other hand, for panels and inlays and decorative uses generally, the variegated stones are quite in place. See C, D on the Frontispiece.

[32] See Note on 'Tuscan Marble Quarries' postea, p. 119 f.

[33] S. Giusto, commonly called S. Giusto a Monte Martiri, lies by Monte Rantoli, between the valleys of the Ema and Greve, to the south of Florence.

the effect is most beautiful. Also for the garden of the Pitti, very fine columns seven braccia high have been quarried from the same place, and I am astonished that in this stone such large pieces should be found free from flaws.[34] Being of the nature of limestone, it takes a beautiful polish and in colour inclines to a reddish purple streaked with white and yellowish veins. But the finest examples of all are in Greece and Egypt,[35] where the stone is much harder than ours in Italy, and it is found in as many different colours as mother nature has delighted and still delights to produce in all perfection. In the breccias formed in this way one sees at Rome at the present day both ancient and modern works, such as columns, vases, fountains, door ornaments, and various inlays on buildings, as well as many pieces in the pavements. There are various sorts, of many colours; some draw to yellow and red, others to white and black, others again to grey and white speckled with red and veined with numerous colours; then there are certain reds, greens, blacks and whites which are oriental : and of this sort of stone the Duke has an antique urn, four and a half braccia across, in his garden at the Pitti, a thing most precious, being as I said of oriental breccia very beautiful and extremely hard to work.[36] Such stones are all very hard, and exquisite in colour and quality, as is shown by

[34] Breccia columns answering to this description are to be seen in the lower part of the Boboli Gardens to the west of the 'island basin' with John of Bologna's 'Oceanus.'

[35] The Egyptian breccia is found at Hamamat to the east of Luxor. It consists, Mr. Brindley writes, in rich-coloured silicious fragments cemented together, and is very difficult to work and to polish, 'owing to the cementing matrix being frequently harder than the boulders.' Its general colour is greenish and it is called sometimes 'Breccia Verde.' The most important known work executed in this breccia is the grand sarcophagus of Nectanebes I, about 378 B.C., now in the British Museum. It is on the left in the large Hall a little beyond the Rosetta stone. *Transactions*, R.I.B.A., 1888, p. 24 ff.

[36] Signor Cornish, the courteous castellan of the Royal Palace, believes this to be the urn that now serves as the basin of the fountain surmounted with a figure of the Arno, near the Annalessa gate of the Boboli Gardens. It has two masks carved on the front, as is common in antique *conche* of the kind.

the two columns, twelve braccia high at the entrance of St. Peter's in Rome, which support the first arcades of the aisles, one on each side.[37] Of this stone, the kind which is found in the hills of Verona, is very much softer than the oriental; and in that place is quarried a sort which is reddish, and inclines towards a vetch colour.[38] All these kinds are worked easily in our days with the tempering-baths and the tools used for our own local stones. Windows, columns, fountains, pavements, door posts and mouldings are made of them, as is seen in Lombardy and indeed throughout Italy.

§ 6. Of Granite.

There is another sort of extremely hard stone, much coarser and speckled with black and white and sometimes with red, which, on account of its grain and consistency, is commonly called granite.[39] In Egypt it exists in solid masses of immense size that can be quarried in pieces incredibly long, such as are seen nowadays in Rome in obelisks, needles, pyramids, columns, and in those enormous vessels for baths which we have at San Pietro in Vincola, at San Salvadore del Lauro and at San Marco.[40]

[37] On entering the porch or narthex of St. Peter's by the central archway, the visitor may note on each side of the external opening a column of breccia, or strictly speaking of 'pavonazzetto brecciato,' over twenty-five feet in height. They are worn, patched, and discoloured, and evidently come from some earlier building. It can be reasonably conjectured that these are the two columns to which Vasari refers, and that they were originally in the old basilica which was being replaced in Vasari's time by the existing structure. Vasari would see them in their original position forming part of the colonnade between nave and aisles, for the entrance part of the old Constantinian basilica was still standing in the sixteenth century, and the columns were only removed to their present position when Paul V constructed the existing façade at the beginning of the century following.

[38] The familiar red Verona marble is not a true breccia, but a fossil marble.

[39] 'Granite' is from the Italian 'granito,' which means the 'grained' stone.

[40] The 'grandissimi vasi de' bagni,' to which Vasari here refers, are those vast granite bath-shaped urns, some twenty feet long, of which the best known is probably the specimen that stands by the obelisk in the centre of the amphitheatre of the Boboli Gardens at Florence. This, with a fellow urn, that stands

It is also seen in columns without number, which for hardness and compactness have had nothing to fear from fire or sword, so that time itself, that drives everything to ruin, not only has not destroyed them but has not even altered their colour. It was for this reason that the Egyptians made use of granite in the service of their dead, writing on these obelisks in their strange characters the lives of the great, to preserve the memory of their prowess and nobility.

From Egypt there used also to come another variety of grey granite, where the black and white specks draw rather towards green. It is certainly very hard, not so hard however, but that our stonecutters, in the building of St. Peter's, have made use of the fragments they have found, in such a manner that by means of the temper of the tools at present adopted, they have reduced the columns and other pieces to the desired slenderness and have given them a polish equal to that of porphyry.

Many parts of Italy are enriched with this grey granite, but the largest blocks found are in the island of Elba, where the Romans kept men continually employed in quarrying countless pieces of this rock.[41] Some of the

not far off in the Piazzale della Meridiana, came from the Villa Medici at Rome, and they may have been seen in Rome by Vasari before they were placed in that collection. No such urns are now to be found in or about any of the three churches at Rome here mentioned by Vasari. Documents however, recently published in the first volume of Lanciani's *Storia degli Scavi*, pp. 3-5, show that there stood formerly in the Piazza S. Salvatore in Lauro, north west from the Piazza Navona, a 'conca maximae capacitatis,' to which Vasari no doubt refers. Two other such conchae were found in the Thermae of Agrippa, and one was placed by Paul II, 1464-71, in the Piazza di S. Marco, which was then called 'Piazza della Conca di S. Marco,' while the other was located by Paul III (Farnese), 1534-49, in front of his palace. Cardinal Odoardo Farnese afterwards united the two and formed with them the two fountains now in the Piazza Farnese. Lanciani also mentions a 'conca di bigio in S. Pietro in Vinculis.' There is a fine specimen, which may be one of those Vasari has mentioned, in front of the little church of S. Stefano at the back of St. Peter's. We wish cordially to thank Signor Cornish, of the Royal Palace, Florence, for information kindly given about the Boboli monuments.

[41] The quarries opened by the Romans in Elba are now practically abandoned.

columns of the portico of the Ritonda are made of it, and they are very beautiful and of extraordinary size.[42] It is noticed that the stone when in the quarry is far softer and more easy to work than after it has lain exposed.[43] It is true that for the most part it must be worked with picks that have a point, like those used for porphyry, and at the other end a sharp edge like a toothed chisel.[44] From a piece of this granite which was detached from the mass, Duke Cosimo has hollowed out a round basin twelve braccia broad in every direction and a table

The Catalogue to the Italian Section of the London International Exhibition of 1862 speaks of the granites of Elba as 'but little used, although blocks and columns of almost any size may be had.' In the late mediaeval and Renaissance period however, the quarries of Elba were worked, and the granite columns of the Baptistry of Pisa were cut there in the twelfth century, while Cosimo I extracted thence the granite block out of which he cut the tazza of the Boboli Gardens mentioned by Vasari a few sentences further on. Jervis, *I Tesori Sotterranei dell' Italia*, Torino, 1889, p. 315, speaks of the remains of Roman quarrying works to be seen on the Island. He believes that the grey columns of the Pantheon (see Note infra) are Elban, and Cellini (*Scultura*, ch. vi) claims an Elban origin for the granite column of S. Trinità, Florence, which is certainly antique and of Roman provenance, see postea, p. 110 f.

[42] The portico of the Pantheon is now supported by sixteen monoliths of granite nearly 40 ft. high. Seven of these in the foremost row are of grey granite, the eighth (that at the north-east angle) and all those behind are of red granite. The present portico is a reconstruction by Hadrian in octostyle form of the original decastyle portico built by Agrippa. Agrippa's portico had columns of a grey granite called 'granito del foro,' because it is the same kind that is used for the columns of the Forum of Trajan (Basilica Ulpia). This according to Corsi, *Delle Pietre Antiche*, Roma, 1845, is Egyptian from Syene, the Lapis Psaronius of Pliny, and Professor Lanciani, who has kindly written in reply to our question on the subject, endorses this opinion, though Jervis, see above, thinks the grey Pantheon columns are Elban. When Hadrian reconstructed the portico, he added columns of red granite, which are admitted by all to be Egyptian. The two columns at the east of the present portico were brought in in the year 1666 to fill gaps caused by the fall of the two Hadrianic ones. They came from the Baths of Nero and were found near S. Luigi dei Francesi. See postea, p. 128 f.

[43] See Note 4, ante, p. 26.

[44] The form of the pick Vasari seems to have in his mind is given in the sketch, C, Fig. 2, postea, p. 48. Among other tools figured in the illustration, A and B are some that are employed at this day in Egypt for the working of hard stones.

of the same length for the palace and garden of the Pitti.[45]

§ 7. Of Paragon (Touchstone).[46]

A kind of black stone, called paragon, is likewise quarried in Egypt and also in some parts of Greece. It is so named because it forms a test for trying gold; the workman rubs the gold on this stone and discerns its colour, and on this account, used as it is for comparing or testing, it comes to be named paragon, or index-stone (a). Of this there is another variety, with a different grain and colour, for it has, almost but not quite, the tint of the mulberry, and does not lend itself readily to the tool. It was used by the ancients for some of those sphinxes and other animals seen in various places in Rome, and for a figure of greater size, a hermaphrodite in Parione,[47] alongside of another most beautiful statue of porphyry.[48] This stone is hard to carve, but is extraordinarily beautiful and takes a wonderful polish (b). The same sort is also to be found in Tuscany, in the hills of Prato, ten miles distant from Florence (c), and in the mountains of Carrara. On modern tombs many sarcophagi and repositories for the dead are to be seen of it; for example, in the principal chapel in the Carmine at Florence, where is the tomb of Piero Soderini (although

[45] This tazza is still in evidence and serves as the basin of the great fountain in the 'island' lake in the western part of the Boboli Gardens. It is said that Duke Cosimo extracted a second tazza larger than this one from the Elban quarry but it was unfortunately broken. Signor Cornish says the fragments are still to be seen. The sculptor Tribolo was sent to Elba to obtain the basins. Of the 'tavola' or table nothing is known.

[46] In this apparently innocent section Vasari has mixed up notices of some half-dozen different kinds of stone, on most of which his ideas are somewhat vague. Hence a separate Note is required, and this will be found at the end of the 'Introduction' to Architecture, postea, p. 117 ('Paragon and other Stones associated with it by Vasari'). The letters (a), (b), etc., are referred to in the Note.

[47] The 'Apollo' at Naples, in basalt, no. 6262. See Note, postea, p. 104.

[48] The porphyry 'Apollo' at Naples, no. 6281. See Note, as above.

he is not within it) made of this stone, and a canopy too of this same Prato touchstone, so well finished and so lustrous that it looks like a piece of satin rather than a cut and polished stone (d). Thus again, in the facing which covers the outside of the church of Santa Maria del Fiore in Florence, all over the building, there is a different kind of black marble (e) and red marble (f), but all worked in the same manner.

§ 8. *Of Transparent Marbles for filling window openings.*

Some sorts of marble are found in Greece and in all parts of the East, which are white and yellowish, and very transparent. These were used by the ancients for baths and hot-air chambers and for all those places which need protection against wind, and in our own days there are still to be seen in the tribune of San Miniato a Monte, the abode of the monks of Monte Oliveto, above the gates of Florence, some windows of this marble, which admit light but not air.[49] By means of this invention people gave light to their dwellings and kept out the cold.

§ 9. *Of Statuary Marbles.*

From the same quarries [50] were taken other marbles free from veins, but of the same colour, out of which were carved the noblest statues. These marbles were of a

[49] The five eastern window-openings of S. Miniato are filled with slabs of antique pavonazzetto with red-purple markings, nearly two inches thick and measuring in surface about 9 ft. by 3 ft. The windows are square headed. The slabs transmit the light unequally according to the darker or lighter patches in their markings, but the effect is pleasing. Similar window-fillings are to be seen at Orvieto. 'Almost any marble,' it has been said, 'with crystalline statuary ground, an inch thick, placed on the sunny side of a church in Italy would admit sufficient light for worship, but it would not do in our variable climate.' The so-called Onyx marbles of Algeria and Mexico, as well as Oriental alabasters, are specially suitable for the purpose here in view. The 'white and yellowish' eastern marbles that Vasari writes of were probably of this kind.

[50] By 'the same quarries' Vasari means, no doubt, those of Egypt and Greece, of Carrara, of Prato, etc., mentioned in § 7 in connection with 'paragon.' On the subject see the Note on 'Tuscan Marble Quarries,' postea, p. 119 f.

very fine grain and consistency, and they were continually being made use of by all who carved capitals and other architectural ornaments. The blocks available for sculpture were of great size as appears in the ˙Colossi of Montecavallo at Rome,[51] in the Nile [52] of the Belvedere and in all the most famous and noble statues. Apart from the question of the marble, one can recognize these to be Greek from the fashion of the head, the arrangement of the hair, and from the nose, which from its juncture

[51] The reference is to the two so-called 'Horse-Tamers' opposite the Quirinal Palace at Rome, that probably once stood in front of the Thermae of Constantine, which occupied the slope of the Quirinal. The figures of the youths, perhaps representing the Dioscuri, are eighteen feet high, and the material was long ago pronounced Thasian marble (see Matz-Duhn, *Antike Bildwerke in Rom*, Leipzig, 1881, I, 268). The works are Roman copies of Greek originals. They have recently been overhauled, with very good result as regards their appearance. The sculptor, Professor Ettore Ferrari, who superintended this work, reports that the material is 'marmo greco,' which may be held to settle the question in favour of Greek as against Luna marble.

[52] The 'Nile' is now in the Braccio Nuovo of the Vatican, the fellow-statue, the 'Tiber,' see ante, p. 36, in the Louvre at Paris. They are said to have been discovered at Rome early in the sixteenth century, near S. Maria Sopra Minerva where was the Temple of Isis and Serapis, and Pope Leo X had them placed in the Cortile di Belvedere of the Vatican. They were removed to Paris in 'the year X' by Napoleon, and in 1815 the 'Nile' was sent back to Rome, the 'Tiber' remaining in the Louvre. The 'Nile' is much the better work of art and is a copy or a study from an Alexandrian original, perhaps the 'Nilus' in basalt, which, according to Pliny, *Hist. Nat.*, XXXVI, 7, Augustus dedicated in the Temple of Peace. Amelung, in his *Sculpturen des Vaticanischen Museums*, only states that the 'Nile' is in 'grobkornigem Marmor.' The material of the statue certainly differs from that of the restored parts, and we should guess it as Pentelic marble repaired with Carrara. About the 'Tiber,' Froener, in the Louvre Catalogue, states that it is of Pentelic marble, and it is so labelled. Our measurements show that both statues required blocks of the dimensions 10 ft. by 5 ft. by 5 ft. in height. It may be noted that the finest statuary marble known, that of the island of Paros, is not to be obtained in very large blocks. That out of which the Hermes of Praxiteles has been carved must have measured about 8 ft. by 5 ft. by 3 ft. 6 in. and is considered an exceptionally fine block. Pentelic and Carrara marble can be obtained in much larger pieces. We saw not long ago in the modern quarries behind Mount Pentelicus a block nearly 20 ft. in cube. One seventeen feet long has recently been cut in the Monte Altissimo quarries in the Carrara mountains for a copy of the 'David' of Michelangelo. A piece of Monte Altissimo marble of the best quality is shown as J on the Frontispiece.

with the eyebrows down to the nostril is somewhat square.[53] This marble is worked with ordinary tools and with drills, and is polished with pumice-stone, with chalk from Tripoli, and with leather and wisps of straw.

In the mountains of Carrara in the Carfagnana,[54] near to the heights of Luni, there are many varieties of marble, some black,[55] some verging towards grey, some mingled with red and others again with grey veins.[56] These form an outer crust over the white marbles, and they take those colours, because they are not refined, but rather are smitten by time, water and the soil. Again, there are other sorts of marble, called ' cipollini,'[57] ' saligni,' ' campanini ' and ' mischiati.'[58] The most abundant kind is pure white and milky in tone; it is easy to work and quite perfect for carving into figures. Enormous blocks lie there ready to be quarried, and in our own days, pieces measuring nine braccia have been hewn out for colossal statues. Two of these colossi have recently been sculptured, each from a single block. The one is Michelagnolo's ' David,' which is at the entrance of the Ducal Palace in Florence ; [59]

[53] This remark shows a just observation on the part of Vasari. The Greek nose is markedly different from the Florentine. The latter, as may be seen in the ' St. George ' of Donatello, or the ' David ' of Michelangelo, has more shape than the classical nose. There is more difference marked between the nasal bone and the cartilaginous prolongation towards the tip, and there is more modelling about the nostril, which the Italian sculptors make thinner and more sensitive.

[54] The Carfagnana, or more properly Garfagnana, is the name applied to the upper part of the valley of the Serchio, between the Apennines and the Apuan Alps, on the western slopes of which the marble quarries are situated. See Note on ' Tuscan Marble Quarries,' postea, p. 119 f., for the different marbles and their provenance.

[55] Benvenuto Cellini, *Scultura*, ch. iv, mentions this black marble from Carrara, which he says is very hard and brittle and difficult to work. Black marble is still quarried in the Carrara district, but only to a small extent.

[56] The grey marble is that known now as ' Bardiglio '; the grey-veined ' Marmo-' or ' Bardiglio-' ' fiorito '; the red, ' Breccia.'

[57] For ' Cipollino ' see footnote 70 on p. 49, postea.

[58] The ' Mischiati ' are the variegated stones we know as ' Breccias,' already noticed in § 5. Vasari explains the names ' Saligni ' and ' Campanini ' in § 10. The terms are not now in use.

[59] The ' David ' stood formerly on the left hand side as one entered the gateway of the Ducal Palace, or Palazzo Vecchio. It is 15 feet high. In 1873 it was

the other is the ' Hercules and Cacus ' from the hand of Bandinello standing at the other side of the same entrance. Another block of nine braccia in length was taken out of the quarry a few years ago, in order that the same Baccio Bandinello should carve a figure of Neptune for the fountain which the Duke is having erected on the piazza. But, Bandinello being dead, it has since been given to Ammannato, an excellent sculptor, for him likewise to carve a Neptune out of it.[60] But of all these marbles, that of the quarry named Polvaccio,[61] in the place of that name, has the fewest blemishes and veins and is free from those knots and nuts which very often occur in an extended surface of marble—occasioning no little difficulty to the worker, and spoiling the statues even when they are finished. From the quarries of Seravezza, near to Pietrasanta, there have been taken out a set of columns, all of the same height, destined for the façade of San Lorenzo at Florence, which is now sketched out in front of the door of that church;[62] one of these

removed, and is now in the Academy, but Bandinello's group still holds its original position to the right of the entrance, on the side towards the Uffizi.

[60] The existing figure of Neptune is the work of Ammanati, to whom Florence owes the stately Ponte S. Trinità. The subsidiary figures of sea-deities on the fountain are by other hands.

[61] See Note, postea, p. 119 f.

[62] On the subject of the Seravezza quarries and their exploitation by Michelangelo see Note, as above. With regard to the Façade of S. Lorenzo much might be said, as the project for its completion has now again come forward into prominence. See articles by Sig. B. Supino in *L'Arte*, Anno IV, fasc. 7, and M. Marcel Reymond in the *Revue Archéologique* for 1906. It is well known that Brunelleschi, who reconstructed the basilica in the fifteenth century, left the façade incomplete and with no indication of his design for it. As it was the church of the Medici, the popes of this family, Leo X and Clement VII, furthered by means of a competition a grand project for its completion ; and in this work Michelangelo was for many years involved. Drawings of his for the proposed façade are to be seen in the Casa Buonarroti, and he prepared marbles, as noticed in the Note, postea, p. 119 f., but the preparations proved abortive.

What Vasari says about Michelangelo's façade that it ' è oggi abbozzata fuor della porta di detta chiesa,' and that there is one column on the spot, is interesting but not very easy to understand. Milanesi, in a note on this passage in his edition of Vasari, I, 119, going one better than the Lemonnier editors, gives a circum-

columns is to be seen there, the rest remain, some in the quarry, some at the seashore.

But returning to the quarries of Pietrasanta,[63] I say that they were the quarries in which all the ancients worked, and no other marbles but these were used for their statues by those masters, who were so excellent. While the masses were being hewn out, they were always at work, blocking out figures in the rough on the stones while they were still in the quarry. The remains of many of these can be seen even yet in that place.[64] This same marble, then, the moderns of to-day use for their statues, not only in Italy, but in France, England, Spain and Portugal, as can be seen to-day in the tomb executed in Naples by Giovan da Nola, the excellent sculptor, for Don Pietro di Toledo, viceroy of that kingdom, to whom all the marbles were presented, and sent to Naples by Duke Cosimo de' Medici.[65] This kind of marble has in itself larger available pieces and is more yielding and softer to work and receives a finer polish than any other marble. It is true that occasionally the workman meets with flaws called by the sculptors ' smerigli ' (emery veins)

stantial account to the effect that 'The preliminary work (abbozzata) which was outside the church in the days of Vasari, was buried in the first years of the seventeenth century, along with other architectural fragments, in a trench excavated on the piazza along the left side of the church.' Unfortunately among the authorities at S. Lorenzo this statement is smiled at as a mere popular legend, but it is hoped that in connection with the long-delayed completion, which is now again on the *tapis*, the truth on this matter will come to light.

[63] Milanesi remarks, ad loc., that for ' Pietrasanta ' Vasari should have written ' Carrara,' as the quarries at the latter place were actually exploited by the ancients, whereas the Pietrasanta workings were only opened up in the time of Michelangelo. See postea, p. 122. The Pietrasanta people however do claim that the Romans were at work among their hills.

[64] There are abundant instances both from Greek and from Roman times of statues, heads, architectural members, columns, and the like, blocked out in the quarries, and still lying unfinished as they were left many hundreds of years ago.

[65] Vasari gives a notice of Giovanni da Nola, whose surname was Merliano, in the *Lives* of Alfonso Lombardi and other sculptors. See *Opere*, ed. Milanesi, v, 94 f. He there describes the tomb mentioned above, which was to have been transported to Spain, but owing to the death of the viceroy, Don Pietro, Marquis of Villafranca, it has remained in S. Giacomo at Naples.

which usually cause the tools to break. The blocks are first roughed into shape, by a tool called 'subbia' (point) [66] which is pointed like a stake in facets, and is heavier or lighter as the case may be. At the next stage are used chisels, named 'calcagnuoli' (toothed chisels),

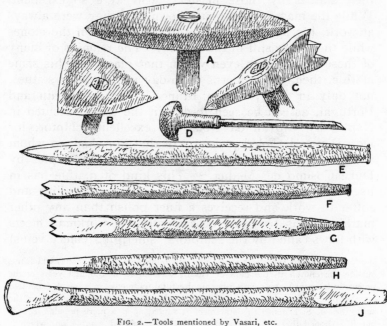

FIG. 2.—Tools mentioned by Vasari, etc.

A, B, Models of Tools used in Egypt at the present day for working hard stones.
C, The pick referred to by Vasari, p. 41.
D, A burin or graver.
E-J. Tools in actual use in a stone-cutter's yard at Settignano:

E, Subbia, a point.
F, Calcagnuolo, a toothed chisel.
G, Gradina, a broader toothed chisel.
H, Scarpello, a chisel.
J, Trapano, a drill.

which have a notch in the middle of the edge of the blade; after that finer and finer tools with more teeth are used to score the marble, after which it is smoothed with another chisel called 'gradina,' (broader toothed chisel) used to reduce and refine the figures. The tooth-marks left in the marble are removed with iron rasps straight and curved,

[66] Some of the tools of sculptors and masons referred to by Vasari are shown in Fig. 2, E—J, above.

and thus at last, by polishing gradually with pumice-stone the surface aimed at is attained. In order not to fracture the marble, all the drill-holes are made with drills of different sizes weighing from twelve pounds each even to twenty, according to the size of the hole needed,[67] and they serve to finish every sort of work and to bring it to perfection.

Of certain white marbles, streaked with grey,[68] sculptors and architects make ornaments for doors and columns for houses and the same are used also for pavements and for facings of large buildings, and for all sorts of things. All the marbles called ' mischiati ' [69] are used for the same purposes.

§ 10. Of Cipollino Marble.[70]

The cipollini marbles are another kind, different in grain and colour, and found in other places besides Carrara. Most of them are greenish, and full of veins; they are useful for various things, but not for figures.

[67] A worker in stones at Settignano knew of drills of the weight of about twelve pounds each, and thought twenty pounds conceivable, for very large work.

[68] Vasari seems to refer to the common greyish marble popularly called 'Sicilian.' There are finer kinds of veined marble called 'fioriti,' 'flowered,' including ' marmi fioriti' and 'bardigli fioriti,' the last in two shades of grey.

[69] i.e., the breccias noticed in § 5.

[70] 'Cipollino' marble, a very familiar material, receives its name from 'cipolla' an onion, but there is a curious divergence of opinion as to the reason of the appellation. (1) The onion colour the marble shows in many specimens; (2) the onion-like shape of the large bossy markings which occur in the marble ; (3) the fact that it is disposed to scale away under the influence of the weather like the coats of an onion ; and (4) the concentric curves in which the edges of these coats are seen to lie in a section across the grain, have all been adduced as explanatory of the name. Herrmann in his Steinbruchindustrie, Berlin, 1899, p. 68, pronounces for the third, and this is also the opinion of Corsi, who says, Pietre Antiche, p. 97, 'gli scarpellini lo conoscono sotto il nome di cipollino, per la ragione che, trovandosi fra la sostanza calcare di tel marmo lunghi e spessi strati di mica, facilmente su tali strati si divide a somiglianza della cipolla.' Zirkel however, in his Lehrbuch der Petrographie, Leipzig, 1894, III, 452, pronounces for the fourth, which seems on the whole the one to be preferred. There are two cipollino columns standing in the Roman Forum a little to the east of the temple of Antoninus and Faustina, famous for its monoliths of this same marble, that in the concentric wavy lines marking the alternate layers in the stone remind us curiously of an onion cut in half. See for a specimen H on the Frontispiece.

Those which the sculptors call 'saligni,'[71] because they are partly transparent, and have that lustrous appearance seen in salt, have something of the nature of stalagmite, and are troublesome enough to make figures of; because the grain of the stone is rough and coarse, or because in damp weather water drops from it continually or else it sweats. The 'campanini' marbles are so named because they sound like a bell under the hammer and give out a sharper note than other marbles.[72] These are hard and crack more easily than the kinds above mentioned. They are quarried at Pietrasanta.[73] Again at Seravezza[74] in many places and at Campiglia[75] there are marbles excavated, which are for the most part excellent for ashlar work and even fairly good sometimes for statues.

§ 11. *Of White Pisan Marble.*

A kind of white marble, akin to limestone, is found likewise at Monte San Giuliano near Pisa.[76] It has been used for covering the outside walls of the Duomo and the Camposanto of Pisa, as well as for many other ornaments to be seen in that city. Formerly the said marbles were brought to Pisa from the hill at San Giuliano with trouble and expense, but now it is different, because Duke Cosimo, in order to make the district more healthy and also to facilitate the carriage of the marbles and other stones taken from those mountains, has turned into a straight canal the river Osoli and many other streams, which used to rise in those plains and do damage to the

[71] Vasari explains the name 'saligno' as 'salt-like.' The term is not recognized at Carrara, nor in the Florentine manufactory of Mosaics.

[72] The term 'campanino' for a kind of marble is not known now in the Carrara district.

[73] About 10 miles south east of Carrara.

[74] Near Pietrasanta in the Apuan Alps.

[75] On the promontory of Piombino, opposite Elba.

[76] In the so-called Pisan Mountains between Pisa and Lucca. For these places and their quarries see Note on 'Tuscan Marble Quarries,' postea, p. 119 f.

country. By means of this canal, the marbles, either
worked or rough, can be easily conveyed, at a trifling
cost, and with the greatest advantage to the city which
is now almost restored to its former magnificence, thanks
to the said Duke, who has no object more dear to him
than that of improving and restoring the city, which was
falling into ruins, before His Excellency became its lord.[77]

§ 12. Of Travertine.

There is another sort of stone called travertine, which
is much used for building and also for carvings of various
sorts. It is always being quarried in many places
throughout Italy, as in the neighbourhood of Lucca, at
Pisa, and round about Siena; but the largest blocks and
the best, that is, those which are most easily worked, are
taken from above the river Teverone at Tivoli.[78] The
stone is all a kind of coagulation of earth and of water,
which by its hardness and coldness congeals and petrifies
not only earth, but stumps and branches and leaves of
trees. On account of the water that remains within the
stones—which never can be dry so long as they lie under
water—they are full of pores which give them a spongy
and perforated appearance, both within and without.

Of travertine the ancients constructed their most won-
derful buildings, for example, the Colosseum, and the

[77] See Note, as above, especially p. 126.

[78] There are great quarries of this stone below Tivoli near the course of the
ancient Anio, now Teverone. The station Bagni on the Roma-Tivoli railway is
close to them. Those near the place called Barco were exploited by the ancient
Romans, while Bernini derived the stone for the colonnades in front of St.
Peter's from the quarries called ' Le Fosse,' a little to the north of the former.
Vitruvius, De Arch., II, vii, 2, writes of the ' Tiburtina saxa ' as resisting all
destructive agencies save that of fire, and the remark is repeated by Pliny,
Hist. Nat., XXXVI, 22. Vasari's account of its origin is correct. It is a deposit
of lime in water, and the cavities in it are partly caused by plants, moss, etc.,
round which the deposit has formed itself and which of course have long ago
decayed away. See O on the Frontispiece. The stone did not come into
use at Rome until about the last century of the Republic, and it was not, like
peperino, one of the old traditional building materials.

Treasury by the church of Ss. Cosimo e Damiano [79] and many other edifices. They used it without stint for the foundations of their public buildings, and in working these basements, they were not too fastidious in finishing them carefully, but left them rough, as in rustic work; and this they did perhaps because so treated they possess a certain grandeur and nobility of their own.[80] But in our days there has been found one who has worked travertine most skilfully, as was formerly seen in that round temple, begun but never finished, save only the basement, on the piazza of San Luigi de' Francesi in Rome.[81] It was undertaken by a Frenchman named Maestro Gian, who studied the art of carving in Rome and became so proficient, that his work in the beginning of this temple could stand comparison with the best things, either ancient or modern, ever seen carved in travertine. He carved astrological globes, salamanders in the fire, royal emblems, devices of open books showing the leaves, and carefully finished trophies and masks. These, in their own place, bear witness to the excellence and quality of the stone which, although it is coarse, can be worked as freely as marble. It possesses a charm of its own, owing to the spongy appearance produced by the little cavities which cover the surface and look so well. This unfinished temple being left imperfect, was razed by the French, and the said stones and other pieces that formed part of its construction were placed in the façade of the church of San Luigi [82] and in some of its chapels, where they are well arranged, and produce a beautiful effect.

[79] Vasari evidently refers to the remains of the Templum Sacrae Urbis behind the present church of Ss. Cosma e Damiano, to which was affixed the ancient 'Capitoline' plan of Rome.

[80] See the remarks on Rusticated masonry in § 20, and Notes, postea, pp. 65 and 132.

[81] On the 'round temple,' and its designer, 'Maestro Gian,' see Note on the subject, postea, p. 128 f.

[82] S. Luigi dei Francesi is the national church of the French, and is situated close to the Palazzo Madama, the meeting place of the Italian Senate, near the Piazza Navona. The present edifice was built by Giacomo della Porta and consecrated in 1589. See Note, postea, p. 128 f.

Travertine is excellent for walls, because after it is built up in squared courses and worked into mouldings, it can be entirely covered with stucco [83] and thereafter be impressed with any designs in relief that are desired, just as the ancients did in the public entrances to the Colosseum [84] and in many other places; and as Antonio da San Gallo has done in the present day in the hall of the Pope's palace, in front of the chapel,[85] where he has faced the travertine with stucco bearing many excellent devices. More than any other master however has Michelagnolo Buonarroti ennobled this stone in the decoration of the court of the Casa Farnese.[86] With marvellous judgement

[83] For which it offers in the cavities above spoken of an excellent key.

[84] Traces of these stucco decorations are still to be seen in the public entrance to the Colosseum next the Esquiline. They are said to have been taken as models by some of the plaster-workers of the Renaissance. See Vasari's Life of Giovanni da Udine, *Opere*, VI, 553.

[85] This is the so-called 'Sala Regia' which serves as a vestibule to the Sistine Chapel. Sixtus IV planned it and San Gallo enlarged it and began the adornment of the vault with plaster work, which was carried on afterwards by Perino del Vaga and Daniele da Volterra (Pistolesi, *Il Vaticano Descritto*, VIII, 89). It is the most richly decorated of all the Vatican apartments, but is florid and overladen. The stucco enrichment of the roof is heavy, and the figures in the same material by Daniele da Volterra that are sprawling on the tops of the doorways and on the cornices are of the extravagant later Renaissance type. The contrast between this showy hall and the exquisitely treated Appartamento Borgia of earlier date is very marked.

[86] The Farnese Palace is in the main the work of Antonio da San Gallo, the younger, who at his death in 1546 had carried up the façade nearly to the cornice and completed the ground story and half the second story of the cortile. Michelangelo finished the second or middle story of the cortile, as far as the architecture went, according to San Gallo's design, and added the third story from his own. His are also the enrichments of the frieze of the second order in the cortile, and he has the chief credit for the noble external cornice, of which Vasari writes in this section. It is now rather the fashion to criticize severely Michelangelo's architectural forms, and G. Clausse, *Les San Gallo*, Paris, 1901, condemns his third story of the cortile and says of his frieze (p. 85), 'Michelange fit ajouter dans la frise ces guirlandes et ces mascarons en stuc qui enlèvent à ce beau portique le caractère de grandeur simple et d'harmonieuse majesté dû à ses proportions mêmes.' It will not escape notice that Vasari regards these ornaments as not in stucco but in the travertine itself. On the question thus raised Monseigneur Duchesne, the distinguished Director of the French School at Rome

he has used it for windows, masks, brackets, and many other such fancies; all these are worked as marble is worked and no other similar ornament can be seen to excel this in beauty. And if these things are rare, more wonderful than all is the great cornice on the front façade of the same palace, than which nothing more magnificent or more beautiful can be sought for. Michelagnolo has also employed travertine for certain large chapels on the outside of the building of St. Peter's, and in the interior, for the cornice that runs all round the tribune; so finished is this cornice that not one of the joints can be perceived, everyone therefore can well understand with what advantage to the work we employ this kind of stone. But that which surpasses every other marvel is the construction in this stone of the vault of one of the three tribunes in St. Peter's; the pieces composing it are joined in such a manner that not only is the building well tied together with various sorts of bonds, but looked at from the ground it appears made out of a single piece.[87]

§ 13. *Of Slates.*

We now come to a different order of stones, blackish in colour and used by the architects only for laying on roofs. These are thin flags produced by nature and time near the surface of the earth for the service of man. Some

which is housed in the Farnese, has had the kindness in reply to our inquiry to say that so far as can be ascertained without the use of scaffolding the ornaments of the frieze are in stucco, with the exception of the Fleur-de-lys which occur in the position of key-stones above the centre of each window arch. These are in travertine, as are the ornaments (trophies of arms etc.) carved on the metopes of the frieze of the order of the ground story in the cortile. The point has some interest in connection with the travertine carvings by the French artist at S. Luigi dei Francesi (see postea, p. 131), and the suggestion of M. Marcel Reymond (loc. cit.) that the Italians of the first half of the fifteenth century were not accustomed, as the French were, to execute decorative carvings in soft stone.

[87] The exterior of St Peter's is built of travertine, and a walk round it gives an opportunity for a study of the fine effect of the stone when used on a vast scale. The details of construction in the interior, which are lauded by Vasari, are now concealed under the decoration that covers all the interior surfaces.

of these are made into receptacles, built up together in such a manner that the pieces dovetail one into the other. The vessels are filled with oil according to their holding capacity and they preserve it most thoroughly. These slates are a product of the sea coast of Genoa, in a place called Lavagna; [88] they are excavated in pieces ten braccia long and are made use of by artists for their oil paintings, because pictures painted on slate last much longer than on any other material, as we shall discuss more appropriately in the chapters on painting.

§ 14. Of Peperino.[89]

We shall also refer in a future chapter to a stone named piperno or more commonly peperigno, a blackish and spongy stone, resembling travertine, which is excavated in the Roman Campagna. It is used for the posts of windows and doors in various places, notably at Naples and in Rome; and it also serves artists for painting on in oil, as we shall relate in the proper place. This is a very thirsty stone and indeed more like cinder than anything else.

[88] Lavagna is on the coast about half way between Genoa and Spezzia. The slate of the district is pronounced by Mr. Brindley to be of poor quality and liable to bleach to a dirty ochre colour like that of brown paper. In the Official Catalogue of the Italian section of the International Exhibition of 1862 it is stated that in modern times also 'large jars or reservoirs for containing oil, made of this slate, are employed in Liguria, as well as in the principal maritime dépôts of the oil trade.'

[89] Peperino is a volcanic product in origin quite distinct from travertine. It consists of ashes and fragments of different materials compacted together and is called 'pepper stone' from the black grains that occur in it. It was one of the two old traditional building stones at Rome before the introduction of travertine from the quarries by Tibur, the other being the coarser and commoner tufa of which the wall of Servius Tullius was built. The most interesting monument in the material is the sarcophagus of Lucius Cornelius Scipio Barbatus in the Vatican, dating from the third century B.C. A characteristic piece, with the black 'pepper' marks, is shown as Q on the Frontispiece.

§ 15. *Of the Stone from Istria.*[90]

There is moreover quarried in Istria a stone of a livid white, which very easily splits, and this is more frequently used than any other, not by the city of Venice alone, but by all the province of Romagna, for all works both of masonry and carving. It is worked with tools and instruments longer than those usually employed, and chiefly with certain little hammers that follow the cleavage of the stone, where it readily parts. A great quantity of this kind of stone was used by Messer Jacopo Sansovino, who built the Doric edifice of the Panattiera [91] in Venice, and also that in the Tuscan style for the Zecca (mint) on the Piazza of San Marco.[92] Thus they go on executing all their

[90] Istrian stone is a fine-grained limestone of a warm yellowish grey tint; it is capable of taking a polish, and is obtainable in large pieces. It is broken at various points of the coast from Merlera near Pola to the island of Lesina off the coast by Spalato, and was largely used in the buildings of Venice, and generally in north-eastern Italy. A considerable amount has been recently employed in the monumental buildings of the Ring at Vienna. See L on the Frontispiece.

[91] 'The Doric edifice of the Panattiera' sounds a very curious description of Sansovino's famous and magnificent Library of S. Marco, the finest late Renaissance building in Italy, but this seems to be what Vasari had in his mind. Dr. Robertson of Venice has been kind enough to explain in a letter the history of the site which he has ascertained from the archives. The ground where the Library now stands was occupied up to 1537 by a government grain and bread store, the 'Panattiera' (or more properly 'Panatteria'). The shops for the sale of bread were then removed and grouped round the base of the Campanile, where they were replaced a little later by Sansovino's Loggetta. Vasari visited Venice in 1542, and at that time if the shops and store had themselves been removed their name would still cling to the place and explain his words. We should hardly call the Library a 'Doric edifice,' as only the lower Order is 'Doric,' but we must remember that it was only this lower Order that would be completed at the date of Vasari's visit.

[92] The Tuscan Zecca. The original Zecca or mint was at the Rialto, and it was afterwards transferred to the Piazzetta, where Sansovino in 1535 erected for it the present edifice, in the rusticated or Tuscan style. The situation of it is between the Library and the quay. The façade shows an arcaded lowest story in rusticated masonry, with two stories above, one in the Doric the other in the Ionic Order, and the columns in both cases are themselves rusticated; that is to say they have projecting horizontal courses of stone that appear to mark them with a series of bands or bars.

works for that city, doors, windows, chapels, and any other decorations that they find convenient to make, notwithstanding the fact that breccias and other kinds of stone could easily be conveyed from Verona, by means of the river Adige. Very few works made of these latter materials are to be seen, because of the general use of the Istrian stone, into which porphyry, serpentine and other sorts of breccias are often inlaid, resulting in compositions which are very ornamental. This stone is of the nature of the limestone called ' alberese,' not unlike that of our own districts, and as has been said it splits easily.

§ 16. *Of Pietra Serena.*

There only remains now the pietra serena and the grey stone called ' macigno ' [93] and the pietra forte which is much used in the mountainous parts of Italy, especially in Tuscany, and most of all in Florence and her territory. The stone that they call pietra serena [94] draws towards

[93] ' Macigno ' is a green grey sandstone of the lower tertiary formation in Italy.

[94] Pietra Serena is a very fine sedimentary sandstone, and Vasari does not say too much in its praise. Baldinucci in his *Vocabolario* repeats much of what Vasari has said, but mentions also a ' pietra bigia ' or grey stone, which lies outside the ' serena,' and is inferior to it.

The quarries of pietra serena are abundant along the southern slopes of Monte Ceceri, to the south east of Fiesole, overhanging Majano. The blue colour Vasari ascribes to it is the cause of its name, the epithet ' sereno ' being specially applicable to the clear blue sky. See G on the Frontispiece. Vasari's account of the stones dealt with in §§ 16, 17, is not very clear, as he returns to the epithet ' serena ' at the close of § 16 for a stone that he makes to differ essentially from the ' serena ' of the beginning of the section in that it is weather-resisting. Cellini in his second Treatise, *Della Scultura*, ed. Milanesi, 1893, p. 201, is clearer. He distinguishes three kinds, (1) ' pietra serena,' azure in hue and only good for work in interiors ; (2) a stone of a brownish hue (tanè) that he calls ' pietra morta.' The lexicographers fight shy of this term, but it seems to mean a stone without any lime in it and therefore unchangeable by the action of fire, while a limestone would be ' pietra viva.' See Cellini, loc. cit., p. 187. This is suitable for figure carving, and it resists ' wind and rain and all violence of the weather.' It is evidently the stone Vasari writes of as the material of Donatello's ' Dovizia.' (3) The third kind is the pietra forte, also brownish in hue, and useful for decorative carvings on exteriors. Cellini notes as Vasari does that it is only found in small pieces.

blue or rather towards a greyish tint. There are quarries of it in many places near Arezzo, at Cortona, at Volterra, and throughout the Apennines. The finest is in the hills of Fiesole, and it is obtained there in blocks of very great size, as we see in all the edifices constructed in Florence by Filippo di Ser Brunellesco, who had all the stones needed for the churches of San Lorenzo and of Santo Spirito quarried there, and also an unlimited quantity which are in every building throughout the city. It is a very beautiful stone to look at, but it wastes away and exfoliates where it is subjected to damp, rain, or frost. Under cover however it will last for ever. Much more durable than this and of finer colour is a sort of bluish stone, in our day called 'pietra del fossato.'[95] When quarried, the first layer is gravelly and coarse, the second is never free from knots and fissures, the third is admirable being much finer in grain. Michelagnolo used this, because of its yielding grain, in building the Library and Sacristy of San Lorenzo for Pope Clement, and he has had the mouldings, columns, and every part of the work executed with such great care that even if it were of silver it would not look so well.[96] The stone takes on a very fine polish, so much so that nothing better in this kind of material could be wished for. On this account it was forbidden by law that the stone be used in Florence for other than public buildings, unless permission had been obtained from the governing authorities.[97] The Duke

[95] Pietra del fossato. Signor Cellerini, of the Opera del Duomo, Florence, says that the name 'pietra del fossataccio' is still used among practical stone workers. It is stone gained by excavation.

[96] The colour of the stone in the Library and New Sacristy of S. Lorenzo is a brownish grey rather than 'bluish.' It tells as warm in hue against the white walls, which are of marble in the Sacristy and in the Library of plaster.

[97] Dr. A. Gherardi, Director of the State Archives at Florence, has been so kind as to make researches in the documents under his charge for the purpose of discovering Vasari's authority for this statement. These investigations have so far however proved without result. Among the 'Leggi e Bandi' of the sixteenth century in Tuscany collected by Cantini in the first volume of his *Legislazione Toscana* there are various regulations about trades, prohibitions against cutting

Cosimo has had a great quantity of this stone put into use, as for example, in the columns and ornaments of the loggia of the Mercato Nuovo, and for the work begun by Bandinello in the great audience chamber of the palace and also in the other hall which is opposite to it; but the greatest amount, more than ever used elsewhere, has been taken by his Excellency for the Strada de' Magistrati,[98] now in construction, after the design and under the direction of Giorgio Vasari of Arezzo. This stone demands as much time for working it as marble. It is so hard that water does not affect it and it withstands all other attacks of time.

Besides this there is another sort called pietra serena, found all over the hill, which is coarser, harder, and not so much coloured, and contains certain knots in the stone. It resists the influence of water and frost, and is useful for figures and carved ornaments. Of this is carved La Dovizia (Abundance), a figure from the hand of Donatello on the column of the Mercato Vecchio in Florence;[99] and it serves also for many other statues

timber on the hills, measures facilitating the import of building materials into certain ocalities, and the like, which show that an edict such as Vasari refers to was quite possible in the early days of the Grand Ducal régime. The nearest approach to it that we have been able to discover are certain edicts of the end of the sixteenth century, published by Mariotti, *La legislazione delle Belle Arti*, Roma, 1892, p. 246 f., that prohibit the exportation from the state of 'pietre mischie dure' (agates, jaspers, and the like) of which the Grand Duke had need for a certain chapel he was building, evidently the 'Cappella dei Principi' at S. Lorenzo.

[98] This is of course the well known 'Uffizi,' erected by Vasari between 1560 and 1574 for the accommodation of various state departments. The expression 'strada' or 'street' has reference to the scheme of the building, which is erected along the two sides and one end of a very elongated, and indeed street-like, court, from which the various entrances into the building open. In documents relating to its construction it is sometimes referred to as 'Via dei Magistrati.' A little later Vasari gives an interesting note on the scheme of construction he employed in the lower order of the edifice. See postea, p. 72 f.

[99] The Mercato Vecchio at Florence was an open square that occupied the northern portion of the site now covered by the new Piazza Vittorio Emmanuele. On the side next the Via Calimara a granite column was erected in 1431, and on this column was set up the statue by Donatello representing 'Abundance'

executed by excellent sculptors, not only in this city, but throughout the territory.

§ 17. *Of Pietra Forte.*[100]

The pietra forte is quarried in many places; it resists rain, sun, frost, and every trial, and demands time to work it, but it behaves very well; it does not exist in very large blocks.[101] Both by the Goths [102] and by the moderns have been constructed of this stone the most beautiful buildings to be found in Tuscany, as can be seen in Florence in the filling of the two arches, which form the principal doors of the oratory of Orsanmichele,[103] for

('Dovizia'). This stood till October 20, 1721, when in consequence of damage due to time and exposure it fell to the ground and was dashed into pieces. In the following year, 1722, Giov. Batt. Foggini carved another figure representing the same allegorical personage, and this remained till our own time; and may be seen *in situ* in one of Alinari's photographs. It is now in the museum of S. Marco with other fragments from the demolitions in the 'Centro.' See Guido Carocci, *Il Mercato Vecchio di Firenze*, Firenze, 1884.

[100] On 'Pietra Forte,' the Official Catalogue of the Italian Section of the International Exhibition of 1862 reports, p. 62, as follows. 'The rock called *Pietraforte* . . . is very largely used in Florence; it is very durable, as may be seen in the older palaces of the city. In composition it is an arenaceous limestone, which is very hard and unalterable, as its name implies.' It has been extensively quarried by Fiesole and to the north of Majano, and Monte Ripaldi, above the valley of the Ema to the south of Florence, furnishes large supplies of it. See M, N, on the Frontispiece.

[101] The blocks used for the façade of the Pitti have been remarked on for their great size, one of them, an exceptional one it is true, measures 28 ft. in length.

[102] On this use of the word 'Goth' or 'Gothic' in the sense of 'mediaeval,' see Note on 'Vasari's Opinion on Mediaeval Architecture,' postea, p. 133 f.

[103] Or San Michele, as every visitor to Florence knows, is the church occupying the lower story of a lofty building in the Via Calzaiuoli. Constructively speaking the upper part is supported on the ground story by piers between which are round headed arches, three on the north and south sides and two on the east and west. The heads of these are in every case filled with florid late Gothic tracery with intersecting arches and rich cusping, and on all sides but the west the openings below the heads are walled in. On the west the arches contain the doorways of entrance, and the tracery above the doors, about which Vasari is writing, is richer than on the other sides of the building. It is curious to find Vasari calling this work 'truly admirable,' whereas a page or two later we shall find him inveighing against the 'Goths' (the mediaeval builders) and all their works and ways.

these are truly admirable things and worked with the utmost care. Of this same stone there are throughout the city, as has been said, many statues and coats of arms,[104] as for instance in the Fortress and various other places. It is yellowish in colour with fine white veins that add greatly to its attractiveness, and it is sometimes employed for statues where there are to be fountains, because it is not injured by water. The walls of the palace of the Signori, the Loggia, and Orsanmichele are built of it, also the whole interior of the fabric of Santa Maria del Fiore, as well as all the bridges of our city, the Palace of the Pitti and that of the Strozzi families. It has to be worked with picks because it is very compact. Similarly, the other stones mentioned above must be treated in the manner already explained for the working of marble and other sorts of stones.

§ 18. *Conclusion of Chapter.*

After all however, good stones and well tempered tools apart, the one thing essential is the art, the intelligence, and the judgement of those who use them, for there is the

[104] Coats of arms. These 'stemmi,' as they are often called, are very familiar objects on the exterior of Tuscan palaces, and the arms of the Medici, six round balls or pellets, are constantly in evidence. In the view of the Fortress in Fig. 3 a 'stemma' of the Medici is to be seen displayed on the face of the wall. It is referred to by Vasari, *Opere*, ed. Milanesi, IV, 544. Mariotti, *La Legislazione delle Belle Arti*, Roma, 1892, p. 245, has printed an interesting edict of the year 1571, in Tuscany, designed to protect these memorials of the ancient Florentine families. The memory of those who built the houses, it says, 'is preserved and perpetuated by their Arms, Insignia, Titles, Inscriptions, which are affixed or painted or carved or suspended over the doors, arches, windows, projecting angles or other places where they are conspicuously to be seen,' and the edict, re-enacting older regulations, reminds the citizens that no one who purchases or becomes possessed of an old house on which there are insignia of the kind is allowed to remove or in any way deface them. No new owner is to presume to add his own arms or other memorial by the side of the old ones of the founder and constructor of the house. Only in cases where these are absent may the new owner put up his own insignia. This regulation shows a historical sense and a care for the tangible memorials of a city's past which have been too often lacking in more modern times. No doubt it is due to its enforcement that so many of these 'stemmi' are left to add interest to the somewhat modernized streets of the Florence of to-day.

greatest difference between artists, although they may all use the same method, as to the measure of grace and beauty they impart to the works which they execute. This enables us to discern and to recognize the perfection of the work done by those who really understand, as opposed to that of others who know less. As, therefore, all the excellence and beauty of the things most highly praised consist in that supreme perfection given to them by those who understand and can judge, it is necessary to strive with all diligence always to make things beautiful and perfect—nay rather, most beautiful and most perfect.

CHAPTER II.

The Description of squared Ashlar-work (lavoro di quadro) and of carved Ashlar-work (lavoro di quadro intagliato).

§ 19. *The work of the Mason.*

HAVING thus considered all the varieties of stone, which our artificers use either for ornament or for sculpture, let us now go on to say, that when stone is used for actual building, all that is worked with square and compasses and that has corners is called squared ashlar work (lavoro di quadro). The term (quadro) is given, because of the squared faces and corners, for every order of moulding or anything which is straight, projecting, or rectangular is work which takes the name of 'squared,' and so is it commonly known among the artificers. But when the stone does not remain plain dressed, but is chiselled into mouldings, friezes, foliage, eggs, spindles, dentels and other sorts of carving, the work on the members chosen to be so treated is called by the mason carved ashlar work (opera di quadro intagliato or lavoro di intaglio). Of this sort of plain and carved ashlar are constructed all the different Orders, Rustic, Doric, Ionic, Corinthian, and Composite, and so too, in the times of the Goths, the German work [1] (lavoro tedesco) : and no kind of ornament can be made that is not founded on both sorts of the work above described. It is the same with breccias and marbles and every sort of stone, and also with bricks, used as a foundation for

[1] 'In the times of the Goths;' 'German work.' See Note on 'Vasari's Opinion on Mediaeval Architecture,' postea, p. 133 f.

moulded stucco work. The same applies to walnut, poplar, and every kind of wood. But, because many do not recognize the difference between one Order and another, let us discuss distinctly and as briefly as possible in the chapter which follows, every mode and manner of these.

CHAPTER III.

Concerning the five Orders of Architecture, Rustic, Doric, Ionic, Corinthian, Composite, and also German Work.

§ 20. *Rusticated masonry and the Tuscan Order.*

THE work called Rustic [1] is more stunted, and more massive than that of any other Order, it being the beginning and foundation of all. The profiles of the mouldings are simpler and in consequence more beautiful, as are the capitals and bases as well as every other member. The Rustic socles or pedestals, as we call them, on which rest the columns, are square in proportion, with a solid moulding at the foot and another above which binds it like a cornice. The height of the column measures six heads, [2] in imitation of people who are dwarfed and adapted

[1] It will be seen that in this section Vasari combines two quite distinct things, the so-called 'Tuscan,' or as he calls it, the 'Rustic' Order, and rusticated masonry, which has nothing to do with the Orders of Architecture, but is a method of treating wall-surfaces. On this see the Note on 'Rusticated Masonry,' postea, p. 132. The reason why the 'Tuscan' is called the 'Rustic' Order, is that, being the simplest and, so to say, rudest of the Orders, it is most suitably employed in connection with walling of a rough and bossy appearance. The shafts of columns are sometimes rusticated to correspond with the walling, as at the Venetian 'Zecca,' mentioned ante, p. 56, but the expedient is of doubtful advantage, as the clear upright appearance of the column is thereby sacrificed.

[2] Vasari says here that the 'Rustic' or Tuscan column is six 'heads' high. What does he mean by this? There is evidently in his mind the familiar comparison of different columns to human figures of different proportions, a conceit found in Vitruvius (IV, i, 6 f.) and in writers of the Renaissance (see Alberti, *De Re Aedificatoria*, Lib. IX, c. 7), and so he measures by 'heads,' which would apply to a figure but not to a column. 'Testa,' 'head,' cannot, as the context shows, mean the height of the capital of the column. It really means here the

to sustain weights. Of this Order there are to be seen in Tuscany many colonnades both plain and rusticated, with and also without bosses and niches between the columns: and many porticoes which the ancients were accustomed to construct in their villas; and in the country one still sees many tombs of the kind as at Tivoli and at Pozzuolo. This Order served the ancients for doors, windows, bridges, aqueducts, treasuries, castles, towers, and strongholds for storing ammunition and artillery; also for harbours, prisons and fortresses; in these the stones project in an effective manner in points like a diamond, or with many facets. The projections are treated in various ways, either in bosses, flattened, so as not to act as a ladder on the walls—for it would be easy to climb up if the bosses jutted out too much—or in other ways, as one sees in many places, and above all in Florence, in the principal façade of the chief citadel, built by Alexander, first duke of Florence.[3] This façade, out of

lower diameter of the column. It is this lower diameter (or sometimes half the lower diameter) that is the normal unit of measurement for the proportions of a column. Thus the height of the Tuscan column is given by Vitruvius and by Palladio and other moderns as six times the lower diameter. Though 'head' may seem a very curious word with which to describe this, there is no doubt that such is the meaning of it. Alberti, in his tract on the Orders and their proportions, uses the lower diameter as his measure but applies to it this very term 'testa.' There is a certain letter from Vasari to Duke Cosimo that deals with the measurements of a column of granite presented to him by the Pope and afterwards conveyed from Rome and set up in the Piazza di S. Trinità, where it carries the porphyry statue by Francesco del Tadda (postea, p. 111). Vasari gives the diameter of the 'head' of this column, but notes afterwards that the shaft diminishes from the 'head' upwards towards the necking (collarino). Hence there is no doubt about the interpretation of the word in question. See the letter in *Opere*, ed. Milanesi, VIII, 352.

[3] The Citadel of Florence. This is not the 'Belvedere' fortress on the hill behind the Palazzo Pitti, but the so-called 'Fortezza da Basso' to the north of the town, now used as barracks, which the railway skirts just before entering the station near S. Maria Novella. It dates from 1534, and was built by Alessandro dei Medici with the intention of overawing the citizens. It occupied the site of the Faenza gate, and was partly within and partly outside the enceinte of the city. The 'principal façade' of which Vasari writes, is still well preserved in the middle of the southern face, opposite the town, and a sketch

respect to the Medici emblems, is made with ornaments of diamond points and flattened pellets, but both in low relief. The wall composed of pellets and diamonds side by side is very rich and varied and most beautiful to look at. There is abundance of this work at the villas of the Florentines, the gates and entrances, and at the houses and palaces where they pass the summer, which

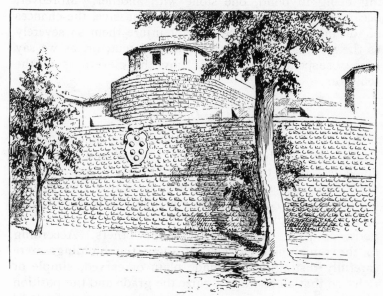

FIG. 3.—Fortezza da Basso at Florence.

not only beautify and adorn that neighbourhood, but are also of the greatest use and convenience to the citizens. But much more is the city itself enriched with magnificent buildings, decorated with rusticated masonry, as for

of it is shown in Fig. 3, but nothing else of interest is said to remain from the Renaissance period.

The masonry of the façade is an excellent example of elaborate rustication, and is very carefully executed in pietra forte. The illustration, Fig. 4, bears out Vasari's description, and exhibits in alternation round bosses 18 in. in diameter and 4 in. in salience, and oblong diamonds about 3 ft. by 1 ft. 6 in. There are worked borders about 1 in. in width round all the lines of juncture, and the scheme is worth noticing.

example the Casa Medici, the façade of the Pitti Palace, the palace of the Strozzi family and innumerable others. When well designed, the more solid and simple the building, the more skill and beauty do we perceive in it, and this kind of work is necessarily more lasting and durable than all others, seeing that the pieces of stone are bigger and the assemblage much better, all the building being in bond, one stone with another. Moreover, because the members are smooth and massive, the chances of fortune and of weather cannot injure them so severely as the stones that are carved and undercut, or, as we say here, 'suspended in the air' by the cleverness of the sculptors.

§ 21. *The Doric Order.*

The Doric Order was the most massive known to the Greeks, more robust both as to strength and mass, and much less open than their other Orders. And not only the Greeks but the Romans also dedicated this sort of building to those who were warriors, such as generals of armies, consuls, praetors—and much more often to their gods, as Jove, Mars, Hercules and others. According to the rank and character of these the buildings were carefully distinguished—made plain or carved, simple or rich—so that all could recognize the grade and the position of the different dignitaries to whom they were dedicated,[4] or of him who ordered them to be built. Consequently one sees that the ancients applied much art in the composition of their buildings, that the profiles of the Doric

[4] Vitruvius in his first book (I, ii, 5) gives directions as to the Orders suitable for temples to different deities. Thus Minerva, Mars, and Hercules are to have temples in the Doric style, etc.; while in the eighteenth century Sir William Chambers, transferring the same idea to modern times, says that Doric 'may be employed in the houses of generals, or other martial men, in mausoleums erected to their memory, or in triumphal bridges and arches built to celebrate their victories.' The modern architect is disposed to smile at these restrictions, but there underlies them a sound appreciation of the aesthetic significance of architectural forms.

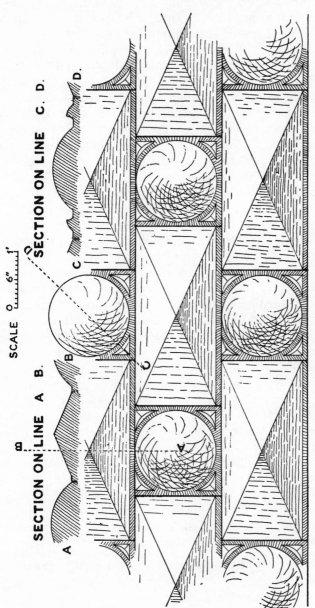

FIG. 4.—Rusticated masonry on the exterior of the Fortezza da Basso at Florence.

mouldings are very graceful, and the features harmonious and of a high degree of beauty; and also that the proportion of the shafts of the columns is very well understood, as they are neither too thick nor too thin. The form of the columns, as is commonly said, resembles that of Hercules; it shows a certain solidity capable of sustaining the weight of the architraves, friezes, cornices and the rest of the upper parts of the building. Because this Order, as more secure and stable than the others, has always much pleased Duke Cosimo, he desires that the building, which he has charged me to construct for thirteen civil magistrates of his city and dominion, should be of the Doric Order. This building is to have splendid decoration in stone, and is to be placed between his own palace and the river Arno.[5] Therefore, in order to bring back into use the true mode of construction, which requires the architraves to lie level over the columns, and avoid the falsity of turning the arches of the arcades above the capital, I have followed in the principal façade the actual method of the ancients, as can be seen in the edifice. This fashion of building has been avoided by architects of the recent past, because stone architraves of every sort both ancient and modern are all, or the greater part of them, seen to be broken in the middle, notwithstanding that above the solid of the columns and of the architraves, frieze, and cornice, there are flat arches of brick that are not in contact with and do not load the work below. Now, after much consideration on the whole question, I have finally found an excellent way of putting into use the true mode of proceeding so as to give security to the said architraves, by which they are prevented from suffering in any part and everything remains as sound and safe as can be desired, as the result has proved. This then, is the method, that is stated here below for the benefit of the world at large and of the artificers.

[5] The building referred to is the well-known Uffizi palace at Florence. See ante, p. 59.

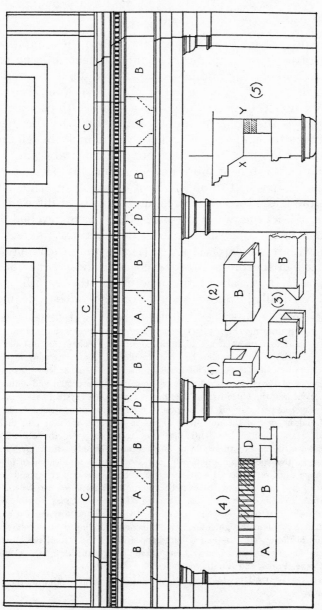

FIG. 5.—Construction of the portico of the Uffizi at Florence, from Vasari's description.

§ 22. *A constructive device to avoid charging architraves.*[6]

Having set up the columns, and above the capitals the architraves, which are brought into contact the one with the other above the middle axis of the column, the builder proceeds to make a square block or die (D, D, Fig. 5). For example, if the column be a braccio thick and the architraves the same in width [7] and height, let the die in the frieze be made equal to them; but in front let there remain an eighth in the face for the vertical joint, and let another eighth or more have a sinking into the die on each side, bevelled to an angle of 45°, Fig. 5 (1). Then since the frieze in each intercolumniation is in three pieces (B, A, B), let the two at the sides (B, B) have bevelled projections in the opposite sense to the sinkings, increasing from within outwards, Fig. 5 (2), so that each may be mortised in the die and be keyed after the manner of an arch, and in the front the amount of the eighth must bond vertically; while the part on the other side must

[6] The construction described by Vasari is evidently of the kind indicated in the accompanying drawing, Fig. 5. The pieces of the frieze are joggled one into the other so as to form a flat arch, but the construction is kept to the inner part and the face shows vertical joints between the pieces. As this passage in Vasari seems to have escaped the notice of those interested in Renaissance construction, the existence of the device he describes has remained unsuspected and nothing is known about it at the Uffizi itself. The fact is that Vasari's system has succeeded in one way too perfectly for his purpose. Everything has remained 'safe and sound,' and no one of the architrave beams shows signs of failure, so that no technical examination of the fabric has been called for. On the other hand, neither the artificers nor the world at large seem to have benefitted by Vasari's kindness, for the books do not notice his device. There is no mention of it even in the huge work on Tuscan Renaissance architecture now just completed under the editorship of Baron Henri de Geymüller, nor in Raschdorff's *Palast-Architectur*, nor Durm's *Baukunst der Renaissance*, though references to it may possibly occur in older books that have escaped our notice. Joggled lintels forming flat arches are of course common enough. The new Parliament Building at Stockholm shows them conspicuously with the actual joints appearing on the face of the building. Mediaeval and Renaissance fireplaces often have lintels of the kind, as in Coningsburgh Castle, Yorks, and Linlithgow Palace.

[7] i.e. width on the soffit, or, as it might be expressed, in depth from the outer face inwards.

do the same to the other die. And so above the column [8] one must arrange that the piece in the middle of the said frieze closes within and is recessed in quarter-round form up to the middle, while the other half must be squared and straight and set with an empty space below, in order that it may hold as does an arch, the wall on the external face appearing worked with vertical joints.[9] Do not let the stones of the said frieze rest on the architrave, but let a finger's breadth be between them; in this way, making an arch, the frieze comes to support itself and does not burden the architrave. Afterwards make on the inside, for filling up the said frieze, a flat arch of bricks as high as the frieze, that stretches from die to die above the columns. Then make a piece of cornice as wide as the die [10] above the columns, which has the joints in front like those of the frieze, and within let the said cornice be keyed like the blocks of the frieze, care being taken to make the cornice, as the frieze, in three pieces, of which the two at the sides hold from within the middle piece of the cornice above the die of the frieze,[11] and mind that

[8] 'Sopra la colonna.' This does not mean strictly the piece vertically above the column, which is the die (dado quadro) already mentioned. It is equivalent to the expression just below 'sopra le colonne,' and means simply 'in the upper part.' The piece referred to is A, A, in Fig. 5, the 'pezzo del mezzo' of the text as quoted below.

[9] 'Così si faccia sopra la colonna, che il pezzo del mezzo di detto fregio stringa di dentro, e sia intaccato a quartabuono infino a mezzo; l'altra mezza sia squadrata e diritta e messa a cassetta, perchè stringa a uso d'arco mostrando di fuori essere murata diritta.' The sense of this sentence seems to be indicated by the drawing Fig. 5. The centre pieces A, A, will slip down into their places and in a fashion key the flat arch. There is the same construction in the cornice, see below.

[10] The dimension here implied is not the width on the face from right to left, but the soffit-width, or depth from the outer face inwards. The dies and the cornice-pieces are of the same soffit-width as the architrave, but the frieze pieces are so much narrower as to allow space behind them for a flat arch of brick abutting at each end on that part of the die that exceeds in soffit-width the frieze. See plan, Fig. 5 (4), and section, Fig. 5 (5). The plan is at the level x, y.

[11] 'Sopra il dado del fregio' see note on 'Sopra la colonna.' The middle piece which goes 'a cassetta,' i.e. spanning a void, is at the centre of the inter-columniation, not vertically over the die above the column.

the middle piece of the cornice, C, C, slips down into
the sinkings so as to span the void, and unites the two
pieces at the sides so as to lock them in the form of an
arch. In this fashion everyone can see that the frieze
sustains itself, as does the cornice, which rests almost
entirely on the arch of bricks.[12] Thus one thing helping
another, it comes about that the architrave does not sustain
any but its own weight, nor is there danger of its ever
being broken by too heavy a load. Because experience
shows this method to be the most sure, I have wished to
make particular mention of it, for the convenience and
benefit of all; especially as I know that when the frieze
and the cornice were put above the architrave as was
the practice of the ancients, the latter broke in course of
time, possibly on account of an earthquake or other
accident, the arch of discharge which was introduced above
the cornice not being sufficient to preserve it. But throw-
ing the arches above the cornices made in this form, and
linking them together with iron, as usual,[13] secures the
whole from every danger and makes the building endure
eternally.

Returning to the matter in hand, let us explain then
that this fashion of work may be used by itself alone,
or can be employed in the second floor from the ground
level, above the Rustic Order, or it can be put higher up
above another variety of Order such as Ionic, Corinthian
or Composite, in the manner shown by the ancients in
the Colosseum in Rome, in which arrangement they used
skill and judgement. The Romans, having triumphed not
only over the Greeks but over the whole world, put the
Composite Order at the top, of which Order the Tuscans
have composed many varieties. They placed it above all,

[12] Fig. 5 (4) and (5) show the nature of the construction across from the
façade inwards. The corridor is spanned with a barrel vault that conceals the
back of the entablature. It starts from the top of the architrave.

[13] For this use of iron ties, which Vasari regards here as normal, see the illustra-
tion on p. 25 of Professor Durm's *Baukunst der Renaissance in Italien*, in the
Handbuch der Architectur, Stuttgart, 1903.

as superior in force, grace, and beauty, and as more striking than the others, to be a crown to the building; for to be adorned with beautiful members gives to the work an honourable completion and leaves nothing more to be desired.

§ 23. *The proportions and parts of the Doric Order.*

To return to the Doric Order, I may state that the column is made seven heads in height. Its pedestal must be a little less than a square and a half in height and a square in width,[14] then above are placed its mouldings and beneath its base with torus and two fillets, as Vitruvius directs. The base and capital are of equal height, reckoning the capital from the astragal upwards. The cornice with the frieze and architrave attached projects over every column, with those grooved features, usually called triglyphs, which have square spaces [15] interposed between the projections, within which are the skulls of oxen, or trophies, or masks, or shields, or other fancies. The architrave, jutting out, binds these projections with a fillet,

[14] The expression is a little awkward, but the meaning evidently is that the pedestal is half as high again as it is wide. There is some doubt whether the clause 'then above are placed' to 'as Vitruvius directs' refers to the pedestal or the column itself. In the case of all the other Orders Vasari mentions the upper and lower mouldings of the pedestal, and it would be most natural to imagine him doing so here, but the 'torus and two fillets (bastone e due piani) as Vitruvius directs' sounds more like the 'Attic' base of the column, and the reference to Vitruvius should be conclusive that it is *not* the pedestal of which there is question, for the good reason that Vitruvius knows nothing of the pedestal under the single column of any of the Orders. Such a feature does occur in classical work, as in the temple at Assisi, but it is not a normal classical form, and architectural purists in modern times reject it. Vitruvius is however again referred to by Vasari in this connection, in § 25, and Giorgio may have in his mind the sentence in Vitruvius, III, iv, 5, in which there is a reference to the mouldings on the continuous podium that serves as the substructure of the Roman temple, and forms one difference between it and the Greek temple. The single pedestal was often used in Renaissance work, and Vasari regards it as a matter of course.

[15] The metopes; these are always set back a little behind the face of the triglyphs, which are here termed the projections. The metope offers a suitable field for carved ornaments.

and under the fillet are little strips square in section, at the foot of each of which are six drops, called by the ancients 'guttae' (goccie). If the column in the Doric order is to be seen fluted, there must be twenty hollow facets instead of flutes,[16] and nothing between the flutes but the sharp arris. Of this sort of work there is an example in Rome at the Forum Boarium which is most rich;[17] and of another sort are the mouldings and other members in the theatre of Marcellus, where to-day is the Piazza Montanara, in which work there are no bases (to the Doric columns) and those bases which are visible are Corinthian. It is thought that the ancients did not make bases, but instead placed there a pedestal of the same size as the base would have been. This is to be met with in Rome by the prison of the Tullianum where also are capitals richer in members than others which appear in the Doric Order.[18] Of this same order Antonio da San

[16] Vasari merely has in mind the familiar difference in form between the Doric and Ionic flutes, the former being much shallower than the latter, and not showing the plain strip or fillet which in the Ionic column comes between every two of the flutes.

[17] The reference probably is to the portion of the ancient Basilica Aemilia, which in Vasari's time still stood erect where recent excavations have revealed the plan and part of the architectural members of this famous structure. We must bear in mind that what Vasari and his contemporaries called the 'Forum Boarium' was not the part between the Capitol and the Palatine, near the 'Bocca della Verità' which was the ancient Cattle Market and now has resumed its antique name, but the Forum proper, which used even in the memory of those now living to be called 'Campo Vaccino.' It seems to have derived the name 'Forum Boarium' from this very fragment of the Basilica Aemilia which Vasari has in his mind in this passage. The fragment was figured by Giuliano da San Gallo in a drawing in the Barberini Library, which is reproduced in *Monumenti dell' Istituto*, XII, T. 11, 12, and from this, by the kind permission of the Imperial German Archaeological Institute, has been taken Fig. 6. The destruction of this most interesting fragment, which stood over against the arch of Septimius Severus, is one of the many almost inconceivable acts of vandalism of which the men of the later Renaissance period were guilty. The richness of which Vasari speaks can be seen in the illustration.

[18] Here again Renaissance and modern topographical nomenclature do not agree. What Vasari knew as the 'Tullianum' was not the familiar 'Carcer Mamertinus' above the Forum on the way up to S. Maria in Araceli, but certain

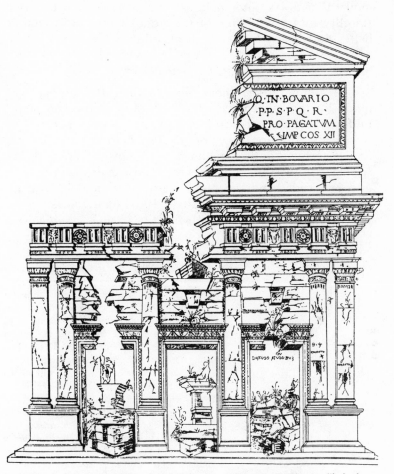

Q·IN·BOVARIO
·P·P·S·P·Q·R·
PRO·PAGATVM
C·IMP·COS·XII

FIG. 6.—Drawing by Giuliano da San Gallo of a portion of the Basilica Aemilia in the Roman Forum, that survived to the time of Vasari.

Gallo has made the inner court of the Casa Farnese in the Campo di Fiore at Rome, which is highly decorated and beautiful; thus one sees continually ancient and modern temples and palaces in this style, which for stability and assemblage of the stones have held together better and lasted longer than all other edifices.

§ 24. *The Ionic Order.*

The Ionic Order, more slender than the Doric, was made by the ancients in imitation of persons who stand mid-way between the fragile and the robust; a proof of this is its adoption in works dedicated to Apollo, Diana, and Bacchus, and sometimes to Venus. The pedestal which sustains the column is one and a half squares high and one wide, and the mouldings, above and below, are in accordance with this Order. Its column measures in height eight times the head, and its base is double with

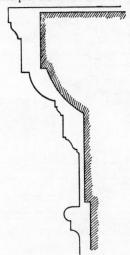

FIG. 7.—Roman Doric cap, with stucco finish, at S. Nicola in Carcere, Rome.

antique structures under the church of S. Nicola in Carcere, near the Piazza Montanara. These were the 'favissae' or cells within the structure of the podium or platform of one of several ancient Roman temples on this site, which was formerly the 'Forum Olitorium.' These substructures are now accessible, and the worthy sacristan of the church who shows them is still of opinion that he has in charge the prison of the Tullianum. One of the travertine columns of one of these temples is to be seen within the church, and this though Doric is extremely simple, even rude, in its outline. Dr. Huelsen has however in a recent paper (*Mitteilungen d. k. deutschen Archaeologischen Instituts*, XXI, 169 f.) shown that this column was originally finished with stucco, in which somewhat elaborate mouldings were worked. It was drawn by several of the Renaissance architects, and Peruzzi notes it as being 'in carcere Tulliano.' Huelsen has drawn out a scheme of the mouldings in profile and this is reproduced by permission in Fig. 7. It will be seen that Vasari's remark about its richness in membering is quite justified.

two tori, as described by Vitruvius in the third chapter of his third book. Its capital with its volutes or scrolls or spirals, as anyone may call them, should be well turned, as one sees in the theatre of Marcellus in Rome, above the Doric Order; and its cornice adorned with modillions and with dentils, and its frieze slightly convex (pulvinated). Should it be desired to flute the columns, there must be twenty-four flutes, but divided in such a manner as to leave between each two of them a flat piece that measures the fourth part of the flute. This order has in itself the most beautiful lightness and grace and is consequently adopted by modern architects.

§ 25. *The Corinthian Order.*

The Corinthian style was invariably a favourite among the Romans, who delighted in it so greatly that they chose this Order for their most elaborate and most prized buildings to remain as a memorial of themselves; as is seen in the Temple at Tivoli above the Teverone, in the remains of the temple of Peace,[19] in the arch of Pola, and in that of the harbour of Ancona; but much more beautiful is the Pantheon, that is the Ritonda of Rome. This Order is the richest and most decorated of all the Orders spoken of above. The pedestal that supports the column is measured in the following way; a square and two thirds wide (high) [20] and the mouldings above and below in proportion, according to Vitruvius [21] : the height of the column nine heads with base and capital, which last shall be in height the diameter of the column at the foot, and its base half of the said thickness. This base the ancients used to carve in various ways. Let the ornament

[19] Vasari probably refers to the great Corinthian column which was still to be seen in his time in the interior of the Basilica of Constantine (formerly called the Temple of Peace). The column was placed early in the seventeenth century in the Piazza in front of S. Maria Maggiore, where it is still in evidence.

[20] 'Largo' is the word in the text, but it must be merely a clerical error for 'alto.'

[21] See Note 14, ante, p. 75.

of the capital be fashioned with its tendrils and its leaves, as Vitruvius directs in the fourth book, where he records that this capital has been taken from the tomb of a Corinthian girl. Then follow its proper architrave, frieze and cornice measured as he describes, all carved with the modillions and ovolos and other sorts of carving under the drip. The friezes of this Order may be carved with leafage, or again they may be plain, or adorned with letters of bronze let into marble, as those on the portico of the Ritonda. There are twenty-six flutes in the Corinthian columns, although sometimes also there are fewer, and the fourth part of the width of each flute remains flat between every two, as is evident in many ancient works and in modern works copied from the ancients.

§ 26. *The Composite Order.*

The Composite Order, although Vitruvius has not made mention of it—having taken account of none others than the Doric, Ionic, Corinthian, and Tuscan, and holding those artists lawless, who, taking from all four Orders, constructed out of them bodies that represented to him monsters rather than men—the Composite Order has nevertheless been much used by the Romans and in imitation of them by the moderns. I shall therefore proceed, to the end that all may have notice of it, to explain and give the proportions of buildings in this Order also, for I am convinced of this, that if the Greeks and Romans created these first four Orders and reduced them to a general rule and measure, there may have been those who have done the same for the Composite Order, forming of it things much more graceful than ever did the ancients.

As an example of the truth of this I quote the works of Michelagnolo Buonarroti in the Sacristy and Library of San Lorenzo in Florence, where the doors, niches, bases, columns, capitals, mouldings, consoles and indeed all the details, have received from him something of the new and of the Composite Order, and nevertheless are

wonderful, not to say beautiful. The same merit in even greater measure is exhibited by the said Michelagnolo in the second story of the Court of the Casa Farnese [22] and again in the cornice which supports on the exterior the roof of that palace. He who wishes to see in this manner of work the proof of this man's excellence—of truly celestial origin—in art and design of various kinds, let him consider that which he has accomplished in the fabric of St. Peter's in compacting together the body of that edifice and in making so many sorts of various and novel ornaments, such beautiful profiles of mouldings, so many different niches and numerous other things, all invented by him and treated differently from the custom of the ancients. Therefore no one can deny that this new Composite Order, which through Michelagnolo has attained to such perfection, may be worthily compared with the others. In truth, the worth and capacity of this truly excellent sculptor, painter, and architect have worked miracles wherever he has put forth his hand. Besides all the other things that are clear as daylight, he has rectified sites which were out of the straight and reduced to perfection many buildings and other objects of the worst form, covering with lovely and fanciful decoration the defects of nature and art.[23] In our days certain vulgar architects,

[22] See Note 86, ante, p. 53.

[23] On Michelangelo's use of architectural details M. Garnier had some rather severe remarks in the *Gazette des Beaux Arts* for Jan. 1, 1876. He denied to him an understanding of the grammar of the use of such forms. It is generally admitted that for the details of the Farnese cornice, the fittings and decoration of the Library of S. Lorenzo, and other such works to which his name attaches, he was indebted to professional architects, such as Vignola, whom he employed. We must never forget however that we owe to Michelangelo the dome of St Peter's, one of the greatest architectural creations of its kind in the world. In mentioning the 'siti storti' (sites that were irregular or out of the straight), Vasari probably had in view the design for laying out the Capitol, which is another of Michelangelo's acknowledged successes. Here the existing Palazzo dei Conservatori stood somewhat askew and the site was regularized to correspond with the line of its façade. All this about Michelangelo was added for the second edition, after Vasari had himself worked at his master's staircase at S. Lorenzo.

not considering these things judiciously and not imitating them, have worked presumptuously and without design almost as if by chance, without observing ornament, art, or any order. All their things are monstrous and worse than the German.

Returning now to our subject, it has become usual for this manner of work to be called by some the 'Composite,' by others the 'Latin,' and by others again the 'Italic' Order. The measure of the height of this column must be ten heads, the base the half of the diameter of the column, measured in the same way as the Corinthian column, as we see in the arch of Titus Vespasianus in Rome. And he who wishes to make flutes in this column can do so, following the plan of the Ionian or Corinthian column—or in any way that pleases him who adopts this style of architecture, which is a mixture of all the Orders. The capitals may be made like those of the Corinthian except that the echinus moulding of the capital must be larger and the volutes or tendrils somewhat larger, as we see in the above mentioned arch. The architrave must be three quarters of the thickness of the column and the rest of the frieze supplied with modillions, and the cornice equal to the architrave, because the projection gives the cornice an increase of size, as one sees in the uppermost story of the Roman Colosseum; and in the said modillions grooves can be cut after the manner of triglyphs, and there can be other carving according to the taste of the architect; the pedestal on which the column rests must be two squares high, with the mouldings just as he pleases.

§ 27. Of Terminal Figures.

The ancients were accustomed to use for doors or sepulchres or other kinds of enrichment, various sorts of terminal figures instead of columns, here a figure which has a basket on the head for capital, there a figure down

to the waist, the rest, towards the base, a cone or a tree
trunk; in the same way they made virgins, chubby infants,
satyrs, and other sorts of monsters or grotesque objects,
just as it suited them, and according as the ideas occurred
to them so the works were put into operation.

§ 28. *German Work (the Gothic Style)*.

We come at last to another sort of work called German,
which both in ornament and in proportion is very different
from the ancient and the modern. Nor is it adopted
now by the best architects but is avoided by them as
monstrous and barbarous, and lacking everything that
can be called order. Nay it should rather be called con-
fusion and disorder. In their buildings, which are so
numerous that they sickened the world, doorways are
ornamented with columns which are slender and twisted
like a screw, and cannot have the strength to sustain a
weight, however light it may be. Also on all the façades,
and wherever else there is enrichment, they built a male-
diction of little niches one above the other, with no end
of pinnacles and points and leaves, so that, not to speak
of the whole erection seeming insecure, it appears impos-
sible that the parts should not topple over at any moment.
Indeed they have more the appearance of being made
of paper than of stone or marble. In these works they
made endless projections and breaks and corbellings and
flourishes that throw their works all out of proportion;
and often, with one thing being put above another, they
reach such a height that the top of a door touches the
roof. This manner was the invention of the Goths, for,
after they had ruined the ancient buildings, and killed
the architects in the wars, those who were left constructed
the buildings in this style.[24] They turned the arches with

[24] See Note on ' Vasari's Opinion on Mediaeval Architecture' at the close of the
' Introduction' to Architecture, postea, p. 133 f. The phrase ' this manner was
the invention of the Goths,' etc., is historically important as the first introduction
into literature of the familiar architectural term ' Gothic.'

pointed segments, and filled all Italy with these abominations of buildings, so in order not to have any more of them their style has been totally abandoned.

May God protect every country from such ideas and style of buildings! They are such deformities in comparison with the beauty of our buildings that they are not worthy that I should talk more about them, and therefore let us pass on to speak of the vaults.

CHAPTER IV.

On forming Vaults in Concrete, to be impressed with Enrichment: when the Centerings are to be removed, and how to mix the Plaster.

§ 29. *The Construction of enriched Stucco Vaults.*

WHEN walls have reached the point where the arches of brick or light stone or tufa have to spring, it is necessary to turn a centering with planks in a close circle, over the framework of struts or boarding. The planks are fitted together according to the form of the vault, or in the shape of a boat, and this centering for the vaults must be fixed with strong props in whatever mode you wish, so that the material above does not strain it by its weight; and afterwards every crevice, in the middle, in the corners, and everywhere, must be firmly stopped up with clay so that when the concrete is spread the mixture shall not filter through. This finished, above that surface of boards they make caissons of wood, which are to be worked contrariwise, with projections where a hollow is wanted; in the same way let the mouldings and details that we wish to make be worked by opposites, so that when the material is cast, it may come, where (the mould is) hollow, in relief; where in relief, hollow, and thus similarly must all the members of the mouldings be arranged. Whether the vault is to be smooth or enriched, it is equally necessary to have shapes of wood, which mould the desired forms in clay; with this clay also are made the square panels for such decoration, and these are joined the one to the other on the flat or by mouldings or enriched bands, which can be made to follow the line of this centering. Having finished covering it all with enrichments of clay, formed in intaglio and fitted together,

as was said above, one must then take lime, with pozzolana
earth or sand riddled finely, mixed liquid and mostly
lime, and of that lay evenly a coating over all, till every
mould is full. Afterwards, above this coating make the
vault with bricks, raising or lowering them according as
the vault turns, and continually adding till the arch be
closed. This done, it must all be left to set and get firm,
till the work be dry and solid.[1] Then when the props are
removed and the vault is left free, the clay is easily taken
away and all the work remains modelled and worked as
if done in stucco, and those parts that have not come out
well are gone over with stucco till they are complete. In
this manner have been executed all the works in the ancient
edifices, which had afterwards stucco enrichment upon
them. This the moderns have done to-day in the vaults
of St. Peter's, and many other masters throughout Italy
have done the same.

§ 30. *Stucco made with Marble Dust.*

Now let us show how the stucco is mixed.[2] Chips of
marble are pounded in a stone mortar; no other lime is
used for this stucco save white lime made either of marble
chips or of travertine; instead of sand the pounded marble
is taken and is sifted finely and kneaded with the lime,
in the proportion of two thirds lime to one third pounded
marble. The stucco is made coarser or finer, according
as one wishes to work coarsely or finely. Enough now
of stuccoes because the rest will be said later, when I shall
treat of them in connection with Sculpture. Before
passing to this subject, we shall speak briefly of fountains
which are made for walls and of their various ornaments.

[1] Vasari makes no provision for binding together the vault in stucco and
that in brick. Each is apparently independent of the other, though they are
in contact, and no keys are formed in the upper surface of the stucco for the
purpose of tieing it to the brickwork above.

[2] This same subject is treated in the sixth chapter of the 'Introduction' to
Sculpture and the thirteenth of that to Painting. In connection with it see
Note on 'Stucco Grotesques' at the close of the 'Introduction' to Painting,
postea, p. 299.

CHAPTER V.

How Rustic Fountains are made with Stalactites and Incrustations from water, and how Cockle shells and Conglomerations of vitrified stone are built into the Stucco.

§ 31. *Grottoes and Fountains of 'Rocaille' work.*

THE fountains which the ancients made for their palaces, gardens, and other places, were of different kinds; some stood alone, with basins and vases of different sorts, others were attached to the walls, and bore niches with masks, figures, or ornaments suggesting the sea; others again for use in hot baths, were simpler and plainer, and finally others resembled woodland springs that rise naturally in the groves; while those which the moderns have made and continue to make are also of different kinds. The moderns, always varying them, have added to the inventions of the ancients, compositions of Tuscan work,[1] covered with stalactites from petrified waters, which hang down resembling roots, formed in the lapse of time of congelations of such waters as are hard and are charged with sediment. These exist not only at Tivoli, where the river Teverone petrifies the branches of trees, and all objects that come in contact with it, turning them into gum-like exudations and stalactites; but also at the lake Piè di

[1] The 'Tuscan work' referred to here is the same thing as the 'lavoro chiamato rustico' of which Vasari writes at the beginning of the third chapter (§ 20). The so-called Tuscan Order was the simplest and heaviest of all, and so most suited for work that partook of the rough and unpolished character of natural rock. For the same reason, as was seen above, ante, p. 65, the Tuscan Order lends itself best to association with bossy or 'rusticated' masonry.

Lupo,[2] where the stalactites are very large; and in Tuscany at the river Elsa,[3] whose water makes them clear so that they look like marble, glass, or artificial crystals. But the most beautiful and curious of all are found behind Monte Morello[4] also in Tuscany, eight miles from Florence. Of this sort Duke Cosimo has had made in his garden at Olmo near Castello[5] the rustic ornaments of the fountains executed by the sculptor Tribolo. These stalactites removed from where nature has produced them are introduced into work done by the artificer and fixed with iron bars, with branches soldered with lead or in some other way, or they are grafted into the stones so as to hang suspended. They are fixed on to the Tuscan work in such a way as to leave it here and there exposed to view. Then by adjusting leaden tubes hidden between these stalactites, and distributing holes among them, jets of water are made to pour out, when a key at the entrance of the conduit is turned; and thus are arranged pipes for water and various jets through which the water rains down among the incrustations of these stalactites, and in falling sounds sweet to the ear and is beautiful to the eye.

There is also another kind of grotto, of a more rustic fashion, imitating sylvan fountains in the following way. Some take sponge-like stones and joining them together

[2] Piè di Lupo. This is clearly a mistake for Piè di Lugo, for at the lake of that name above the great Cascade of Terni, there are appearances corresponding exactly with what Vasari says. It is remarked in Hare's *Days near Rome*, II, p. 141, that the waters of the Vellino, which makes the fall, are 'so strongly impregnated with carbonate of lime, that they constantly tend to form a deposit of travertine, and so to block up their own channel.'

[3] The Elsa flows from the Apennines by Colle and Castelfiorentino to join the Arno by S. Miniato, halfway between Florence and Pisa. The valley was the birthplace of Cennino Cennini, the author of the *Trattato*.

[4] Monte Morello, 3065 ft., is the conspicuous height to the north of Florence, which serves the populace for a weather-glass.

'Quando Monte Morello
Ha il cappello
Prendi l'ombrello.'

[5] A few miles to the north west of Florence.

sow grass over them, thus, with an order which appears disorder and wild, the grottoes are rendered very natural and real. Others make smoother and more polished grottoes of stucco, in which are mingled both stones and stucco, and while the stucco is fresh they insert, in bands and compartments, knobs or bosses, cockle shells, sea snails, tortoise shells, shells large and small, some showing the outside and some the reverse : and of these they make flower vases and festoons, in which the cockle shells represent the leaves, and other varieties of shells the fruit; [6] and to these they add shells of turtles, as is seen in the vineyard at the foot of Monte Mario that Pope Clement VII, when still Cardinal, had made by the advice of Giovanni da Udine.[7]

Again a rustic and very beautiful mosaic in many colours is made by using little bits of old bricks that have been too much baked, and pieces of glass which has run owing to the pans of glass bursting in an overheated furnace. The work is done by sticking these bits into the stucco on the wall as was said above, and arranging between them corals and other spoils from the sea, things in themselves full of grace and beauty. Thus are made animals and figures, covered with the shells already mentioned as well as with coloured pastes in various pieces arranged in rustic fashion, very quaint to look upon. There have been many fountains of this kind recently set up at Rome, which by their charm have incited the

[6] These fanciful conceits have a significance for the history of ornament which they hardly seem to deserve. Artificial grottoes of the kind Vasari describes were very popular in the France of the eighteenth century, and pleased the taste of the sophisticated society of the time with an artificial 'nature,' that corresponded to the affected pastoral style in literature. From the shell and stalactite decoration of these grottoes was evolved the ornamental style characteristic of the age of Louis XV, the shell-like forms of which betray its origin. The name commonly given to this ornament, that consists in little but a graceful play of curved forms, is 'rococo,' and this word is connected with 'rocaille,' a regular French term for fantastic grotto-work of the kind here under notice.

[7] The well-known 'Villa Madama.'

minds of countless persons to be lovers of such work. Another kind of ornament entirely rustic is also used now-a-days for fountains, and is applied in the following manner. First the skeleton of the figure or any other object desired is made and plastered over with mortar or stucco, then the exterior is covered in the fashion of mosaic, with pieces of white or coloured marble, according to the object designed, or else with certain little many coloured pebbles : and these when carefully worked have a long life. The stucco with which they build up and work these things is the same that we have before described, and when once set it holds them securely on the walls. To such fountains pavements are made of sling-stones, that is, round and flat river pebbles, set on edge and in ripples as water goes, with excellent effect. Others, for the finer fountains, make pavements with little tiles of terra cotta in various divisions and glazed in the fire, as in clay vases painted in various colours and with painted ornaments and leafage; but this sort of pavement is more suitable for hot-air chambers and baths than for fountains.[8]

[8] One of the best existing examples of these ' rustic' grottoes and fountains is that constructed by Buontalenti in the Boboli Gardens near the eastern entrance. As part of its decoration there are built in four marble figures, supposed to have been sketched out by Michelangelo for the tomb of Julius. A view of the interior of this grotto is given on Plate IV. The statue in the corner is one of the four noticed above, while a little above it and to the left is one of the grotesque figures incrusted with odds and ends, which Vasari praises as so fascinating.

PLATE IV

INTERIOR OF GROTTO IN BOBOLI GARDENS, FLORENCE

Showing an unfinished statue ascribed to Michelangelo

CHAPTER VI.

On the manner of making Pavements of Tesselated Work.

§ 32. *Mosaic Pavements.*

THERE are no possible devices in any department that the ancients did not find out or at any rate try very hard to discover,—devices I mean that bring delight and refreshment to the eyes of men. They invented then, among other beautiful things, stone pavements diversified with various blendings of porphyry, serpentine, and granite, with round and square or other divisions, whence they went on to conceive the fabrication of ornamental bands, leafage, and other sorts of designs and figures. Therefore to prepare the work the better to receive such treatment, they cut the marble into little pieces, so that these being small they could be turned about for the background and the field, in round schemes or lines straight or twisted, as came most conveniently. From the joining together of these pieces they called the work mosaic,[1] and

[1] The ultimate derivation of the word 'mosaic' is a difficult problem. Its immediate parent is the late-Latin 'musivum' which is generally connected with the Greek μουσεῖον, meaning a 'place of the Muses.' With this significance, the Greek word in its Latinized form 'museum' is suitably applied to collections of works of art and similar objects of aesthetic interest and value. A 'place of the Muses' may however be of a different kind. The Muses, like other nymphs, were worshipped in grottoes as guardian genii of fountains, and Pliny, *Hist. Nat.*, XXXVI, 21, writes of 'erosa saxa in aedificiis, quae musaea vocant, dependentia ad imaginem specus arte reddendam,' where the suggestion is of a rustic grotto like that in the Boboli Gardens. Such grottoes, natural or artificial, might fittingly be decked with shells and coloured stones and any bright inlay that offered itself. If incrustations of the kind we call mosaic were actually met with in these haunts of the Muses, the work might readily

used it in the pavements of many of their buildings, as we still see in the Baths of Caracalla in Rome and in other places, where the mosaic is made with little squares of marble, that form leaves, masks, and other fancies, while the background for these is composed of squares of white marble and other small squares of black. The work was set about in the following manner. First was spread a layer of fresh stucco of lime and marble dust thick enough to hold firmly in itself the pieces fitting into each other, so that when set they could be polished smooth on the top; these in the drying make an admirably compacted concrete, which is not hurt by the wear of footsteps nor by water. Therefore this work having come into the highest estimation, clever people set themselves to study it further, as it is always easy to add something valuable to an invention already found out. So they made the marble mosaics finer, and of these, laid pavements both for baths and for hot rooms, and with the most subtle mastery and diligence they delicately fashioned various fishes in them, and imitated painting with many

be called by a name suggestive of these same nymphs, and this might be applied later on to tesselated work in general. There is however no proof, either in Pliny or elsewhere, that what we call mosaic was actually so used, and it has been questioned by more than one authority whether there is really any connection between the word 'mosaic,' in its various forms, and the Muses. An oriental derivation has even been suggested for the term.

Dr. Albert Ilg, in an exceedingly learned paper on the subject in the *Wiener Quellenschriften*, Neue Folge, v, 158 f., offered an entirely new explanation of the word 'mosaic,' which he maintained had in its original sense nothing to do with inlaid work at all, but rather with gilding. He connected it with a root 'mus' or 'mos,' with a sense of 'beating' or 'grinding,' and instanced the mediaeval Latin term 'mosnerium,' which Ducange notices as equivalent to 'molendinum,' 'mill.' 'Musivum opus' would refer on this view to the gilding process in which the gold is ground to powder or beaten out ; and Ilg affirmed 'Musaicum im alten Sinne kann nur eigentlich Vergoldung, nicht das moderne Mosaik, bezeichnen.' If the word at first meant 'gilded work' it would later on be extended to what we know as 'mosaic,' because of the use in mediaeval mosaics of the familiar gold background. The argument of Dr. Ilg is not convincing, and the question must be considered still open. Theophilus, for example, Lib. II, c. 12, uses 'musivum opus' for inlaid work in which there is no question of gold.

colours suitable for that work, and with many different sorts of marbles, introducing also among these some pieces cut into little mosaic squares of the bones of fishes which have a lustrous surface.[2] And so life-like did they make the fishes, that water placed above them, veiling them a little, even though clear, made them appear actually alive in the pavements; as is seen in Parione in Rome, in the house of Messer Egidio and Fabio Sasso.[3]

§ 33. *Pictorial Mosaics for Walls, etc.*

Therefore, this mosaic work appearing to them a picture, capable of resisting to all eternity water, wind, and sunshine, and because they considered such work much more effective far off than near, the ancients disposed it so as to decorate vaults and walls, where such things had to be seen at a distance, for at a distance one would not perceive the pieces of mosaic which when near are easily distinguished. Then because the mosaics were lustrous and withstood water and damp, it was thought that such work might be made of glass, and so it was done, and producing hereby the most beautiful effect they adorned their temples and other places with it, as we still see in our own days at Rome in the Temple of Bacchus[4] and elsewhere.[5] Just as from marble mosaics are derived those which we now call in our time glass mosaics, so from the mosaic of glass we have passed on to egg-shell

[2] Possibly what we call 'mother of pearl.'

[3] See Note on 'The Sassi, della Valle, and other Collections,' etc., postea, p. 102 f. The mosaic here noticed is unfortunately lost. Lanciani, *The Golden Days of the Renaissance in Rome*, 1906, p. 234, states that he has searched for it in vain.

[4] See Note 5, ante, p. 27.

[5] Mosaics made up of small cubes of coloured or gilded glass are abundant in early Christian and Byzantine times, but were also used, though sparingly, by the Romans from the time of Augustus downwards. See Pliny, *Hist. Nat.*, XXXVI, 189, who fixes the time of their introduction.

mosaic,[6] and from this to the mosaic in which figures and groups in light and shade are formed entirely of tesserae, though the effect is like painting; this we shall describe in its own place in the chapters on that art.[7]

[6] Egg-shell mosaic. See Note, postea, p. 136.

[7] See Chapters XV and XVI of the 'Introduction' to Painting. The pavement of the cathedral of Siena exhibits a large collection of such mosaics in black and white executed in different technical processes.

CHAPTER VII.

How one is to recognize if a Building have good Proportions, and of what Members it should generally be composed.

§ 34. *The principles of Planning and Design.*

BUT since talking of particular things would make me turn aside too much from my purpose, I leave this minute consideration to the writers on architecture, and shall only say in general how good buildings can be recognized, and what is requisite to their form to secure both utility and beauty. Suppose then one comes to an edifice and wishes to see whether it has been planned by an excellent architect and how much ability he has shown, also whether the architect has known how to accommodate himself to the site, as well as to the wishes of him who ordered the structure to be built, one must consider the following questions. First, whether he who has raised it from the foundation has thought if the spot were a suitable one and capable of receiving buildings of that style and extent, and (granted that the site is suitable) how the building should be divided into rooms, and how the enrichment on the walls be disposed in view of the nature of the site which may be extensive or confined, elevated or low-lying. One must consider also whether the edifice has been tastefully arranged and in convenient proportion, and whether there has been furnished and distributed the proper kind and number of columns, windows, doors, and junctions of wall-faces, both within and without, in the given height and thickness of the walls; in short whether every detail is suitable in and for its own place. It is necessary that

there should be distributed throughout the building, rooms which have their proper arrangement of doors, windows, passages, secret staircases, anterooms, lavatories, cabinets, and that no mistakes be apparent therein. For example there should be a large hall, a small portico or lesser apartments, which being members of the edifice, must necessarily, even as members of the human body, be equally arranged and distributed according to the style and complexity of the buildings; just as there are temples round, or octagonal, or six sided, or square, or in the form of a cross, and also various Orders, according to the position and rank of the person who has the buildings constructed, for when designed by a skilful hand these exhibit very happily the excellence of the workman and the spirit of the author of the fabric.

§ 35. *An ideal Palace.*

To make the matter clearer, let us here imagine a palace,[1] and this will give us light on other buildings, so that we may be able to recognize, when we see them, whether they are well fashioned or no. First, then, if we consider the principal front, we shall see it raised from the ground either above a range of outside stairs or basement walls, so that standing thus freely the building should seem to rise with grandeur from the ground, while the kitchens and cellars under ground are more clearly lighted and of greater elevation. This also greatly protects the edifice from earthquakes and other accidents of fortune. Then it must represent the body of a man in the whole and similarly in the parts; and as it has to fear wind, water, and other natural forces it should be drained with sewers, that must be all in connection with a central conduit that carries away all the filth and smells that might generate sickness. In its first aspect the façade demands beauty and grandeur, and should be divided as is the face of a man. The door must be low down and

[1] See Note on 'Ideal Architecture' at the close of the 'Introduction' to Architecture, postea, p. 138.

in the middle, as in the head the mouth of the man, through which passes every sort of food; the windows for the eyes, one on this side, one on that, observing always parity, that there be as much ornament, and as many arches, columns, pilasters, niches, jutting windows, or any other sort of enrichment, on this side as on that; regard being had to the proportions and Orders already explained, whether Doric, Ionic, Corinthian, or Tuscan. The cornice which supports the roof must be made proportionate to the façade according to its size, that rainwater may not drench the façade and him who is seated at the street front. The projection must be in proportion to the height and breadth of the façade. Entering within, let the first vestibule have a great amplitude, and let it be arranged to join fittingly with the entrance corridor, through which everything passes; let it be free and wide, so that the press of horses or of crowds on foot, that often congregate there, shall not do themselves any hurt in the entrance on fête days or on other brilliant occasions. The court-yard, representing the trunk, should be square and equal, or else a square and a half, like all the parts of the body, and within there should be doors and well-arranged apartments with beautiful decoration. The public staircase needs to be convenient and easy to ascend, of spacious width and ample height, but only in accordance with the proportion of the other parts. Besides all this, the staircases should be adorned or copiously furnished with lights, and, at least over every landing-place where there are turns, should have windows or other apertures. In short, the staircases demand an air of magnificence in every part, seeing that many people see the stairs and not the rest of the house. It may be said that they are the arms and legs of the body, therefore as the arms are at the sides of a man so ought the stairs to be in the wings of the edifice. Nor shall I omit to say that the height of the risers ought to be one fifth of a braccio at least,[2] and every tread two thirds wide,[3] that is, as has

[2] That is, about 4½ inches.　　　　[3] About 15½ inches.

been said, in the stairs of public buildings and in others in proportion; because when they are steep neither children nor old people can go up them, and they make the legs ache. This feature is most difficult to place in buildings, and notwithstanding that it is the most frequented and most common, it often happens that in order to save the rooms the stairs are spoiled. It is also necessary that the reception rooms and other apartments downstairs should form one common hall for the summer, with chambers to accommodate many persons, while upstairs the parlours and saloons and the various apartments should all open into the largest one. In the same manner should be arranged the kitchens and other places, because if there were not this order and if the whole composition were broken up, one thing high, another low, this great and that small, it would represent lame men, halt, distorted, and maimed. Such works would merit only blame, and no praise whatever. When there are decorated wall-faces either external or internal, the compositions must follow the rules of the Orders in the matter of the columns, so that the shafts of the columns be not too long nor slender, not over thick nor short, but that the dignity of the several Orders be always observed. Nor should a heavy capital or base be connected with a slender column, but in proportion to the body must be the members, that they may have an elegant and beautiful appearance and design. All these things are best appreciated by a correct eye, which, if it have discrimination, can hold the true compasses and estimate exact measurements, because by it alone shall be awarded praise or blame. And this is enough to have said in a general sense of architecture, because to speak of it in any other way is not matter for this place.

NOTES ON 'INTRODUCTION' TO ARCHITECTURE

NOTES ON 'INTRODUCTION' TO ARCHITECTURE

PORPHYRY AND PORPHYRY QUARRIES.

[See § 2, *Of Porphyry,* ante, p. 26.]

Porphyry, which is mineralogically described as consisting of crystals of plagioclase felspar in a purple felspathic paste, is a very hard stone of beautiful colour susceptible of a high polish. ' No material,' it has been said, ' can approach it, either in colour, fineness of grain, hardness or toughness. When used alone its colour is always grand; and in combination with any other coloured material, although displaying its nature conspicuously, it is always harmonious ' (*Transactions,* Royal Institute of British Architects, 1887, p. 48). Though obtained, as Vasari knew, from Egypt, it was not known to the dynastic Egyptians, but was exploited with avidity by the Romans of the later imperial period. The earliest mention of it seems to be in Pliny, *Hist. Nat.,* xxxvi, 11, under the name ' porphyrites ' and statues in the material were according to this author sent for the first time to Rome from Egypt in the reign of Claudius. The new material was however not approved of, and for some time was by no means in fashion. It was not indeed till the age of the Antonines that as Helbig remarks ' the preference for costly and rare varieties of stone, without reference to their adaptability for sculpture, began to spread.' After this epoch, the taste for porphyry and other such strongly marked or else intractable materials grew till it became a passion, and the Byzantine emperors carried on the tradition of its use inherited by them from the later days of paganism. The material was quarried in the mountains

known as Djebel Duchan near the coast of the Red Sea, almost opposite the southern point of the peninsula of Sinai, and the Romans carried the blocks a distance of nearly 100 miles to Koptos on the Nile whence they were transported down stream to Alexandria, where Mr Brindley thinks there would be reserve dépôts where lapidaries and artists resided, a source of supply for the large quantities used by Constantine. The same authority estimates that there must be about 300 monolith porphyry pillars still extant in Europe, the finest being the eight great columns under the side apses in S. Sophia, Constantinople. The most important of all porphyry monuments is the column, 100 feet high, which Constantine erected at Constantinople where it still stands though somewhat mutilated and damaged by fire. It consisted in nine cylindrical drums each 11 feet long and 11 feet in diameter.

The quarries, as Vasari later on remarks, were in his time not known, and seem never to have been worked since the time of the Romans. The site of them was visited by Sir Gardner Wilkinson in 1823, and they were re-discovered by Mr Brindley in 1887. If they are again to be worked, the material will now be transferred to the Red Sea coast, distant only about 20 miles. Mr Brindley's account of his expedition, with notes on the material, is contained in the *Transactions* of the Royal Institute of British Architects for 1888.

THE SASSI, DELLA VALLE, AND OTHER COLLECTIONS OF ANTIQUES OF THE EARLY PART OF THE SIXTEENTH CENTURY.

[See §§ 2, 32, ante, pp. 28, 93.]

In chapters I and VI of the ' Introduction ' to Architecture Vasari refers to the ' casa di Egizio e di Fabio Sasso ' and the ' casa di messer Egidio e Fabio Sasso ' ' in Parione.' Parione is that one of the 14 wards or ' rioni ' of Rome that lies to the south of the Piazza Navona, and according to Gregorovius (*Geschichte der Stadt Rom im Mittelalter*, Stutt., 1886, etc., III, 537) the name is connected with the Latin ' parietes,' ' walls,' and was derived from the ruins of the Theatre of Pompeius, that bulked largely within its borders.

There is now a 'Via Parione' to the west of the Piazza
Navona, but older plans of near Vasari's time show that the
name was then applied to the more important thoroughfare
south of the piazza, which is now called 'Via del Governo
Vecchio.' The truth is that the present Via Parione should
be called, as marked on older maps, 'Via di S. Tommaso in
Parione,' beside which church it runs, and should not have
been allowed to usurp the old historical name.

Among the families noted by Gregorovius as inhabiting this
region were the Sassi, who, he says (VII, 708), possessed there
'a great palace with many antiques.' A notice of the Sassi,
in the *Archivio della R. Società Romana di Storia Patria,*
Roma, vol. xx, p. 479, tells us that they were among the most
illustrious families of the 'rione.' In 1157 one Giovanni Sassi
was a senator of Rome, and the family was especially flourish-
ing in the fifteenth century, but later on declined. Branches
of the Sassi stock still exist. When Vasari was in Rome in
the service of the Cardinal Ippolito de' Medici, about 1530, one
branch at any rate of the family was represented by a certain
Fabio Sasso and his brother, whom Vasari calls 'Egidius'
but who appears in a document quoted by Lanciani (*Storia
degli Scavi di Roma,* Roma, 1902, I, 177) as 'Decidius,' who
possessed the family palace with its antiques, situated a little
west of S. Tommaso in Parione. When Michaelis wrote the
paper presently to be noticed, the exact situation of the palace
was not identified, but the Conte Gnoli, the learned and
courteous director of the Biblioteca Vittorio Emanuele, has
pointed out the remains of the Sassi habitation at No. 48 in
the present Via del Governo Vecchio, where an early Renais-
sance doorway bears above it the cognizance of the family,
and below on one jamb the syllable 'DOM' and on the other
'SAX' (Domus Saxorum). The house in general, which is
claimed by legend as the residence of Raphael's Fornarina,
has been reconstructed. The plan, Fig. 8, is taken from
a large map of Rome dating 1748 and shows this particularly
interesting portion of the city as it was before recent changes.
The line of the present Corso Vittorio Emanuele is shown
by dotted strokes.

By the middle of the sixteenth century the family fortunes

had declined, and in his will made in 1556 Fabio records that
he had let all his three houses in Parione. This may account
for the fact that no Palazzo Sassi occurs in the lists of Roman
palaces of the seventeenth century. Furthermore, in 1546
the two brothers effected a sale of their antiques to the Duke
Ottavio Farnese, who transferred them to the then newly
erected Farnese palace. See text of Vasari, ante p. 28, and
Lanciani, l.c.

When Vasari first knew the Sassi collection it was one of
the best in Rome, and Michaelis (*Jahrbuch d. deutschen
Archeologischen Instituts,* 1891, p. 170) quotes two writers of
the early part of the century who praise it. Moreover there
exists a contemporary drawing of the antiques and the court
in which they were kept, that Michaelis (l.c.) has published.
The early notices just referred to, and the notes of Aldovrandi
(Mauro, *Le Antichità della Città di Roma,* Venet. 1556, p. 147)
who saw the works in the Farnese collection in 1550, give
prominence to the two pieces that are specially mentioned by
Vasari. The ' figura a sedere di braccia tre e mezzo ' in
porphyry (ante, p. 28) is described by Aldovrandi (p. 147) as
' un bellissimo simulacro di una Roma trionfante assisa,' partly
in porphyry and partly in bronze, and as having been formerly
in the house of Messer Fabio Sasso. The statue has passed
with the Farnese antiques to Naples, where it was numbered
when Michaelis wrote, 212 b. It is now recognized as not
a ' Rome ' but a seated Apollo fully draped, and is numbered
6281.

The other one of the Sassi antiques mentioned by Vasari is
referred to in the text § 7, ante, p. 42, as ' una figura in
Parione d' uno ermafrodito ' in the stone called ' paragone '
or ' touchstone.' This is also praised by the earlier writers,
and is seen in the drawing which Michaelis has published.
Aldovrandi calls it (p. 152) ' uno Hermafrodito di paragone,
maggiore del naturale ' and notes its provenance. It is the
' Apollo ' at Naples, No. 6262, and Michaelis gives the material
as basalt. It is noticed by Winckelmann as an Apollo.

The della Valle collection was more important than that of
the Sassi, and was the finest of all those that were being
formed in the early part of the sixteenth century. There is

a full notice of it by Michaelis in the *Jahrbuch,* 1891, p. 218 f.,
who prints the inventory drawn up at the time of the sale of
the collection in 1584 to Cardinal Ferdinando de' Medici, by

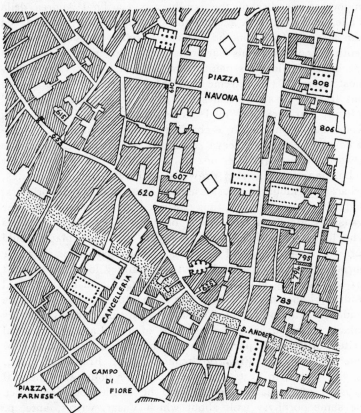

Fig. 8.—Portion of a Plan of Rome, from Nolli, *Nuova Pianta di Roma,* 1748.

607, Palazzo Pamphili Doria.	653, Via di Parione.
610, Torre Millina.	783, Piazza della Valle.
615, S. Tommaso in Parione.	794, Palazzo Capranica.
620, Piazza Pasquino.	795, Teatro della Valle.
625, Palazzo Massimi.	806, Palazzo Medici, or, Madama.

808, S. Luigi dei Francesi.

The dotted portion marks the line of the recent Corso Vittorio Emanuele.
The site of the Sassi Palace, near S. Tommaso, is marked by a cross.

whom the antiques were removed to the Villa Medici, whence
many of them, including most probably the ' Medici Venus,'
found their way to Florence.

The della Valle were a family of high importance, counting

many branches and numerous houses in that part of Rome, south-east of the Piazza Navona, where church and piazza and palace and theatre still keep alive their name. The most important member of the family was Cardinal Andrea della Valle, one of Leo X's creations of 1517. Vasari introduced him into the fresco in the Palazzo Vecchio at Florence representing Leo X with his Cardinals, that is given as a favourable specimen of Giorgio's painting on Plate I. His is the uppermost figure on the extreme right of the picture. Referring to this fresco, Vasari describes him in his third ' Ragionamento ' (*Opere,* VIII, 158) as ' quel cardinale della Valle, che fece in Roma quello antiquario, e che fu il primo che mettessi insieme le cose antiche, e le faceva restaurare.' About the last clause a word will be said later on.

Lanciani (l.c., I, 123) draws attention to the vast estates, urban and suburban, possessed by these wealthy proprietors, and the opportunities thus afforded of obtaining antique treasures for the mere trouble of digging for them. Nobles who had official charge of the streets and open places could turn the opportunities of their position to account for the same purpose, and in the first half of the century lovers of ancient art did not buy antiques but simply dug for them. Cardinal Andrea, Lanciani says, ' era appassionato scavatore,' and he made excavations in the Thermae of Agrippa near which his palace lay, and in the vineyards of the Lateran. Several writers of the early part of the century celebrate this collection. One (Fichard, in *Frankfurtisches Archiv,* Frankfurt, 1815, III, 68) writes, in 1536, that the Cardinal's house was the real treasury of Roman antiquity, and he singles out for notice the same porphyry wolf about which Vasari writes, ante, p. 28. There were so many statues there, he says, that you would have thought everything ever found in Rome had been brought together to that one place! The whole collections of the family however were divided among three or four palaces, but Andrea had the lion's share. He built a new palace for his treasures early in the century and displayed the best pieces in a court. There were to be seen a Venus, that was probably the Medicean, and the Florentine Ganymede, both now in the Uffizi, Nos. 548 and 115, and close to these above a window

the porphyry wolf of which we hear from Vasari. The present location of this piece is not known, but Michaelis suggests it might be looked for at the Villa Medici or at Florence. Vasari also mentions 'two prisoners bound,' also of porphyry, as being in the garden of the palace (ante, p. 29). These are mentioned in the inventory referred to above (*Jahrbuch,* 229) as 'two barbarians, draped, of porphyry, 11 palms high.' They were transported from the Villa Medici at Rome to Florence in 1790, and are now very familiar to visitors in Florence, for they stand just within the Boboli Gardens, one on each side of the main walk that leads up 'towards the Amphitheatre. They are about eight feet high, of porphyry, with heads and hands of white marble. Two similar figures are to be seen in the Louvre, under the staircase at the top of which is the Niké from Samothrace.

Della Valle was not content with his fine house and museum, but desired another which he began to build about 1520. The work was directed by Lorenzo Lotti (Lorenzetto) a pupil and assistant of Raphael, and Vasari gives us an account of it in his life of the former artist (*Opere,* IV, 579). In connection with this we have from Vasari an interesting notice of the beginning of the practice of 'restoring' antiques, which from this period onwards was an established custom. When Lorenzetto, he tells us, was building for the Cardinal Andrea della Valle the upper garden of his palace, situated where is now the Teatro della Valle (see Fig. 8), he arranged niches and other places for the Cardinal's antiques. 'These were imperfect, some wanting a head and others arms, while others again were legless, and all were in some way mutilated. Nevertheless the artist managed everything excellently well, for he got good sculptors to make again everything that was wanting, and this led to other lords doing the same thing, and having many antique fragments restored. This was done for example by Cardinals Cesis, Ferrara, and Farnese, and in a word by all Rome. And in truth these antiques, restored in this fashion, have a much more pleasing effect than those mutilated torsos, and limbs without a head, and such-like fragments.' On the restoration of the Papal antiques see Note, postea, p. 116.

THE PORPHYRY TAZZA OF THE SALA ROTONDA OF THE
VATICAN.

[See § 2, *Of Porphyry*, ante, p. 32.]

Ascanio Colonna, who was brother to the famous Vittoria
Colonna the friend of Michelangelo, was one of the chief repre-
sentatives of the imperial interests in Italy, in the stormy
times of the first half of the sixteenth century. Charles V
made him in 1520 Grand Constable of Naples. With Pope
Paul III he had a bitter feud, and the Pope seized on his
possessions. On the election in 1550 of Julius III, the new
Pope, in order to please the Emperor, reinstated Ascanio, and
it was on the occasion of this reconciliation that Colonna
presented to the Pope the famous basin of porphyry of which
Vasari writes. The 'vineyard' for which the Pope destined
it was connected with the casino and villa outside the Porta
del Popolo which bear the name of the Pope and where is
now installed the Villa Papa Giulio Museum. The tazza in
question is the superb bowl that occupies the centre of
the Sala Rotonda in the Vatican Museum. It is said to
have been found temp. Julius II, in the Thermae of Titus
(Pistolesi, *Il Vaticano Descritto*, v, 206), and after remaining
for a time at the papal villa it was conveyed by Clement XI
to the Vatican and placed in the court of the Belvedere, now
the Cortile Ottagono. Francesco de' Ficorini (*Le Vestigia e
Rarità di Roma*, Roma, 1744, bk. ii, ch. 2, p. 15) says that
in this court was the 'gran conca di porfido,' and another of
white oriental granite, both found in the Thermae of Titus.
When Clement XIV (1769-75) added the octagonal colonnade
in the interior of the Cortile, the tazza was apparently no
longer needed there, for soon afterwards Pius VI, who with
Clement was the creator of the Museo Pio-Clementino, placed
it in his newly constructed Sala Rotonda, where it remains.
Pasquale Massi in his *Indicazione antiquaria del Ponteficio
Museo Pio-Clementino*, 1792, p. 118, speaks of ' una vastissima
tazza di porfido di palmi 62 di circonferenza tutta massiccia
(all of one piece), la quale si trovava già in Vaticano tras-
portatavi dalla Villa di Giulio III, fuori di Porta del Popolo,
ed ora squisitamente risarcita.' This restoration was completed

in 1792 and was no doubt carried out by the same artists whom Pius VI employed for the repair of the porphyry sarcophagi noticed ante, p. 27. In this way the work, which Vasari says in the text had to be left unfinished, was finally accomplished. Cancellieri (*Lettera . . . intorno la maravigliosa Tazza di Porfido,* etc., Roma, 1822) makes the surprising statement that at one time the tazza had been mended with pieces of white granite !

The tazza is the largest existing piece of the kind and measures 14 ft. in diameter. It is shallow and has in the interior the usual projecting central boss. Independently of this boss the tazza has only one arris, or in Vasari's words

FIG. 9.—Sketch of shape of the large porphyry Tazza in the Sala Rotonda of the Vatican.

' canto vivo,' at A in the rough sketch, Fig. 9. A smaller but more artistically wrought porphyry tazza, beautifully restored, and measuring 8 ft. 6 in. in diameter, is in the Pitti at Florence close to the entrance to the passage to the Uffizi. It was a gift from Clement VII to the Medici, and was brought from Rome (Villa Medici) to Florence in 1790, where it was repaired in the Tuscan manufactory of mosaics (Zobi, *Notizie Storiche sull' Origine e Progressi dei Lavori di Commesso in Pietre Dure,* Firenze, 1853, p. 118). Both these pieces are superb works, and display the magnificent qualities of the red Egyptian porphyry to full advantage.

The original purpose of these great basins is not very clear. The ' conche ' mentioned in the footnote to p. 27, ante, though now used as sarcophagi, were certainly in their origin baths, but the shallow tazza would be unsuitable for such a purpose, and moreover the central ornament would have almost

precluded such a use. There seems no sign of a central opening through which a water pipe could have been introduced, so that the tazza might serve as the basin of a fountain. Perhaps their employment was simply ornamental.

FRANCESCO DEL TADDA, AND THE REVIVAL OF SCULPTURE IN PORPHYRY.

[See § 2, *Of Porphyry*, ante, p. 29.]

Vasari does not give a biography of this artist among his *Lives*, though he more than once refers to him in connection with other sculptors. There is on the other hand a notice of him and of other artists of his family in Baldinucci's *Notizie de' Professori del Disegno*, published 1681-1728. Baldinucci knew personally the son of Francesco, but was so poorly informed about Francesco's early life that he makes two persons of him and describes his early career as if it were that of another Francesco del Tadda. (It is true that there was an earlier Francesco Ferrucci but he was not called ' del Tadda ' and he died before 1500). The commentators on Vasari previous to the Milanesi edition seem to have been misled by Baldinucci, but in this edition the mistake is corrected, and a genealogical tree of the whole Ferrucci family is given in vol. IV, p. 487.

Francesco derived his name ' del Tadda ' from his grandfather Taddeo Ferrucci, who belonged to a family of sculptors in Fiesole. In early life he worked with other sculptors under the orders of Clement VII at the completion of the chapel of Our Lady of Loretto, and afterwards assisted Michelangelo in his work in the Sacristy of S. Lorenzo at Florence. In the Life of Giovanni Agnolo Montorsoli Vasari praises him as ' intagliatore excellente ' (*Opere*, VI, 638). The works in porphyry mentioned in Vasari's text, ante, p. 32 f., will be noticed presently, but it may be noted here that del Tadda's chief work in this material, executed after Vasari published his *Lives*, was the figure of ' Justice ' which stands on the granite column in the Piazza di S. Trinità at Florence. The column, which is 36 ft. high, came from the Baths of Caracalla at Rome and was presented by Pius IV to Duke Cosimo I.

Among the letters of Vasari published in the eighth volume of the Milanesi edition is one dated December 18, 1561, to Duke Cosimo, giving the measurements of this column which was then lying at Rome awaiting its transport to Florence. The system of measurement is instructive and has been referred to ante, p. 66 (see *Opere*, VIII, 352). The column was taken to Florence, occupying a year on its journey, and was erected in 1565 on the Piazza S. Trinità where it now stands. Cellini (*Scultura*, ch. 6) says that it is of Elban granite, but it is more likely to be from Egypt.

Francesco del Tadda received the commission for a porphyry figure to surmount it, and the work is said to have taken him and his son eleven years; it is in five or six pieces and about 11 ft. 6 in. high. The statue was placed in position on June 9, 1581, and the drapery of bronze was adjusted to it on July 21 (Francesco Settimanni quoted by Zobi, page 105). The figure has been adversely criticized but is a fairly successful piece of work, considering the difficulties of its execution. Francesco del Tadda died in 1585 and was buried in the church of S. Girolamo at Fiesole, where his epitaph signalizes his unique position as a worker in porphyry 'cum statuariam in Porphyretico lapide mult. ann. unicus exerceret,' and bears his portrait by his own hand in relief in porphyry on a field of green Prato serpentine.

On the whole subject of work in porphyry, after the early Byzantine period when the late Roman imperial tradition was still in force, the following may be noted.

Vasari does not say that the art of working the stone was ever wholly lost, and mentions, ante, p. 29, the cutting of the stone for use in inlaid pavements, Cosmati-work, and the like, as may be seen in St Mark's, Venice; at Ravello, and in numberless Roman churches. He also describes the 'scabbling' of the stone by heavy hammers with steel points to reduce it to even surfaces both rounded and flat (ante, p. 31). Fine examples of the use of the material in mediaeval days, for purposes other than statuesque, can be seen in the Cathedral of Palermo. There are there four noble sarcophagi, with canopies supported by monolithic shafts all in the same stone, dating from the thirteenth century. They contain the

bodies of the Emperor Frederick II, who died in 1250, and of earlier members of his house, and show that at that time the artificers of southern Italy and Sicily could deal successfully on a large scale with this intractable material. Anton Springer, *die Mittelalterliche Kunst in Palermo,* Bonn, 1869, remarks in this connection, p. 29, that the Sicilians are to this day specially expert in the working of hard stones. Porphyry was also used on the original façade of S. Maria del Fiore at Florence that was demolished in 1588. Vasari might too have mentioned the porphyry sarcophagus completed in 1472 by Andrea del Verrocchio for the monument of Piero and Giovanni de' Medici in S. Lorenzo at Florence. The Verrocchio sarcophagus is however composed only of flat slabs of porphyry, like those round the pulpit in St. Mark's, Venice, whereas Vasari is drawing a distinction between this architectural use of the stone and its employment in figure sculpture, of which he makes Francesco del Tadda the first restorer.

In regard to this use of porphyry it must not be forgotten that in the Cabinet of Gems in the Uffizi there is a beautifully executed porphyry statuette, or rather group, of Venus with Cupid, about ten inches high, signed in Greek characters with the name of ' Pietro Maria.' This was Pier Maria da Pescia, noticed by Vasari in his life of Valerio Vicentino and others, as a famous worker in hard stones of the days of Leo X (*Opere,* v, 370). This however was executed, so Zobi says (p. 97), with the wheel after the manner of gem engraving, whereas the works of Ferrucci, of later date, were on the scale of statuary proper.

In connection with the latter we have Vasari's story of the invention of Duke Cosimo. This is explained by Galluzzi, (*Istoria del Granducato di Toscana,* Firenze, 1781, 1, 157 f.) who says that Cosimo's efforts to exploit the mineral wealth of Tuscany (see postea, p. 120 f.) gave him an interest in metals, and that he set up a laboratory in his palace, where he carried on experiments in chemistry and physics. Hence the discovery of which Vasari writes. Cosimo certainly in his own time had some personal association with this cutting of porphyry, for Galluzzi says he used to make presents to his friends of porphyry reliefs executed with tools tempered by the new

process, and quotes (ii, 229) a letter of thanks from a Cardinal to whom a gift of the kind had been forwarded. On the other hand Cellini, (*Scultura* ch. 6) makes Tadda the inventor and ignores Cosimo altogether, while Baldinucci, though, like Vasari, he was devoted to the Medici, scouts the idea of Cosimo having had any personal share in the invention of the new tempering bath, which he ascribes to Tadda alone, and he adduces in support of this Tadda's own testament, in which are the words *Franciscus de Fesulis sculptor porfidi, et ipse inventor, seu renovator talis sculpturae, et artis porfidorum incidendi.* Cosimo's participation in the discovery, whatever it was, can hardly have been ascribed to him without some small foundation in fact, and Aurelio Gotti, *Le Gallerie e I Musei di Firenze,* 2nd Ed., Firenze, 1875, p. 45, gives credit for it to the Duke.

However this may be, Tadda appears to have used the new process for the first time in the production of the tazza for the fountain in the cortile of the Palazzo Vecchio, and to have advanced from this to the more artistic work Vasari goes on to describe. Endeavours to discover the present habitat of the oval portraits of the Medici and the Head of Christ, referred to by Vasari, ante, p. 33, have led to the following result. Signor Supino, the Director of the National Museum at Florence, courteously informed us that the portraits of Cosimo *Pater Patriae,* of Leo X, and of Clement VII, with one of Giovanni de' Bicci, were preserved in the magazines of the Bargello, where he has kindly allowed one of us to photograph them. The head of Cosimo has on the chamfer of the bust the inscription OPA DI FRANC° DA FIESOLE, which identifies it with certainty as the work of Tadda of which Vasari writes. The others are treated in the same fashion, and all are mounted on flat oval slabs of green serpentine of Prato. They are no doubt all by the same hand. They were formerly in the Uffizi but have been for many years in the Bargello, and their historical and artistic interest would certainly vindicate for them more honourable treatment than at present is their lot. Plates III and V give the Cosimo *Pater Patriae* portrait and that of Leo X. They measure about 19 in. by 14 in.

With regard to the other examples noticed by Vasari, Zobi,

l.c., p. 108, informed his readers that the two ovals of Duke Cosimo I and his wife the Duchess Leonora were at that time (about 1850) in the Pitti 'on the wall of the vestibule in the part called Meridiana,' but he complicates matters by announcing the same about the head of the older Cosimo, which we have just found at the Bargello, and which Gotti says, l.c., p. 46, was originally in the Villa of Poggio Imperiale whence it was conveyed in 1862 to the Uffizi. Zobi's words are subjoined in the original. 'Ed i ritratti in profilo del duca Cosimo I, d' Eleonora di Toledo sua moglie, e di Cosimo appellato il *padre della patria,* scolpiti a mezzo rilievo e rapportati sul fondo di serpentino, si trovano oggidì situati insieme con altri ritratti parimente porfiretici, sulle pareti del vestibolo al quartiere detto della *Meridiana* nel palazzo regale.'

The part of the Pitti referred to is on the second floor of the palace and receives its name from a meridian line in brass marked on the floor on which, at the psychological moment, the sun shines through a hole in the roof. Here, through the courtesy of Signor Cornish the Conservator of the Royal Palace, we have seen no fewer than seven oval portraits in porphyry mounted on serpentine that are built into the wall in situations which make their study rather difficult. Among them the marked features of Duke Cosimo are not apparent, but on one of them is the inscription, 'Ferdinandus Magnus Dux Etr. 1609,' and on another the name and date of Christina, Duchess of Tuscany, 1669. This all bears out what Baldinucci tells us, that the Ferrucci family in general put their hands to this particular class of work, which was their speciality, just as the glazed terra-cottas were specialities of the della Robbia, while they also adopted into the circle pupils from outside. Zobi, p. 109, quotes an old inventory of 1574, the date of the death of Duke Cosimo I, which mentions ten such portraits of members of the family as at that time existing, all mounted on serpentine. Later on, Baldinucci mentions three sons of Francesco, to one of whom, Romolo, he is supposed to have left his 'secret.' There was however also an Andrea Ferrucci, and a Mattias Ferrucci, who if they lacked the pretended 'secret' at any rate did the same work, and finally one Raffaello Curradi, a pupil of Andrea, who in 1636

PLATE V

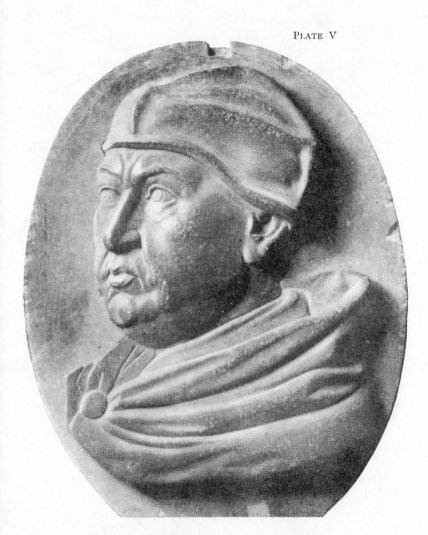

PORTRAIT IN PORPHYRY OF LEO X
BY FRANCESCO DEL TADDA

abandoned sculpture and took the Franciscan habit. According to Zobi, p. 116, he was the last of the porphyry sculptors, and 'dopo quest' epoca affatto s' ignora se furono prodotte altre opere porfiree.' In view of the date 1669 on one of the ovals in the Pitti, this should not perhaps be taken too absolutely. That porphyry has been worked successfully at Florence at later dates, the admirable restoration of the porphyry tazza in the Pitti, mentioned ante, p. 109, and other more recent productions noted by Zobi, sufficiently show.

If we add to the series of ovals the various porphyry busts of members of the Medici house, exhibited in the outer vestibule of the Uffizi and other places, there would be enough porphyry versions of the Medici to furnish material for a monograph.

With regard finally to the 'Head of Christ' which Vasari says was taken to Rome and much admired by Michelangelo, the original seems to be lost, but Zobi states, p. 95, that in his time a scion of the Ferrucci family, living at Lugo in the Province of Ravenna, possessed a head of Christ in porphyry signed MATHIAS FERRUCCEUS CIVIS FLORENTINUS FECIT, and he thinks this may have been copied from the original by Francesco del Tadda, of which there is question in Vasari's text.

THE CORTILE OF THE BELVEDERE IN THE VATICAN, IN THE SIXTEENTH CENTURY.

[See § 4, *Of Cipollaccio*, ante, p. 36.]

The history of this famous Cortile forms the subject of an elaborate paper by Professor Adolf Michaelis in the *Jahrbuch* of the German Archaeological Institute for 1890. It has been described as 'the most noteworthy place of art in all Italy or rather in the world,' as it was the first home of the nascent collection of antique statues formed by successive Popes from the beginning of the sixteenth century, that has grown into the Vatican museum of sculpture. It must be remembered that the octagonal portico which now surrounds the Cortile is a later addition of the last part of the eighteenth century, and when Vasari knew it, about 1530, in the pontificate of Clement VII, it was laid out as a garden of orange trees, with

niches by Bramante in the four corners and in the middle
of the sides. In these niches and on pedestals in the court
were displayed notable antiques, such as the ' Laocoon,' the
' Nile ' now in the Braccio Nuovo, the ' Tiber ' now in the
Louvre, the ' Torso,' the ' Cleopatra,' two Venuses, the ' Apollo
Belvedere,' and others. This was a favourite resort of Clement,
who used to walk here in the mornings reading his breviary,
and listened in the evenings to music made for him by
Benvenuto Cellini and others (Cellini, *Autobiography,* transl.,
Lond., 1878, p. 42). Here too he consulted with Michelangelo
in 1532 on the question of the restoration of the antiques, and
Michelangelo recommended to him for the purpose the youthful
sculptor Fra Giovann' Agnolo Montorsoli, whom the Pope in-
stalled in the Belvedere to carry out the work (see ante, p. 107).
Among the features of the court were fountains in some of the
niches, on which were statues. The ' Cleopatra ' of the Vatican
was one of these, and Clement seems to have desired to make
a second fountain corresponding to that of the Cleopatra, to
be adorned by the river god Tigris. The ' Tigris,' which is
now in the Sala a Croce Greca, is said to have been restored
by the august hands of Michelangelo himself, and it was for
the installation of the ' Tigris ' that Buonarotti designed the
fountain of which Vasari writes. Vasari's account, which had
escaped the notice of Michaelis, is our only authority for this
work by Michelangelo, which is not, so far as the present
writers can discover, mentioned in any of the numerous ' Lives '
of the artist. There is a drawing of the fountain by Heems-
kerck, reproduced by Michaelis, but this only gives the figure,
and not the decorative treatment of the niche, which is the
point of interest as a *parergon* by Michelangelo. The
situation of the ' Tigris ' fountain was in the corner where
is now the Cabinet of the Laocoon. (Michaelis l.c., and Plans
and Drawings of the Vatican in the King's Library at Blooms-
bury. Of older writers Bonanni, *Numismata Summorum
Pontificum Templi Vaticani Fabricam Indicantia,* Roma, 1696,
is praised by Lanciani as the most useful and trustworthy).

PARAGON (TOUCHSTONE) AND OTHER STONES ASSOCIATED WITH IT BY VASARI.

[See § 7, *Of Paragon,* ante, p. 42.]

There are at least six different kinds of stone referred to in this section, and for convenience they are lettered in the text (a) (b) etc.

(a) There is a stone specially suited for the process of testing the precious metals in the way Vasari describes. It is called in various tongues ' touchstone,' ' pierre de touche,' ' Probirstein,' ' pietra di paragone,' ' basanite ' from Greek βάσανος, a test, and in Latin 'Lapis Lydius' from the reason that it was found in Lydia. According to Theophrastus, Περὶ Λίθων, § 35, and Pliny, *Hist. Nat.,* xxxiii, 8, it was only found in small nodules, and this agrees with the character of the stone. It is described by Professor Bonney as a ' silicified argillite,' that is to say a clayey sedimentary stone largely impregnated with silica, and, as used by the modern jeweller and goldsmith, it is in appearance and texture an extremely hard stone of very fine grain and of a velvet blackness, the colour being due to the presence of carbonaceous elements. Small lumps of fine texture are found embedded in a coarser matrix. It has no mystic power of testing metals. The piece of metal to be essayed is simply rubbed on the stone and the mark scrutinized, or compared as regards colour with marks from similar rubbings of metal pins of known composition. A piece of the stone, showing some marks of the kind, is given as I on the Frontispiece. For the above purpose any hard, fine-grained, compact stone of a dark colour will serve, and black jasper Wedgewood-ware answers the demand as well as a natural stone. The small portion of the metal rubbed off as above may however be tested more searchingly by the application of acid, and for this to be practicable the stone must not be a limestone, which would be at once attacked by the acid and confuse the test.

(b) The ' other variety with a different grain and colour,' of which Egyptian sphinxes were made, must be basalt (or diorite) in which material the statue which Vasari calls the ' hermaphrodite in Parione ' is actually cut. A fine-grained

basalt would serve well enough as a touchstone, though it is not the true material.

(c) There appears to be a kind of granitic stone, which Mr Brindley calls ' an augite variety of green granite found alongside the Prato serpentine ' (for which see below) found near Prato (Repetti, art. ' Monte Ferrato,' writes of a ' granito di Prato ' or ' granitone di Figline '), but the stone that Vasari goes on to describe (d) as used for sarcophagi, is of another composition altogether. This is a black or grey limestone that used to be abundantly employed as the setting for Florentine mosaics, and is still used for such purposes as inlaid letters, etc., in white marble. P, as above, shows a piece cut for such use. It is however liable to white or light-grey veins, and is now supplanted at the Florentine mosaic manufactory by a black marble or limestone imported from Belgium. The sarcophagus of Piero Soderini, behind the high altar in the church of the Carmine at Florence is in a grey limestone much traversed by lighter veins. Such a stone could not be suitably used as a touchstone, as in the first place it is not hard enough, and, in the second, would not admit of the use of the acid test. The name ' paragone ' is however very commonly applied to it. The ' canopy of Prato touchstone ' is mentioned by other writers beside Vasari, but is no more to be seen and may have perished in the Carmine fire.

(e) Here again we have a quite different stone, though one very well known and in common use. The dark stone which occurs in bands on Tuscan buildings in Florence and elsewhere is known as ' Verde di Prato ' and is a species of (true) serpentine, very dark in hue and often seeming purplish or puce-coloured rather than green. It would be too soft to make a good touchstone, and is disposed to disintegrate when exposed to severe climatic conditions. Thus on the façade of S. Miniato a Monte on the hill facing the north it is far more weathered than on the Duomo or Campanile below. For the quarries of it and its use see the Note, postea, p. 127. E, as above, shows a characteristic piece kindly lent from his collection by Professor Bonney.

(f) Lastly there is the red marble used in bands on the Campanile and Duomo. For this also see the Note p. 128.

TUSCAN MARBLE QUARRIES.

[See §§ 5, 9, 97, 99, etc.]

The best work on the subject of Italian stones is that by Jervis, *I Tesori Sotterranei dell' Italia,* Torino, 1889, and a considerable amount of information is contained in the local articles in E. Repetti's *Dizionario geographico, etc., della Toscana,* Firenze, 1839, and also in the Official Catalogue of the Italian section in the London International Exhibition of 1862. In connection with investigations which we have had to make on all this subject of the stones, we have to acknowledge with all gratitude the expert aid kindly afforded by Professors Bonney of Cambridge and Geikie of Edinburgh, as well as the valuable local assistance and information kindly given to us by Professor Enrico Bonanni of Carrara and the representatives of the firm Henraux et Cie of Seravezza, the owners of the Monte Altissimo quarries presently to be mentioned. From both these sources we have obtained knowledge which we could not otherwise have compassed, and we desire again to express our obligations to Mr W. Brindley, who is as well known in the Carrara district as in London, and who gave us these introductions as well as much technical information.

The quarries mentioned by Vasari are named in the accompanying table, where there are also indications of the kinds of stone he signalizes as their products. It must of course be understood that extensive quarries generally produce more than one kind of stone, as Vasari notes in the case of the Carrara quarries in § 9, and again in ' Painting ' § 97, where he speaks of variegated marbles alternating with the white.

The principal deposits of marble are those in the Carrara district, in the mountains called the Apuan Alps near the sea coast between Pisa and Spezia. The marbles of the district have been exploited since the time of the Romans, under the name of marbles of Luna or Luni. The site of the Etrusco-Roman town of Luni is a little south of the railway line, about half way between Avenza-Carrara and Sarzana, and traces of the Roman workings are observable in many of the

present quarries. The industry received a notable impulse at the great artistic epoch of the Renaissance. Duke Cosimo de' Medici gave considerable attention to the exploitation of this form of mineral wealth, as was also the case with the metal-producing mines (ante, p. 112). He opened new quarries in the Pietrasanta district of the Apuan Alps, and also gave special attention to the quarries in the Pisan Mountains, between Pisa and Lucca, and to facilitating the transport of the material from the hills to the former town.

The special quarries of which the town of Carrara is the centre and dépôt are the oldest and the most prolific, and a useful local guide to Carrara gives a long list of the effective ones in their different groups, with their respective products. Of these, that which has furnished the finest statuary marble in the largest blocks is the quarry of Polvaccio, in the Ravaccione valley under Monte Sagro, one of the culminating points of the ridge of the Apuan Alps. See the sketch map, Fig. 10. Vasari (ante, p. 46) specially praises the Polvaccio marbles, as being free from the veins and flaws so tiresome to the sculptor. There are now other localities in the district that furnish as good pieces as Polvaccio.

There is another important centre a little to the south-east, that is of more interest in the present connection. This is Pietrasanta, which is the emporium for the quarries of Seravezza several times mentioned by Vasari, and those of Stazzema, a little further up among the hills.

The Seravezza district is quite apart from that of Carrara, and the little town in question nestles in the folds of the ridges that descend from Monte Altissimo, the culminating point next to the south from Monte Sagro, both peaks being between 5 and 6,000 feet high. Both districts are rich in memories of Michelangelo. About his work at Carrara there is more than one published treatise, as for example Carlo Frediani's *Ragionamento Storico,* 2nd Ed., Siena, 1875, while in connection with his proceedings at Seravezza, and especially the identification of localities mentioned in his correspondence and memoranda, MM. Henraux have furnished us with some first-hand information. Both at Carrara and at Pietrasanta inscriptions indicate houses where he lodged on his visits to

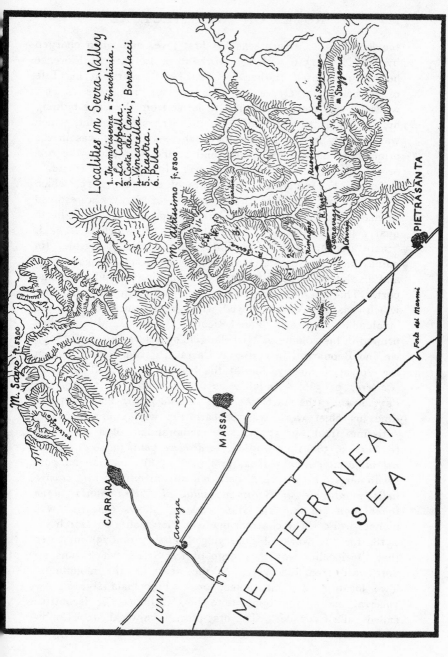

Localities in Serra Valley

1. Tramrissona = Finochiaia.
2. La Cappella.
3. Costa dei Cani, Borellacci.
4. Vincarella.
5. Piastra.
6. Polla.

M. Sagro ft. 5900

M. Altissimo ft. 6300

PIETRASÀNTA

Ponti Stazzema

Stazzema

Ruosina

R. Vezza

Canerazzo

Corvaja

Renara

Polvaccio

Strettoia

Fabr. dei Marmi

CARRARA

MASSA

Avenza

LUNI

MEDITERRANEAN SEA

Fig. 10.—Sketch map of the marble-producing districts of the Apuan Alps.

the localities. Carrara was his first love, and when charged by Leo X in 1516 with the work at S. Lorenzo at Florence he betook himself thither for marbles. Vasari, in his Life of Michelangelo, *Opere,* ed Milanesi, VII, 189, tells us how while he was there he received a letter from the Pope bidding him turn his attention rather to the Seravezza district, which was actually in Tuscan territory, whereas Carrara was in the principality of Massa-Carrara, and at the time under the rule of the Marchese Alberigo, who was Michelangelo's friend.

Repetti has published documents of the year 1515, which show that at that date the Commune of Seravezza resolved to make a donation to the Florentine people of the right to quarry in the cliffs of Monte Altissimo, in which it is said, ' there are supposed to be mines and quarries of marble ' (*in quibus dicitur esse cava et mineria pro marmoribus cavendis*), and also of the ground necessary for making a road for transport. This was the cause of the Pope's orders to Michelangelo, which Vasari says he obeyed with great reluctance. In the invaluable ' Contratti ' and ' Ricordi,' which G. Milanesi has printed in his volume of Michelangelo's *Lettere* (Firenze, 1875), we find Buonarroti in 1516-7 at Carrara, getting material from the Polvaccio quarry, but at the beginning of 1518 he notes (*Lettere,* p. 566) ' *Andai a cavare a Pietra Santa e fecivi l'avviamento* (the start) *che oggi si vede fatto,*' and from this time his chief work was beneath the wild cliffs of Monte Altissimo (ibid., p. 573 f.). A memorandum of a later date (*Lettere,* p. 580) thus worded, ' *a dì circa venticinque di febraio nel mille cinquecento diciassette* (our 1518) . . . *non mi possendo servire a Carrara di detti marmi, mi missi a fare cavare nelle montagnie di Seraveza, villa di Pietra Santa, dove inanzi non era mai più stato cavato,*' shows that this was pioneer work. The contract made at Pietrasanta on March 15, 1518, for the work of quarrying (*Lettere,* p. 673) indicates that the locality was the gorge of the Serra, which runs up northward from Seravezza to the heart of the mountains. Two localities are mentioned, one, ' Finochiaia sive Transvaserra,' and another opposite to this, ' dirimpetto et riscontro,' called ' alla Cappella.' The first place is now called ' Trambiserra,' and will be seen on the sketch map on the west of the

gorge with ' la Cappella ' over against it on the east. Another contract of April 14 in the same year mentions quarrying projected ' a l' Altissimo ' in a locality called ' a la Piastra di verso Strettoia sive Antognia.' There is a Strettoia on the lower hills west of Seravezza, but that the operations in question were really higher up the gorge among the very cliffs of Monte Altissimo is proved by a letter of later date from Vincenzio Danti to Duke Francesco de' Medici (July 2, 1568; Gaye, *Carteggio*, III, 254), who reports that he examined the old workings and road of Michelangelo ' al Altissimo,' and mentions various localities, ' la Polla,' ' Costa dei Cani,' etc., the sites of which are at the head of the valley as shown on the map. ' La Polla ' means the water-head. Moreover, in a letter from Seravezza dated August, 1518, *Lettere,* p. 394, Michelangelo speaks of the road for the transport of the marbles as being nearly finished, though in three places rocks had still to be cut away. The places are ' a Rimagno,' ' poco passato Rimagno per andare a Seraveza,' and ' a l' ultime case di Seravezza, andando verso la Corvara.' The places are marked on the sketch map. Marbles from any part of the upper gorge of the Serra would have to be brought past Rimagno on their way down, and we therefore see that Michelangelo exploited to some extent the actual marbles of the Altissimo, which for the last half century have furnished the very finest and most costly statuary marble of the whole Apuan Alps, Mr Brindley says, of the whole world. The existing quarries are under the serrated peaks of Monte Altissimo, at an elevation of some 3 to 4,000 feet, and the marbles are now brought down in trolleys sliding along a rope stretched across the valley and mounting to the highest levels. It is believed locally that the workings called ' Vincarella ' are some of the first opened by Michelangelo, and from somewhere at any rate among these cliffs, in the latter part of 1518, by the agency of some skilled workmen who had been sent from Settignano as well as local hands, and by means of ropes and windlasses and sledges, Michelangelo was letting down a column, which however fell and was broken.

A letter from Seravezza of April 20, 1519, *Lettere,* p. 403, gives details of the accident, which was due to the fracture

of a defective ring of iron, and he says, ' Siàno stati a un grandissimo pericolo della vita tutti che eravamo attorno : e èssi guasto una mirabil pietra.' No wonder he records in a memorandum that he subsequently left Pietrasanta ill, and that he exclaims in a postscript to a letter of April 1518, *Lettere,* p. 138, ' Oh, cursed a thousand times be the day and the hour when I quitted Carrara ! '

The Monte Altissimo quarries are situated in a scene that to us to-day is sufficiently wild, though the modern lover of the mountains finds it full of an austere beauty. To Michelangelo, who was fretting at his enforced loss of time and in no mood to surrender himself to the influences of nature, it was a savage and inhospitable country. He writes from Seravezza to Florence in August 1518, (*Lettere,* p. 394), ' The place where we have to quarry here is very rugged (*molto aspro*), and the men are very unskilled in such work : nevertheless we must have much patience for several months till the mountains are tamed and the men are instructed. Afterwards we shall go on more quickly : it is enough that what I have promised, that will I at all costs perform, and I will do the finest work that has ever yet been accomplished in Italy, if God be my aid ! ' As a fact it was 1521 before the first column for the façade of S. Lorenzo arrived in Florence, the rest, as Vasari says, (ante, p. 47 and *Opere,* VII, p. 190) remained in the quarries or by the sea-shore, and the ' finest work ' was never even begun. MM. Henraux state that they know of no traces of the columns said to have been left thus ' on the sea shore ' (by Forte dei Marmi) but they possess a piece of a fractured column found near the site of Michelangelo's supposed workings at ' la Polla.'

At the death of Pope Leo nothing had been accomplished but the foundations of the façade, and the transport of a great column from Seravezza to the Piazza di S. Lorenzo ! For nearly thirty years after this time the quarries of this district were almost deserted, and the roads which Michelangelo had begun were not completed.

At a later period however Duke Cosimo I paid special attention to the quarries of the Seravezza region, and had a casino or summer residence built here for himself by

Ammanati, now termed 'Il Palazzo,' and the residence of the Mayor. A commissioner was established at Pietrasanta as the metropolis of the district, to supervise the workings. In the 'Introduction' to Painting at Chapter XVI, § 99, postea, p. 261, Vasari gives us an interesting notice of the opening of some new quarries in 1563 near the village of Stazzema, which lies behind the mountains which overhang Pietrasanta, and is approached from Seravezza up the Versiglia, or the gorge of the river Vezza. The road, of which he speaks in this place (p. 261) as in course of making, he mentions in some of his letters of 1564, and also in the Life of Michelangelo, but he gives no indication of its course. It was probably the road from Seravezza across the marsh-land to the sea, a more troublesome affair than roads along mountain valleys.

As regards the products of all these quarries of the Apuan Alps, statuary marble occurs as we have seen in many places, and it is found, where it occurs, in compact masses or nodules embedded in and flanked by marbles impure in colour and streaked and variegated in divers fashions. A vast amount of the marble quarried in the hills is what the quarrymen call 'Ordinario,' and is of a grey hue and often streaked with veins, which when well marked give it a new value as 'fiorito,' or 'flowered.' Of a more decided grey is the prized marble called 'Bardiglio,' which is the kind furnished by the 'alla Cappella' quarries. Bardiglio again may be 'fiorito.' These correspond to the 'three sorts of marble that come from the mountains of Carrara' of which Vasari writes in § 97, postea, p. 259, 'one of which is of a pure and dazzling white, the other not white but of a livid hue, while the third is a grey marble (*marmo bigio*) of a silvery tint.' The white and the grey are shown in the coloured drawing at J and K.

More decidedly variegated are the marbles known as 'Mischi' or 'Breccias,' and of these the Stazzema quarries yield the chief supply. The 'Mischio di Seravezza' of which Vasari writes in a letter, Gaye, III, 164, was from this locality, and so too the 'Mischi' mentioned in §§ 5, 9, ante, pp. 37, 45, of which some are 'Mischiati di rosso.' C and D as above show characteristic specimens of Breccias of Stazzema.

Repetti, art. ' Stazzema,' says that the ' Bardigli fioriti ' and Breccias of Stazzema are generally known as ' Mischi da Seravezza.'

It should be mentioned that Massa, between Carrara and Pietrasanta, is also a quarry centre of importance.

Leaving the Apuan Alps, the next marble-producing locality we come to on descending the coast is that of the Monti Pisani, the range of hills separating the territories of Pisa and Lucca. Monte S. Giuliano is on the road between the two cities, and there are quarries near Bagni S. Giuliano about six kilometres from Pisa. It will be seen that Vasari (ante, p. 50) speaks favourably of this marble, and Mr W. Brindley thinks this notice in Vasari is of special interest, as he reports of this marble that ' for durability and delicate honey-tint it is superior to Carrara.' The local term ' ceroide ' ' wax-like ' used for this stone conveys the same idea. It was used at Lucca as well as on Pisan buildings. From the same quarries come red and veined marbles and Breccias and ' Mischi ' (Torelli, *Statistica della Provincia di Pisa,* Pisa, 1863).

The exploitation of these marbles was rendered difficult at Pisa by the marshy nature of the ground at the foot of the hills which impeded transport, and Duke Cosimo set himself to find a remedy. He took up the question of drainage and regulation of watercourses in what is called the ' pianura di Pisa,' and among the forty medals struck to celebrate his various achievements were some for ' Clima Pisano Risanato.' In 1545 an ' Uffizio dei fossi ' was constituted, and the modern hydraulic system which has done so much to benefit this region, dates from these measures of Cosimo. Vasari, § 11, ante, p. 50, speaks of a river ' Osoli ' the course of which was straightened and confined. This is probably a mistake for ' Oseri ' or ' Osari,' names applying to one of the small streams close to Pisa in the direction of the quarries. Targioni Tozzetti in his *Viaggi in Toscana* has a long discussion on this river, the Auser of the ancients, for which he gives the modern equivalents ' Oseri,' or ' Osoli ' (the latter probably derived from this passage in Vasari). There is a ' Fossa dell' Oseretto ' to the west of the city. These straightened water-courses facilitated the transport of the stone in barges.

Continuing southwards along the coast we come to some marble quarries mentioned by Vasari on the promontory of Piombino, opposite the island of Elba. The locality Vasari names is Campiglia (§ 10, ante, p. 50) but the whole of Monte Calvi above that town is marble-bearing, and the products were said to be as good in quality as those of the Carrara district (Torelli, l.c., p. xc). Vasari says that the Campiglia marbles are excellent for building purposes, and Repetti asserts that in the fifteenth century, for the cupola of S. Maria del Fiore, more marble was used from this region than from Carrara itself. The ancient reputation of the district is not however now maintained.

Hitherto all the marbles used for building purposes that Vasari has mentioned have been white or variegated, but everyone who has visited the Tuscan cities knows that the decorative effect of the buildings depends on the juxtaposition of bands of white and of black, or at any rate, dark marble, with occasional bands of red. The dark marbles come chiefly from the neighbourhood of Prato, and this introduces us to a group of inland quarries within a few miles of Florence to the north and also to the south and east. Vasari does not say much about this dark stone, which was however of the utmost importance in Tuscan architecture. It is commonly called Prato Serpentine, or ' Verde di Prato,' and the quarries at Monte Ferrato, by Figline, three miles north of Prato, produce it of the finest quality. The Figline quarries are reported on by Professor Bonney in a paper on ' Ligurian and Tuscan Serpentines ' in the *Geological Magazine* for 1879. He has kindly lent us the specimen from the quarry figured as E on the Frontispiece. This stone is of a deep green colour, tending sometimes towards a purple or puce tint. Stone of much the same character is found, as Vasari states, near the Impruneta, six or seven miles east of Florence. It is this Prato Serpentine that has been so largely used from the twelfth century to the fifteenth in Tuscany for alternating with the white marbles in the incrustation of façades. There are deposits of the same stone in the Pisan mountains. The same stone was sometimes used for decorative stone work in connection with sepulchral monuments. Accord-

ing to Vasari however, ante, p. 42 f., it was the 'paragone' or dark limestone of Prato that was chiefly employed for this purpose.

If Vasari's information about this important stone, and his interest in it, seem scanty, it must be borne in mind that it was a mediaeval material rather than a Renaissance one. We find it on the churches and bell towers and baptistries of the twelfth and following centuries, but not on the palaces of the fifteenth and sixteenth. Hence the stone was not so interesting in Vasari's eyes as it is in ours.

Finally, the red stone seen in bands on the Duomo and the Campanile at Florence, that Vasari calls 'marmo rosso' (ante, p. 43), is not fully crystalline and is rather a limestone than a marble. It is deep red when quarried, but on the buildings has bleached to a pinky hue from exposure to the air. It is apt to scale, but this is partly due to its not being laid on its proper bed. The specimens F F on the coloured plate show the smoothed external surface bleached light by exposure. We are informed by Signor Cellerini, the experienced *capomaestro* of the Opera del Duomo at Florence, that in old time this stone was quarried at Monsummano, at the northern extremity of the Monte Albano not far from Pistoja. A more modern source of supply is the Tuscan Maremma, where the stone, called 'Porta Santa,' is quarried between Pisa and Grosseto, near Gavorrano. From this place the stone has been brought for recent use on the new façade of the Duomo at Florence.

Other Tuscan marbles, such as those of Siena, that are not referred to by Vasari, are not noticed in this place.

THE ROUND TEMPLE ON THE PIAZZA S. LUIGI DEI FRANCESI, AND 'MAESTRO GIAN.'

[See § 12, *Of Travertine*, ante, p. 51 f.]

It is surprising that practically nothing appears to be known, either about the French sculptor mentioned here, 'Maestro Gian' (or Jean), or about the French wood carver of the same name called by Vasari 'Maestro Janni,' who is referred to at the close of the 'Introduction' to Sculpture, postea, p. 174. Equally strange is it that their works, which Vasari describes

LIST OF TUSCAN MARBLE QUARRIES WITH THEIR PRODUCTS, AS FAR AS THESE ARE MENTIONED BY VASARI.

[§§ 5-11 and §§ 97-99.]

The reference to pages is to the present volume, the capital letters refer to the coloured drawing of the stones on the Frontispiece. Names in square brackets do not actually occur in Vasari.

DISTRICT.	CHIEF PLACE.	QUARRIES.	PRODUCTS.
[Apuan Alps] Monti di Luni Garfagnana	Carrara	Carrara in general	Breccias (p. 37 f.) (C.D.) [Bardigli] (p. 45) (K.) Paragone (p. 42) (P.) White Statuary Black 'Saligni' 'Campanini' Mischiati } (p. 45)
"	"	Polvaccio	Cippollino (pp. 36, 49) (H.) Best Statuary Marble } (p. 46) in largest blocks
"	Pietrasanta Seravezza	[Monte Altissimo, Alla Cappella, etc.] Stazzema	Columns for S. Lorenzo (p. 46) 'Campanini,' 'Saligni,' coarse marbles (p. 50) Statuary Marble (not now obtained) } (p. 261) (C.D.) Mischi (Breccias)
[Monti Pisani]	Pisa	Monte S. Giuliano	Fine White Marble, used on } (p. 50) Duomo & Campo-Santo
[Tuscan Maremma] [Promontory opposite Elba]	Gavorrano [Piombino]	[Caldana di Ravi] Canpiglia	[Red Limestone] Coarse Marbles, suited for building (p. 50)
[Monte Albano]	[Pistoja]	[Monsummano]	Red Marble (limestone) } (p. 43) (F.) on Duomo, Florence
Neighbourhood of Florence, North	Prato	[Monte Ferrato, Figline] 3 m. N. of Prato	Marmo Nero [Verde di Prato] } (p. 43) (E.) on Duomo, Florence Paragone (limestone) } (p. 42) (P.) for monuments
East	Impruneta 7 m. E. of Florence		Breccias (p. 37)
South	Monte Rantoli between valleys of Ema and Greve	S. Giusto or [Monte Martiri]	Breccias (p. 37)

in terms of high praise, and which are in public view in Rome and in Florence, do not seem to have attracted attention among students either of French art or of Italian. The standard older book on French artists abroad, Dussieux, *Les Artistes Français à l'Étranger,* Paris, 1856, takes no note of either of them, nor are they referred to in Bérard's *Dictionnaire Biographique des Artistes Français du XII au XVII Siècle,* Paris, 1872. In the more recent Italian work however by A. Bertolotti, *Artisti Francesi in Roma nei Secoli XV, XVI, e XVII,* Mantova, 1886, there is a mention on p. 220 of ' un Giovanni Chavenier, che forse disegno quel tempio tondo, attribuito dal Vasari all' architetto Jean,' and on p. 24 it is said that Giovanni Chiavier, o Chavenier, di Rouen lavorò pel Governo pontificio e morì a Roma nel 1527.' Bertolotti unfortunately gives no references to his authorities, while the work of Müntz, *Les Arts à la Cour des Papes* breaks off before the sixteenth century, and gives no help.

In the course of our inquiries we communicated with the Director of the Biblioteca Vittorio Emmanuele at Rome, Commendatore Conte Gnoli, who kindly gave attention to the subject, and contributed to the *Giornale d' Italia* of Dec. 24, 1906, an interesting article, in which, though he could give no account of Maestro Gian, he described fully the extant works of which Vasari writes, and made some pertinent suggestions as to the ' round temple.' He thinks it unlikely that the building of a circular church from the foundations was contemplated by the French, and suggests that they were utilizing the foundations of a round chamber belonging to the Thermae of Nero which were in that neighbourhood, so that the ' round temple ' would have been like the present S. Bernardo in the Thermae of Diocletian. M. Marcel Reymond has suggested that it was the sack of Rome in 1527 that led to the abandonment of the project —for the date of the undertaking can be fixed in the reign of François I of France, who came to the throne in 1515, from the fact that his cognizance, the salamander, occurs in the sculpture prepared for its embellishment. If the artist be really Bertolotti's ' Chavenier,' as he died in 1527, this fact would also explain the abandonment.

The sculptures in question are in part incrusted in the façade

of the present church of S. Luigi (see ante, p. 52) and the fact that some of them are carved on curved surfaces shows at once that they were prepared for a building of cylindrical form. There are two large salamanders in round frames of which one is shown on Plate VI, and two panels higher up in the façade with the curious device of an eagle with the head of a woman and outspread wings from which depend by ribbons on each side small medallions. There are also some lions' heads. The most curious piece of all is built into the wall of the Palazzo Madama close beside the church, and this contains the various devices that Vasari calls ' astrological globes ' ' open books showing the leaves,' ' trophies,' etc. The panel is small and placed too high to be properly seen, but Sig. Gnoli, by the aid of the architect of the palace, was able to give a description of them in the article above mentioned. The work is very minute and elaborate, and there are inscriptions from which it appears that the devices signify that the seven liberal arts are nourished by the lilies of France. The sculpture is not only elaborate in design but most artistic as well as delicate in execution. The ' Salamander ' it will be seen is excellent work. M. Marcel Reymond points out that at the early part of the sixteenth century the Italians were accustomed to use marble for decorative carvings, and that this French artist, whoever he was, having been accustomed to carve the limestones of his native country, took naturally to the manipulation of travertine, and that his success with the material attracted the attention and admiration of the Romans which Vasari's commendations reflect. It has been noticed above that Michelangelo's frieze in the cortile of the Palazzo Farnese was not carved but modelled in stucco. See ante, p. 53.

On the subject of the mysterious artist a word will be said in connection with the later passage indicated at the beginning of this Note. See postea, p. 175.

RUSTICATED MASONRY.

[See § 20, *Rusticated Masonry and the Tuscan Order,*
ante, p. 65.]

In masonry of this kind the sides of the stones, where they
come into contact with each other, are dressed smooth, but the
face of each stone is left to project beyond the plane of the
wall. The projections may be rough and irregular, in which
case the appearance is that of natural stones, and a rugged
rock-like aspect is given to the wall-face. The projections
may however be wrought into bosses of regular form, or into
the diamonds and facets of which Vasari goes on to speak, and
of which a notable example is the so-called ' Palazzo de'
Diamanti ' at Ferrara.

This method of treating stones, at least when they are left
rough and irregular, saves time and labour, and hence it has
been in use among many ancient peoples, but almost always
for substructures and parts not meant to be seen. The
Romans made a more extensive employment of it, and we find
it not only on sustaining walls, such as those of the Hadrianic
platform of the Olympeion at Athens, but on monumental
wall-faces, as on the enclosing wall of the Forum of Augustus
near the Arco dei Pantani at Rome, one of the finest extant
specimens of Roman masonry but still utilitarian in character.
The deliberate use of rustication, as an element of artistic
effect, on the façade of a public building, is another matter,
and it is doubtful if any instance of this occurs before the
Italian Renaissance. There is a piece of Roman rusticated
masonry behind the ancient theatre at Fiesole, the classical
Faesolae, and Professor Durm thought at one time that the
Florentine builders might have derived from this their idea of
using the device as a means of expression in stonework. It
may be questioned however whether this was visible at all in the
fifteenth century, and it is much more likely that Renaissance
rustication was a natural development from the treatment of
the wall in many mediaeval Tuscan buildings, in which the
surface of the stones is left to project in an irregular undesigned
fashion. The Palazzo Vecchio and the Gothic Palazzo Ales-
sandri at Florence are examples. In any case, in the hands

PLATE VI

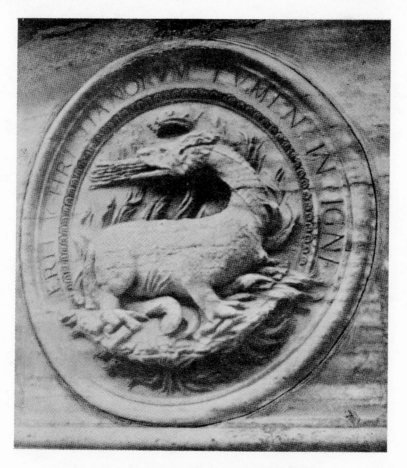

SALAMANDER CARVED IN TRAVERTINE
On the façade of S. Luigi dei Francesi, Rome, by a French artist,
' Maestro Gian '

of the architects of the Renaissance rustication became an important element in the architectural style of the period, and is one of the special contributions of this style to architecture at large.

Rustication has two artistic advantages. In the first place, it emphasizes the separate stones in an assemblage, and when these are of great size and boldly hewn, as at the Pitti Palace at Florence, the work gains in dignity through this individualizing of the distinct units of the structure. The bossed surface of some of the blocks at the Pitti stands out as much as three feet from the wall, and one of the stones is twenty eight feet in length. In the second place, this rustic treatment gives a look of rugged strength that is very effective, especially on the lower stages of monumental buildings, where indeed the treatment is most in place. The façade of Michelozzo's Riccardi Palace, which Vasari refers to under its older name the ' Casa Medici ' is epoch-making in its fine handling of rustication in degrees according to the stages of the elevation.

It needs hardly to be said that the elaborately cut facets which Vasari finds so beautiful, and of which we have seen an example in Fig. 4, ante, p. 69, are too artificial to be reckoned in good architectural style. It was a common practice, when the stones themselves were not all of the same size, to cut these diamonds and other geometrical forms in independence of the joints of the masonry, so that a facet might be half on one stone and half on another. As this ignores the individuality of the blocks, which the simpler rustication so effectually emphasizes, it is by no means to be commended. Vasari's last sentences in § 20, about this treatment of stonework in general, are excellent. The rustication on the Fortezza, shown in Fig. 4 is sincere, in that the jointing corresponds with the design.

VASARI'S OPINION ON MEDIAEVAL ARCHITECTURE.

[See § 28, *German Work (the Gothic Style)*, ante, p. 83.]

Vasari's tirade against the iniquities of the mediaeval mason is of historical interest as reflecting the ideas of his age, but need not now be taken seriously. The reason why he

writes of it as 'German' work is to be found in the close
intercourse during the whole mediaeval period between
Germany and Italy, that were nominally under the one imperial
sceptre, and were only separated by the Brenner. 'Tedesco'
stood to the mind of the Italian for everything north of the
Alps, and though the pointed style in architecture was of
French origin it appears to have found its way into Italy
through the Tyrol. One of the first churches in this style in
Italy, S. Francesco at Assisi, was designed by a German
master from Meran. But not only does Vasari call the manner
he detests 'Tedesco,' he expressly, in this passage and else-
where, ascribes it to the Goths, who, after ruining the ancient
buildings and killing off the classically trained architects, had
set to work to build with pointed arches. It is clear from
this phrase, as well as from the description he gives of the
little niches and pinnacles and leaves and the extravagant
height of doors, that he had in his mind the pointed style, that
dates from about the middle of the twelfth century. The
Goths had then passed out of existence for some six hundred
years and Vasari's chronology is hopelessly at fault. The
name 'Gothic' however, which he was the first to apply in
this sense, has adhered to the style ever since, and in spite of
efforts which have been made to supplant it, will probably
remain always in use, though no one will now or in the future
make the mistake of connecting it ethnologically with the
historical Goths of the fifth and sixth centuries.

The question who was actually the first to apply the term
'Gothic' in this sense has been a subject of controversy.
Some have attributed the invention of the term to Raphael, or
the author of the Report on the condition of Roman monuments
which passes under his name; while others have claimed the
dubious honour for Cesare Cesariano, the translator and com-
mentator of Vitruvius. Neither of these writers however uses
the word in the sense referred to. Raphael it is true writes
of a 'Gothic' style in architecture which succeeded to the
classic Roman, but he makes it, quite correctly, belong to the
actual era of the Gothic conquest of Italy in the fifth century
and to the succeeding hundred years. The later mediaeval
architecture Raphael terms 'architectura Tedesca,' and when

he writes of this he seems to have in his view what we should rather call Lombard Romanesque, for he blames in it the ' strange animals and figures, and foliage out of all reason.' In other words Raphael, or the author of the Report, distinctly does *not* commit the historical enormity of dragging the word ' Gothic ' six centuries out of its proper location and use.

With regard to Cesare Cesariano, this personage was born in 1483 and studied architecture under Bramante. He was of good repute, Vasari tell us, (*Opere,* IV, 149) as a geometrician and architect, and at one time he was employed as director of the works on the cathedral of Milan, the interior of which he completed in its present form. In 1521 there was published at Como, at the charges of certain scholars and notables of Milan and Como, an edition of Vitruvius headed ' Di Lucio Vitruvio Pollione a Caesare Augusto De Architectura Incomenza Il Primo Libro. Translato In Vulgare Sermone Commentato Et Affigurato Da Caesare Caesariano Citadino Mediolanense Professore Di Architectura Et Cª.' Cesariano's commentary is a fearsome work of appalling verbosity, but there is nothing in it about the Goths being the originators of the pointed style. He mentions the Goths on fol. cviii, b, but not in connection with architecture, whereas when he does refer to late mediaeval building he calls it not Gothic but German. On fol. xiii b and on the succeeding pages he gives some interesting plans and drawings of the cathedral of Milan, important in connection with the theory of the use in Gothic design of the equilateral triangle, but distinctly notes it as constructed by ' Germanici architecti,' ' Germanico more,' and ' secundum Germanicam symmetriam '; while on fol. cx b he again says that the building was in the hands of a German architect. (See Mothes, *Baukunst des Mittelalters in Italien,* Jena, 1884, p. 502 ff.) It is clear therefore that Cesare Cesariano has nothing to do with the use of ' Gothic ' as an architectural term, and his name need not be mentioned in this connection.

Filarete's *Trattato dell' Architettura,* dating about 1464, is not the source of the usage, and as far as can be seen at present the credit, if it be such, of the invention of the term ' Gothic ' rests with Vasari.

EGG-SHELL MOSAIC.

[See § 33, *Pictorial Mosaics for Walls, etc., ante,* p. 93.]

This reference on the part of Vasari to ' musaico di gusci d' uovo,' ' mosaic of egg shells,' is puzzling. In his Life of Gaddo Gaddi (*Opere,* I, 348) he is more explicit, and states there ' Dopo ciò, ritornò Gaddo a Firenze, con animo di riposarsi : perchè, datosi a fare piccole tavolette di musaico, ne condusse alcune di guscia d' uova con diligenza e pacienza incredibile; come si può, fra le altre, vedere in alcune che ancor oggi sono nel tempio di San Giovanni di Firenze.'

The Lemonnier editors of Vasari added a note to this passage to the effect that one of these small plaques, representing a Christ with an open book in His left hand, was preserved when they wrote in the Uffizi, and that the mosaic was ' composed of very minute pieces of egg-shell united together with a diligence and a patience truly incredible.' This piece is now in the Chapel in the Bargello and Dr Giovanni Poggi has had the kindness to examine it minutely. He reports that there is no sign of the use of egg-shell in it, but that it is a finely executed mosaic of small pieces of coloured materials of a hard substance, in all respects similar to the portable Byzantine mosaics of which there are two notable specimens in the Opera del Duomo at Florence (Gori, *Thes. Vet. Diptychorum,* III, 320 f.). Eugène Müntz noticed various examples of this kind of work in an article in the *Bulletin Monumental,* 1886, and one of them, an ' Annunciation ' in the Victoria and Albert Museum, is a typical piece. It is composed of tesserae of minute size of different coloured marbles, lapis lazuli, etc., on a ground of gold formed of little cubes of the metal, all bedded in wax or similar yielding substance. There is no sign of the use of egg-shell, and indeed the idea of a mosaic of pieces of egg-shell seems absurd, because there is no variety of colour, and therefore no possibility of mosaic effect without painting each piece some special hue.

Were it only Vasari who mentioned this supposed egg-shell mosaic the matter might be passed over, but as a fact one of the chapters of Cennino Cennini's *Trattato* is devoted to this very subject. He there describes, c. 172, what he calls a

'mosaic' of small cubes of the pith of feathers and of egg-shells, but the technique as he explains it is not mosaic, properly so-called, but rather an imitation of mosaic by means of painting on a roughened ground giving something of the effect of a ground laid with tesserae. Egg-shells are apparently crushed down on the surface so as to give it a sort of crackled appearance, and varieties of colour are added by the paint-brush. Vasari mentions in his life of Agnolo Gaddi, *Opere*, 1, 643 f., that he had seen a MS. of Cennino's treatise, and it is possible that he remembered the heading ' musaico di gusci d' uovo ' and, with his instinct for giving a personal interest to everything, attributed to one of his early Florentines, Gaddo Gaddi, the use of the supposed technique. We have not been able to hear of any extant piece of work corresponding to Cennino's description, though we have to thank several expert authorities for kindly interesting themselves in the matter. Cennino's notice is appended in the original. It does not occur in the Tambroni text.

Description of the technique in Cennino Cennini, *Il Libro dell' Arte*, ed. Milanesi, Firenze, 1859, cap. clxxii.

' Come si Lavora in Opera Musaica per adornamento di Reliquie ; e del Musaico di Bucciuoli di penne, e di Gusci d' Uovo.

.

. . A questa opra medesima, e molto fine, buccioli di penne tagliati molto minuti sì come panico e tinti sì come detto ho. Ancora puoi lavorare del detto musaico in questo modo. Togli le tue guscia d' uovo ben peste pur bianche, e in sulla figura disegnata campeggia, riempi e lavora sì come fussi coloriti : e poi quando hai campeggiata la tua figura coi colori propii da cassetta, e temperati con un poco di chiara d' uovo, va' colorendo la figura di parte in parte, sì come facessi in su lo 'ngessato propio, pur d' acquerelle di colori ; e poi quando è secco, vernica sì come vernici l'altre cose in tavola. Per campeggiare le dette figure, sì come fai in muro, a te conviene pigliare questo partito, di togler fogliette dorate, o arientate, o oro grosso battuto o ariento grosso battuto : taglialo minutissimo, e colle dette mollette va' campeggiando a modo che campeggi i tuoi gusci pesti, dove il campo richiede

oro. Ancora, campeggiare di gusci bianchi il campo; bagnare di chiara d' uovo battuta, di quella che metti il tuo oro in sul vetro; bagna della medesima; metti il tuo oro come trae il campo; lascia asciugare, e brunisci con bambagia. E questo basti alla detta opera musaica, o vuoi greca.'

IDEAL ARCHITECTURE; AN IDEAL PALACE.

[See § 35, *An Ideal Palace,* ante, p. 96.]

The construction—in words—of an imaginary mansion of the type suited to the ideas of the Renaissance was a favourite exercise among both professional and amateur writers, and Vasari might have made a greater effort than he has done to rise to the height of his subject. The theme had some significance. The intent of those who dealt with it was to provide the man of the Renaissance with a fit setting for his life, and the spacious and lordly palace corresponded to the amplitude of the personality developed by the humanistic culture of the age. The representative man of the Renaissance may have missed certain of the higher ethical qualities, but he was many-sided, in mind and person a finely developed creature, self-reliant, instinct with vigour and set on mastery. Such a being demanded space and opulence with an air of greatness in his habitation, and fitly to house him was a task calling forth all the powers of the architects of the period. An imposing façade with heraldic achievements should proclaim his worth, wide gateways and roomy courts and loggie give an impression of lordly ease, broad staircases and ample halls suggest the coming and going of companies of guests. He would need a garden, where marble seats in ilex shades or in grottoes beside cool fountains should await him in hours when reflection or reading, music or conversation, called him awhile from keen conflict of wit or policy with his peers in the world outside. He would exact moreover that over all the place Art should breathe a spell to soothe the senses and to flatter pride; art sumptuous in materials, accomplished in technique, pagan in form and spirit, should people the galleries with sculptured shapes, cover walls and roof with graceful imagery, and set here and there on cabinet or console some jewel of carved ivory or gilded wood or chiselled bronze.

All the great architects of the Renaissance were at work on these palaces first at Florence and then in every rich Italian town, but the actual achievement that circumstances allowed fell far short of the ideal perfection, the effort after which was the best spiritual product of the Renaissance. Hence it became the fashion to draw out visionary schemes of princely dwellings, and even of whole city quarters for the setting of these, and ideal architecture furnishes matter for a chapter in the art history of the times. Filarete's *Trattato dell' Architettura* is full of matter of the kind. In his eighth Book he describes a palace for a prince, in Book eleven an ideal mansion for a nobleman; and his proposed arrangements are all on a grandiose scale. Ammanati, who built the Ponte della Trinità at Florence, left a whole collection of drawings for a ' Città Ideale,' and Leonardo da Vinci's codices are fertile in similar suggestions. In France, where this phase of the artistic activity of the Renaissance was as much in evidence as in Italy, the actual palaces of king or noble were far outdone in splendour and in symmetry by the schemes of Palissy or De l'Orme, of which Baron de Geymüller has given an interesting notice in his *Baukunst der Renaissance in Frankreich,* published in the *Handbuch der Architectur.*

Nor was it only the professed artists who occupied themselves in this fashion. It was a literary exercise to scheme out in vague and general outlines the ideal habitation for prince or for community, and Rabelais' Abbey of Theleme, with its nine thousand three hundred and thirty two rooms, its libraries, theatres, and recreation halls, is the most famous example of its kind. In our own literature too there must not be forgotten Francis Bacon's Essay on Building, in which he draws out the general configuration of what he calls a ' perfect palace,' where the façade is in two wings ' uniform without, though severally partitioned within,' and these are to be ' on both sides of a great and stately tower, in the midst of the front; that as it were joineth them together on either hand.' Symmetry is of course the characteristic of all these ideal structures, as it was long ago of the visionary temple described by Ezechiel, and Vasari's palace is no exception to the rule. Vasari's description does not convey a very clear idea of what

he conceived the ideal palace would be, and he might have done better for the theme had he not hampered himself at the outset with the otiose comparison of the house to a human body. This he may have derived from Filarete, who also employs the conceit.

OF SCULPTURE

OF SCULPTURE

CHAPTER I. (VIII.)

What Sculpture is ; how good works of Sculpture are made, and what qualities they must possess to be esteemed perfect.

§ 36. *The Nature of Sculpture.*

SCULPTURE is an art which by removing all that is superfluous from the material under treatment reduces it to that form designed in the artist's mind.[1]

§ 37. *Qualities necessary for Work in the Round.*

Now seeing that all figures of whatever sort, whether carved in marble, cast in bronze, or wrought in plaster or wood, must be in salient work in the round, and seeing too that as we walk round them they are looked at from every side, it is clear that if we want to call them perfect they must have many qualities. The most obvious is that when such a figure is presented to our eyes, it should show at the first glance the expression intended, whether pride or humility, caprice, gaiety or melancholy—according to the personage portrayed. It must also be balanced in all its members : that is, it must not have long legs, a thick head, and short and deformed arms; but be well proportioned, and from head to foot have each part conforming with the others. In the same way, if the figure have the face of an old man, let it have the arms, body,

[1] See note on ' The Nature of Sculpture,' at the close of the ' Introduction ' to Sculpture, postea, p. 179.

legs, hands, and feet of an old man, the skeleton sym-
metrically ordered throughout, the muscles and sinews and
veins all in their proper places. If it have the face of a
youth, it must in like manner be round, soft and sweet
in expression, harmonious in every part. If it is not to
be nude, do not let the drapery that is to cover it be
so meagre as to look thin, nor clumsy like lumps of stone,
but let the flow of the folds be so turned that they reveal
the nude beneath—and with art and grace now show now
hide it without any harshness that may detract from the
figure. Let the hair and beard be worked with a certain
delicacy, arranged and curled to show they have been
combed, having the greatest softness and grace given to
them that the chisel can convey; and because the sculptors
cannot in this part actually counterfeit nature, they make
the locks of hair solid and curled, working from manner [2]
rather than in imitation of nature. Even though the
figures be draped, the feet and hands must be modelled
with the care and beauty shown in the other parts. And
as the figure is in the round, it is essential that in front,
in profile, and at the back, it be of equal proportions,
having at every turn and view to show itself happily
disposed throughout. Indeed the whole work must be

[2] 'Working from manner.' Vasari refers here to what artists call 'treatment,'
which is a process of analysis and grouping, applied to appearances in nature
where the eye sees at first little more than a confused medley of similar forms
that are perhaps constantly changing. Under such an aspect the hair as well
as the folds of drapery on the human figure presented themselves to the early
Greek sculptor, and it was a long time before he learned to handle them
aright. In the case of the hair he had no help in previous work, for in
Egyptian statues it is often covered, or is replaced by a formal wig, and in
Assyrian art the hair is very severely though finely conventionalized. It was
not until the age of Pheidias that the Greeks learned how to suggest the soft
and ample masses of the hair, and at the same time to subdivide these into
the distinct curls or tresses, each one 'solid,' as Vasari requires, but individually
rendered with the minuter markings which suggest the structure and 'feel' of
the material. The Italians started of course with this treatment or 'manner'
already an established tradition founded on antique practice. In the mediaeval
sculpture of the thirteenth and fourteenth centuries in France and England
the hair is often very artistically rendered.

harmonious, and exhibit pose, drawing and unity, grace and finish; these qualities taken together show the natural talent and capacity of the artist.

§ 38. *Works of Sculpture should be treated with a view to their destined position.*

Figures in relief as well as in painting ought to be produced with judgement rather than in a mechanical way,[3] especially when they are to be placed on a height, at a great distance. In this position the finish of the last touches is lost, though the beautiful form of the arms and legs, and the good taste displayed in the cast of drapery, with folds not too numerous, may easily be recognized; in this simplicity and reserve is shown the refinement of the talent. Figures whether of marble or of bronze that stand somewhat high, must be boldly undercut in order that the marble which is white and the bronze which tends towards black may receive some shading from the atmosphere, and thus the work at a distance appear to be finished, though from near it is seen to be left only in the rough. This was a point to which the ancients paid great attention, as we see in their figures in the round and in half relief, in the arches and the columns in Rome, which still testify to the great judgement they possessed. Among the moderns, the same quality is notably exhibited in his works by Donatello. Again, it is to be remembered, that when statues are to be in a high position, and there is not much space below to enable one to go far enough off to view them at a distance, but one is forced to stand almost under them, they must be made one head or two taller. This is done because those figures which are placed high up lose in the fore-shortening, when viewed by one standing beneath and looking upwards. Therefore that which is added in height

[3] This paragraph opens up a subject of much artistic interest, on which see Note on 'Sculpture Treated for Position,' at the close of the 'Introduction' to Sculpture, postea, p. 180 f.

comes to be consumed in the foreshortening, and they turn out when looked at to be really in proportion, correct and not dwarfed, nay rather full of grace. And if the artist should not desire to do this he can keep the members of the figure rather slender and refined, this gives almost the same effect.

§ 39. *The Proportions of the Human Figure.*

It is the custom of many artists to make the figure nine heads high; dividing it in the following manner; the throat, the neck, and the height of the foot (from the instep to the sole) are equal to one head and the rest of the body to eight; of these, the shinbone measures two heads, from the knee to the organs of generation two more, while the body up to the pit of the throat is equal to three, with another from the chin to the top of the forehead, so that there are nine in all.[4] As to the measurements across, from the pit of the throat to the shoulder on each side is the length of a head, and each arm to the wrist is three heads. Thus the man with his arms stretched out measures exactly as much as his height.

§ 40. *Artists must depend on their Judgement rather than on the Measuring Rule.*

After all the eye must give the final judgement, for, even though an object be most carefully measured, if the eye remain offended it will not cease on that account to censure it.

[4] For Vasari, a practical artist, to commit himself to the statement that figures are made nine heads high, is somewhat extraordinary, for eight heads, the proportion given by Vitruvius (III, 1) is the extreme limit for a normal adult, and very few Greek statues, let alone living persons, have heads so small. The recently discovered 'Agias' by Lysippus, at Delphi, is very nearly eight heads high. The 'Doryphorus' at Naples not much more than seven. The 'Choisseul Gouffier Apollo' about seven and a half, etc. Vasari seems to have derived his curious mode of reckoning from Filarete, who in Book I of his Treatise on Architecture measures a man as follows: Head = 1 head, neck = ½, breast = 1, body = 2, thighs = 2, legs = 2, foot = ½, total nine heads. Alberti, Leonardo, Albrecht Dürer, and indeed almost all the older writers on art, discourse on the proportions of the human figure.

Let me repeat that although measurement exercises a just control in enlarging the figure so that the height and breadth, kept according to rule, may make the work well proportioned and beautiful, the eye nevertheless must decide where to take away and where to add as it sees defect in the work, till the due proportion, grace, design and perfection are attained, so that the work may be praised in all its parts by every competent authority. And that statue or figure which shall have these qualities will be perfect in beauty, in design and in grace. Such figures we call figures ' in the round,' provided that all the parts appear finished, just as one sees them in a man, when walking round him; the same holds good of all the details which depend on the whole. But it seems to me high time to come to the particulars of the subject.

CHAPTER II. (IX.)

Of the manner of making Models in Wax and in Clay; how they are draped, and how they are afterwards enlarged in proportion in the Marble; how Marbles are worked with the point and the toothed tool, and are rubbed with pumice stone and polished till they are perfect.

§ 41. *The small Sketch-Model in Wax or Clay.*

SCULPTORS, when they wish to work a figure in marble, are accustomed to make what is called a model for it in clay or wax or plaster; that is, a pattern, about a foot high, more or less, according as is found convenient, because they can exhibit in it the attitude and proportion of the figure that they wish to make, endeavouring to adapt themselves to the height and breadth of the stone quarried for their statue.

§ 42. *The Preparation of Wax.*

In order to show how wax is modelled, let us first speak of the working of wax and not of clay. To render it softer a little animal fat and turpentine and black pitch are put into the wax, and of these ingredients it is the fat that makes it more supple; the turpentine adds tenacity, and the pitch gives it the black colour and a certain consistency, so that after it has been worked and left to stand it becomes hard. And he who would wish to make wax of another colour, may easily do so by putting into it red earth, or vermilion or red lead; he will thus make it of a yellowish red or some such shade; if he add verdigris, green, and so on with the other colours. But it is well to notice that the colours should be ground into powder

and sifted, and in this state afterwards mixed with the wax made as liquid as possible. The wax is also made white for small things, medals, portraits, minute scenes and other objects of bas-relief. And this is done by mixing powdered white lead with the white wax as explained above.

§ 43. *Polychrome Wax Effigies.*[1]

Nor shall I conceal that modern artists have discovered the method of working in wax of all sorts of colours, so that in taking portraits from the life in half-relief, they make the flesh tints, the hair, the clothes and all the other details so life-like that to these figures there lacks nothing, as it were, but the spirit and the power of speech.

§ 44. *The Manipulation of Wax over an Armature.*

But to return to the manner of preparing the wax; when the mixture has been melted and allowed to go cold, it is made into sticks or rolls. These from the warmth of the hands become, in the working, like dough and are suitable for modelling a figure that is seated or erect or as you please. To make the figure support itself, it may have underneath the wax an armature either of wood, or of iron wires according to the pleasure of the artist; or this can be omitted if it suit him better. Little by little, always adding material, with judgement and manipulation, the artist impresses the wax by means of tools made of bone, iron, or wood, and again putting on more he alters and refines till with the fingers the utmost finish is given to the model.

§ 45. *The Small Model in Clay.*

Should he wish to make his model in clay, he works exactly as with wax, but without the armature of wood or iron underneath, because that would cause the clay to

[1] See Note on 'Waxen Effigies and Medallions,' at the close of the 'Introduction' to Sculpture, postea, p. 188.

crack open or break up;² and that it may not crack while it is being worked he keeps it covered with a wet cloth till it is completed.

§ 46. *The Full-sized Model in Clay.*

When these small models or figures of wax or clay are finished, the artist sets himself to make another model as large as the actual figure intended to be executed in marble. In fashioning this he must use deliberation, because the clay which is worked in a damp state shrinks in drying; he therefore, as he works, adds more bit by bit and at the very last mixes some baked flour with the clay to keep it soft and remove the dryness.³ This trouble is taken that the model shall not shrink but remain accurate and similar to the figure to be carved in marble. To ensure that the large clay model shall support itself and the clay not crack, the artist must take some soft cuttings of cloth or some horse hair, and mix this with the clay to render it tenacious and not liable to split. The figure is supported by wood underneath with pressed tow or hay fastened to it with string.⁴ The bones of the figure are made and placed in the necessary pose after the pattern of the small model, whether erect or seated; and from the beginning to the end of the process of covering it with clay the figure is formed in the nude.

§ 47. *Drapery on the Clay Model.*

This completed, if the artist desire afterwards to clothe it with thin drapery, he takes fine cloth, if with heavy,

² One objection to an armature of wood is that the material may swell with the damp of the clay and cause fissures. Iron is objectionable because the rust discolours the clay. Modern sculptors often use gas-piping in the skeletons of their models, as this is flexible and will neither rust nor swell.

³ Baked flour used to be employed by plasterers to keep the plaster they were modelling from setting too rapidly. See the Introduction by G. F. Robinson to Millar's *Plastering Plain and Decorative*, London, 1897. The former used rye dough with good effect for the above purpose.

⁴ The tow or hay tied round the wood affords a good hold for the clay, which is apt to slip on anything smooth.

he takes coarse, and wets it and then covers it over with clay, not liquid but of the consistency of rather thick mud, and arranges it around the figure in such folds and creases as the mind suggests; this when dry, becomes hardened and continues to keep the folds.[5]

§ 48. *Transference of the Full-sized Model to the Marble Block.*

Models, whether of wax or of clay, are formed in the same manner. To enlarge the figure proportionately in the marble [6] it is necessary that against this same block, whence the figure has to be carved, there shall be placed a carpenter's square, one leg of which shall be horizontal at the foot of the figure while the other is vertical and is always at right angles with the horizontal, and so too with the straight piece above; and similarly let another square of wood or other material be adjusted to the model, by means of which the measures may be taken from the model, for instance how much the legs project forward and how much the arms. Let the artist proceed to carve out the figure from these measurements, transferring them to the marble from the model, so that measuring the marble and the model in proportion he gradually chisels away the stone till the figure thus measured time after time, issues forth from the marble, in the same manner that one would lift a wax figure out of a pail of water, evenly and in a horizontal position. First would appear the body, the head, and the knees, the figure gradually revealing itself as it is raised upwards, till there would come to view the relief more than half completed and finally the roundness of the whole.

§ 49. *Danger of dispensing with the Full-sized Model.*

Those artificers who are in a hurry to get on, and who hew into the stone at the first and rashly cut away the

[5] This method of producing drapery is not very artistic.

[6] See Note on 'Proportionate Enlargement' at close of the 'Introduction' to Sculpture, postea, p. 190.

marble in front and at the back have no means afterwards
of drawing back in case of need.[7] Many errors in statues
spring from this impatience of the artist to see the round
figure out of the block at once, so that often an error is
revealed that can only be remedied by joining on pieces,
as we have seen to be the habit of many modern artists.
This patching is after the fashion of cobblers and not of
competent men or rare masters, and is ugly and despicable
and worthy of the greatest blame.

§ 50. *The Tools and Materials used in Marble Carving.*

Sculptors are accustomed, in working their marble
statues, to begin by roughing out the figures with a kind
of tool they call ' subbia,' which is pointed and heavy;
it is used to block out their stone in the large, and
then with other tools called ' calcagnuoli ' which have a
notch in the middle and are short, they proceed to round
it, till they come to use a flat tool more slender than
the calcagnuolo, which has two notches and is called
' gradina ': with this they go all over the figure, gently
chiselling it to keep the proportion of the muscles and
the folds, and treating it in such a manner that the notches
or teeth of the tool give the stone a wonderful grace.
This done, they remove the tooth marks with a smooth
chisel, and in order to perfect the figure, wishing to add
sweetness, softness and finish to it, they work off with
curved files all traces of the gradina. They proceed in
the same way with slender files and straight rasps, to
complete the smoothing process,[8] and lastly with points
of pumice stone they rub all over the figure to give that
flesh-like appearance that is seen in marvellous works of

[7] See Note on 'The Use of Full-sized Models' at the close of the 'Intro-
duction' to Sculpture, postea, p. 192.

[8] The carvers' tools described by Vasari are the same that appear to have
been in use in ancient Greece (see the article by Professor E. Gardner already
referred to), that are figured in the *Encyclopédie* of the eighteenth century,
and are now in use. Fig. 2, E to J, ante, p. 48, shows a set of them actually
employed in a stone carver's workshop at Settignano near Florence.

sculpture. Tripoli earth is also used to make it lustrous and polished, and for the same reason it is rubbed over with straw made into bunches—till, finished and shining, it appears before us in its beauty.[9]

[9] Actual polish of the surface of a marble figure is to be avoided, as the reflections from it where it catches the light destroy the delicacy of the effect of light and shade. Greek marbles were not polished, save in some cases where the aim seems to have been to imitate the appearance of shining bronze, but the Greeks finished their marbles more smoothly than the sculptors of to-day, most of whom prefer a 'sensitive' surface on which the marks of the last delicate chiselling can be discerned. Michelangelo's Dead Christ in the 'Pietà' of St. Peter's, his most finished piece of marble work, may almost be said to show polish, and Renaissance marbles generally are quite as smoothly finished as antiques. In the case of coloured marbles, used for surface decoration in plain panels, polish is of course necessary in order that the colour and veining may appear, but it does not follow from this that a self-coloured marble, carved into the similitude of a face or figure, should be polished.

CHAPTER III. (X.)

Of Low and Half Reliefs, the difficulty of making them and how to bring them to perfection.

§ 51. *The Origin of Reliefs.*

THOSE works that sculptors call half reliefs [1] were invented by the ancients to make figure compositions with which to adorn flat walls, and they adopted this treatment in theatres and triumphal arches, because, even had they wished to sculpture figures in the round, they could not place them unless they first constructed a standing ground or an open place that was flat. Desiring therefore to avoid this, they invented a kind of sculpture which they named half relief, and it is called ' mezzo rilievo ' still among ourselves.

§ 52. *Pictorial or Perspective Reliefs.*

In the manner of a picture this kind of relief sets forth first the whole of the principal figures, either in half round or still greater salience, as may happen, the figures on the second plane partly hidden by the first, and those on the third by the second, just as living people are seen when they are assembled and crowded together. In this kind of half relief, for the sake of perspective, they make the most distant figures low, some of the heads indeed extremely low, and no less so the houses and scenery which are the objects most remote. By none has this

[1] English terminology for the different kinds of reliefs, and for sculpture generally, is very deficient, and many Italian terms are employed. It may be noted that Vasari's ' half relief ' (mezzo rilievo) is the highest kind he mentions, and would correspond to what is called in English ' high relief.'

species of half relief ever been better executed, with more observation, or with its figures diminished and spaced one from the other more correctly than by the ancients; [2] for they, who were students of the truth and gifted artists, never made the figures in such compositions with ground that is foreshortened or seems to run away, but placed them with their feet resting on the moulding beneath them. In contrast to this, some of our own moderns, over eager, have, in their compositions in half relief, made their principal figures stand on the plane which is in low relief and recedes, and the middle figures on the same plane in such a position that, as they stand, they do not rest the feet as firmly as is natural, whence it not infrequently happens that the points of the feet of those figures that turn their backs actually touch the shins of their own legs, so violent is the foreshortening. Such things are seen in many modern works, and even in the gates of the Baptistry and in many examples of that period. Therefore half reliefs of this character are incorrect, because, if the foremost figures project half out of the stone while others have to be placed behind them, there must be a rule for the retiring and diminution; the feet of the figures have to be on the ground, so that the ground may come forward in front as required by the eye and the rule in things painted. Accordingly the figures must be gradually reduced in proportion as they recede till they reach the flattened and low relief; and because of the harmony required it is difficult to carry out the work perfectly seeing that in relief the feet and heads are foreshortened. Great skill in design therefore is necessary if the artist wish to exhibit his ability in this art. The same degree of perfection is demanded for figures in clay or wax as for those worked in bronze and marble. Therefore of all the works which have the qualities that I indicate the half reliefs may be considered most beautiful and most highly praised by experienced artists.

[2] See Note on 'Italian and Greek Reliefs,' at the close of the 'Introduction' to Sculpture, postea, p. 196.

§ 53. *Low Reliefs (Bassi Rilievi).*

The second species called low reliefs projects much less than the half reliefs; they have not more than half the boldness of the others, and one can rightly make in these low reliefs the ground, the buildings, the prospects, the stairs and the landscapes as we see in the bronze pulpits in San Lorenzo at Florence, and in all the low reliefs of Donatello, who in this art produced things truly divine with the greatest truth to nature. These reliefs present themselves easily to the eye and without errors or barbarisms, seeing that they do not project forward so much as to give occasion for errors or censure.

§ 54. *Flat Reliefs (Stiacciati Rilievi).*

The third species called low or flattened reliefs only shows up the design of the figure in the very lowest and most depressed relief. These reliefs are very difficult for they demand great skill in design and invention, and as all depends on the outlines it is a hard thing to impart charm to them. Donatello worked better here than did any other, with art, design and invention.[3] In the ancient vases of Arezzo,[4] many figures, masks, and

[3] Donatello's flat, or 'stiacciati' reliefs are deservedly famous. The difficulty here is to convey the impression of solid form of three dimensions with the slightest possible actual salience. The treatment of the torso of the Christ in the marble 'Pietà' of the Victoria and Albert Museum is a good example.

[4] The antique vessels of so-called 'Arezzo' ware are called Aretine vases. Messer Giorgio was in duty bound to take some note of the ancient pottery of his native city for it was from this that the Vasari derived their family name. According to the family tree given in a note to the Life of an ancestor of the historian (*Opere*, ed. Milanesi, II, 561), the family came from Cortona, and the first who settled in Arezzo was the historian's great-grandfather, one Lazzaro, an artist in ornamental saddlery. He had a son, Giorgio, who practised the craft of the potter, and was especially concerned with the old Roman Aretine vases the technique of which he tried to reproduce. Hence he was called 'Vasajo,' 'the vase maker,' from which came the family appellation Vasari.

This ancient Aretine ware 'must be regarded as the Roman pottery *par excellence*' (Waters, *History of Ancient Pottery*, Lond., 1905, II, 480). It

other ancient compositions are to be seen in this sort of work : likewise in the antique cameos, in moulds for striking bronze pieces for medals, and also in coins. This style was chosen because, if the relief had been too high, the coins could not have been struck, for the blow of the hammer would not have produced the impression since the punches have to be pressed on to the cast material, and when this is in low relief it costs little trouble to fill the cavities of the punch. Now-a-days we see that many modern artists have worked divinely in this style, more even than did the ancients, as shall be fully described in their Lives. Therefore, he who recognizes in the half reliefs the perfection of the figures so carefully made to diminish, and in the lower reliefs the excellence of the design in the perspectives and other inventions, and in the flattened reliefs the clearness, the refinement and the beautiful form of the figures, will do well to regard them on account of these qualities as worthy of praise or blame, and will teach others also so to regard them.

is practically the same ware that is known by the popular but unscientific term 'Samian,' and consists in cups and bowls and dishes usually of a small size of a fine red clay, ornamented with designs in low relief, produced by the aid of stamps or moulds. It is these relief ornaments that Vasari had in his mind when he wrote the words in the text. Arezzo is noticed by Pliny and other ancient writers as a great centre for the fabrication of this sort of ware, and Vasari tells us how his grandfather, Giorgio the 'vasajo,' discovered near the city some kilns of the ancient potters and specimens of their work. Very good specimens of Aretine ware are to be seen in the Museum at Arezzo, and the fabrique is represented in all important collections of ancient pottery.

CHAPTER IV. (XI.)

How Models for large and small Bronze Figures are made, with the Moulds for casting them and their Armatures of iron ; and how they are cast in metal and in three sorts of Bronze ; and how after they are cast they are chased and refined ; and how, if they lack pieces that did not come out in the cast, these are grafted and joined in the same bronze.

§ 55. *The Full-sized Model for Bronze.*

IT is the custom of competent artists, when they wish to cast large figures in metal or bronze,[1] to make first a statue of clay as large as that intended to be cast in metal, and to perfect the clay statue as far as their art and their knowledge will allow.

§ 56. *The Piece-Mould in Plaster.*

When this, which they call the model, is finished and brought to this point of perfection, they then begin, with plaster that will set, to build over it piece by piece, making the pieces correspond to the relief of the model. On every piece they make a key, marking the pieces with numbers

[1] See Note on 'The Processes of the Bronze Founder' at the close of the 'Introduction' to Sculpture, postea, p. 199, which the reader who is unacquainted with the subject, will find it useful to read forthwith. The best commentary on Vasari's and Cellini's account of bronze casting is to be found in the French *Encyclopédie*, where there is a description, with numerous illustrations, of the casting in 1699 of Girardon's great equestrian statue of Louis XIV, destined for the Place Vendôme. It was claimed at the time to be the largest known single casting in the world, and represents in their utmost elaboration the various processes described by Vasari. Some of the illustrations are here reproduced, and will help to render clearer the descriptions in the text.

or letters of the alphabet or with other signs in order
that the pieces can be taken off and register together. So
they mould it part by part, oiling the pieces of the cast
where the edges have to be connected; till from piece to
piece the figure grows, the head, the arms, the body and
the legs, to the last detail, in such a manner that the
concave of the statue, that is the hollow mould, comes
to be imprinted on the inner surface with all the parts
and with the very minutest marking which is in the
model.[2] This completed, the plaster casts are laid aside
to harden.

§ 57. *The Construction of the Core.*

The workers then take a rod of iron longer than the
whole figure that they wish to make, and that is to be
cast, and over this they make a core of clay into which,
while kneading it to make it soft, they mix horse dung
and hair. The core has the same form as the model and
is baked in successive layers so as to draw out the
dampness of the clay; this is of use afterwards to the
figure, for in casting the statue all this core, which is solid,
leaves an empty space that is not filled with bronze,
because if it were, the figure could not be moved on
account of the weight. They make this core large enough
and justly measured, so that when the layers are heated and
baked, as has been said, the clay becomes well burned
through and so entirely freed from damp, that in pouring
the bronze upon it afterwards it does not spurt nor do
injury, as has happened many times, involving the death
of the masters and the ruin of the work. Thus they go
on balancing the core and adjusting and examining the
pieces, till they tally with it and represent it, so that there

[2] Plate VII shows a section or two of a piece-mould round a portion of a
figure. It will be noticed that the pieces are so planned that they will all
come away easily from the model and not be held by any undercut projections.
The small pieces are then all enclosed in an outer shell divided into two
halves, and called in French 'chape' answering to the 'cappa' of Vasari's
text. Plate VIII, A, shows the model of the Louis XIV statue as piece-moulded.

comes to be left exactly the thickness, or, (if we like to say so,) the thinness, of the metal, according as you wish the statue to be.

Frequently this core has an armature of rods of copper across it, and irons that can be taken out and put in to hold it with security and with greater strength.[3] The core, after it is finished, is yet again baked with a gentle heat, and the moisture, should any have remained, entirely removed; it is then again laid aside.

§ 58. *The Piece-Mould lined with a Skin of Wax.*

Returning now to the pieces of the hollow mould, these are lined severally with yellow wax that has been softened and incorporated with a little turpentine and tallow.[4] When the wax is melted at the fire, it is poured into the two halves of the mould made up of the hollow pieces in such a manner as causes the wax to come thin according to the worker's idea for the cast, and the pieces, which have been shaped to correspond with the relief of the core already made of clay, are joined to it and fitted and grafted together.

§ 59. *This Skin of Wax applied over the Core.*

With thin skewers of copper the pieces of wax pierced with the said skewers are now fixed to the baked core, and

[3] In the case of a heavy casting such an armature is necessary, and must be carefully constructed to give support at all points. The armature within the core of the horse of Louis XIV is shown in Plate VIII, D.

[4] Vasari here describes a method of constructing the indispensable shell of wax which is to be replaced by the bronze. The hollow piece-mould is lined section by section with wax and a core is then formed to fill the rest of the interior and touch the inner surface of the wax at every point. The plaster mould is then removed and the wax linings of each of its sections are applied, each in its proper place, to the core, and fixed thereon by skewers. There is then a complete figure in wax, but, as this is made up of very many pieces, it has to be gone over carefully to smooth over the joins and secure unity of surface. Cellini's plan seems a better one. He lines his hollow mould with a sort of paste or dough, and then fills up with the core. The dough is then removed and wax is poured in in its place, thus forming a continuous skin and securing a more perfect unity in the waxen shell.

PLATE VII

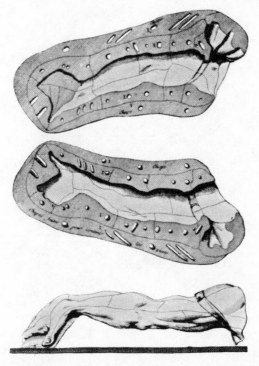

ILLUSTRATION SHOWING PROCESS OF PIECE-MOULDING
IN PLASTER

so, piece by piece, they are inserted and fitted to the figure and render it entirely finished. This completed they proceed to remove all the superfluous wax that has over-flowed into the interstices of the pieces, and bring it as well as possible to that finished excellence and perfection which one desires in the bronze cast. Before going further, the craftsman sets up the figure and considers diligently if the wax have any deficiency, and he proceeds to repair it and to fill up again, putting on more or taking away where necessary.[5]

§ 60. *The fire-resisting Envelope applied over the Wax*

After that, the wax being completed and the figure braced together, he puts it where fire can be applied to it [6] on two andirons of wood, stone, or iron like a roast, arranging so that it can be raised or lowered; and with moistened ash, specially fitted for that purpose, by means of a paint brush he covers the entire figure so that the wax is quite concealed, and over every hollow and chink he clothes it well with this material. Having applied the ash to it he replaces the transverse rods, which pass through the wax and the core, just as he has left them in the figure, because these have to support the core within and the mould without, which is the casing of the hollow space between the core and the mould, where the bronze is to be poured. When this armature has been fixed, the artificer begins to take some fine earth, beaten together with horse dung and hair, as I said, and carefully

[5] On Plate VIII at B we see the core covered with the skin of wax and carefully gone over and finished in every part. The system of pipes with which it is covered are the 'vents' that Vasari notices in § 62, and also the channels through which the melted wax is to escape and the molten bronze to enter, as noticed in §§ 63, 64.

[6] Vasari actually says that it must be put 'al fuoco' ' to the fire,' but it is clear that he does not mean that heat is at once to be applied to it. If this were done the wax would all be melted off the core too soon, before it was covered by the outer skin. It is only when the wax has been securely enclosed between the core and the outer skin that heat is needed to melt it away and leave its place free for the molten metal.

lays a very thin coating all over which he allows to dry, and so on time after time with other coatings, always allowing each to dry until the figure becomes covered with earth raised to the thickness of half a span at the most.

§ 61. *The External Armature.*

This done, he girds those irons that hold the core within with other irons which hold the mould outside, and fixes them together, so that chained and bound the one to the other they form a mutual support,[7] the core within sustaining the mould without and the mould without holding firm the core within.

§ 62. *The Vents.*

It is usual to make certain little pipes between the core and the outer mould called vents, that have issue upwards; they are put, for instance, from a knee to an arm that is raised, because these give passage to the metal[8] to make up for that which on account of some impediment may not flow properly, and these little tubes are made many or few, according as the casting is difficult or not.

§ 63. *The Wax melted out.*

This done, the worker proceeds to apply heat to the said mould equally all over, so that it may become united and little by little be warmed through, and he increases the heat till the mould is thoroughly hot throughout, so that the wax which is in the hollow space becomes melted and all flows out at the spot through which the metal is to be poured, without any particle of the wax remaining within.[9] To be sure of this, it is needful, before the

[7] Plate VIII, C, shows this outer armature, with the ends of the transverse rods holding core and envelope together.

[8] 'Give passage to the metal.' Their essential purpose is to allow for the escape of air which would be dangerous if driven by the metal into a confined space.

[9] It should be understood that, in the process Vasari has in mind, the melted metal is introduced at the *bottom* of the mould so as to rise in it and expel before it the air. It is not poured in at the top. Hence the metal enters at the same orifice at which the wax flows out.

pieces of wax are grafted in to their places on the figure, to weigh them piece by piece; in the same way after drawing out the wax, it must be weighed again, when by making the subtraction the artist sees if any wax be left between the core and the mould, and how much has come out. Notice that the skill and care of the artist is manifested in the process of taking out the wax; herein is seen the difficulty of producing the casts so that they come out sharp and beautiful, for if any of the wax be left, it would ruin the whole cast, especially that part where the wax remains.

§ 64. *The Mould in the Casting-pit.*

This finished, the craftsman puts the mould under ground near to the furnace where the bronze is melted, propping it so that the bronze may not strain it, and he makes the channels through which the bronze is to flow, and at the top he leaves a certain thickness, which allows for the surplus of the bronze to be sawn off afterwards, and this he does in order to secure sharpness.[10]

§ 65. *The Composition of the Bronze.*

The artist prepares the metal as he thinks fit, and for every pound of wax he puts ten pounds of metal.[11] Statuary metal is made of the combination of two thirds of copper and one third of brass according to the Italian rule. The Egyptians, from whom this art took its origin, put into

[10] Plate VIII, D, gives a section through the model in the casting pit, when all is ready for the actual operation of introducing the molten metal. The wax has all been run out, and the outline of the figure and of the horse is marked by a double line with a narrow space between. It is this space that will be filled by the bronze which will be introduced through numerous channels so that it may be distributed rapidly and evenly over the whole surface it is to cover. When in the pit the mould is packed all round with broken bricks or similar material, so that 'the bronze may not strain it,' nor cause it to shift.

[11] The wax has already been carefully weighed, and in order to estimate how much bronze will be required for the cast a rough calculation is made based on the amount of wax.

the bronze two thirds of brass and one third of copper. In electron metal, which is the finest of all, two parts copper are put to one part silver. In bells, for every hundred parts of copper there are twenty of tin, in order that the sound of the bells may carry far and be more blended; and for artillery, in every hundred parts of copper, ten of tin.[12]

§ 66. *Making up Imperfections.*

There only remains to us now to teach the method of grafting a piece into the figure should it have a defect, either because the bronze coagulated, or ran too thin, or did not reach some part of the mould. In this case let the artificer entirely remove the defective part of the cast and make a square hole in its place, cutting it out under the carpenter's square, then let him adjust a piece of metal

[12] The subject of the composition of bronze and of other alloys of copper is a complicated one, for the mixtures specified or established by analysis are very varied. Normally speaking, bronze is a mixture of copper with about ten per cent. of tin, brass of copper with twenty to forty per cent. of zinc. Vasari's proportions for bells and for cannon are pretty much what are given now. In the *Manuel de Fondeur* (Manuels Roret) Paris, 1879, II, p. 94, eight to fifteen per cent. of tin are prescribed for cannon, fifteen to thirty per cent. for bell metal, the greater percentage of tin with the copper resulting in a less tough but harder and so sharper sounding metal. It will be noted however that for statuary metal Vasari specifies a mixture not of copper and tin but of copper and brass, that is, copper and zinc. Brass is composed of, say, twenty-five per cent. of zinc and seventy-five per cent. of copper, so that a mixture of two thirds, or sixty-six per cent., of copper with one third, or thirty-three per cent., of brass would work out to about ten parts of zinc to ninety of copper, and this agrees with classical proportions. The Greeks used tin for their bronzes, but various mysterious ingredients were supposed to be mingled in to produce special alloys. The Romans used zinc, or rather zinciferous ores such as calamine, with or in place of tin, and this is the tradition that Vasari follows.

A recent analysis of the composition of the bronze doors at Hildesheim, dating from 1015 A.D., gives about seventy-six parts copper, ten lead, eight tin, four zinc; and of the 'Bernward' pillar ascribed to about the same date, seventy copper, twenty-three tin, and five lead. These differences may surprise us, but metal casting in those days was a matter of rule of thumb, and we may recall Cellini's account of his cramming all his household vessels of pewter into the melting pot to make the metal flow for casting his 'Perseus.'

PLATE VIII

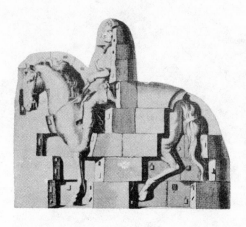

A

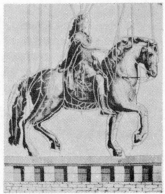

B

C

D

ENGRAVINGS ILLUSTRATING THE PROCESS OF CASTING IN BRONZE

From the French *Encyclopédie*

prepared for that spot, that may project upward as much as he pleases, and when fitted exactly in the square hole let him strike it with the hammer to send it home, and with files and tools make it even and thoroughly finished.

§ 67. *A simpler Method of Casting small Figures and Reliefs.*

Now should the artificer wish to cast small figures in metal, they are first made of wax, or if he happen to have them in clay or other material, he makes the shell of plaster over them in the same way as for the large figures, and fills it all with wax. But the shell must be moistened that the wax, when poured into it, may set (with a hard skin) by reason of the coldness of the wet cast. Then by shaking about and agitating the cast, the wax (which is not hardened) within the cavity is thrown out, so that the cast remains hollow in the interior: the craftsman afterwards fills up the vacant space with clay and puts in skewers of iron. This clay serves then for core, but it must be allowed to dry well. Thereafter he adjusts the mould as for the other large figures, giving it its armature and placing the tubes for the vents. Then he bakes it and gets rid of the (skin of) wax and thus the vacant space remains clear so that the bronze can easily be poured in. The same is done with the low and half reliefs and with every other work in metal.

§ 68. *Chasing the Cast and Colouring the Bronze.*

These casts being finished, the workman then, with suitable tools, that is, with burins, burnishers, chasing tools, punches, chisels and files, removes material where needed, and where needed presses inward the overflow of the metal and smoothes it down; and with other tools that scrape, he shaves and cleans the whole of it diligently, and finally with pumice stone gives the last polish. This bronze which is red when it is worked assumes through time by a natural change a colour that draws towards

black. Some turn it black with oil, others with vinegar make it green, and others with varnish give it the colour of black, so that every one makes it come as he likes best.

§ 69. *Modern Tours de Force in small Castings.*

But that is a truly marvellous thing which is come to pass in our times, this mode of casting figures, large as well as small, so excellently that many masters make them come out in the cast quite clear so that they have not to be chased with tools, and as thin as the back of a knife. And what is more, some clays and ashes used for this purpose are actually so fine, that tufts of rue and any other slender herb or flower can be cast in silver and in gold, quite easily and with such success, that they are as beautiful as the natural; from which it is seen that this art is more excellent now than it was in the time of the ancients.

CHAPTER V. (XII.)

Concerning Steel Dies for making Medals of bronze or other metals
and how the latter are formed from these metals and from
Oriental Stones and Cameos.

§ 70. *The Fabrication of Matrices for Medals.*

THE craftsman who wishes to make medals of bronze or
silver or gold after the manner of the ancients, must first
with iron punches work in relief the faces of steel dies
of which the metal has been softened piece by piece in
the fire; as for example, the head alone in low relief, in
a single steel die; and so with the other parts which are
joined to it. Fashioned thus of steel, all the dies needed
for the medal are tempered by fire; and on the block of
tempered steel, that is to serve for mould and matrix
of the medal, the artist proceeds to imprint by means
of hammer strokes the head and the other parts in
their proper places. And after imprinting the whole,
he diligently smoothes it and polishes it again, giving
finish and perfection to the said mould that has afterwards
to serve for matrix. Many artificers have been in the
habit however of carving the matrices with wheels, just
as intaglio work is done in crystals, jaspers, calcedonies,
agates, amethysts, sardonyx, lapis lazuli, chrysolites, cor-
nelians, cameos and other oriental stones; and the work
done in this way makes the matrices more sharp, as is
the case in the aforesaid stones. In the same way they
make (the matrix for) the reverse of the medal, and with
these two, the matrix of the head and that of the reverse
side, (trial) medals of wax and of lead are struck. These
are moulded afterwards with a very finely powdered earth
suitable for the purpose; and in these moulds, when

the wax or leaden (trial) medal has been taken out, and they are pressed together in the frame, you may cast any kind of metal which pleases you for your medal.

These casts are then replaced in the steel matrices that correspond to them and by force of screws or wedges and with hammer blows they are pressed so tightly, that they take that finish of surface from the stamp that they have not taken from the casting process. But coins and other medals in low relief are stamped without screws, by blows of the hammer struck by hand.[1]

§ 71. *The Cutting of Intaglios and Cameos.*

Those oriental stones that we spoke of above are cut in intaglio with wheels by means of emery, which with

[1] Vasari's account of the making of dies for medals and of the process of striking these is clear, and agrees with the more elaborate directions contained in the seventh and following chapters of Cellini's *Trattato dell' Oreficeria.* Cellini however, unlike Vasari, was a practical medallist, and he goes more into detail. The process employed was not the direct cutting of the matrices or dies with chisels, nor, as gems are engraved, by the use of the wheel and emery (or diamond) powder, but the stamping into them of the design required by main force, by means of specially shaped hard steel punches on which different parts of the design had been worked in relief. The steel of the matrix or die had of course to be previously softened in the fire, or these punches would have made no impression on it. When finished it was again hardened by tempering. It may be noticed that the dies from which Greek coins were struck were to all appearance engraved as gems were engraved by the direct use of cutting tools or tools that, like the wheel, wore away the material with the aid of sand or emery.

The two matrices, or dies, for the obverse and reverse of the medal, being now prepared, the medal is not immediately struck. In the case of the Greek coin a bean-shaped piece, or a disk, of plain metal, usually of silver, called a 'blank' or 'flan,' was placed between the two dies and pressed into their hollows by a blow or blows of the hammer, so that all that was engraved on them in intaglio came out on the silver in relief. Vasari's process is more elaborate. A sort of trial medal is first struck from the matrices in a soft material such as lead or wax, and this trial medal is reproduced by the ordinary process of casting in the gold or silver or bronze which is to be the material of the final medal. This cast medal has of course the general form required, but it is not sharp nor has it a fine surface. It is therefore placed between the matrices and forcibly compressed so as to acquire all the finish of detail and texture desired.

the wheel cuts its way through any sort of hardness of
any stone whatever. And as the craftsman proceeds, he
is always testing by wax impressions the intaglio which
he is fashioning; and in this manner he goes on removing
material where he deems it necessary, till the final touches
are given to the work. Cameos however are worked in
relief; and because this stone is in layers, that is white
above and dark underneath, the worker removes just so
much of the white as will leave the head or figure white
on a dark ground. And sometimes, in order to secure
that the whole head or figure should appear white on a
dark ground, he dyes the ground when it is not so dark
as it should be. In this art we have seen wondrous and
divine works both ancient and modern.

CHAPTER VI. (XIII.)

How works in White Stucco are executed, and of the manner of preparing the Wall underneath for them, and how the work is carried out.

§ 72. *Modelled and stamped Plaster Work.*

THE ancients, when they wished to make vaults or panels or doors or windows or other ornaments of white stucco, were in the habit of building a skeleton of walling either of baked bricks or of tufa, that is, a stone that is soft and easy to cut. Making use of these, they built up the bones underneath, giving them the form of mouldings or figures or whatever they wished to make, cutting them out of the bricks or stones, which were afterwards put together with mortar.

Then with stucco, which in our fourth chapter (of Architecture) we described as crushed marble mixed with lime from travertine, they begin to cover the aforesaid skeleton with the first daub of rough stucco, that is coarse and granulated, to be covered over with finer when the first stucco has set and is firm, but not thoroughly dry. The reason for this is that to work the mass of the material above a damp bed makes it unite better, therefore they keep wetting the stucco at the place where the upper coating is laid on so as to render it more easy to work.

To make (enriched) mouldings or modelled leafage it is necessary to have shapes of wood carved in intaglio with those same forms that you wish to render in relief. The worker takes stucco that is not actually hard nor really soft, but in a way tenacious, and puts it on the

work in the quantity needed for the detail intended to be formed. He then places over it the said hollowed mould which is powdered with marble dust, striking it with a hammer so that the blows fall equally, and this leaves the stucco imprinted; he then proceeds to clean and finish it so that the work becomes true and even. But if he desire the work to have bolder relief in projection, in the spot where this is to come he fixes iron supports or nails or other armatures of a similar kind which hold the stucco suspended in the air, and by these means the stucco sets firmly, as one sees in the ancient edifices where the stucco and the iron supports are found still preserved to the present day.[1] Moreover, when the artificer wishes to produce a composition in bas-relief on a flat wall, he first inserts numerous nails in the wall, here projecting less, there more, according as the figures are to be arranged, and between these he crowds in little bits of

[1] Plaster, or stucco, is sometimes regarded as an inferior material only to be used when nothing better can be obtained. It should not however be judged from the achievements of the domestic plasterer of to-day, who has to trust sometimes to the wall-paper to keep his stuff from crumbling away. Plaster as used by the ancients, and through a good part of the mediaeval and Renaissance periods up to the eighteenth century, is a fine material, susceptible of very varied and effective artistic treatment. It was made by the Greeks of so exquisite a quality that it was equivalent to an artificial marble. It could be polished, so Vitruvius tells us, till it would reflect the beholder's face as in a mirror, and he describes how the Roman connoisseurs of his time would actually cut out plain panels of Greek stucco from old walls and frame them into the plaster-work of their own rooms, just as if they were slabs of precious marble. (*De Architectura*, VII, iii, 10.) Vitruvius prescribes no fewer than six successive coats of plaster for a wall, each laid on before the last is dry, the last coat being of white lime and finely powdered marble.

By the Villa Farnesina at Rome some Roman, or more probably Greek, plaster decoration was discovered a few years ago that surpassed any work of the kind elsewhere known. We find there the moulded or stamped ornament Vasari describes, as well as figure compositions modelled by hand, while the plain surfaces are in themselves a delight to the artistic eye.

Among the best and best known stucco work, in figures and ornaments, of the later Italian Renaissance, may be ranked that at Fontainebleau by Primaticcio and other artists from the peninsula who were invited thither by François I, for the decoration of the 'Galerie François I' and the 'Escalier du Roi.'

brick or tufa, in order that the ends or heads of these may hold the coarse stucco of the first rough cast, which he afterwards goes on refining delicately and patiently till it consolidates. While it is hardening he works diligently, retouching it continually with moistened paint-brushes in such a manner as may bring it to perfection, just as if it were of wax or clay. By means of this same arrangement of nails and of ironwork made on purpose, larger and smaller according to need, vaults and partition walls and old buildings are decorated with stucco, as one sees all over Italy at the present day to be the habit of many masters who have given themselves to this practice. Nor is one to suspect work so done of being perishable; on the contrary it lasts for ever, and hardens so well as time goes on, that it becomes like marble.

CHAPTER VII. (XIV.)

How Figures in Wood are executed and of what sort of Wood is best
for the purpose.

§ 73. *Wood Carving.*

HE who wishes figures of wood to be executed in a
perfect manner, must first make for them a model of wax
or clay, as we have said. This sort of figure is much
used in the Christian religion, seeing that numberless
masters have produced many crucifixes and other objects.
But in truth, one never gives that flesh-like appearance
and softness to wood that can be given to metal and to
marble and to the sculptured objects that we see in stucco,
wax, or clay. The best however of all the woods used
for sculpture is that of the lime, because it is equally
porous on every side, and it more readily obeys the rasp
and chisel. But when the artificer wishes to make a large
figure, since he cannot make it all of one single piece,
he must join other pieces to it and add to its height and
enlarge it according to the form that he wishes to make.
And to stick it together in such a way that it may hold
he must not take cheese mucilage, because that would
not hold, but parchment glue;[1] with this melted and the

[1] The composition of these two mucilages is given by Theophilus, in the
Schedula, Book one, chapter 17, and also by Cennini, *Trattato*, chapters
110-112.

Soft cheese from cows' milk must, according to the earlier recipe, be
shredded finely into hot water and braised in a mortar to a paste. It must
then be immersed in cold water till it hardens, and then rubbed till it is
quite smooth on a board and afterwards mixed with quick lime to the
consistency of a stiff paste. Panels cemented with this, says Theophilus,

said pieces warmed at the fire let him join and press them together, not with iron nails but with pegs of the wood itself; which done, let him work it and carve it according to the form of his model. There are also most praiseworthy works in boxwood to be seen done by workmen in this trade, and very beautiful ornaments in walnut, which when they are of good black walnut almost appear to be of bronze. We have also seen carvings on fruit stones, such as those of the cherry and apricot executed by the hand of skilful Germans [2] with a patience and delicacy which are great indeed. And although foreigners do not achieve that perfect design which the Italians exhibit in their productions, they have nevertheless wrought, and still continue to work, in such a manner that they bring their art to a point of refinement that makes the world wonder: as can be seen in a work, or to speak more correctly, in a miracle of wood carving by the hand of the Frenchman, Maestro Janni, who living in the city of Florence which he had chosen for his country, adopted, for his designs, in which he always delighted, the Italian style. This, with the practice he had in working in wood, enabled him to make a figure in lime wood of San Rocco as large as life. With exquisite carving he fashioned the soft and undercut draperies that clothe it, cut almost to the thinness of paper and with a beautiful flow in the order of the folds, so that one cannot see anything more marvellous. In like manner, he has carried out the head, beard, hands and feet of that Saint with such perfection that it has deserved, and always will deserve infinite praise from every man; and what is more, in order that the excellence of the artist may be seen in all its parts,

will be held so fast when they are dry that neither moisture nor heat will bring them apart. Vasari does not seem to have such faith in the mucilage, and prefers that made from boiling down shreds of parchment and other skins. The twelfth century writer knows how to make this also. See chapter eighteen of the first Book of the *Schedula*.

[2] Every museum contains examples of these delicate German carvings in hard materials.

the figure has been preserved to our days in the church of the Annunziata at Florence beneath the pulpit, free from any covering of colour or painting, in its own natural colour of wood and with only the finish and perfection that Maestro Janni gave it, beautiful beyond all other figures that can be seen carved in wood.[3] And this suffices for

[3] In a Note to the 'Introduction' to Architecture, ante, p. 128 f., an account was given of some sculptures in travertine on the façade of the church of S. Luigi dei Francesi at Rome by a 'Maestro Gian' who has been conjecturally identified as a certain Jean Chavier or Chavenier of Rouen who worked at Rome in the first quarter of the sixteenth century. Vasari in this place introduces an artist of the name of 'Maestro Janni francese,' and the question at once arises whether he is the same person as the 'Maestro Gian' of Rome.

The statue here described is to be seen in the church of the Annunziata at Florence, but not where Vasari saw it. It has been placed for about the last half century in the spacious round choir, where it occupies a niche in the wall of the second chapel to the left as one faces the high altar. It has been painted white in the hope that it may be mistaken for marble, and this characteristic performance dates from about 1857. Certain fissures observable show however that it is of wood, and one of the Frati remembers it when it was as Vasari saw it 'nello stesso colore del legname.' The work is shown on Plate IX. We have been unable to discover anything certain about the artist. The figure, which is in excellent preservation, speaks for itself. The Saint has a tight fitting cap over his head and curling hair and beard. His eyes are almost closed as he looks down with a somewhat affected air at his wounded leg to which the finger of his right hand is pointing. The other hand holds a staff, round which the drapery curls and over the top of which it is caught. This drapery bears out Vasari's description of it as 'traforato' 'cut into.' It is floridly treated with the sharp angles common in the carving of the fifteenth and sixteenth centuries in Germany, Flanders, and parts of France. M. Marcel Reymond, who has kindly given his opinion on the photographs submitted to him, has written about it as follows: 'Le St Roch, par la surcharge de vêtements, l'excès de reliefs, l'agitation des draperies, se rattache à l'art français tel qu'il s'était constitué au xivme siècle, et tel qu'il s'était continué jusqu'au xvime siècle, notamment dans le Bourgogne et la Champagne.' He does not consider the two 'Maîtres Jean' the same person. 'Ce sont sans doute deux artistes du xvime siècle, l'un travaillant la pierre, le travertin, l'autre travaillant le bois. C'est leur aptitude à travailler ces deux matières, que les artistes italiens travaillaient moins bien que les français qui a retenu l'attention de Vasari sur eux et qui leur a fait attribuer une place si importante dans les préfaces de Vasari.' Our study of the originals at Rome and Florence has led us to the same opinion. The S.

a brief notice of all the things relating to sculpture. Let us now pass on to painting.

Rocco is Gothic in feeling, the ' Salamander' and other pieces at Rome are Renaissance. The Roman ' Maestro Gian' may be credited with an Italian style, but Vasari does not show much critical acumen when he sees ' la maniera italiana' in the S. Rocco of the Florentine Janni.

PLATE IX

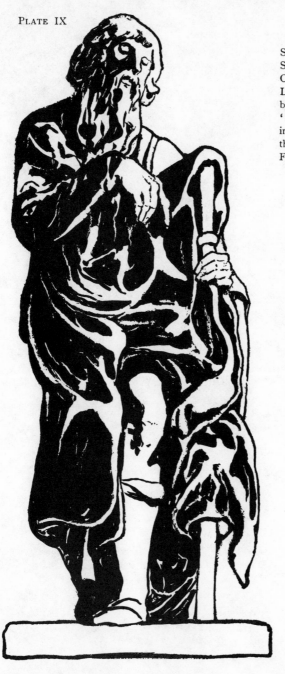

STATUE OF
S. ROCCO
CARVED IN
LIMEWOOD,
by a French Artist
' Maestro Janni,'
in the Church of
the Annunziata,
Florence

NOTES ON 'INTRODUCTION' TO SCULPTURE

NOTES ON 'INTRODUCTION' TO SCULPTURE

THE NATURE OF SCULPTURE.

[§ 36, *The Nature of Sculpture,* ante, p. 143.]

The remark with which Vasari opens his ' Introduction ' to Sculpture, though it sounds rather trite, involves a point of some interest. Vasari says that the sculptor removes all that is superfluous from the material under treatment, and reduces it to the form designed for it in his mind. This is true of the technique of sculpture proper, that is stone or marble carving, but there are processes in the art other than that of cutting away a block of hard material. Michelangelo, in a letter he wrote in 1549 to Benedetto Varchi, on the ever-recurring theme of the relative dignity of painting and sculpture, notices the fact that the sculptor proceeds in two ways, by the progressive reduction of a mass, as is the case with the marble carver, or in his own words, ' per forza di levare '; and also by successive additions, as in modelling in clay or wax, which he calls ' per via di porre,' ' by the method of putting on.' The distinction is one of fundamental importance for a right understanding of the art, and upon it depends the characteristic difference between Greek reliefs, which are almost all carved in marble, and if not are beaten up on metal plates by the repoussé process, and Italian reliefs that are very often in cast bronze, the models for which have been prepared by modelling, ' per via di porre,' in wax. On this point something will be found in the Note on ' Italian and Greek Reliefs,' postea, p. 196 f.

With regard to sculpture effected ' by taking away,' ' per forza di levare,' Michelangelo has left a famous utterance in

one of his sonnets, No. xv in the edition of Guasti, which opens as follows :—

> ' Non ha l' ottimo artista alcun concetto,
> Ch' un marmo solo in sè non circonscriva
> Col suo soverchio; e solo a quello arriva
> La man che ubbidisce all' intelletto,'

and is thus translated by J. A. Symonds :—

> ' The best of artists hath no thought to show
> Which the rough stone in its superfluous shell
> Doth not include. To break the marble spell
> Is all the hand that serves the brain can do.'

The conceit is really a classical one, and is probably due to some Greek writer used by Cicero in his tract *De Divinatione*. Some one had testified to the fact that, in a certain marble quarry on Chios, a block, casually split open, had disclosed a head of Pan; and Cicero, or the writer he had before him, remarks that such a chance might occur, though the similitude would only be a rude one. In any case however, he goes on, it must be conceded that even the very finest heads imaginable are really in existence throughout all time in every block of stone of sufficient size. All that even a Praxiteles could do would be to bring them into view by taking off all that was superfluous in the marble. He would add nothing to what was there already. The whole process would be the removal of what was superfluous and bringing to light what was concealed within.

SCULPTURE TREATED FOR POSITION.

[§ 38, *Works of Sculpture should be treated with a view to their destined Position*, ante, p. 145.]

Vasari is dealing with sculpturesque treatment as conditioned by the position and lighting for which works of statuary are destined, and a somewhat interesting question in the aesthetics of the plastic art is opened up.

There are here two matters to be distinguished; one is the general treatment of a figure or relief in relation to position, and the other is the deliberate alteration in the proportions of

it, with a view to the same consideration. It is almost a matter of course that an artist, in preparing his model, will keep in view the aspect under which the finished work will be presented to the spectator, but the definite change in proportions is another matter. Vasari is clear in his own mind that Donatello and other sculptors did make changes of proportions as well as of general treatment on the grounds indicated, but in alleging this he is not drawing on his own expert knowledge as an artist, so much as echoing a judgement of literary critics often expressed in both ancient and modern times. There is a passage in Plato's *Sophist* which shows that in Greek aesthetics this question was discussed, and a distinction is there drawn, pp. 235-6, between exact imitation of nature, and an imitation that modifies the forms of nature for artistic effect. In large works, Plato points out, if the true proportions were given ' the upper part which is further off from the eye would appear to be out of proportion in comparison with the lower, which is nearer; and so our artists give up the truth in their images and make only the proportions which appear to be beautiful disregarding the true ones.' The same idea connected with a concrete instance is embodied in a legend preserved in some verses by the Byzantine writer Tzetzes, to the effect that Pheidias and Alcamenes competed on one occasion with rival figures of the goddess Athene. Alcamenes finished his with great delicacy, and on a near view it was preferred to that by Pheidias. The latter sculptor, ' being versed in optics and geometry,' had allowed for distance and exaggerated certain details. When both figures were put into position the superiority of that by Pheidias was at once apparent. It has been argued from a passage in Eustatius that Pheidias fashioned his Zeus at Olympia with the head slightly inclined forwards, so as to bring it more directly into view from the floor of the temple below.

In modern times Donatello's works have been specially singled out as illustrating this same principle, and not by Vasari alone. The following, for instance, is an *obiter dictum* of the Florentine writer Davanzati in a letter affixed to his translation of Tacitus published first in 1596, (see *Opere di Tacito,* Bern. Davanzati, Padova, 1755, p. 656), where he says,

'You must look at the way an effect is introduced, as in the case of Donatello and his famous Zuccone (Bald Head) on our Campanile of the Duomo. The eyes of this statue as one looks at it on high seem as if dug out with the spade, but if he had worked it on the ground (for a near view) the figure would appear to be blind. The reason is that distance swallows up all refinement of work (la lontananza si mangia la diligenzia) . . . In the same way the rudeness of rustic work on great palace walls does not take away from but rather adds to the effect of majesty.' Modern critics have agreed in commending Donatello for his judicious treatment, with a view to situation, of works like the statues on the Campanile, which are more than fifty feet above the ground. Hans Semper praises specially from this stand-point the ' Abraham and Isaac ' on the Campanile, and remarks that if this group were taken down and seen on the ground there would be a great outcry about faults of proportion in the legs, (*Donatello,* Wien, 1875, p. 122.) In Lord Balcarres's recent book on Donatello there is a discussion of the Campanile statues, and other works by the master, in relation to the same aesthetic principle, (*Donatello,* London, 1903, p. 17 ff.)

There is no question that the boldness and vigour which were characteristic of Donatello were well suited to give his works a telling effect at a distance, and this may be noticed in the case of his ' Cantoria ' with the dancing children in the Opera del Duomo at Florence. We are reminded here of the Pheidias and Alcamenes story. On a near view Donatello's Cantoria suffers in a comparison with the more delicate work on the same theme of Luca della Robbia, but when both galleries were ' in position,' high up, and in the semi-darkness of the Duomo, the effect of Donatello's relief must have been far finer. This bold and sketchy treatment was not due to the fact that the master could work in no other way, for Donatello treated very low relief, spoken of later on by Vasari as ' stiacciato,' with remarkable delicacy and finish. Hence we may fairly credit him with intention in the strong effects of some of his monumental works.

This is however quite a different matter from deliberate alteration of the proportions of a figure in view of the position

it is to occupy. In spite of what Vasari and some modern writers have said, it must be doubted whether Donatello or any other responsible sculptor has done anything of the kind. Vasari speaks of figures ' made a head or two taller ' when they have to be seen in a near view from below, but he does not refer to any examples. Decorative figures of elongated proportions may be instanced, but it does not follow that these proportions were intended to correct perspective foreshortening. The twelfth century statues in the western portals at Chartres are curiously elongated, and so too are the stucco nymphs of Primaticcio in the Escalier du Roi at Fontainebleau, but in both cases the figures are but little above the level of the eye, and their shape is certainly not due to any such consideration as was in the mind of Vasari. The actual proportions of Donatello's Campanile statues seem perfectly normal, though the works may have been deliberately treated with a view to position.

It is worth notice that, proportions apart, the principle of ' treatment for position ' has by no means been generally observed. In the greatest and most prolific periods of sculpture indeed, there seems to have been little consistency of practice in this regard, while some of the finest decorative works in the world appear to have been very little affected by any considerations of the kind. As in duty bound, Vasari appeals to the antique, but as a matter of fact, classical decorative sculpture exhibits only in a very minor degree these studied modifications of treatment in relation to position. In the frieze of the Parthenon the background is cut back a little deeper above than below, so as to increase the apparent salience of the parts farthest from the eye, and on the column of Marcus Aurelius at Rome, which may have been in Vasari's mind when he mentions reliefs on columns, the salience of the relief is much bolder above than below. The well-known band of ornament on the framing of Ghiberti's ' Old Testament ' gates shows similar variety in treatment. On the earlier column of Trajan, on the other hand, the eye can detect no variation in treatment of the kind. The groups from the pediments of the Parthenon give little indication that they were designed to be looked at sixty feet above the eye, while

the heads by Scopas from the pediments at Tegea are finished with the utmost delicacy, as if for the closest inspection.

In the matter of the choice of low or high relief according to the distance from the eye, the frieze of the Parthenon is often adduced as canonical, because, being only visible from near, it is in very low relief. It is forgotten however that the nearly contemporary friezes on the Theseum and from the interior of the temple at Bassae, though they were correspondingly placed and actually nearer to the eye, are both in high relief. On the Roman triumphal arches, of which Vasari writes, there are similar anomalies. Thus the well-known panels within the passage way of the Arch of Titus, that must have been calculated for very near stand-points, are in boldest projection.

The magnificent decorative sculpture on the French Gothic cathedrals shows little trace of the sort of calculation here spoken of. It is true that the figures of Kings in the ' Galeries des Rois ' across the west fronts are as a rule rudely carved, but this is because they are so purely formal and give the artist little opportunity. At Reims some of the finest and most finished work is to be found in the effigies of Kings, the Angels, and other figures, on the upper stages of the building, while the ' Church Triumphant ' up above on the southern transept façade is every whit as delicately beautiful as the ' Mary of the Visitation,' in the western porch.

Enough has been said to show that on this subject literary statements are not to be trusted and practice is very uncertain. It remains to be seen what light can be thrown upon it, first, from the side of aesthetic principle; and, second, from that of the actual procedure and expert judgement of sculptors of to-day.

The principle will hardly be controverted that anything abnormal, either in the proportions of a figure or even in its treatment, will tend to defeat its own object by confusing our regular and highly effective visual process. The organs which co-operate in this are so educated that we interpret by an unconscious act of intelligence what we actually see, and make due allowance for distance and position. It is often said that objects look larger through a mist. This is not the case.

They do not look larger but they look further off, and the equation between apparent size and apparent distance which we unconsciously establish is vitiated, so that the impression is produced that the particular object is abnormally large. Now in the same way we allow for the distance and the perspective angle at which a work of sculpture is seen and interpret accurately the actual forms and effects of texture and light and shade the image of which falls on the retina. If the sculptor have altered his proportions there is a danger that we shall derive the impression of a distorted figure, because we have made our allowances on the supposition that the proportions are normal. If he have forced the effect by emphasizing the modelling, he will make the parts where this is done appear too near the eye, and this will involve a false impression of the height and dimensions of the structure on which the sculpture is displayed. There is this forcing of effect in the case of the column of Marcus Aurelius, but it is of no artistic advantage, and would tend to make the column itself look lower than it really is. In the column of Trajan the spiral lines have a certain artistic wavyness, so that the band of sculpture varies in width in different parts, but the treatment is the same throughout, and as the reliefs were not only to be seen from below but also from the lofty neighbouring structures of the Trajanic Forum, this was not only in accordance with principle but with common sense. It is obvious indeed that works of monumental sculpture are practically always visible from other points than the one for which their effect is chiefly calculated; and hence if proportions be modified so as to suit one special standpoint, the work may look right in this one aspect, but in all others may appear painfully distorted.

As regards the second point, we have asked Mr. Pittendrigh Macgillivray, R.S.A., a question on this subject, and he has kindly given us his opinion in the following note.

' The question as to whether or not sculptors deliberately
' alter the normal proportions of the human figure in order
' to adapt their works to special circumstances is one which
' is frequently asked, and which I have never found reason to
' answer otherwise than in the negative. The rule in the

'classic examples of all periods, as far as I have observed, is
'normal proportion and execution, irrespective of site and
'circumstances, and, to anyone familiar with the art and
'practice of sculpture, the difficulties and uncertainties con-
'sequent upon a lawless method of dealing with the normal
'quantities of the figure, are a sufficient deterrent against
'vagaries in scale and proportion. To change the proportions
'of the figure in order to meet the peculiarities and limitations
'of some special site, seems on the surface so reasonable that
'one is not greatly surprised at the persistence of the idea in
'literary circles, where it has not been possible to balance it
'against that technical knowledge which is the outcome of
'actual practice and experience in handling the _métier_ of the
'art. To adapt statuary by fanciful proportions to unfortunate
'conditions and circumstances, for which truer artistic taste
'and understanding, on the part of architects, would never
'propose it, seems such a 'cute notion that it has occasionally
'attracted the clever ones of the profession as a way out of the
'difficulty, but one which has led only to ultimate discom-
'fiture.

'The fact is, I imagine, that the normal proportions of the
'human figure are so deeply printed on the inherited memory
'of the race that, except within very narrow limitations, they
'cannot be modified and yet at the same time convey lastingly
'any high order of serious emotion or effect. The great men
'doing serious work in sculpture will never find it necessary to
'go beyond the law of nature for the architectonic basis of
'their expression. Faulty or arbitrary proportion in handling
'the human figure is unnecessary; it is of no real help to the
'artist, and no more desired by him than is the liberty of
'16 lines and ballad measure, by the sonneteer expert in the
'Petrarchan form and rhyme of 14 pentameter verses. The
'real matter to be dealt with in respect of peculiarities of site
'and circumstances lies within the sphere of the artistic
'capacity, and is at once more easy and more difficult than any
'wooden process of mis-handling the proportions of the figure.
'It is at issue in the legend of the Byzantine writer, Tzetzes,
'to which reference is made, wherein it is said that Pheidias
'and Alcamenes competed on one occasion with rival figures of

'Athene, but the explanation given of the reason why the work
'of Pheidias was admired and preferred at the site, is, I
'venture to say, the wrong one, in as far as it presupposes
'abnormal proportions in the successful statue. To the
'author's mind, no doubt, something profound and abstruse
'was necessary in order to explain such a triumph, and the
'idea that Pheidias was deeply versed in what must then have
'been the occult mysteries of optics and geometry, fitted the
'need and was pleasant to the love of the marvellous.

'In such a case, Pheidias would certainly, with the intuitive
'artistic sense and experience of a master, handle the style,
'composition, lights and shadows, mass, line and silhouette of
'his work in relation to its size, and the average height and
'distance from which it was to be viewed. It might be
'finished highly in respect of surface, or left moderately rough,
'a condition of little consequence compared with the factors
'enumerated above. It would be made readable and expres-
'sive, but there would be no modification of the sacred
'proportions of the figure; no trace of allowance in order
'that " the upper part which is further off from the eye should
'appear to be in proportion when compared with the lower,
'which is nearer." That artists should appear to give up
'natural truth in their images for considerations of abstract
'beauty, was grateful to the mind of Plato, but is only another
'proof of the soaring qualities of the White Horse in the
'Human Chariot !

'Outside of a somewhat conscious effort towards the
'decorative in form and towards the effective articulation of
'parts, I find little in the work of Donatello to justify his being
'specially singled out as illustrating those principles of the
'modification of true proportions for sculpture in relation to
'the exigencies of site. The statues on the Campanile need
'not, I imagine, be taken too seriously as exhibitions of
'Donatello's most careful judgement. Compared with such
'works of his as we may feel at liberty to believe personal,
'they are rude and ill-considered in design and execution.
'There is in the bones, mass, and arrangement of the work
'very probably something of Donatello, but in the detail and
'execution there is little or nothing of the hand that did the

' Christ of S. Antonio of Padua, the bronze David of the
' Bargello, or the bust of Niccolo da Uzzano.'

WAXEN EFFIGIES AND MEDALLIONS.

[§ 43, *Polychrome Wax Effigies*, ante, p. 149.]

Wax has been used from the time of the ancients as a
modelling material, both in connection with casting in bronze,
and with the making of small studies for reproduction in more
permanent materials. The production of a plastic work in wax
intended to remain as the finished expression of the artist's idea
is of course a different matter. Among the Greeks, Lysistratos,
the brother of Lysippos, about the time of Alexander the
Great, introduced the practice of taking plaster moulds from
the life, and then making casts from them in wax. These he
may have coloured, for the use of colour, at any rate on terra
cotta, was at the time universal, and in this way have produced
waxen effigies. (Hominis autem imaginem gypso e facie ipsa
primus omnium expressit ceraque in eam formam gypsi infusa
emendare instituit Lysistratus Sicyonius frater Lysippi. Plin.
Hist. Nat., xxxv, 153). Busts in coloured wax of departed
ancestors were kept by the Romans of position in the atria of
their houses, and the funereal use of the wax effigy can be
followed from classical times to those comparatively modern,
for in Westminster Abbey can still be seen the waxen effigies
of Queen Elizabeth, Charles II, and other sovereigns and
nobles of the sixteenth and seventeenth centuries. These, like
the modern wax-works of popular exhibitions, are hardly pro-
ductions of art. What Vasari writes of is a highly refined and
artistic kind of work, that was practised in Italy from the
early part of the sixteenth century, and spread to France,
Germany, and England in each of which countries there were
well-known executants in the seventeenth or eighteenth
centuries. *The Connoisseur* of March, 1904, contained an
article on the chief of these.

Though modelled effigies in wax of a thoroughly artistic kind
were executed of or near the size of life and in the round, as
may be seen in the Italian waxen bust of a girl in the Musée
Wicar at Lille, that has been ascribed to Raphael, yet as a

rule the execution was in miniature and in relief. Specimens of this form of the work are to be seen in the British Museum, in the Wallace Collection, and at South Kensington.

In the *Proceedings* of the Huguenot Society of London, III, 4, there is an article on the Gossets, a Huguenot family, some members of which practised the art in England from the early part of the eighteenth century, and a recipe for colouring the wax is there quoted which it may be interesting to compare with that given by Vasari. ' To two ounces of flake white (the biacca of Vasari) add three of Venice turpentine, if it be in summer, and four in winter, with sufficient vermilion (cinabrio) to give it a pinkish tint. Grind these together on a stone with a muller; then put them into a pound of fine white wax, such as is used for making candles : this is molten ready in an earthen pipkin. Turn them round over the fire for some time. When thoroughly mixed the composition should be immediately removed and poured into dishes previously wetted to prevent the wax from sticking to them. '

This refers to the preparation of a self-coloured wax which may be prepared of a flesh tint, or of a creamy white, or of any other desired hue like those Vasari enumerates. The portraits in wax referred to in our museums are sometimes in self-coloured material of this kind, but at other times are coloured polychromatically in all their details. This is the technique referred to by Vasari in § 43 as having been introduced by certain 'modern masters.' In *Opere,* IV, 436 he refers to one Pastorino of Siena as having acquired great celebrity for wax portraits, and as having ' invented a composition which is capable of reproducing the hair, beard and skin, in the most natural manner. It would take me too long ' he continues ' to enumerate all the artists who model wax portraits, for now-a-days there is scarcely a jeweller who does not occupy himself with such work. ' This last remark is significant, for one feature of these polychrome medallions is the introduction of real stones, seed pearls, gold rings, and the like, in connection with the modelled wax, so that collectors used to style the works ' Italian sixteenth century jewelled waxes. ' A portrait bust in the Salting collection, shown on loan at South Kensington, representing Elizabeth of France, wife of Philip II, is a good

specimen of the technique. The lady wears a jewelled hair net
set with real red and green stones, and a necklet of seed pearls.
In her ear is a ring of thin gold wire. The flesh parts are
naturally coloured, the hair is auburn, the bodice black, and
there are two white feathers in the headdress. We should
gather from Vasari's words in § 43 that works of the kind
were built up of waxes variously coloured in the mass, and a
close examination of extant specimens clearly shows that this
was the case. Local tints such as the red of the lips, etc.,
were added with pigment.

The best modern notice of wax modelling in these forms is
that contained in Propert's *History of Miniature Art,* Lond.
1887, chapter xii, but little is said there of the technique. It
should be noticed that the medallion in coloured wax as a form
of art has been revived with considerable success in our own
time and country by the Misses Casella and others. The artists
just named consider that it would be impossible to finish work
on the usual small scale in coloured waxes alone, without
touches of pigment added with the brush. It would be interest-
ing in this connection to know what were the exact processes
of painting in wax used by the ancients. Paintings, which
must have been on a small scale because they were on a ground
of ivory, were executed in coloured waxes laid on by the
' cestrum ' (Pliny, *Hist. Nat.,* xxxv, 147), which is usually
described as a sort of spatula, something like one of the steel
tools used by artists for finishing figures in plaster. However
the substance was applied, the whole process was apparently
carried out in the coloured waxes. There must have been
some similarity between this technique and that of the wax
medallions of Renaissance and modern times.

PROPORTIONATE ENLARGEMENT.

[§ 48, *Transference of the full-sized Model to the Marble Block,*
ante, p. 151.]

' To enlarge the figure proportionately in the marble.'
Vasari has said, ante, p. 150, that the model is to be the full size
of the marble so that there would be no question of enlargement
but only of accurately copying the form of the model in the new

material. For this mechanical aids are invoked, the latest and most elaborate of which is the ' pointing machine ' now in common use. The appliances in Vasari's time were much simpler. Cellini, in his *Trattato sopra la Scultura,* describes the mechanical arrangements he made for enlarging a model to the size of a proposed colossal effigy, and the principle is the same whether there is to be enlargement or exact reproduction.

The model, and a block roughly trimmed by rule of thumb to the size and shape required, but of course somewhat larger than will ultimately be needed, are placed side by side on tables of exactly the same form and dimensions. About the model is set up a sort of framework simple or elaborate, according to the character of the piece, and a framework precisely similar in all respects is disposed about the block. A measurement is then taken from one or more points on the framework to a point on the model, and from a point or points similarly situated on the other framework, and in the same relative direction, a similar measurement is led towards the block. As this is *ex hypothesi* a little larger than the model, the full measurement cannot be taken until some of the superfluous marble has been removed by suitable tools. When this is done a point can be established on the block exactly corresponding to the point already fixed on the model. This process can be repeated as often as is necessary until all the important or salient points on the model have been successively established on the marble block, which will ultimately have approached so nearly to the exact similitude of the model, that the artist can finish it by the eye.

The nature of what has been termed the framework, from which all the measurements are taken, may vary. Cellini, on the occasion referred to, surrounded his model with a sort of skeleton of a cubical box, from the sides and corners of which he measured. In the *Encyclopédie* of Diderot and d'Alembert, of the middle of the eighteenth century, similar square frames, like those used as stretchers for canvases, are suspended horizontally over model and block, and plumb lines are hung from the corners, so that skeleton cubes are established, which would answer the same purpose as Cellini's box. See Plate X, A. The arrangement contemplated by Vasari was somewhat simpler.

He does not establish a complete hollow cube about his model and his block, but is apparently satisfied with erecting perpendiculars beside each, from which the measures would be led. The carpenter's square (squadra) he has in mind consists of two straight legs joined together at right angles. If one leg be laid horizontally along the table the one at right angles to it will be vertical, and from this the measurements are taken. In the treatise on Sculpture by Leon Battista Alberti there is an elaborate description of a device he invented for the purpose in view, and one of his editors has illustrated this by a drawing reproduced here in Plate X, B. The device explains itself, and any number of similar contrivances could be employed.

THE USE OF FULL-SIZED MODELS.

[§ 49, *Danger of Dispensing with the Full-sized Model,*
ante, p. 151.]

The question here is of the possibility of dispensing altogether with a full-sized clay model, and proceeding at once to attack the marble with the guidance only of the small original sketch. In modern times this is practically never done, but it was the universal practice of the Greek sculptors at any rate down to the later periods of Hellenic art. These remarks of Vasari come just at the time of the change from the ancient to the modern technique, for we shall see that Donatello in the fifteenth century worked according to the simpler ancient method, while Michelangelo in the sixteenth after beginning in the same fashion finally settled down to the use of the full model, which has ever since remained *de rigeur*.

The technique of the Greeks furnished the subject for an article by Professor Ernest Gardner in the 14th volume of the *Journal of Hellenic Studies.* He shows there by a comparison of unfinished works that the Greek sculptors attacked the marble directly, and proceeded apparently on the following method. Having obtained a block about the size and shape required they set it up before them as if in a front view, and then hewed away at the two sides till they had brought the contour of these to the exact lines required for the finished work. They then passed round through a right angle to the

PLATE X

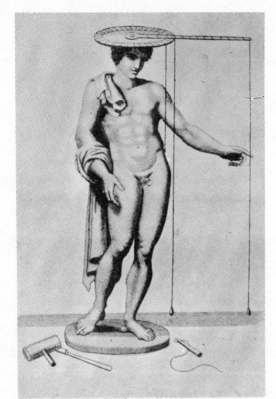

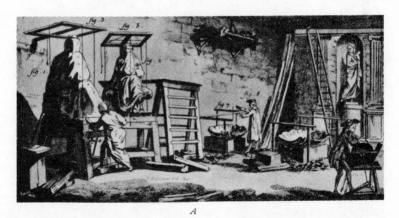

A

INTERIOR OF A SCULPTOR'S STUDIO IN THE EIGHTEENTH CENTURY

With illustrations of methods of measurement

side, and treated in a similar fashion the front and back of the
block, bringing these to the shape of the front and back of the
desired figure. The block would then, when looked at from

FIG. 11.—Two views of unfinished Greek marble statue blocked out on the ancient system.
In quarries on Mount Pentelicus, Athens.

the front or back or from the sides, present the required
outlines, but the section of it would still be square in every
part—there would be no rounding off. The sketches, Fig. 11,
show two views of a figure blocked out in this fashion by an
ancient Attic sculptor. It was found in old marble workings

on Mount Pentelicus, and is preserved at the modern marble quarry at the back of that mountain. We owe the use of the photographs employed to the courtesy of M. Georges Nicole, of Geneva. They were published in the volume entitled *Mélanges Nicole,* Geneva, 1905, in connection with an article on the figure by the archaeologist just named. The next process was to cut away these corners and with the guidance of the already established contours gradually bring the whole into the required shape. A small model may in every case be presupposed and there must have been some system of measurement. Indeed on some antiques, as on a crouching Venus in the gallery leading to the Venus of Milo in the Louvre, there are still to be seen the knobs (puntelli) to which measurements were taken during the progress of the work. Of the use of full-sized clay models there is in Greece no evidence at all, until the late period of the first century B.C., when we are told of Pasiteles, a very painstaking sculptor of a decadent epoch, that he never executed a work without first modelling it (nihil unquam fecit antequam finxit). This no doubt implies a full-sized model in clay, for a small sketch would not be mentioned as it is a matter of course.

The practice of the Italians is described by Cellini in words which are important enough to quote. They are from the fourth chapter of his treatise on Sculpture. ' Now although many excellent masters of assured technique have boldly attacked the marble with their tools, as soon as they had carved the little model to completion, yet at the end they have found themselves but little satisfied with their work. For, to speak only of the best of the moderns, Donatello adopted this method in his works; and another example is Michelangelo, who had experience of both the methods, that is to say, of carving statues alike from the small model and the big, and at the end, convinced of their respective advantages and disadvantages, adopted the second method (of the full-sized model). And this I saw myself at Florence when he was working in the sacristy of S. Lorenzo (on the Medici tombs).' As regards Michelangelo's early practice, Vasari records in his Life that he carved the colossal marble ' David ' with the sole aid of a small wax model, according to Vasari one of those

now preserved in the Casa Buonarroti at Florence. This was in 1504. The Medici tombs date twenty years later.

In connection with the direct practice of Donatello, it is worth while referring to some words of Francesco Bocchi, a rhetorical eulogist of the arts and artists of his native Florence, who wrote in 1571 a literary effusion on the sculptor's St. George. He notes in his introduction that Donatello was accustomed to compose his marble figures compactly and to avoid projecting hands and arms, while for his effigies in bronze he used much greater freedom in action. The difference is really one of material, and Donatello's practice of working directly on the marble would necessarily involve this restraint in composition. Anyone accustomed to deal with marble blocks as vehicles of artistic expression, would avoid unnecessary projections as these cause great waste of material and expenditure of time. When plastering clay or wax on a flexible armature this consideration is not present, and modelled figures will naturally be freer in action than carved ones. As will presently be seen, certain marked differences in the treatment of relief sculpture depend on these same considerations of material and technique.

In direct work on the marble there is of course always the danger of the sort of miscalculation that Vasari goes on to notice. Greek figures sometimes show variations from correct proportions, for example, the left thigh of the Venus of Milo is too short, but the errors are not such as to destroy the effect of the works. Greek work in marble shows a marvellously intimate knowledge on the part of the carver of his material as well as a clear conception of what he was aiming at. Even Michelangelo yields in this respect to the ancients, for though no one was ever more thoroughly a master of the carver's technique, he made serious mistakes in calculating proportions, as in the ' Slave ' of the Louvre, where he has not left enough marble for the leg of the figure. Moderns generally have not the ease which tradition and practice gave to the Greek sculptors, and the full-sized model is now a necessary precaution.

ITALIAN AND GREEK RELIEFS.

[§ 52, *Pictorial or Perspective Reliefs,* ante, p. 154.]

Vasari ascribes comprehensively to the 'ancients' the invention of the pictorial or perspectively treated relief, which was not in use in mediaeval times, but came into vogue in the early years of the fifteenth century. The first conspicuous instance of its employment was in the models by Ghiberti for the second set of gates for the Baptistry at Florence begun in 1425, but as these gates were not finally completed till 1452, other artists had in the meantime produced works in the same style. Donatello's bronze relief of the beheading of John the Baptist, on the font at Sienna, was completed in 1427 and shows the same treatment in a modified form. It is a treatment often called pictorial as it aims at effects of distance, with receding planes and objects made smaller according to their supposed distance from the foreground. The style has been sufficiently criticized, and it is generally agreed that it represents a defiance of the barriers fixed by the nature of things between painting and sculpture. It depended mainly however not on the influence of painting but on the study of perspective, which Brunelleschi brought into vogue somewhere about the year 1420. Brunelleschi's perspectives, or those which he inspired, were worked out in inlaid woods, or tarsia work, see postea, p. 303 f., and exhibited elaborate architectural compositions crowded with receding lines. These compositions were adopted by Donatello and others for the backgrounds of their figure reliefs, and Ghiberti filled his nearer planes with a crowd of figures represented as Vasari describes according to the laws of linear, and so far as the material permitted, of aerial perspective.

The question of the amount of warrant for this in antique practice as a whole calls attention to an interesting moment in the general history of relief sculpture. This has been dealt with recently by Franz Wickhoff, in the Essay contributed by him to the publication of the Vienna ' Genesis,' and issued in an English translation by Mrs Strong under the title *Roman Art* (London, 1900), and also in Mrs Strong's own *Roman Sculpture* (London, Duckworth, 1907). The tendency to multiply

planes in relief, and to introduce the perspective effects and the backgrounds of a picture, shows itself in some of the late Greek or ' Hellenistic ' reliefs, published by Schreiber under the title *Die Hellenistischen Reliefbilder* (Wien, 1889 etc.), and more especially in the smaller frieze from the altar base at Pergamon. Etruscan relief sculpture is also affected by it. It is however in Roman work of the early imperial period that we actually find the antique prototypes for the kind of work that Vasari has in his mind. The reliefs on the tomb of the Julii at St Rémy, of the age of Augustus, those on the Arch of Titus, and most conspicuously the decorative sculpture connected with the name of Trajan, are instances in point. They show differences in plane, and occasionally a distinct effort after perspective effects, and it is possible that the study of some of these Roman examples by Brunelleschi and Donatello at the opening of the fifteenth century may have contributed to the formation of the picturesque tradition in Florentine relief sculpture of the period. This style was however by no means universal in Roman work. The carved sarcophagi are not much influenced by it, and these sarcophagi are of special importance in the later history of sculpture, in that they were the models used by Nicola Pisano and the other French and Italian sculptors of the so-called ' proto-Renaissance ' of the twelfth and thirteenth centuries. In relation to antique sculpture as a whole the pictorial style is quite abnormal. The genius of the classical Greek relief is indeed totally opposed to that of the Italian reliefs represented centrally by those of Ghiberti. The difference is fundamentally one of material and technique. It is the same distinction that was drawn by Michelangelo in his letter to Benedetto Varchi, and noticed already in the Note on ' The Nature of Sculpture,' *ante*, p. 179, the distinction, that is, between sculpture that proceeds by additions, ' per via di porre,' and that which advances by taking material away, ' per forza di levare.' The normal Italian relief was in cast bronze and was necessarily modelled work. The classical relief was in marble and was essentially carved work, for the diversifying of a flat surface. When the Greek relief was in baked clay it was generally stamped from moulds and not modelled up by hand. The cast bronze relief in classical

Greece may be said only to have existed in the form of small plaques for the decoration of vases or other objects in metal. The normal bronze relief in the ancient world was beaten up in sheet metal by the repoussé process.

In the case alike of the relief carved on the marble slab, or stamped in clay from moulds, or beaten up in the sheet of metal, the nature of the technique renders flatness of effect almost obligatory. The Greek decorative relief cut ' per forza di levare ' in a smooth marble slab, that is most often one of the constructive stones of an edifice, naturally sacrifices as little of the material as is possible, and in all Greek reliefs, whether low or high, as much as possible of the work is kept to the foremost plane, the original surface of the stone. Again, a mould that is undercut, or at all deeply recessed, cannot be used for stamping clay, while the difficulty of relief work in sheet metal is greatly increased in proportion to the amount of salience of the forms. Hence the general flatness of the antique relief, observable even on the late Roman sarcophagi which served as models at the first revival of Italian sculpture. Whether the field of the relief is open or crowded, the objects all come together to the front.

How different are the conditions when the relief is modelled up by hand in clay or wax! Here the starting point is the background, not as in the carved relief the foreground, and the forms, worked ' per via di porre,' can be made to stand out against this with an ease and effectiveness which tempt the modeller to try all sorts of varieties of relief in the same composition or the same figure, and to multiply planes of distance till the objects on the foremost plane are starting out clear of the ground. There is direct evidence (see ante, p. 194) that in the first century B.C. the use of clay modelling as a preliminary process in sculpture was greatly extended, and Roman pictorial reliefs may themselves have been influenced from this side. There is no question at any rate that the Italians of the Renaissance surrendered themselves without hesitation to the fascination of this kind of work, and the style of it dominates their later reliefs. The contrast in this respect between Ghiberti's second, or Old Testament, Gates, and his earlier ones which adhered to the simpler style of Andrea

Pisano's reliefs on the first of the three Baptistry Gates, is most instructive. Andrea's reliefs are in character mediaeval, and the nearest parallel to them are the storied quatrefoils on the basement of the western portals at Amiens. It is worthy of notice how classical these are in style, and this is due to the fact that like Greek reliefs, such as the frieze of the Parthenon, they were cut in the constructive stones of the edifice *in situ,* and are in true stone technique.

This contrast of Greek and Italian reliefs furnishes a most conspicuous object lesson on the importance of material and technique in conditioning artistic practice. As was pointed out in the Introductory Essay, these considerations have not in the past been sufficiently emphasized in the scheme of education in design recognized in our Schools of Art, though in several quarters now there is a promise of better things.

THE PROCESSES OF THE BRONZE FOUNDER.

[§§ 55-69, ante, p. 158 ff.]

Vasari's account of the processes attendant on casting in bronze is intelligible and interesting, though he had himself little practical acquaintance with the craft. Benvenuto Cellini on the other hand was an expert bronze founder and the account he gives of the necessary operations in the first three chapters of his treatise on Sculpture is extremely graphic and detailed, and may be usefully employed to amplify and explain Vasari's notice. An expert knowledge of the founder's craft was not by any means universal among the Italian sculptors of the Renaissance. Donatello did not possess it, nor did Michelangelo. In the case of the former this is somewhat remarkable, for Donatello was such a vigorous craftsman that we should have expected to find him revelling in all the technical minutiae of the foundry. We are expressly told however by Pomponius Gauricus that Donatello lacked this knowledge, and never cast his own works but always relied on the help of bell founders (Hans Semper, *Donatello,* Wien, 1875, p. 317). Michelozzo on the other hand, who worked with Donatello, could cast, and so could Ghiberti, A. Pollaiuolo, and Verrocchio, while Alessandro Leopardi of

Venice, who cast Verrocchio's Colleoni statue, was famed for his practical skill in this department. It was customary, when expert help in casting was required, to enlist the services of bell founders and makers of cannon, but Cellini warns sculptors against trusting too much to these mere mechanicians who lacked ingenuity and resource.

The following general sketch of the processes of casting will render Vasari's account more easy to follow. A successful cast in bronze consists in a thin shell of the metal, representing on the exterior the exact form of the model, or the complete design in the artist's mind. The best way to procure this is to provide first a similar shell, perfect on its exterior surface, of wax, and then to melt away the wax and replace it by molten bronze. For this to be possible the shell of wax must be closely sealed between an outer envelope and an inner packing or core. It can then be got rid of by melting, but care must have been taken lest the core when it loses the support of the wax should shift its position in relation to the envelope. To prevent this, metal rods are run, skewer-fashion, through core and envelope to retain them firmly in their relative positions. Molten bronze may then be introduced into the space formerly occupied by the wax, and this, when it is cold, and the envelope and core are both removed, will be the cast required.

Attention has to be paid to secure that there shall be no moisture and no remnant of wax in the parts where the molten bronze is to come, otherwise steam may be generated and a dangerous explosion follow. Similarly, air holes or vents must be provided, so that the air may escape before the flowing metal. The cast when cold should, theoretically, give a perfect result, but as a matter of fact, unless very accomplished skill or great good fortune have presided over the operations, the metal will be blistered or seamed or flawed in parts, and these imperfections will have to be remedied by processes which come under the head of chasing, and are described by Vasari at the close of the chapter.

A direct and ingenious method of procuring the needful shell of wax is that described by Vasari in § 67 as suitable for small figures and reliefs. Over the model for such a small figure an envelope is formed, in the shape of a hollow mould

of fire-resisting material, so constructed that it can be taken to
pieces, the model extracted, and the mould closed up again.
The mould must now be cooled with cold water and it is then
filled with melted wax. Contact with the cold sides of the
mould chills the wax, which hardens all over in a sort of crust
or skin. The rest of the wax, still liquid, is then poured out
and the skin or crust suffered to harden. The interior is then
filled with clay of a kind that will stand heat. Rods or skewers
are passed through this and the envelope, the wax is melted
out and its place taken by the molten bronze.

This process, one of course only suitable for small objects,
presupposes the existence of a completely finished model to be
exactly reproduced in the metal. The simplest of all processes
of bronze casting dispenses with this model. Vasari does not
describe this simplest method but Cellini, who employed it both
for his ' Nymph of Fontainebleau ' and his ' Perseus,' gives an
account of it which is worth summarizing because the process
is probably the one adopted in most cases by the old Greek
masters.

Cellini tells us that in making his large lunette-shaped relief
of the ' Nymph of Fontainebleau,' now in the Louvre, he began
by modelling up the piece in fire-resisting clay, of course over
a proper armature or skeleton. He worked it out to full size
and then let it dry till it had shrunk about a finger's breadth.
He then covered it with a coating of wax of rather less than
this thickness, which he modelled with the utmost care, finishing
it in every detail so that it expressed to the full his own idea
for the finished work. This was then carefully covered in
successive layers with an envelope of fire-resisting material,
which would be properly tied by transverse rods to the core,
and braced on the exterior by an armature. The wax was then
melted out, and the core and envelope thoroughly dried, when
the molten bronze was poured in so as to reproduce the wax in
every detail.

It is obvious that this is not only the most direct but the
most artistic method of work. The wax forms a complete
unbroken surface and receives and retains the exact impression
in every detail of the master's hand. If the cast be thoroughly
successful, the bronze will reproduce the surface of the wax so

perfectly that no further work upon it will be needed, and an ' untouched cast ' will be the result. This method would suit the genius of the Greeks, and was no doubt commonly employed by them, but it has the practical drawback that if anything go wrong, and the bronze do not flow properly, the whole work is spoilt, and will have to be built up again *de novo* from the small study. Cellini tells us that his ' Perseus,' which he was casting in this fashion, nearly came to grief from the cause just indicated, and he accordingly recommends what he calls the second method, a longer and less direct process, which has however the advantage that a full-sized completed model is all the time preserved.

This process is the one described by Vasari. A full-sized clay model is prepared and finished, and this is then covered with a plaster envelope made in numerous sections, so that it can be taken to pieces and put together again without the model, which may be preserved for further use. The next step is to line the inside of the empty envelope, or piece-mould, as it is called, with wax, and to fill up all the rest of the interior with a core. The piece-mould is then removed, and the surface of the wax is carefully gone over to secure that it shall be perfect in every part. Over it is then laid in successive coats a fire-resisting envelope between which and the core the wax is hermetically sealed. The wax can then be melted out and replaced with bronze. The piece-mould, which has been detached section by section from the wax, will serve again for other reproductions. The processes in which wax is employed are called *cire perdue* processes, because the wax is got rid of in order to be replaced by the metal. The usual process in vogue at the present day dispenses with any employment of wax. The figure to be cast is piece-moulded and reproduced in a suitable material, a certain thickness of which is in every part pared away according to the thickness required for the bronze. This core is then replaced with proper adjustments within a fireproof mould, and the bronze is poured into the space prepared for it.

OF PAINTING

OF PAINTING

CHAPTER I. (XV.)

What Design is, and how good Pictures are made and known, and concerning the invention of Compositions.

§ 74. *The Nature and Materials of Design or Drawing.*[1]

SEEING that Design, the parent of our three arts, Architecture, Sculpture, and Painting, having its origin in the intellect, draws out from many single things a general judgement, it is like a form or idea of all the objects in nature, most marvellous in what it compasses, for not only in the bodies of men and of animals but also in plants, in buildings, in sculpture and in painting, design is cognizant of the proportion of the whole to the parts and of the parts to each other and to the whole. Seeing too that from this knowledge there arises a certain conception and judgement, so that there is formed in the mind that something which afterwards, when expressed by the hands, is called design, we may conclude that design is not other than a visible expression and declaration of our inner conception and of that which others have imagined and given form to in their idea. And from this, perhaps, arose the proverb among the ancients ' ex ungue leonem ' when a certain clever person, seeing carved in a stone block the claw only of a lion, apprehended in his mind

[1] The first two sections, §§ 74, 75, of this chapter were added by Vasari in the second edition. They contain his contribution to the philosophy of the graphic art. It will be noted that his word ' Disegno ' corresponds alike to our more general word ' design ' and the more special term ' drawing.'

from its size and form all the parts of the animal and then the whole together, just as if he had had it present before his eyes. Some believe that accident was the father of design and of the arts, and that use and experience as foster-mother and schoolmaster, nourished it with the help of knowledge and of reasoning, but I think that, with more truth, accident may be said rather to have given the occasion for design, than to be its father.

But let this be as it may, what design needs, when it has derived from the judgement the mental image of anything, is that the hand, through the study and practice of many years, may be free and apt to draw and to express correctly, with the pen, the silver-point, the charcoal, the chalk, or other instrument, whatever nature has created. For when the intellect puts forth refined and judicious conceptions, the hand which has practised design for many years, exhibits the perfection and excellence of the arts as well as the knowledge of the artist. And seeing that there are certain sculptors who have not much practice in strokes and outlines, and consequently cannot draw on paper, these work instead in clay or wax, fashioning men, animals, and other things in relief, with beautiful proportion and balance. Thus they effect the same thing as does he who draws well on paper or other flat surface.

The masters who practise these arts have named or distinguished the various kinds of design according to the description of the drawing which they make. Those which are touched lightly and just indicated with the pen or other instrument are called sketches, as shall be explained in another place. Those, again, that have the first lines encircling an object are called profiles or out-lines.

§ 75. *Use of Design (or Drawing) in the Various Arts.*

All these, whether we call them profiles or otherwise, are as useful to architecture and sculpture as to painting. Their chief use indeed is in Architecture, because its designs are composed only of lines, which so far as the

architect is concerned, are nothing else than the beginning and the end of his art, for all the rest, which is carried out with the aid of models of wood formed from the said lines, is merely the work of carvers and masons.[2]

In Sculpture, drawing is of service in the case of all the profiles, because in going round from view to view the sculptor uses it when he wishes to delineate the forms which please him best, or which he intends to bring out in every dimension, whether in wax, or clay, or marble, or wood, or other material.

In Painting, the lines are of service in many ways, but especially in outlining every figure, because when they are well drawn, and made correct and in proportion, the shadows and lights that are then added give the strongest relief to the lines of the figure and the result is all excellence and perfection. Hence it happens, that whoever understands and manages these lines well, will, with the help of practice and judgement, excel in each one of these arts. Therefore, he who would learn thoroughly to express in drawing the conceptions of the mind and anything else that pleases him, must after he has in some degree trained his hand to make it more skilful in the arts, exercise it in copying figures in relief either in marble or stone, or else plaster casts taken from the life, or from

[2] This remark of Vasari is significant of the change in architectural practice between the mediaeval and modern epochs. That the architect is a man that sits at home and makes drawings, while practical craftsmen carry them out, is to us a familiar idea, but the notion would greatly have astonished the builders of the French Gothic cathedrals or the Florentines of the fourteenth century. In mediaeval practice the architect was the master of the work, carrying the scheme of the whole in his head, but busy all the time with the actual materials and tools, and directing progress rather from the scaffolding than from the drawing office. On the tombstone of the French architect of the thirteenth century, Hughes Libergier, at Reims, he is shown with the mason's square, rule, and compasses about him; while in the relief that illustrates 'Building' on Giotto's Campanile at Florence we see the master mason directing the operations of the journeymen from a position on the structure itself. In the present day there is a strong feeling in the profession that this separation of architect and craftsman, which dates from the later Renaissance, is a bad thing for art, and that the designer should be in more intimate touch with the materials and processes of building.

some beautiful antique statue, or even from models in
relief of clay, which may either be nude or clad in rags
covered with clay to serve for clothing and drapery. All
these objects being motionless and without feeling, greatly
facilitate the work of the artist, because they stand still,
which does not happen in the case of live things that have
movement. When he has trained his hand by steady
practice in drawing such objects, let him begin to copy
from nature and make a good and certain practice herein,
with all possible labour and diligence, for the things
studied from nature are really those which do honour to
him who strives to master them, since they have in them-
selves, besides a certain grace and liveliness, that simple
and easy sweetness which is nature's own, and which
can only be learned perfectly from her, and never to a
sufficient degree from the things of art. Hold it more-
over for certain, that the practice that is acquired by
many years of study in drawing, as has been said above,
is the true light of design and that which makes men
really proficient. Now, having discoursed long enough
on this subject let us go on to see what painting is.

§ 76. Of the Nature of Painting.

A painting, then, is a plane covered with patches of
colour on the surface of wood, wall, or canvas filling up
the outlines spoken of above, which, by virtue of a good
design of encompassing lines, surround the figure.[3] If

[3] It is characteristically Florentine to regard painting as essentially the filling
up of outlines, and to colour in staccato fashion with an assorted set of tints
arranged in gradation. To the eye of the born painter outlines do not exist
and nature is seen in tone and colour, while colours are like the tones of a
violin infinite in gradation, not distinct like the notes of a piano. With the
exception of the Venetians and some other North Italians such as Correggio
and Lotto, the Italians generally painted by filling outlines with local tints
graded as light, middle, and dark, and the Florentines were pre-eminent in the
emphasis they laid on the well-drawn outline as the foundation of the art.
Since the seventeenth century the general idea of what constitutes the art of
painting has suffered a change and Vasari's account of Florentine practice, in
which he was himself an expert, is all the more interesting. Vasari's point

the painter treat his flat surface with right judgement, keeping the centre light and the edges and the background dark and medium colour between the light and dark in the intermediate spaces, the result of the combination of these three fields of colour will be that everything between the one outline and the other stands out and appears round and in relief. It is indeed true that these three shades cannot suffice for every object treated in detail, therefore it is necessary to divide every shade at least into two half shades, making of the light two half tints, and of the dark two lighter, and of the medium two other half tints which incline one to the lighter and the other to the darker side. When these tints, being of one colour only whatever it may be, are gradated, we see a transition beginning with the light, and then the less light, and then a little darker, so that little by little we find the pure black. Having then made the mixtures, that is, these colours mixed together, and wishing to work with oil or tempera or in fresco, we proceed to fill in the outlines putting in their proper place the lights and darks, the half tints and the lowered tones of the half tints and the lights. I mean those tints mixed from the three first, light, medium and dark, which lights and medium tints and darks and lower tones are copied from the cartoon or other design which is made for any work before we begin to put it into execution. It is necessary that the design be carried out with good arrangement, firm drawing, and judgement and invention, seeing that the composition in a picture is not other than the parcelling out of the places where the figures come, so that the spaces be not unshapely but in accordance with the judgement of the eye, while the field is in one place well covered and in another void. All this is the result of drawing

of view is that of the frescoist. In that process, which, as we shall see, had to be carried out swiftly and directly so as to be finished at one sitting, it was practically necessary to have the various tints in their gradations mixed and ready to hand. The whole method and genius of oil-painting, as moderns understand it, is different, and its processes much more varied and subtle.

and of having copied figures from the life, or from models of figures made to represent anything one wishes to make. Design cannot have a good origin if it have not come from continual practice in copying natural objects, and from the study of pictures by excellent masters and of ancient statues in relief, as has been said many times. But above all, the best thing is to draw men and women from the nude and thus fix in the memory by constant exercise the muscles of the torso, back, legs, arms, and knees, with the bones underneath. Then one may be sure that through much study attitudes in any position can be drawn by help of the imagination without one's having the living forms in view. Again having seen human bodies dissected one knows how the bones lie, and the muscles and sinews, and all the order and conditions of anatomy, so that it is possible with greater security and more correctness to place the limbs and arrange the muscles of the body in the figures we draw. And those who have this knowledge will certainly draw the outlines of the figures perfectly, and these, when drawn as they ought to be, show a pleasing grace and beautiful style.

He who studies good painting and sculpture, and at the same time sees and understands the life, must necessarily have acquired a good method in art. Hence springs the invention which groups figures in fours, sixes, tens, twenties, in such a manner as to represent battles and other great subjects of art. This invention demands an innate propriety springing out of harmony and obedience; thus if a figure move to greet another, the figure saluted having to respond should not turn away. As with this example, so it is with all the rest. The subject may offer many varied motives different one from another, but the motives chosen must always bear relation to the work in hand, and to what the artist is in process of representing. He ought to distinguish between different movements and characteristics, making the women with a sweet and beautiful air and also the youths, but the old always

grave of aspect, and especially the priests and persons in authority. He must always take care however, that everything is in relation to the work as a whole; so that when the picture is looked at, one can recognize in it a harmonious unity, wherein the passions strike terror, and the pleasing effects shed sweetness, representing directly the intention of the painter, and not the things he had no thought of. It is requisite therefore, for this purpose, that he form the figures which have to be spirited with movement and vigour, and that he make those which are distant to retire from the principal figures by means of shade and colour that gradually and softly become lower in tone. Thus the art will always be associated with the grace of naturalness and of delicate charm of colour, and the work be brought to perfection not with the stress of cruel suffering, so that men who look at it have to endure pain on account of the suffering which they see has been borne by the artist in his work, but rather with rejoicing at his good fortune in that his hand has received from heaven the lightness of movement which shows his painting to be worked out with study and toil certainly, but not with drudgery; so will it be that the figures, every one in its place, will not appear dead to him who observes them, but alive and true. Let painters avoid crudities, let it be their endeavour that the things they are always producing shall not seem painted, but show themselves alive and starting out of the canvas. This is the secret of sound design and the true method recognized by him who has painted as belonging to the pictures that are known and judged to be good.

CHAPTER II. (XVI.)

Of Sketches, Drawings, Cartoons, and Schemes of Perspective ; how
they are made, and to what use they are put by the Painters.

§ 77. *Sketches, Drawings, and Cartoons of different kinds.*

SKETCHES, of which mention has been made above, are
in artists' language a sort of first drawing made to find
out the manner of the pose, and the first composition of
the work. They are made in the form of a blotch,
and are put down by us only as a rough draft of
the whole. Out of the artist's impetuous mood they are
hastily thrown off, with pen or other drawing instru-
ment or with charcoal, only to test the spirit of that
which occurs to him, and for this reason we call them
sketches. From these come afterwards the drawings
executed in a more finished manner, in the doing of which
the artist tries with all possible diligence to copy from
the life, if he do not feel himself strong enough to be
able to produce them from his own knowledge. Later
on, having measured them with the compasses or by the
eye, he enlarges from the small to a larger size according
to the work in hand. Drawings are made in various
materials,[1] that is, either with red chalk, which is

[1] The innumerable sketches and finished drawings that have come down to
us from the hands of Florentine artists testify to the importance given in
the school to preliminary studies for painting, and any collection will furnish
examples of the different methods of execution here described. Drawings by
Venetian masters, who felt in colour rather than in form, are not so numerous
or so elaborate.

a stone coming from the mountains of Germany, soft enough to be easily sawn and reduced to a fine point suitable for marking on leaves of paper in any way you wish; or with black chalk that comes from the hills of France, which is of the same nature as the red. Other drawings in light and shade are executed on tinted paper which gives a middle shade; the pen marks the outlines, that is, the contour or profile, and afterwards half-tone or shadow is given with ink mixed with a little water which produces a delicate tint: further, with a fine brush dipped in white lead mixed with gum, the high lights are added. This method is very pictorial, and best shows the scheme of colouring. Many work with the pen alone, leaving the paper for the lights, which is difficult but in effect most masterly; and innumerable other methods are practised in drawing, of which it is not needful to make mention, because all represent the same thing, that is drawing.

The designs having been made in this way, the artist who wishes to work in fresco, that is, on the wall, must make cartoons; many indeed prepare them even for working on panel. The cartoons are made thus: sheets of paper, I mean square sheets, are fastened together with paste made of flour and water cooked on the fire. They are attached to the wall by this paste, which is spread two fingers' breadth all round on the side next the wall, and are damped all over by sprinkling cold water on them. In this moist state they are stretched so that the creases are smoothed out in the drying. Then when they are dry the artist proceeds, with a long rod, having a piece of charcoal at the end, to transfer to the cartoon (in enlarged proportions), to be judged of at a distance, all that in the small drawing is shown on the small scale. In this manner little by little he finishes, now one figure and now another. At this point the painters go through all the processes of their art in reproducing their nudes from the life, and the drapery from nature, and they draw the perspectives in the same schemes

that have been adopted on a small scale in the first drawing, enlarging them in proportion.

If in these there should be perspective views, or buildings, these are enlarged with the net, which is a lattice of small squares that are made large on the cartoon, reproducing everything correctly, for of course when the artist has drawn out the perspectives in the small designs, taking them from the plan and setting up the elevations with the right contours, and making the lines diminish and recede by means of the intersections and the vanishing point, he must reproduce them in proportion on the cartoon. But I do not wish to speak further of the mode of drawing these out, because it is a wearisome theme and difficult to explain. It is enough to say that perspectives are beautiful in so far as they appear correct when looked at, and diminish as they retire from the eye, and when they are composed of a varied and beautiful scheme of buildings. The painter must take care too, to make them diminish in proportion by means of delicate gradations of colour that presuppose in the artist correct discretion and good judgement.[2] The need of this is shown in the difficulty of the many confused lines gathered from the plan, the profile, and the intersection; but when covered with colour everything becomes clear, and in consequence the artist gains a reputation for skill and understanding and ingenuity in his art.

Many masters also before making the composition on the cartoon, adopt the plan of fashioning a model in clay on a plane and of setting up all the figures in the round to see the projections,[3] that is, the shadows caused by a light being thrown on to the figures, which projections correspond to the shadow cast by the sun, that more sharply than any artificial light defines the figures by shade on the ground; and so portraying the whole of the work, they have marked the shadows that strike across now one

[2] That is to say, by observation of aerial as well as linear perspective.

[3] This practice is noticed in the case of more than one artist of whom Vasari has written the biography. Tintoretto is one. See also postea, p. 216.

figure, now another, whence it comes that on account of
the pains taken the cartoons as well as the work reach the
most finished perfection and strength, and stand out from
the paper in relief. All this shows the whole to be most
beautiful and highly finished.

§ 78. *The Use of Cartoons in Mural and Panel Painting.*

When these cartoons are used for fresco or wall painting,
every day at the junction with yesterday's work a piece
of the cartoon is cut off and traced on the wall, which
must be plastered afresh and perfectly smoothed.[4] This
piece of cartoon is put on the spot where the figure is to
be, and is marked; so that next day, when another piece
comes to be added, its exact place may be recognized,
and no error can arise. Afterwards, for transferring the
outlines on to the said piece, the artist proceeds to impress
them with an iron stylus upon the coat of plaster, which,
being fresh, yields to the paper and thus remains marked.
He then removes the cartoon and by means of those marks
traced on the wall goes on to work with colours; this
then is how work in fresco or on the wall is carried out.
The same tracing is done on panels and on canvas, but
in this case the cartoon is all in one piece, the only
difference being that it is necessary to rub the back of
the cartoon with charcoal or black powder, so that when
marked afterwards with the instrument it may transmit
the outlines and tracings to the canvas or panel. The
cartoons are made in order to secure that the work shall
be carried out exactly and in due proportion. There are
many painters who for work in oil will omit all this; but
for fresco work it must be done and cannot be avoided.
Certainly the man who found out such an invention had
a good notion, since in the cartoons one sees the effect
of the work as a whole and these can be adjusted and
altered until they are right, which cannot be done on the
work itself.

[4] See the Note on 'Fresco Painting' at the close of the 'Introduction' to
Painting, postea, p. 287.

CHAPTER III. (XVII.)

Of the Foreshortening of Figures looked at from beneath, and of those on the Level.

§ 79. *Foreshortenings.*

OUR artists have had the greatest skill in foreshortening figures, that is, in making them appear larger than they really are; a foreshortening being to us a thing drawn in shortened view, which seeming to the eye to project forward has not the length or height that it appears to have; however, the mass, outlines, shadows, and lights make it seem to come forward and for this reason it is called foreshortened. Never was there painter or draughtsman that did better work of this sort than our Michelagnolo Buonarroti,[1] and even yet no one has been able to surpass him, he has made his figures stand out so marvellously. For this work he first made models in clay or wax, and from these, because they remain stationary, he took the outlines, the lights, and the shadows, rather than from the living model. These foreshortenings give the greatest trouble to him who does not understand them because his intelligence does not help him to reach the depth of such a difficulty, to overcome which is a more formidable task than any other in painting. Certainly our old painters, as lovers of the art, found the solution of the difficulty by using lines in perspective,

[1] Michelangelo's greatest *tour de force* in foreshortening, much lauded by Vasari in his Life of the master, is the figure of the prophet Jonah on the end wall of the Sistine chapel. It is painted at the springing of the vault, on a surface that is inclined sharply towards the spectator, but the figure is so drawn as to appear to be leaning back in the opposite direction.

a thing never done before, and made therein so much progress that to-day there is true mastery in the execution of foreshortenings. Those who censure the method of foreshortening, I speak of our artists, are those who do not know how to employ it; and for the sake of exalting themselves go on lowering others. We have however a considerable number of master painters who, although skilful, do not take pleasure in making foreshortened figures, and yet when they see how beautiful they are and how difficult, they not only do not censure but praise them highly. Of these foreshortenings the moderns have given us some examples which are to the point and difficult enough, as for instance in a vault the figures which look upwards, are foreshortened and retire. We call these foreshortenings ' al di sotto in su ' (in the ' up from below ' style), and they have such force that they pierce the vaults. These cannot be executed without study from the life, or from models at suitable heights, else the attitudes and movements of such things cannot be caught. And certainly the difficulty in this kind of work calls forth the highest grace as well as great beauty, and results in something stupendous in art. You will find, in the Lives of our Artists, that they have given very great salience to works of this kind, and laboured to complete them perfectly, whence they have obtained great praise. The foreshortenings from beneath upwards (di sotto in su) are so named because the object represented is elevated and looked at by the eye raised upwards, and is not on the level line of the horizon : wherefore because one must raise the head in the wish to see them, and perceives first the soles of the feet and the other lower parts we find the said name justly chosen.[2]

[2] Correggio is responsible for many of the forced effects of drawing in the decorative painting of vaults and ceilings in later times, but the Umbrian Melozzo da Forlì in his painting of the Ascension of Christ, now destroyed save for the fragments in the Quirinal and in the sacristy of St. Peter's at Rome, may have the doubtful honour of beginning the practice of foreshortening a whole composition, so that the scene is painted as it would appear were we looking up at it from underneath.

CHAPTER IV. (XVIII.)

How Colours in oil painting, in fresco, or in tempera should be blended : and how the Flesh, the Draperies and all that is depicted come to be harmonized in the work in such a manner that the figures do not appear cut up, and stand out well and forcibly and show the work to be clear and comprehensible.

§ 80. *On Colouring.*

UNITY in painting is produced when a variety of different colours are harmonized together, these colours in all the diversity of many designs show the parts of the figures distinct the one from the other, as the flesh from the hair, and one garment different in colour from another. When these colours are laid on flashing and vivid in a disagreeable discordance so that they are like stains and loaded with body, as was formerly the wont with some painters, the design becomes marred in such a manner that the figures are left painted by the patches of colour rather than by the brush, which distributes the light and shade over the figures and makes them appear natural and in relief. All pictures then whether in oil, in fresco, or in tempera ought to be so blended in their colours that the principal figures in the groups are brought out with the utmost clearness, the draperies of those in front being kept so light that the figures which stand behind are darker than the first, and so little by little as the figures retire inwards, they become also in equal measure gradually lower in tone in the colour both of the flesh tints and of the vestments. And especially let there be great care always in putting the most attractive, the most charming, and the most beautiful colours on the principal figures, and above all on those that are complete and not

cut off by others, because these are always the most con-
spicuous and are more looked at than others which serve
as the background to the colouring of the former. A
sallow colour makes another which is placed beside it
appear the more lively, and melancholy and pallid colours
make those near them very cheerful and almost of a certain
flaming beauty.[1] Nor ought one to clothe the nude with
heavy colours that would make too sharp a division
between the flesh and the draperies when the said draperies
pass across the nude figures, but let the colours of the
lights of the drapery be delicate and similar to the tints
of the flesh, either yellowish or reddish, violet or purple,
making the depths either green or blue or purple or
yellow, provided that they tend to a dark shade and make
a harmonious sequence in the rounding of the figures
with their shadows; just as we see in the life, that those
parts that appear nearest to our eyes, have most light
and the others, retiring from view, lose light and colour.

In the same manner the colours should be employed
with so much harmony that a dark and a light are not
left unpleasantly contrasted in light and shade, so as to
create a discordance and a disagreeable lack of unity,
save only in the case of the projections, which are those
shadows that the figures throw one on to the other, when
a ray of light strikes on a principal figure, and makes it
darken the second with its projected shadow. And these
again when they occur must be painted with sweetness
and harmony, because he who throws them into disorder
makes that picture look like a coloured carpet or a handful
of playing cards, rather than blended flesh or soft clothing
or other things that are light, delicate, and sweet. For as
the ear remains offended by a strain of music that is noisy,
jarring or hard—save however in certain places and times,

[1] This truth, about the mutual influence of colours in juxtaposition, was
well put by Sir Charles Eastlake when he wrote, in his *Materials for a
History of Oil Painting*, 'flesh is never more glowing than when opposed
to blue, never more pearly than when compared with red, never ruddier than
in the neighbourhood of green, never fairer than when contrasted with black,
nor richer or deeper than when opposed to white.'

as I said of the strong shadows—so the eye is offended by colours that are overcharged or crude. As the too fiery mars the design; so the dim, sallow, flat, and over-delicate makes a thing appear quenched, old, and smoke-dried; but the concord that is established between the fiery and the flat tone is perfect and delights the eye just as harmonious and subtle music delights the ear. Certain parts of the figures must be lost in the obscure tints and in the background of the group; for, if these parts were to appear too vivid and fiery, they would confound the distinction between the figures, but by remaining dark and hazy almost as background they give even greater force to the others which are in front. Nor can one believe how much grace and beauty is given to the work by varying the colours of the flesh, making the complexion of the young fresher than that of the old, giving to the middle-aged a tint between a brick-colour and a greenish yellow; and almost in the same way as in drawing one contrasts the mien of the old with that of youths and young girls and children, so the sight of one face soft and plump, and another fresh and blooming, makes in the painting a most harmonious dissonance.

In this way one ought, in working, to put the dark tints where they are least conspicuous and make least division, in order to bring out the figures, as is seen in the pictures of Raffaello da Urbino and of other excellent painters who have followed this manner. One ought not however to hold to this rule in the groups where the lights imitate those of the sun and moon or of fires or bright things at night, because these effects are produced by means of hard and sharp contrasts as happens in life. And in the upper part, wherever such a light may strike there will always be sweetness and harmony. One can recognize in those pictures which possess these qualities that the intelligence of the painter has by the harmony of his colours assured the excellence of the design, given charm to the picture, and prominence and stupendous force to the figures.

CHAPTER V. (XIX.)

Of Painting on the Wall, how it is done, and why it is called Working in Fresco.

§ 81. *The Fresco process.*

Of all the methods that painters employ, painting on the wall is the most masterly and beautiful, because it consists in doing in a single day that which, in the other methods, may be retouched day after day, over the work already done. Fresco was much used among the ancients,[1] and the older masters among the moderns have continued to employ it. It is worked on the plaster while it is fresh and must not be left till the day's portion is finished. The reason is that if there be any delay in painting, the plaster forms a certain slight crust whether from heat or cold or currents of air or frost whereby the whole work is stained and grows mouldy. To prevent this the wall that is to be painted must be kept continually moist; and the colours employed thereon must all be of earths and not metallic and the white of calcined travertine.[2] There is needed also a hand that is dexterous, resolute and rapid, but most of all a sound and perfect judgement; because while the wall is wet the colours show up in one fashion, and afterwards when dry they are no longer the same.

[1] Vitruvius describes the fresco process in his seventh Book. See Note on ' Fresco Painting' at the end of the ' Introduction' to Painting, postea, p. 287. This chapter is one of the most interesting in the three ' Introductions.'

[2] Travertine, next to marble, makes when burnt the whitest lime (see § 30, ante, p. 86). From this lime the fresco white, called bianco Sangiovanni, is made, and Cennini gives the recipe for its preparation in his 58th chapter. The ordinary lead white (biacca) cannot be used in fresco.

Therefore in these works done in fresco it is necessary
that the judgement of the painter should play a more
important part than his drawing, and that he should have
for his guide the very greatest experience, it being
supremely difficult to bring fresco work to perfection.
Many of our artists excel in the other kinds of work, that
is, in oil or in tempera, but in this do not succeed, fresco
being truly the most manly, most certain, most resolute
and durable of all the other methods, and as time goes
on it continually acquires infinitely more beauty and
harmony than do the others. Exposed to the air fresco
throws off all impurities, water does not penetrate it, and
it resists anything that would injure it. But beware of
having to retouch it with colours that contain size pre-
pared from parchment, or the yolk of egg, or gum or
tragacanth, as many painters do, for besides preventing
the wall from showing up the work in all clearness, the
colours become clouded by that retouching and in a short
time turn black. Therefore let those who desire to work
on the wall work boldly in fresco and not retouch in the
dry, because, besides being a very poor thing in itself, it
renders the life of the pictures short, as has been said
in another place.

CHAPTER VI. (XX.)

Of Painting in Tempera,[1] or with egg, on Panel or Canvas, and how it is employed on the wall which is dry.

§ 82. *Painting in Tempera.*

BEFORE the time of Cimabue and from that time onwards, works done by the Greeks in tempera on panel and occasionally on the wall have always been seen. And these old masters when they laid the gesso ground on

[1] The word 'tempera' is used by Vasari and other writers as a noun meaning (1) a substance mixed with another, as a medium with pigments (2) a liquid in which hot steel is plunged to give it a particular molecular quality (ante, p. 30) (3) the quality thus given to the steel (ante, p. 32), while (4) it has come to mean in modern times, as in the heading of this Note, a particular kind of painting. It is really to be regarded as the imperative of the verb 'temperare,' which alike in Latin and in Italian means 'to divide or proportion duly,' 'to qualify by mixing,' and generally 'to regulate' or 'to discipline.' 'Tempera' thus means strictly 'mix' or 'regulate.' It is used in the latter sense in metallurgy, as the liquid which Vasari calls (ante, p. 30) a 'tempera' (translated 'tempering-bath') regulates the amount of hardness or elasticity required in the metal, and the quality the steel thus receives is called (ante, p. 32) its 'temper.' In the case of painting the 'tempera' is the binding material mixed with the pigment to secure its adhesion to the ground when it is dry. The painting process is, in Italian, painting 'a tempera' 'with a mixture,' and our expression 'tempera painting' is a loose one. For the form of the word we may compare 'recipe,' also employed as a substantive but really an imperative meaning 'take.'

Strictly speaking any medium mixed with pigments makes the process one 'a tempera.' Many substances may be thus used, some soluble in water, as size, gum, honey, and the like ; others insoluble in water, such as drying oils, varnishes, resins, etc., while the inside of an egg which is in great part oleaginous may have a place between. It is not the usage however to apply the term 'tempera' to drying oils or varnishes, and a distinction is always made between 'tempera painting' and 'oil painting.' See Note on 'Tempera Painting,' postea, p. 291.

their panels, fearing lest they should open at the joints, were accustomed to cover them all over with linen cloth attached with glue of parchment shreds, and then above that they put on the gesso to make their working ground.[2] They then mixed the colours they were going to use with the yolk of an egg or tempera,[3] of the following kind. They whisked up an egg and shredded into it a tender branch of a fig tree, in order that the milk of this with the egg should make the tempera of the colours, which after being mixed with this medium were ready for use. They chose for these panels mineral colours of which some are made by the chemists and some found in the mines. And for this kind of work all pigments are good, except the white used for work on walls made with lime, for that is too strong. In this manner their works and their pictures are executed, and this they call colouring in tempera. But the blues are mixed with parchment size, because the yellow of the egg would turn them green whereas size does not affect them, nor does gum. The same method is followed on panels whether with or without a gesso ground; and thus on walls when they are dry the artist gives one or two coats of hot size, and afterwards with colours mixed with that size he carries out the whole work. The process of mixing colours with size is easy if what has been related of tempera be observed. Nor will the colours suffer for this since there are yet seen things in tempera by our old masters which have been

[2] This practice of covering wooden panels with linen and laying over this the gesso painting ground was in use in ancient Egypt. In fact the methods described by Cennini of preparing and grounding panels are almost exactly the same as those used in ancient Egypt for painting wooden mummy-cases. Even the practice, so much used in early Italian art, of modelling details and ornaments in relief in gesso and gilding them, is common on the mummy-cases. On the subject of gesso see Note 5 on p. 249.

[3] Vasari's expression 'rosso dell' uovo o tempera, la quale è questa' calls attention to the fact, to which his language generally bears testimony, that he looked upon the yolk of egg medium as the tempera *par excellence*. When he uses the term 'tempera' alone he has the egg medium in his mind, and the size medium is something apart. See this chapter throughout.

preserved in great beauty and freshness for hundreds of years.[4] And certainly one still sees things of Giotto's, some even on panel, that have already lasted two hundred years and are preserved in very good condition. Working in oil has come later, and this has made many put aside the method of tempera : in so much that to-day we see that the oil medium has been, and still is, continually used for panel pictures and other works of importance.

[4] Tempera painting has had a far longer history and more extensive use than any other kind. The technique predominated for all kinds of painting among the older Oriental peoples and in classical lands, and was in use both on walls and on panels in Western Europe north of the Alps during the whole mediaeval period, while south of the Alps and at Byzantium it was to a great extent superseded for mural painting by fresco, but remained in fashion for panels till the end of the fifteenth century. After the fifteenth century the oil medium, as Vasari remarks, superseded it entirely for portable pictures, and partly for work on walls and ceilings, but in our own time there has been a partial revival of the old technique. See Note on 'Tempera Painting,' postea, p. 291.

The whole question of the different vehicles and methods used in painting at various periods is a difficult and complicated one, and too often chemical analysis fails to give satisfactory results owing to the small amount of material available for experiment. Berger, in his *Beiträge zur Entwicklungs-Geschichte der Maltechnik*, an unfinished work that has already run to a thousand pages, goes elaborately into the subject, but has to admit that many points are still doubtful. It makes comparatively little difference what particular medium is used in tempera painting, but it is of great importance to decide whether a particular class of work is in tempera or in fresco. In connection with this Berger has reopened the old controversy as to the technique of Pompeian wall paintings, which have been accepted as frescoes, on the authority of Otto Dönner, for a generation past. There are difficulties about Pompeian work and it is well that the question has again been raised, but Berger goes much too far when he attempts to deny to the ancients the knowledge and use of the fresco process. The evidence on this point of Vitruvius is quite decisive, as he, and Pliny after him, refer to the process of painting on wet plaster in the most unmistakeable terms. See Note on 'Fresco Painting, postea, p. 287.

CHAPTER VII. (XXI.)

Of Painting in Oil on Panel or on Canvas.

§ 83. *Oil Painting, its Discovery and Early History.*

A MOST beautiful invention and a great convenience to the art of Painting, was the discovery of colouring in oil. The first inventor of it was John of Bruges in Flanders,[1] who sent the panel to Naples to King Alfonso,[2]

[1] This passage about the early painters of Flanders occurs just as it stands, with some trifling verbal differences, in Vasari's first edition of 1550. The best commentary on it is, first, the account of the same artists in Guicciardini's *Descrittione di Tutti i Paesi Bassi*, first published at Antwerp in 1567, and next, Vasari's own notes on divers Flemish artists which he added at the end of the *Lives* in the second edition of 1568 (*Opere*, ed. Milanesi, VII, 579 f.). He there made certain additions and corrections from Guicciardini, the most noteworthy of which is the mention of Hubert van Eyck, whom Vasari ignores in this passage of the Introduction, but who is just referred to by Guicciardini at the end of his sentences on the younger brother—'A pari a pari di Giovanni andava Huberto suo fratello, il quale viveva, e dipingeva continuamente sopra le medesime opere, insieme con esso fratello.' Vasari however in the notes of 1568 goes much farther than this, and, though he does not call Hubert the elder brother, he seems to ascribe to him personally the supposed 'invention'—'Huberto suo fratello, che nel 1510 (*sic*) mise in luce l' invenzione e modo di colorire a olio' (*Opere*, l.c.). 'John of Bruges' is of course Jan van Eyck. Vasari writes of him at the end of the *Lives* as 'John Eyck of Bruges.' Vasari's statement in this sentence is of great historical importance, for it is the first affirmation of a definite 'invention' of oil painting, and the first ascription of this invention to van Eyck. As van Eyck's own epitaph makes no mention of this, and as oil painting was practised long before his time, Vasari's statement has naturally been questioned, and on the subject the reader will find a Note at the close of the 'Introduction' to Painting, postea, p. 294.

[2] It was long supposed that this picture was the 'Epiphany' preserved behind the High Altar of the Church of S. Barbara, Naples, but Crowe and Cavalcaselle, *History of Painting in North Italy*, II, 103, pronounce this 'a feeble and injured picture of the eighteenth century.'

and to the Duke of Urbino, Federico II,[3] the paintings for his bathroom. He made also a San Gironimo,[4] that Lorenzo de' Medici possessed, and many other estimable things. Then Roger of Bruges [5] his disciple followed him; and Ausse (Hans) [6] disciple of Roger, who painted

[3] Frederick of Urbino (there were not two of the name as Vasari supposes) seems to have had a bathroom decorated with secular compositions by the Flemish master. Facio, whose tract *De Viris Illustribus*, written in the middle of the fifteenth century, was printed at Florence in 1745, writes, p. 46, of 'Joannes Gallicus' (who can be identified as Jan van Eyck) who had painted certain 'picturae nobiles' then in the possession of Cardinal Octavianus, with 'representations of fair women only slightly veiled at the bath.' Such pictures were considered suitable decorations for bath chambers. There is a curious early example of mediaeval date in the Schloss Runkelstein near Botzen in the Tyrol, in the form of wall paintings round a bathroom on one side of which nude figures are seen preparing to enter the water, while on two other walls spectators of both sexes are seen looking in through an open arcade. The pictures here referred to by van Eyck are now lost, but by a curious coincidence attention has just been directed to an existing copy of one of them, of which Facio gives a special notice. The copy occurs in a painting by Verhaecht of Antwerp, 1593-1637, that represents the picture gallery of an Antwerp connoisseur at about the date 1615. There on the wall is seen hanging the van Eyck, that corresponds closely to the full description given by Facio. The painting by Verhaecht was shown at Burlington House in the Winter Exhibition, 1906-7, and in the 'Toison d'Or' Exhibition at Bruges in 1907. See also the *Burlington Magazine*, February, 1907, p. 325. It may be added that the Cardinal Octavianus mentioned above was a somewhat obscure prelate, who received the purple from Gregory XII in 1408.

[4] The latest editors of Vasari (*Opere*, ed. Milanesi, I, 184) think this may be a picture in the Museum at Naples, ascribed there to an apocryphal artist 'Colantonio del Fiore.' Von Wurzbach says it is by a Neapolitan painter influenced by the Flemings.

[5] Roger van der Weyden, more properly called, as by Guicciardini and by Vasari in 1568, 'Roger of Brussels.' In 1449 he made a journey to Italy, and stayed for a time at Ferrara, which under the rule of the art-loving Este was very hospitable to foreign craftsmen. He was in Rome in 1450 and may have visited Florence and other centres. His own style in works subsequent to this journey shows little of Italian influence.

[6] Hans Memling. 'No Flemish painter of note,' remark Crowe and Cavalcaselle, *Early Flemish Painters*, p. 256, 'produced pictures more attractive to the Italians than Memling.' The Portinari, for whom Memling worked, were Florentine merchants who had a house at Bruges, the commercial connection of which with Tuscany was very close. In his Notes on Flemish Painters at

for the Portinari at Santa Maria Nuova in Florence a small picture which is to-day in Duke Cosimo's possession. From his hand also comes the picture at Careggi, a villa outside of Florence belonging to the most illustrious house of the Medici. There were likewise among the first painters in oil Lodovico da Luano [7] and Pietro Crista, [8] and

the end of the *Lives*, Vasari says that the subject of 'a small picture in the possession of the Duke' which is probably the one here mentioned, was 'The Passion of Christ.' If this be the case, it cannot be the beautiful little Memling now in the Uffizi, No. 703, for the subject of this is 'The Virgin and Child.' It might possibly however be the panel of 'The Seven Griefs,' a Passion picture in the Museum at Turin. On the other hand, Passavant thought the Turin panel was the 'Careggi' picture that Vasari goes on to mention. See Note on p. 268 of Crowe and Cavalcaselle's work.

[7] The German editors of Vasari identified Lodovico da Luano with the well-known painter Dierich Bouts of Louvain, but the name Ludovico (Chlodwig, 'Warrior of Renown') is not the same etymologically as Dierich (Theodoric, 'Prince of the People'). It is to be noted that in Guicciardini we find a mention of 'Dirich da Louano,' who is undoubtedly Dierich Bouts (the surname is derived from St Rombout the patron of Haarlem, where the painter, who is also called 'Dirick van Haarlem' [see below], was born) and also a mention of Vasari's 'Ludovico da Luvano.' A scrutiny however of the sentence in Guicciardini, where the last-mentioned name occurs, shows that it is copied almost verbatim from our text of Vasari. (Vasari [1550]:— 'Similmente Lodovico da Luano & Pietro Christa, & maestro Martino, & ancora Giusto da Guanto, che fece la tavola della comunione de'l Duca d' Vrbino, & altre pitture; & Vgo d' Anuersa, che fe la tauola di Sancta Maria Nuoua di Fiorenza'; Guicciardini:—'Seguirono a mano a mano Lodouico da Louano, Pietro Crista, Martino d' Holanda, & Giusto da Guanto, che fece quella nobil' pittura della comunione al Duca d' Vrbino, & dietro a lui venne Vgo d' Anuersa, che fece la bellissima tauola, che si vede a Firenze in santa Maria nuoua'). Vasari is accordingly responsible for this 'Ludovico da Luano,' whose name is duly chronicled in von Wurzbach's ' *Niederländisches Künstler-Lexicon*, Leipzig, 1906, II, p. 69, on the authority of Guicciardini alone, and who is called in M. Ruelens's annotations to the French edition of Crowe and Cavalcaselle 'Louys de Louvain (peintre encore inconnu).' Subsequently Guicciardini mentions also a 'Dirich d' Harlem,' who can be none other than the same Dierick Bouts, and Vasari, as a return favour, copies back all three Diericks into his Notes at the end of the edition of 1568. The first 'Ludovico' may be merely due to a mistake in the text of Vasari carelessly adopted by Guicciardini. Vasari's copyist may have written 'Ludovico' in place of the somewhat similar 'Teodorico.' There was however a certain Ludovicus Dalmau or Dalman (D'Alamagna?), a Flemish

master Martin [9] and Justus of Ghent [10] who painted the panel of the communion of the Duke of Urbino and other pictures; and Hugo of Antwerp who was the author of the picture at Santa Maria Nuova in Florence.[11] This art was afterwards brought into Italy by Antonello da Messina, who spent many years in Flanders, and when he returned to this side of the mountains, he took up his abode in Venice, and there taught the art to some friends. One of these was Domenico Veniziano, who brought it afterwards to Florence, where he painted in oil the chapel of the Portinari in Santa Maria Nuova. Here Andrea dal Castagno learned the art and taught it to other masters,[12] among whom it was amplified and

painter who worked at Barcelona in Spain about 1445 (von Wurzbach, *sub voce*) who may be meant, though there is no indication of a connection between him and Louvain.

[8] Pietro Crista is of course Petrus Christus or Christi of Bruges, an imitator, though as Mr Weale has shown not an actual pupil, of the van Eycks. Von Wurzbach says that Guicciardini was the first to mention his name, but Vasari in 1550 already knows him. As an explanation of the surname it has been suggested that the artist's father may have had a reputation as a painter or carver of Christ-figures, so that Petrus would be called 'son of the Christ-man.'

[9] The name Martin belongs to painters of two generations in Ghent, and von Wurzbach thinks it is the earlier of these, Jan Martins, apparently a scholar of the van Eycks, who is referred to here, and called by Guicciardini (see above), and by Vasari in 1568, 'Martino d' Holanda.' There was a later and better known Martin of Ghent called 'Nabor Martin.' The more famous 'Martins,' 'of Heemskerk,' and 'Schongauer,' when referred to by Vasari, have more distinct indications of their identity. See, e.g., *Opere*, v, 396.

[10] Justus of Ghent worked at Urbino, where he finished the altar piece referred to by Vasari in 1474. The 'other pictures' may be a series of panels painted for the library at Urbino, on which Crowe and Cavalcaselle have an interesting paragraph, *op. cit.* p. 180.

[11] Hugo of Antwerp is Hugo van der Goes, whose altar piece painted for S. Maria Nuova at Florence has now been placed in the Uffizi.

[12] Vasari's stories about the connection with oil painting of Antonello da Messina, Domenico Veneziano, and Andrea dal Castagno have of course been subjected to a good deal of hostile criticism. Those about the two latter artists are in the meantime relegated to the limbo of fable, but the case of

went on gaining in importance till the time of Pietro Perugino, of Leonardo da Vinci and of Raffaello da Urbino, so much so that it has now attained to that beauty which thanks to these masters our artists have achieved. This manner of painting kindles the pigments and nothing else is needed save diligence and devotion, because the oil in itself softens and sweetens the colours and renders them more delicate and more easily blended than do the other mediums. While the work is wet the colours readily mix and unite one with the other; in short, by this method the artists impart wonderful grace and vivacity and vigour to their figures, so much so that these' often seem to us in relief and ready to issue forth from the panel, especially when they are carried out in good drawing with invention and a beautiful style.

§ 84. *How to Prime the Panel or Canvas.*

I must now explain how to set about the work. When the artist wishes to begin, that is, after he has laid the gesso on the panels or framed canvases and smoothed it, he spreads over this with a sponge four or five coats of the smoothest size, and proceeds to grind the colours with walnut or linseed oil, though walnut oil is better because it yellows less with time. When they are ground with these oils, which is their tempera (medium), nothing else is needed so far as the colours are concerned, but to lay them on with a brush. But first there must be made a composition of pigments which possess seccative qualities as white lead, dryers, and earth such as is used for bells,[13]

Antonello da Messina is somewhat different, and we are not dependent in his case on Vasari alone. He certainly did not visit Flanders in the lifetime of Jan van Eyck, for this artist died before Antonello was born, but von Wurzbach accepts as authentic a visit on his part to Flanders between 1465 and 1475, and sees evidence of what he learned there in his extant works (*Niederländisches Künstler-Lexicon*, sub voce, ' Antonello').

[13] ' Terre da campane,' ' bell earths.' There seem to be two possible meanings for the phrase. It may refer to the material used for the moulds in bell casting, or to the clay from which are made the little terra-cotta

all thoroughly well mixed together and of one tint, and when the size is dry this must be plastered over the panel and then beaten with the palm of the hand, so that it becomes evenly united and spread all over, and this many call the ' imprimatura ' (priming).

§ 85. *Drawing, by transfer or directly.*

After spreading the said composition or pigment all over the panel, the cartoon that you have made with figures and inventions all your own may be put on it, and under this cartoon another sheet of paper covered with black on one side, that is, on that part that lies on the priming. Having fixed both the one and the other with little nails, take an iron point or else one of ivory or hard wood and go over the outlines of the cartoons, marking them firmly. In so doing the cartoon is not spoiled and all the figures and other details on the cartoon become very well outlined on the panel or framed canvas.

He who does not wish to make cartoons should draw with tailors' white chalk over the priming or else with charcoal made from the willow tree, because both are easily erased. Thus it is seen that the artist, after the priming is dry, either tracing the cartoon or drawing with white chalk, makes the first sketch [14] which some call ' imporre ' (getting it in). And having finished covering the whole the artist returns to it again to complete it with the greatest care : and here he employs all his art and diligence to bring it to perfection. In this manner do the masters in oil proceed with their pictures.

bells by which children in Italy set great store on the occasion of the mid-summer festival. This last is improbable.

Baldinucci, *Vocabolario del Disegno*, sub voce ' Nero di Terra di Campana,' says that this is a colour made out of a certain scale that forms on moulds for casting bells or cannon, and that it is good with oil, but does not stand in fresco. Lomazzo also mentions the pigment.

[14] ' L' abbozza ' evidently refers to the first or under-painting, not to the sketch in chalk, for in the first edition the passage has some additional words which make this clear. They run as follows: ' desegnando quella : e così ne primi colori l' abozza, il che alcuni chiamono imporre.'

CHAPTER VIII. (XXII.)

Of Painting in Oil on a Wall which is dry.

§ 86. *Mural Painting in Oil.*

WHEN artists wish to work in oil on the dry wall two methods may be followed: first, if the wall have been whitened, either 'a fresco' or otherwise, it must be scraped; or if it be left smooth without whitening but only plastered there must be given to it two or three coats of boiled oil, the process being repeated till the wall cannot drink in more, and when dry it is covered over with the composition or priming spoken of in the last chapter. When this is finished and dry, the artist can trace or draw on it and can finish such work in the same manner as he treats the panel, always having a little varnish mixed with the colours, because if he does this he need not varnish it afterwards. The other method is for the artist to make, either with stucco of marble dust or finely pounded brick, a rough cast that must be smoothed, and to score it with the edge of a trowel, in order that the wall may be left seamed. Afterwards he puts on a coat of linseed oil, and then mixes in a bowl some Greek pitch and resin (mastice) and thick varnish, and when this is boiled it is thrown on to the wall with a big brush, and then spread all over with a builder's trowel that has been heated in the fire. This mixture fills up the scores in the rough cast and makes a very smooth skin over the wall, when dry it is covered with priming, or a composition worked in the manner usually adopted for oil, as we have already explained.[1]

[1] With the above may be compared ch. 9 of Book VII of L. B. Alberti's *De Re Aedificatoria*.

§ 87. *Vasari's own Method.*

Since the experience of many years has taught me how to work in oil on a wall, I have recently, in painting the halls, chambers, and other rooms of Duke Cosimo's palace,[2] followed the method frequently used by me in the

[2] The matter in our § 87 was added in the edition of 1568. Though Vasari declared so unhesitatingly for fresco as the finest of all processes of painting, he tells us that he used oil for a portion of his mural work in the Palazzo Vecchio at Florence, when he prepared it for the residence of Duke Cosimo, and we shall notice later his praise of tempera (postea, p. 291). Vasari describes how he painted in oil on the walls of a refectory at Naples (*Opere*, VII, 674), and gives us an interesting notice of his experiments in the technique about the year 1540 at the monastery of the Camaldoli, near Arezzo, where he says 'feci esperimento di unire il colorito a olio con quello (fresco) e riuscimmi assai acconciamente' (*Opere*, VII, 667). The technique required proper working out, for it was not a traditional one.

The most notable instance of its employment before the end of the fifteenth century is in the case of the 'Last Supper' by Leonardo da Vinci at Milan. A commission of experts has recently been examining the remains of this, the most famous mural painting in the world, and has ascertained that the original process employed by Leonardo was not pure oil painting but a mixed process in which oil played only a part. The result at any rate, as all the world is aware, was the speedy ruin of the work, which now only tells as a design, there being but little of its creator's actual handiwork now visible.

Some words of the Report are of sufficient interest to be quoted. 'Pur troppo, dunque, la stessa tecnica del maestro aveva in sè il germe della rovina, ben presto, infatti, avvertita nelle sue opere murali. Spirito indagitore, innovatore, voglioso sempre di "provare e riprovare" egli volle abbandonare i vecchi, sicuri e sperimentati sistemi, per tentare l' esito di sostanze oleose in miscela coi colori. Perchè nemmeno può dirsi ch' ei dipingesse, in questo caso, semplicemente, ad olio come avrebbe fatto ogni altro mortale entrato nell' errore di seguire quel metodo anche pei muri. Egli tentò invece cosa affato nuova; poichè, se da un lato appaiono tracce di parziali e circoscritte arricciature in uso pel fresco, dall' altro, la presenza delle sostanze oleose è accertata dalla mancanza di adhesione dei colori con la superficie del muro e dalle speciali screpolature della crosta o pelle formata dai colori stessi, non che dal modo con quale il dipinto si è andato e si va lentamente disgregando e sfaldando.' *Bollettino d' Arte del Ministero della Pubblica Istruzione*, Roma, 1907, I, p. 17.

Another famous instance of the use of oil paint in mural work about a generation later is to be found in the Sala di Costantino in the Vatican, where Raphael's pupils have left two of the decorative figures by the side of the Popes executed in that medium. One (Urbanity) is close to the door leading

past for this sort of work; which method is briefly this.
Make the rough cast, over which put the plaster made
of lime, pounded brick, and sand, and leave it to dry
thoroughly; that done, make a second coating of lime,
very finely pounded brick, and the scum from iron works;
these three ingredients in equal proportions, bound with
white of egg sufficiently beaten and linseed oil, make a
very stiff stucco, such as cannot be excelled. But take
great care not to neglect the plaster while it is fresh, lest
it should crack in many places; indeed it is necessary,
if one wish to keep it good, to be ever about it with the
trowel or spatula or spoon, whichever we choose to call
it, until it be all evenly spread over the surface in the

to the Chapel of Nicholas V, the other is on the wall containing the battle,
and is in better preservation than the first which is covered with wrinkles.
The oil paint gives a certain depth and richness of effect, but there is the
fatal disadvantage that the painting does not look a part of the wall as is the
case with work done in fresco. The fresco is really executed in the material
of the ground, whereas oils and varnishes have nothing in common with lime
and earths, and the connection of structure and decoration is broken. One
of the most successful pieces of work of the kind is the painting of 'Christ at
the Pillar' by Sebastian del Piombo in S. Pietro in Montorio at Rome. The
work, which is executed on a cylindrical surface, is rather shiny, an appearance
which in mural painting is to be avoided, and it has darkened somewhat,
though this defect is not very apparent and the experiment has on the
whole succeeded well. Vasari's Life of Fra Sebastiano contains a good deal
of information about this particular technique, which was essayed in the later
age of Italian painting more often than is sometimes imagined. It needs
hardly to be said that this oil painting on the actual plaster of the wall is a
different thing from the modern process of painting on canvas in the studio
and then cementing the completed picture on to the wall. Mural painting
on canvas was introduced by the Venetians in the fifteenth century, for at
Venice atmospheric conditions seem to have been unfavourable to the pre-
servation of frescoes, and the Venetians preferred canvas to plaster for their
work in oils. It would be interesting to know whether the canvas was ever
fixed *in situ* before the painter commenced operations, as from the point of
view of the preservation of decorative effect this would be of importance.
Vasari's story about Tintoretto's proceedings at the Scuola di S. Rocco
(*Opere*, VI, 594) is evidence that canvases were painted at home and put up
on walls or ceilings when finished. Of course if a wall be covered with
canvas before the painting begins the canvas is to all intents and purposes the
wall itself, grounded in a certain way.

way it has to remain. Then when this plaster is dry and some priming or composition laid over it, the figures and scenes can be perfectly carried out, as the works in the said palace and many others will clearly demonstrate to everyone.

CHAPTER IX. (XXIII.)

Of Painting in Oil on Canvas.

§ 88. *Painting on Canvas.*[1]

In order to be able to convey pictures from one place to another men have invented the convenient method of painting on canvas, which is of little weight, and when rolled up is easy to transport. Unless these canvases intended for oil painting are to remain stationary, they are not covered with gesso, which would interfere with their flexibility, seeing that the gesso would crack if they were rolled up. A paste however is made of flour and walnut oil with two or three measures[2] of white lead put

[1] The use of canvas for the purpose in view was, as Vasari mentions below, very common at Venice, where as early as about 1476, if we believe Vasari (*Opere*, III, 156), Gentile Bellini executed in this technique the large scenic pictures with which he adorned the Hall of Grand Council in the Ducal Palace. Such a process would come naturally enough to Italian painters as well as to the Flemings, for they had been accustomed from time immemorial to paint for temporary purposes on banners and draperies, after a fashion of which Mantegna's decorative frieze on fine canvas at Hampton Court is a classic example. Canvas had however been actually used for pictures even in ancient Egypt. Not only was the practice of stretching linen over wooden panels to receive the painting ground in use there in the time of the New Empire, but some of the recently discovered mummy-case portraits from Egypt, of the earliest Christian centuries, are actually on canvas. There is an example in the National Gallery. At Rome painting on canvas is mentioned by Pliny (*Hist. Nat.*, XXXV, 51) and Boethius (*de Arithmetica*, Praef., 1) says that 'picturae . . . lintea operosis elaborata textrinis . . . materiam praestant.' The Netherland painters of the fifteenth century nearly always painted on panel, but canvas was sometimes used, as by Roger van der Weyden in his paintings for the Town Hall at Brussels.

[2] Vasari prescribes 'due o tre *macinate*' of white lead for mixture with the flour and nut oil for the priming of canvas. A 'macinata' was the amount

into it, and after the canvas has been covered from one side to the other with three or four coats of smooth size, this paste is spread on by means of a knife, and all the holes come to be filled up by the hand of the artist. That done, he gives it one or two more coats of soft size and then the composition or priming. In order to paint on it afterwards he follows the same method as has been described above for the other processes. Because painting on canvas has seemed easy and convenient it has been adopted not only for small pictures that can be carried about, but also for altar pieces and other important compositions, such as are seen in the halls of the palace of San Marco at Venice,[3] and elsewhere. Consequently, where the panels are not sufficiently large they are replaced by canvases on account of the size and convenience of the latter.[4]

placed at one time on the 'macina' or stone for grinding colours. Berger suggests 'handfuls' as a translation, but the amount would be small, as for careful grinding only one or two lumps of the pigment would be dealt with at one time.

[3] The Ducal Palace, that adjoins S. Marco, is probably the building in Vasari's mind. The Library of S. Marco, Sansovino's masterpiece, might also be meant, as this was called sometimes the Palace of S. Marco. We must remember however that, as noticed before, ante, p. 56, this building, at the time of Vasari's visit to Venice, was still unfinished.

[4] On panels and canvases as used at Venice Vasari has an interesting note at the beginning of his Life of Jacopo Bellini (*Opere*, III, 152). This was a subject that would at once appeal to his practical mind when he visited the city. He notices incidentally that the usual woods for panels were 'oppio' *acer campestris*, maple; or 'gattice,' the *populus alba* of Horace, but that the Venetians used only fir from the Alps. (Cennini, c. 113, recommends poplar or lime or willow. Pliny, *Hist. Nat.*, XVI, 187, speaks of larch and box, and Ilg says that northern painters generally used oak.) The Venetian preference for canvas, Vasari says, was due to the facts that it did not split nor harbour worms, was portable, and could be obtained of the size desired; this last he notes too in our text. Berger (*Beiträge*, IV, 29), gives the meaning of 'Grossartigkeit' to the word 'grandezza' used above by Vasari, but of course it only means material size, not 'grandeur' in an aesthetic sense.

CHAPTER X. (XXIV.)

Of painting in Oil on Stone, and what stones are good for the purpose.

§ 89. *Oil painting on Stone.*

THE courage of our pictorial artists has gone on increasing, so that colouring in oil, besides the use made of it on the wall, can when they desire be employed also for painting on stones. Of these last they have found a suitable kind on the sea-coast of Genoa, in those flagstones we have spoken of in connection with Architecture,[1] which are very well fitted for this purpose, for the reason that they are compact and of fine grain, and take an even polish. In modern times an almost unlimited number of artists have painted on these slabs and have found the true method of working upon them. Later they have tried the finer stones, such as marble breccias, serpentines, porphyries and the like, which being smooth and polished admit of the colour attaching itself to them. But in truth when the stone is rough and dry it imbibes and takes the boiled oil and the colour much better; as is the case with some kinds of soft peperino, which, when they are worked over the surface with an iron tool and are not rubbed down with sand or a piece of hearth stone, can be brought to a smooth surface with the same mixture that I spoke of in connection with the rough cast and that heated trowel. Therefore it is not necessary to begin by spreading size on all these stones, but only a coat of priming of oil

[1] See 'Introduction' to Architecture, § 13, ante, p. 54. The stone is a species of slate. Slate is suitable for painting on. See Church's *Chemistry of Paints and Painting*, 1890, p. 21.

colour, that is, the composition already referred to, and when this is dry the work may be begun at will.

He who desires to paint a picture in oil on stone can take some of those Genoese flagstones and have them cut square and fixed in the wall with clamps over a layer of stucco, spreading the composition well over the joinings so as to make a flat surface of the size the artist needs. This is the true way of bringing such works to a finished state, and when completed, ornaments can be added of fine stones, breccias, and other marbles. These, provided they are worked with diligence and care, endure for ever. They may or may not be varnished, just as you like, because the stone does not suck up, that is, absorb as much as does the panel or canvas, and it is impervious to worms, which cannot be said for wooden panels.[2]

[2] Greek paintings on marble panels have come down to us from various periods of ancient art. Some early Attic specimens on tombstones are in the museums of Athens, and at Herculaneum there was found an interesting painting on marble of a group of Greek heroines playing at knuckle bones. A much earlier slab with a figure of a warrior is in the Acropolis Museum at Athens.

CHAPTER XI. (XXV.)

Of Painting on the wall in Monochrome with various earths: how objects in bronze are imitated: and of groups for Triumphal Arches or festal structures, done with powdered earths mixed with size, which process is called Gouache and Tempera.

§ 90. *Imitative Paintings for Decorations.*

MONOCHROMES according to the painters are a kind of picture that has a closer relation to drawing than to work in colour because it has been derived from copying marble statues and figures in bronze and various sorts of stone; and artists have been accustomed to decorate in monochrome the façades of palaces and houses, giving these a semblance other than the reality, and making them appear to be built of marble or stone, with the decorative groups actually carved in relief; or indeed they may imitate particular sorts of marble, and porphyry, serpentine, and red and grey granite or other stones, or bronze, according to their taste, arranging them in many divisions; and this style is much in use now-a-days for the fronts of houses and palaces in Rome and throughout Italy.

These paintings are executed in two ways, first, in fresco which is the true way; secondly, on canvas to adorn arches erected on the occasion of the entrance of princes into the city, and of processions, or in the apparatus for fêtes and plays, since on such structures they produce a very beautiful effect. We shall first treat of the manner of working these in fresco, and then speak of the other method. In the first kind the backgrounds are laid in with potters' clay, and with this is mixed powdered charcoal or other black for the darker shadows, and white of travertine.

There are many gradations from light to dark; the high lights are put in with pure white, and the strongest shadows are finished with the deepest black. Such works must have boldness, intention, power, vivacity, and grace, and must be expressed with an artistic freedom and spirit and with nothing cramped about them, because they have to be seen and recognized from a distance.[1] In this style too must bronze figures be imitated; they are sketched in on a background of yellow and red earth, the darker shades put in with blended tints of black, red, and yellow, the middle tints with pure yellow, and the high lights with yellow and white.[2] And with these painters have composed decorations on the façades, intermingling statues, which in this kind of work give a most graceful effect.

Those pictures however intended for arches, plays, or festivals, are worked after the canvas has been prepared with clay, that is, with that pure earth (terretta) before mentioned which potters use, mixed with size,[3] and the

[1] These chiaroscuri or monochromes are characteristic of the later Renaissance. They may either be frankly decorative, and in this form obey the rules of all other pictorial enrichment; or they may have an illusive intention, and be designed to produce the appearance on a flat wall of architectural members or sculptured or cast-bronze reliefs. In this case, when on monumental buildings and permanent, they are insincere and opposed to sound decorative principles, though on temporary structures they are quite in place. Vasari was a famous adept at the construction and adornment of such fabrics, which were in great demand for the numerous Florentine pageants and processions. See his letters, passim.

[2] There are examples of painted imitations of bronze in Michelangelo's frescoes on the vault of the Sistine. The medallions held by the pairs of decorative figures of youths on the cornice are painted to represent reliefs in this metal. Raphael's Stanze and Loggie also furnish instances, and there are good examples on the external façade of the Palazzo Ricci at Rome.

[3] The clay or earth that Vasari speaks of forms the body of the 'distemper' or 'gouache,' as it would be called respectively in Britain and in France, and takes the place of the 'whitening' used in modern times. Baldinucci in his *Vocabolario* explains 'Terra di cava o Terretta' as 'the earth (clay) with which vessels for the table are made, that mixed with pounded charcoal is used by painters for backgrounds and monochromes, and also for primings, and with

back of the canvas must be moistened while the artist is painting on it, that the darks and lights of his work may unite better with the ground of clay.[4] It is customary to mix the blacks with a little tempera;[5] white leads are used for the white, and red lead to simulate relief in things that appear to be of bronze, and Naples yellow (giallino) to put in the high lights over the red lead, and for the backgrounds and the darks the same red and yellow earths and the same blacks that I spoke of in connection with fresco work; these make the half tints and shadows. The painter uses also other different pigments to shade other kinds of monochromes, such as umber to which is added terra verte and yellow ochre and white; in the same way is used black earth, which is another sort of terra verte and the dark colour that is called ' verdaccio.[6]

a tempera of size for the canvases with which are painted triumphal arches, perspectives, and the like.' It is of very fine and even texture, and Baldinucci says it was found near St Peter's at Rome, and also in great quantity at Monte Spertoli, thirteen miles from Florence.

[4] This process of wetting the back of the canvas is to be noted. The chief inconvenience of the kind of work here spoken of is that it dries very quickly, and dries moreover very much lighter than when the work is wet. Hence it is an advantage to keep the ground wet as long as possible till the tints are properly fused, so that all may dry together. Wetting the back of the canvas secures this end. The technique that Vasari is describing is the same as that of the modern theatrical scene-painter, and would be called ' distemper painting.' The colours are mixed with whitening, or finely-ground chalk, and tempered with size. The whitening makes them opaque and gives them ' body,' but is also the cause of their drying light. F. Lloyds, in his *Practical Guide to Scene Painting and Painting in Distemper*, Lond. 1879, says (p. 42) ' In the study of the art of distemper painting, a source of considerable embarrassment to the inexperienced eye is that the colours when wet present such a different appearance from what they do when dry.'

[5] Does Vasari mean by ' tempera' yolk of egg? It has this sense with him sometimes, as in the heading of chapter VI.

[6] Cennini in his 67th chapter gives directions for preparing the mixed colour he calls verdaccio. It was a compound of white, dark ochre, black and red.

CHAPTER XII. (XXVI.)

Of the Sgraffiti for house decoration which withstand water ; that which is used in their production ; and how Grotesques are worked on the wall.

§ 91. *Sgraffito-work.*

PAINTERS have another sort of picture which is drawing and painting both together. This is called sgraffito; it serves only for ornament on the façades of houses and palaces, and is very quickly executed, while it perfectly resists the action of water, because all the outlines, instead of being drawn with charcoal or other similar material, are etched by the hand of the painter with an iron tool. The work is done in this manner. They take lime mixed with sand in the usual fashion and tinge it by means of burnt straw to a tint of a medium colour inclining to pearl grey, a little more towards the dark than the middle tint, and with this they plaster the façade. That done and the façade smoothed, they give it a coat of white all over with the white lime of travertine, and then dust over the (perforated) cartoons, or else draw directly that which they wish to execute. Afterwards pressing upon it with an iron stylus they trace the contours and draw lines on the cement, which, because there is a black substance underneath, shows all the scratches of the tool as marks of drawing.[1]

[1] The principle of sgraffito work, that is the scratching through a thin superimposed coat to bring to view an under layer of a different colour, seems to have been established first in pottery making, and in this connection the Italians called it 'Sgraffiato.' The adoption of the process for the decoration of surfaces of plaster or cement was an innovation of the Renaissance, and

It is customary too to scrape away the white in the backgrounds, and then to prepare a water colour tint, darkish and very watery, and with that reinforce the darks, as one would do on paper; this seen at a distance is most effective. But if there be grotesques or leafage in the design, cast shadows are painted on the background by means of that water colour. This is the work that the painters have called sgraffito, on account of its being scratched by the iron instrument.

§ 92. *Grotesques, or Fanciful Devices, painted or modelled on Walls.*[2]

There remains to us now to speak of the grotesques done on the wall. For those, then, that go on a white ground, when the background is not of stucco (white plaster), because the ordinary lime plastering is not white, therefore a thin coat of white is laid over; and that done the cartoons are powdered and the work executed in fresco

Vasari appears to have been the first writer who gives a recipe for it. According to his account in the *Lives*, it was a friend of Morto da Feltro, the Florentine Andrea di Cosimo, who first started the work, and Vasari describes the process he employed in phrases that correspond with the wording of the present chapter (*Opere*, ed. Milanesi, v, 207). A modern expert describes the process as follows: 'A wall is covered with a layer of tinted plaster, and on this is superimposed a thin coating of white plaster. The outer coat is scratched through, and the colour behind it is revealed. Then all the white surface outside the design is cut away, and a cameo-like effect given to the design. This is the art of Sgraffito as known to the Italian Renaissance' (*Transactions, R.I.B.A.*, 1889, p. 125). The process dropped out of use after a while, but was revived in Germany in the middle of the nineteenth century, mainly through the agency of the architect Gottfried Semper, the author of *Der Stil*. It is sometimes used in our own country both on monumental and on domestic buildings, and as it is simple and cheap and permanent it is well fitted for modern use in our climate. The back of the Science School in Exhibition Road, S. Kensington, was covered with sgraffiti by the pupils of the late F. W. Moody about 1872. They would be the better now for a cleansing with the modern steam-blast.

[2] See the Notes on 'Enriched Façades,' and 'Stucco "Grotesques,"' at the close of the 'Introduction' to Painting, postea, pp. 298, 299.

PLATE XI

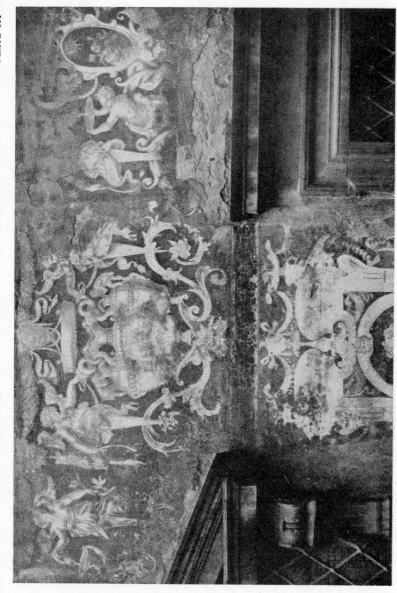

SPECIMEN OF SO-CALLED 'SGRAFFITO' DECORATION

On the exterior of the Palazzo Montalvo, Florence

with opaque colours,[3] but these will never have the charm
of those worked directly upon the stucco. In this style
there may be grotesques both coarse and fine, and these
are done in the same way as the figures in fresco or on
the dry wall.

[3] This passage presents some difficulty. It runs 'Dunque, quelle che vanno
in campo bianco, non ci essendo il campo di stucco per non essere bianca la
calce, si dà per tutto sottilmente il campo di bianco.' Vasari seems to have
in his mind the difference between ordinary plaster made, as he has just
described, of 'lime mixed with sand in the ordinary fashion,' which would
not be white, and what he calls 'stucco,' by which term is probably meant
the finer plaster made of white lime from travertine and marble dust.
Ordinary plaster has accordingly to be coated with white before the work
begins.

How Grotesques are worked on the Stucco.

THE grotesque is a kind of free and humorous picture produced by the ancients for the decoration of vacant spaces in some position where only things placed high up are suitable. For this purpose they fashioned monsters deformed by a freak of nature or by the whim and fancy of the workers, who in these grotesque pictures make things outside of any rule, attaching to the finest thread a weight that it cannot support, to a horse legs of leaves, to a man the legs of a crane, and similar follies and nonsense without end.[1] He whose imagination ran the most oddly, was held to be the most able. Afterwards the grotesques were reduced to rule and for friezes and compartments had a most admirable effect. Similar works in stucco were mingled with the painting. So generally was this usage adopted that in Rome and in every place where the Romans settled there is some vestige of it still preserved. And truly, when touched with gold and modelled in stucco such works are gay and delightful to behold.

They are executed in four different ways.[2] One is to work in stucco alone : another to make only the ornaments

[1] Examples of this whimsical style of decoration are abundant in the Pompeian wall paintings, and the mind of Vitruvius was much exercised about their frivolity and want of meaning (*De Architectura*, VII, v).

[2] Vasari is not very clear in his account of these methods of work, but it is enough to know that both by the ancients, and at the time of the Renaissance, colour was used largely in connection with these reliefs, and the combination could of course take several forms. In the loggia of the Villa

of stucco and paint groups in the spaces thus formed
and grotesques on the friezes : the third to make the figures
partly in stucco, and partly painted in black and white so
as to imitate cameos and other stones. Many examples
of this kind of grotesque and stucco work have been, and
still are seen, done by the moderns, who with consummate
grace and beauty have ornamented the most notable build-
ings of all Italy, so that the ancients are left far behind.
Finally the last method is to work upon stucco with water
colour, leaving the stucco itself for the lights, and shading
the rest with various colours. Of all these kinds of work,
all of which offer a good resistance to time, antique
examples are seen in numberless places in Rome, and at
Pozzuoli near to Naples. This last sort can also be
excellently worked in fresco with opaque colours, leaving
the stucco white for the background.[3] And truly all these
works possess wonderful beauty and grace. Among them
are introduced landscape views, which much enliven them,
as do also little coloured compositions of figures on a
small scale. There are to-day many masters in Italy who
make this sort of work their profession, and really excel
in it.

Farnesina, where Raphael worked with his assistants, there are painted panels
in fresco framed in mouldings of stucco, modelled plaster figures in white against
a coloured ground, coloured stuccos against coloured fields, and tinted bands
separating the framed plaster medallions. The same kind of work is found in
the Loggie of the Vatican, the Doria Palace at Genoa, and other localities
innumerable. Plate XII shows a characteristic section of the decoration of the
Vatican Loggie.

[3] As in the work described at the close of ch. XII (the beginning of the
present section).

CHAPTER XIV. (XXVIII.)

Of the manner of applying Gold on a Bolus,[1] or with a Mordant,[2] and other methods.

§ 93. *Methods of Gilding.*

It was truly a most beautiful secret and an ingenious investigation—that discovery of the method of beating gold into such thin leaves, that for every thousand pieces beaten to the size of the eighth of a braccio in every direction, the cost, counting the labour and the gold, was not more than the value of six scudi.[3] Nor was it in any way less ingenious to discover the method of spreading the gold over the gesso in such a manner that the wood and other material hidden beneath it should appear a mass of gold.

[1] The word 'bolus' is derived from the Greek βῶλος, a lump or clod, and means, according to Murray's *Dictionary*, a pill, or a small rounded mass of any substance, and also a kind of reddish clay or earth, used medically for its astringent properties, that was brought from Armenia, and called by the pharmacologist 'bole armeniac.' Its use in the arts is due to its unctuous character, which made gold adhere to it. See below. In mediaeval illuminations a 'bolus' or small lump of a properly prepared gesso is generally laid on the parchment where gold is to come, so that the raised surface may give the polished metal more effect. The gold over the bolus was always burnished. It may be noticed that our word 'size' is really 'assise,' the bed or layer under gilding, for which a gluey substance was suitable.

[2] A 'mordant' as the word implies is some corrosive liquid, such as is used by dyers to bite into the fabric and carry in with it the colouring matter. The word is also employed, as in this passage, for a glutinous size used as ground for gilding, such as the modern decorator's 'gold-size.' Gold laid in this way has a 'mat' surface.

[3] The scudo was worth in Tuscany about four-and-sixpence of our money. In Florence its value was a little greater.

This is how it is done. The wood is covered with the thinnest gesso kneaded with size weak rather than strong, and coarser gesso is laid on in several coats according as the wood has been well or badly prepared. When the gesso is scraped and smoothed, white of egg beaten carefully in water is mixed with Armenian bole, which has been reduced with water to the finest paste. The first coat of this is made watery, I mean to say liquid and clear, and the next thicker. This is laid on to the panel at least three times, until it takes it well all over, then with a brush the worker gradually wets with pure water the parts where the Armenian bole has been applied and there he puts on the gold leaf, which quickly sticks to that soft substance;[4] and when partially but not entirely dry he burnishes it with a dog's tooth or the tooth of a wolf in order to make it become lustrous and beautiful.[5]

Gilding is effected in another fashion also, 'with a mordant,' as it is said.[6] This is used for every sort of material—stone, wood, canvas, metals of all kinds, cloth, and leather; and is not burnished as is the former. The mordant, which is the lye that holds the gold, is made of various sorts of drying oil pigments and of oil boiled with the varnish in it. It is laid upon the wood which

[4] See Note 1, ante, p. 248.

[5] For the various processes of preparing a panel for painting and for gilding reference must be made to Cennini's *Trattato*, where many technical matters are elucidated that Vasari passes over almost without notice. It must be remembered that Cennini writes as a tempera painter, while in Vasari's time these elaborate processes were falling out of use. In his chapters 115-119, Cennini gives recipes for what he calls 'gesso grosso' and 'gesso sottile.' They are made of the same materials, 'volterrano,' or plaster from Volterra, which is a sulphate of lime corresponding to our 'plaster of Paris,' and size made from parchment shreds; but the plaster for 'gesso sottile' is more finely prepared. The plaster, produced by calcining gypsum, is first thoroughly slaked by being drenched with water till it loses all tendency to 'set,' and is then as a powder or paste mixed with the heated size. The size makes the composition dry quite hard, and Cennini speaks of its having a surface like ivory.

[6] See Note 2, ante, p. 248.

has first received two coats of size. And after the mordant is so applied, not when it is fresh, but half dry, the gold leaf is laid upon it. The same can be done also with gum-ammoniac, when there is hurry, provided that the stuff is good. This is used more to adorn saddles and make arabesques and other ornaments than for anything else. Sometimes also gold leaves are ground in a glass cup with a little honey and gum [6] and made use of by miniature-painters and many others who, with the brush, delight to draw outlines and put very delicate lights into pictures. And all these are most valuable secrets; but because they are very numerous one does not take much account of them.

[6] This we should call 'shell gold.' It is in common use. The employment of the shell represents a very ancient tradition, for shells were the usual receptacles for pigments in late classical and Early Christian times.

CHAPTER XV. (XXIX.)

Of Glass Mosaic and how it is recognized as good and praiseworthy.

§ 94. *Glass Mosaics.*

WE have spoken sufficiently above, in the sixth chapter on Architecture, of the nature of mosaic and how it is made, and, adding here just so much as really refers to pictures, let us say that very great mastery is needed to arrange the pieces so harmoniously that the mosaic appears at a distance a genuine and beautiful picture, seeing that this kind of work demands great experience and judgement and a profound knowledge of the art of design. For if any one in his designs obscure the mosaic with too great wealth and abundance of figures in the groups, and with multiplying over-much the pieces, he will bring it all into confusion. Therefore the design of the cartoons made for mosaic must be open, broad, easy, clear, and carried out with excellence and in admirable style.[1] The artist who understands the force of shadows in the design and of giving few lights and many darks, leaving in these certain vacant spaces or fields, he above all others will make his mosaic beautiful and well arranged. Mosaic to be praised must have clearness in itself, with a certain harmonious obscurity towards the shadows, and must be executed far from the eye with the greatest discretion that it may be

[1] This is excellent advice. The architectural character of mosaic decoration, the distance of the work from the eye, the nature of the technique and material, all invite to a broad and simple treatment, such as we find in the best mosaics at Ravenna and Rome. Modern work is often too elaborate and too minute in detail.

esteemed painting and not inlaid work.[2] Therefore the
mosaics that have these qualities, are good and will be
praised by everyone; and it is certain that mosaic is the
most durable picture that exists. Other painting fades
through time, but mosaic continually brightens with age;
other painting fails and wastes away, while mosaic on
account of its long life may almost be called eternal.[3]
For this reason we perceive in it not only the perfection
of the old masters, but also of the ancients [4]—by means
of those examples from their epoch that we recognize as
such to-day, as in the Temple of Bacchus at Sant' Agnese
outside of Rome, where all that is there executed is
exceedingly well done.[5] At Ravenna also there is some
very beautiful old mosaic in many places, and at Venice
in San Marco, at Pisa in the Duomo, and at Florence in
the tribune of San Giovanni,[6] but the most beautiful of

[2] A modern would say that if the work be really inlaid, it should look like
inlaid work, and not like something else. In the Italy of Vasari's day
however, as we have seen, painting had so thoroughly got the upper hand,
that to ape the nobler art would seem a legitimate ambition for the mosaicist.

[3] The durability of mosaic depends on the cement in which the cubes are
embedded and on the care taken in their setting. The pieces themselves are
indestructible but they will sometimes drop out from the wall. Hence
extensive restorations have been carried out on the Early Christian mosaics
at Ravenna and other places.

[4] In his *Proemio delle Vite* (*Opere*, I, 242) Vasari explains what he means
by the words 'antique' and 'old.' The former refers to the so-called
'classical' epoch before Constantine; the latter to the Early Christian and
early mediaeval period, prior to the Italian revival of the thirteenth century.

[5] At S. Costanza (see Note 5, ante, p. 27) on the vault of the aisle there are
decorative mosaics of the time of Constantine showing vine scrolls issuing out
of vases, and classical genii gathering the grapes. Birds are introduced among
the tendrils.

[6] The mosaics at Ravenna and S. Marco, Venice, are well known. In the
Duomo at Pisa, in the apse, there still remains the Saviour in Glory between
the Madonna and John the Baptist, designed by a certain Cimabue, and the
only existing work which modern criticism would accept as from the hand of
the traditional father of Florentine painting. It may however have been
another painter nicknamed 'Cimabue,' who worked at Pisa early in the
fourteenth century. The mosaics of the Tribune of the Baptistry at Florence
were executed in 1225 by Jacobus, a monk of the Franciscan Order, and this
fact is attested by an inscription in mosaic which forms part of the work.

all is that of Giotto in the main aisle of the porch at
St. Peter's at Rome [7]—truly a miraculous thing in that
kind of work—and among the moderns there is that of
Domenico Ghirlandaio above the door outside Santa Maria
del Fiore that leads to the Annunziata.[8]

§ 95. *The Preparation of the Mosaic Cubes.*

The pieces for mosaic are prepared in the following
manner. When the glass furnaces are ready and the pans
full of glass, the workers go round giving to every pan
its own colour, starting from a true white which contains
body and is not transparent, and carefully proceeding to
the darker tints by gradual transitions, in the same manner
as they make the mixtures of colours for ordinary paint-
ing. Afterwards when the glass is fused and in a fit state,
and the mixtures both light and dark and of every tint
are prepared, they ladle out the hot glass with certain long
iron spoons and spread it on a flat piece of marble, then
with another piece of marble press it evenly, making
round discs that come equally flat and remain the third
part of the breadth of a finger in thickness. Then some
cut little square pieces with an iron tool called dog's
mouth, and others break it with a hot iron tool, cracking
it as they wish.[9] The same pieces if too long are cut

[7] This mosaic, called the 'Navicella,' represents the Gospel ship manned by
Christ and the disciples, with Peter struggling in the waves. It has been so
much restored that little if any of Giotto's work remains in it. It was replaced
in the seventeenth century, after some wanderings, in the porch of the
present Basilica, but Vasari saw it of course in the porch of the old, or
Constantinian, church, the entrance end of which was still standing in his day.

[8] This mosaic was executed at the end of the fifteenth century by Domenico
Ghirlandajo and his brother over the northern door of the nave of the
cathedral of Florence. It is still *in situ* but has been greatly restored. The
date 1490 is introduced in the composition.

[9] This corresponds with modern practice. The following is from a paper by
Mr. James C. Powell, who, as practical worker in glass, has been engaged
with Sir W. B. Richmond in the decoration in mosaic of the vaults of St

with emery and so are all the pieces of glass that have need of it. They are then put into boxes and kept arranged as is done with the pigments for fresco work, which are kept separately in various little pots so that the mixtures of the lighter and the darker tints may be ready at hand for working.

There is another sort of glass covered with gold that is used for the background and for the lights of the draperies.[10] When the glass is to be gilded, the workers take the glass disc which they have made, and damp it over with gum-water, and then apply the gold-leaf; this done they put this gold-covered disc on an iron shovel

Paul's. 'The glass which is rendered opaque by the addition of oxide of tin, is coloured as required by one of the metallic oxides; this is melted in crucibles placed in the furnace, and when sufficiently fused is ladled out in small quantities on to a metal table, and pressed into circular cakes about eight inches in diameter and from three-eighths to half an inch in thickness; these are then cooled gradually in a kiln, and when cold are ready for cracking up into tesserae, which can be further subdivided as the mosaicist requires. It is the fractured surface that is used in mosaic generally, as that has a pleasanter surface and a greater richness of colour; the thickness of the cake, therefore, regulates the limit of the size of the tesserae, and the fractured surface gives that roughness of texture which is so valuable from an artistic point of view.' (*Transactions, R.I.B.A.*, 1893-4, p. 249).

[10] This is a point attended to by the best modern workers in mosaic. Where gold backgrounds are used it is advisable to carry the gold into the figures by using it as Vasari suggests for the lights on the draperies. If this were not done the figures would be liable to tell as dull masses against the more brilliant ground. The use of gold backgrounds is specially Byzantine. The earlier mosaics at Rome and at Ravenna have backgrounds of blue generally of a dark shade, which is particularly fine at Ss. Cosma e Damiano at Rome and in the tomb of Galla Placidia at Ravenna. The mosaics at S. Sophia at Constantinople of the sixth century had gold backgrounds, and this is the case also with all the later examples in Italy from the ninth and tenth centuries onwards. The finest displays of these varied fields of gold, now deep now lustrous of hue, are to be seen in S. Sophia, S. Marco at Venice, and the Cappella Palatina at Palermo.

Vasari's account of the fabrication of the gilded tesserae required for this part of the work is quite clear and agrees with modern practice. The gold leaf is hermetically sealed between two sheets of glass by the fusion of a thin film over it. The technique of the 'fondi d' oro,' or glass vessels adorned with designs in gold, found in the Roman catacombs, was of the same nature.

and that in the mouth of the furnace, first covering with a thin piece of glass all the glass disc that they had coated with gold. These coverings are made either of glass bubbles or of broken bottles so that one piece covers the whole disc, and it is then held in the furnace till it becomes almost red, and quickly drawn out, when the gold at once becomes admirably set so as to be imprinted in the glass and remain there. This is impervious to water and resists every attack, and afterwards the disc is cut and disposed as the other coloured pieces described above.

§ 96. *The Fixing of the Mosaic Cubes.*

In order to fix the mosaic in the wall, the custom is to make a coloured cartoon, though some make it without colour, and to trace or mark the cartoon bit by bit on the stucco,[11] and then to proceed to arrange the pieces

[11] It has been noticed at some places, as at Torcello, that before the cubes were laid in the soft cement the whole design was washed in in colour on the surface of the cement. This facilitated correct setting and avoided any appearance of white cement squeezed up in the interstices between the cubes. On this particular feature of the mosaic technique Berger has founded an ingenious theory of the origin of painting in fresco. It is his thesis, in his *Beiträge zur Entwicklungs-Geschichte der Maltechnik,* I, München, 1904, that the ancients did not employ the fresco process, but that this was evolved in early mediaeval days out of the mosaic technique as seen, *e.g.,* at Torcello. The stucco, that Vasari describes, must be put on portion by portion, for it only keeps soft two or three days, and can only be used for setting the cubes while in a moist state. Now, Berger contends, if the design for the mosaic be painted in colours on the wet stucco, and the whole allowed to dry, without any use of the mosaic cubes, we should have a painting in fresco, and he imagines that fresco painting began in this way. Unfortunately for the theory, (1), the testimony of Vitruvius and Pliny is absolutely decisive in favour of the knowledge in antiquity of the fresco technique, and, (2), the use of the coloured painting on the stucco as a guide for the setting of the cubes was not normal, and can never have been used so freely as to give rise to a new technique of painting. As a fact, this colouring of the stucco is objected to by the best modern workers on aesthetic grounds, for they point out that the lines of grey cement between the coloured cubes answer to the lead lines in the stained glass window, and should be reckoned with by the designer as part of his artistic effect. No doubt the older mosaicists, like the workers in stained glass, instinctively apprehended this, and had no desire for the coloured cement.

as many as are needed to fill in the mosaic work. The stucco, when put on in a thick coat over the wall, remains available two days and sometimes four, according to the kind of weather. It is made of travertine, lime,[12] pounded brick, gum-tragacanth and white of egg, and once made it is kept moist with damp cloths. Thus then, bit by bit, they cut the cartoons for the wall, and trace the design on the stucco; afterwards with certain little tongs, they pick up the bits of vitreous paste and fit them together in the stucco, and give lights to the lights, middle tints to the middle tints and darks to the darks, imitating minutely the shadows, the lights, and the half tints as they are in the cartoons.[13] Thus, working with diligence they gradually bring it all to perfection, and he who best

[12] One would expect here ' lime of travertine,' for what Vasari must mean is lime prepared by burning this stone, which he recommends elsewhere, *e.g.* ' Architettura,' cap. iv, and ' Scultura,' cap. vi (calce di trevertino). The cement here given is a lime cement mixed with water. A sort of putty mixed with boiled oil is also employed, and is said to have been introduced by Girolamo Muziano of Brescia, a contemporary of Vasari. Each mosaic worker seems to have his own special recipe for this compound.

[13] The process described by Vasari of building up the mosaic *in situ*, tessera by tessera, according to the design pounced portion by portion on the soft cement, is the most direct and by far the most artistic, and was employed for all the fine mosaics of olden time. In modern days labour-saving appliances have been tried, though it is satisfactory to know that they are all again discarded in the best work of to-day, such as that of Sir W. B. Richmond in St. Paul's. One of the methods referred to, which can be carried out in the studio, is to take a reversed tracing of the design, covered with gum, and place the cubes face downwards upon it according to the colour scheme. When they are all in position, as far as can be judged when working from the back, a coating of cement is laid over them and they are thus fixed in their places. The whole sheet is then lifted up and cemented in its proper place on the wall, the drawing to which the faces of the cubes are gummed being afterwards removed by wetting. A better plan than this is called by the Italians ' Mosaico a rivoltatura.' For this process the tesserae are laid, face upwards, in a bed of pozzolana, slightly damp, which forms a temporary joint between the adjacent cubes. Coarse canvas is pasted over the face of the work ; it is lifted up, and the pozzolana brushed out of the interstices. The whole is then applied to the wall surface and pressed into the cement with which this has been coated. When the cement has set the canvas is removed from the face.

succeeds in joining it so that it comes out even and smooth, is most worthy of praise and is more esteemed than the others. Some are so clever in working mosaic that they make it appear as if painted in fresco. So firmly does the glass harden into the stucco, after the latter has set, that this mosaic lasts for ever—as is testified by the antique mosaics, which are in Rome, and those also which are of the older (modern) times. In both methods of working the moderns of our days have done marvellous things.

CHAPTER XVI. (XXX.)

Concerning the Compositions and Figures made in Inlaid Work on
Pavements in imitation of objects in monochrome.

§ 97. *Pavements in Marble Mosaic and Monochrome.*

To the mosaic in small pieces our modern masters have
added another kind of mosaic, that of marbles fitted
together to counterfeit painted groups in monochrome.
This art takes its origin from the very ardent desire that
there should remain in the world to those who come after,
even if other kinds of painting were to be destroyed, a
light that may keep alive the memory of modern painters.
Hence they have produced with wondrous skill very large
compositions that can be placed not only on the pavements,
where one walks, but also on the face of walls and palaces,
with such beautiful and marvellous art that there can be
no danger lest time should waste away the design of those
who excel in this profession. Examples of these works
can be seen in the Duomo at Siena begun first by Duccio
of Siena, then added to by Domenico Beccafumi, and
continued by others even to our own day.[1]

[1] The Duomo of Siena is a veritable museum of floor decorations in incised
outlines and in black and white, in the various processes described by Vasari.
There is a good notice of them in Labarte, *Histoire des Arts Industriels.*
None of the work is as early as the time of Duccio, but Beccafumi executed
a large amount of it. See the Life of that artist by Vasari.

It is worthy of notice that Dante had something of this kind in his thoughts,
when in the 12th Canto of the *Purgatorio* he describes the figure designs on the
ground of the first circle of Purgatory.

> ' So saw I there . . .
> . . . with figures covered
> Whate'er of pathway from the mount projects.

· · · · · · · · ·

This art possesses so much that is good, new, and durable, that for pictorial work made up of black and white greater excellence and beauty can hardly be desired. It is composed of three sorts of marble, which come from the Carrara mountains:[2] one of these is the finest pure white marble; another is not white but inclines to a livid tint, which furnishes a middle shade; and the third is grey marble that inclines towards a silvery hue, and this serves for dark. When the artist wishes to compose a figure from these marbles he first prepares a cartoon in light and shade with the same tints, and that done, following the outlines of those medium and dark and pale tints, he fits together with great care in their proper places first of all in the middle, the light of that pure white marble, and then the half tones and the darks beside them, according to the actual outlines that the artist has drawn in the cartoon. When all the pieces of marble, the light pieces as well as the darks and half tints, are joined together and are laid quite flat, the artist who has prepared the cartoon takes a fine brush dipped in moist black, and, with all the work fitted together before him on the ground, traces in lines the contours and where the shadows come, in the same manner in which one would prepare an outlined drawing for monochrome. That done the carver proceeds to cut in with chisels all those lines and contours

> O Niobe! with what afflicted eyes
> Thee I beheld upon the pathway traced,
> Between thy seven and seven children slain!
> O Saul! how fallen upon thy proper sword
> Didst thou appear there lifeless in Gilboa
> That felt thereafter neither rain nor dew!
>
> Whoe'er of pencil master was or stile,
> That could portray the shades and traits which there
> Would cause each subtle genius to admire?
> Dead seemed the dead, the living seemed alive;
> Better than I saw not who saw the truth,
> All that I trod upon while bowed I went.'
> Longfellow's Translation.

[2] See Note on 'Tuscan Marble Quarries,' ante, p. 119.

that the painter has made, and he hollows out all that part which the brush has marked with black. Having finished this, the pieces are built in on the flat bit by bit, and then with a mixture of boiled black pitch, or asphalt, or black earth, all the hollows which the chisel has made are filled up. When the material is cold and has set, the worker proceeds to remove and rub away the projecting parts with pieces of soft stone, and to smooth and polish with sand, bricks, and water, till all that remains is brought to a true surface, that is, the marble itself and the substance put in to fill up the hollows. When that is done the work remains in aspect exactly like a flat picture, and possesses great force combined with art and masterly skill. This kind of work has come much into use on account of its beauty.

§ 98. *Pavements in Variegated Tiles.*

Hence it is that the pavements of many apartments in our day are made of variegated bricks, one portion of white clay, that is of clay that draws towards a bluish shade when it is fresh and when baked becomes white, and the other portion of the ordinary earth for making bricks which becomes red when baked. Of these two sorts are made pavements, inlaid in various designs and compartments, as the papal halls at Rome in the time of Raffaello da Urbino bear testimony; [3] and now recently many apartments in the castle of Sant' Angelo where emblems of lilies of fitted pieces showing the arms of Pope Paolo, and many other devices, have been made with these same bricks.

[3] The Appartamento Borgia still contains a good display of these variegated tiles; the original ones are however rather the worse for wear. In the Life of Raphael, Vasari says they were supplied by the della Robbia of Florence. In the Castle of S. Angelo there is a collection of interesting specimens of the tiles Vasari goes on to mention. They are in cases in the Sala della Giustizia, and exhibit the devices of Alexander VI, Julius II, Leo X, Paul III, and other Popes. The pavement of the Laurentian Library at Florence is laid with tiles showing a very effective design of yellow upon red. They are ascribed to Tribolo.

In Florence also there is the pavement of the library of San Lorenzo ordered to be made by Duke Cosimo. All have been executed with such great care that anything more beautiful in that sort of workmanship cannot be desired, and the point of departure for all these inlaid things was the first mosaic.

§ 99. *Pavements in Breccia Marble.*

To explain why no mention was made of some breccias recently discovered by Duke Cosimo while stones and marbles of all sorts were being spoken of—I may say that in the year 1563 His Excellency found in the mountains of Pietrasanta, near to the village of Stazzema, a hill which extends for two miles, whose outer crust is of white marble excellent for statues. The under layer is a red and yellowish breccia, and those farther down are greenish, black, red, and yellow with various other mixtures of colour; all these marbles are hard, and their nature is such that the farther one penetrates inwards the greater is their solidity. Up to the present time there can be seen quarried from thence columns of fifteen to twenty braccia; but these marbles are not yet put into use, because a road three miles in length is only now being constructed by order of his Excellency to make it possible to transport the marbles from the said quarries to the sea shore.[4] These breccias will, so far as one can see, be most suitable for pavements.

[4] Was this the road from Seravezza seawards which Michelangelo had begun? See Note on 'Tuscan Marble Quarries,' ante, p. 119. Specimens of these Stazzema breccias are shown as C, D, on the Frontispiece.

CHAPTER XVII. (XXXI.)

Of Mosaic in wood, that is, of Tarsia; and of the Compositions that
 are made in Tinted Woods, fitted together after the manner of
 a picture.

§ 100. *Inlays in Wood.*

How easy a thing it is to add some new discovery to the
inventions of the past, is clearly shown to us, not only by
the aforesaid fitted pavement, which without doubt comes
from mosaic work, but also by these same tarsias and the
figures of many different things, that closely resembling
mosaic and painting have been made by our elder artists
out of little pieces of wood, variously coloured, fitted and
joined together in panels of walnut. This is called by
the moder's ' lavoro di commesso ' (inlaid work) although
to the elder artists it was tarsia. The best specimens of
this work were to be found in Florence in the time of
Filippo di Ser Brunellesco and afterwards in that of
Benedetto da Maiano, who, however, strangely enough
judged tarsia a useless thing and completely abandoned
it as will be told in his Life. He, like the others of past
times, executed tarsia in black and white only, but Fra
Giovanni of Verona who was very proficient in the art
improved it greatly, giving various colours to the woods
by means of dyes in boiling water and of penetrating
oils, in order to produce the lights and shadows with
these variously tinted woods, as in the art of painting,
and skilfully putting in the high lights by means of the

very white wood of the silio.[1] This work began in the
first instance with designs in perspective, because the
forms in these end with plane angles, and the pieces
joined together showed the contours, and the work
appeared all of one flat piece, though it was made up of
more than a thousand. The ancients worked however in
the same manner with incrustations of fine stones : as is
plainly seen in the portico of St Peter's, where there is a
cage with a bird and all the details of the wooden bars
etc., on a ground of porphyry inlaid with other different
stones.[2] But, because wood is more pliant and much
more amenable for this work, our masters have been able
to make more abundant use of it and in the way that
best pleased them. Formerly for making the shadows
they used to scorch the wood with fire on one side, this
imitated shade well; but others afterwards have used oil
of sulphur and corrosive sublimate and preparations of
arsenic, with which substances they have obtained the
hues that they desired, as is seen in the work of Fra
Damiano in San Domenico in Bologna.[3] And because
such a line of work consists only in the choice of designs
that may be adapted to it—those containing blocks of
buildings and objects with rectangular outlines to which
force and projection can be lent by means of light and
shade—it has always been exercised by persons possessing
more patience than skill in design. And thus it is that
though many things have been produced in this line, such
as representations of figures, fruit, and animals, some
of which are in truth most life-like, yet since it is a work
that soon becomes black and does not do more than
counterfeit painting, being less than painting, and is also
of short duration because of worms and fire, it is con-

[1] Lat. *Evonymus Europaeus*. The only English example of the family is the
spindle tree.

[2] The Lemonnier editors say that this work is lost. Of course Vasari is
speaking of the Old St. Peter's, not the present structure.

[3] Fra Damiano of Bergamo is mentioned by Vasari in his Life of Francesco
Salviati (*Opere*, ed. Milanesi, VII).

sidered time thrown away in vain to practise it, although
it may indeed be both praiseworthy and masterly.[4]

[4] Inlays of different coloured woods, forming what is known as tarsia
work, and sometimes as marqueterie, compose an easily understood kind of
decoration that has been practised especially in the East from time immemorial.
There is however a special interest attaching to this work in the Italy of the
fifteenth century, in that it was connected with the studies in perspective that
had so potent an influence on the general artistic progress of the time. For
some reason that is not clearly apparent the designs for this work often took
the form of buildings and city views in perspective, and artists amused them-
selves in working out in this form problems in that indispensable science.
The history of the craft is so instructive that it is worth a special Note,
which the reader will find at the end of this 'Introduction,' postea, p. 303.

CHAPTER XVIII. (XXXII.)

On Painting Glass Windows and how they are put together with
Leads and supported with Irons so as not to interfere with the
view of the figures.

§ 101. *Stained Glass Windows; their Origin and History.*

FORMERLY the ancients were in the habit of filling in
their windows, but only in the houses of great men, or
of those at least of some importance, in such a manner
as to prevent the wind or cold from entering, while not
excluding the light. This plan was adopted only in their
baths and sweating rooms, vapour baths and other retiring
rooms, and the apertures and vacant places of these were
closed with transparent stones, such as onyx marbles,[1]
alabasters, and other delicate marbles that are variegated
or that incline towards a yellowish tint. But the moderns,
who have had glass furnaces in much greater abundance,
have made the windows of glass, either of bull's-eyes[2]

[1] 'The onyx marbles of Algeria, Mexico, and California (which are of the
same nature as the Oriental alabasters) can be cut and ground sufficiently thin
for window purposes' (Mr. W. Brindley in *Transactions, R.I.B.A.*, 1887,
p. 53). See also ante, p. 43.

[2] The 'occhi' of Vasari correspond to the old-fashioned 'bull's eyes' which
are still to be seen surviving in cottage windows. The 'bull's eye' pane was
the middle part of a sheet of so-called 'crown' glass where was attached the
iron rod or tube with which the mass of molten glass was extracted from the
furnace, before, by rotation of the rod, it was spread out into the form of a
sheet. When the rod was ultimately detached a knob remained, and this part
of the sheet was used for glazing as a cheap 'waste product.' In connection
with the modern revival in domestic architecture, for which Mr. Norman
Shaw deserves a good deal of the credit, these rough panes have come again
into fashion, and manufacturers make them specially and supply them at the
price of an artistic luxury! In Vasari's time they were evidently quite common,

or of panes, similar to or in imitation of those that the ancients made of stone; and they have fastened them together and bound them with strips of lead, grooved on both sides, and furnished them and secured them with irons let into the walls for this purpose, or indeed into wooden frames,[3] as we shall relate. Whereas at first the windows used to be made simply of clear bull's-eyes with white or coloured corners, afterwards the artists thought of making a mosaic of the shapes of these glasses differently coloured and joined after the manner of a picture.[4] And so refined has the skill in this art become, that in our days glass windows are seen carried to the same perfection that is arrived at in fine pictures upon panel, with all their harmony of colour and finish of execution, and this we shall amply show in the Life of the Frenchman Guglielmo da Marcilla.[5]

and we find numerous specimens represented in the pictures of the fifteenth and sixteenth centuries. The bedroom of S. Ursula in Carpaccio's picture at Venice; the cell of S. Jerome in Dürer's engraving; the room in which van Eyck paints Arnolfini and his wife, those 'in which Jost Amman's '[Hand-workers' are busy, etc., etc., have casements glazed in this fashion, [the knob, called in English 'bullion,' in French 'boudine,' in German 'Butzen,' being distinctly represented as in relief.

[3] The 'telajo di legno' is a window frame of wood such as we are familiar with in modern days, only in olden times these were often made detachable and taken about from place to place when lords and ladies changed their domicile. When Julius II wanted Bramante to fill some windows of the Vatican with coloured glass, it was found that the French ambassador to the Papal court had brought a painted window in such a frame from his own country, and the sight of this led to the invitation to Rome of French artists in this material. See *infra*, Note 5.

[4] See Note on 'The Stained Glass Window' at the close of this 'Introduction,' *postea*, p. 308.

[5] Vasari wrote the life of this artist, who had been his own teacher in early years at Arezzo (*Opere*, IV, 417). Gaye, *Carteggio*, II, 449, gives documentary evidence that he was the son of a certain Pierre de Marcillat, and was born at S. Michel in the diocese of Verdun in France. His name therefore has nothing to do with Marseilles, which moreover is not in a glass-painting locality, whereas Verdun, between France and Germany, is just in the region where the art was developed and flourished. Guglielmo and another Frenchman named Claude came to Rome about 1508 in the circumstances

In this art the Flemings and the French have succeeded
better than the other nations, seeing that they, with their
cunning researches into pigments and the action on them
of fire, have managed to burn in the colours that are put
on the glass, so that wind, air, and rain may do them no
injury, whereas formerly it was customary to paint
windows in colours coated with gum and other temperas
that wasted away through time and were carried off by
the winds, mists, and rains, till nothing was left but the
mere colour of the glass. In the present age, we see this
art brought to that high grade beyond which one can
hardly desire further perfection of fineness and beauty
and of every quality which contributes thereto. It supplies
a delicate loveliness not less beneficial to health, through
securing the rooms from wind and foul airs, than useful
and convenient on account of the clear and unimpeded
light that by its means is offered to us.

In order to produce such windows, three things are
necessary, namely, luminous transparency in the glasses
chosen,[6] beautiful arrangement in that which is worked
out with them, and clear colour without any confusion.
Transparency is secured by knowing how to choose glasses

described in the foregoing Note, and made some windows for the Sala Regia
of the Vatican and other parts of the Palace. These have all perished, but
there still survive two windows from their hands in the choir of S. Maria
del Popolo, on which are the name and arms of Pope Julius II. They are
placed north and south behind and above the high altar, and have each three
lights. They contain scenes from the lives of Christ and the Madonna, in
which the figures are carefully drawn but the colour is patchy. Though the
reds are clear and strong, there is a good deal of grey and the architectural
backgrounds are rather muddy in hue. The artist was invited from Rome to
Cortona and from thence to Arezzo, which as Vasari notices in the beginning of
his Life remained his home to the end. He executed many windows there, in
the cathedral and in S. Francesco, some of which still remain ; and also works in
fresco. Vasari declares that he owed to his teaching the first principles of art.

On the whole subject of the glass-painting craft see the Note on ' The Stained
Glass Window,' postea, p. 308, where the curious confusion of two different
processes, between which Vasari's treatment oscillates, is elucidated.

[6] The significance of Vasari's demand for transparency in glass is explained in
the Note, postea, p. 308.

that are clear in themselves, and in this respect French, Flemish, and English glasses are better than the Venetian,[7] because the Flemish are very clear and the Venetian much charged with colour. In clear glasses when shaded with darker tints the light is not totally lost, they are transparent even in their shadows, but the Venetian, being obscure in their nature and darker still in their shadow, lose all transparency. Again many delight in having the glasses loaded with colours artificially laid on so that when the air and sun strike upon them, they exhibit I cannot tell how much more beauty than do the natural colours; nevertheless, it is better to have the glasses clear in their own substance, rather than obscure, so that when heavily coloured they may not be left too dim.

§ 102. The Technique of the Stained Glass Window.[8]

For painting on glass, we must first have a cartoon on which are drawn the outlines of the figures and of the folds of the drapery. These show where the pieces of glass have to be joined; then the bits of red, yellow, blue, and white glass must be picked out and divided according to the design for the flesh parts and for the draperies, as occasion demands. To bring each piece of glass to the dimensions traced on the cartoon, the said pieces are laid on the cartoon and the outline marked with a brush dipped

[7] It is somewhat remarkable that the Venetians, who practised the art of glass mosaic from about the ninth century, and in the thirteenth began their famous glass works, never achieved anything in the technique of the stained glass window. Venetian glass vessels, like the glorious lamps from the Cairo Mosques, owe much of their beauty to the fact that the material is not clarified but possesses a beautiful warm tone. It is indeed more difficult to get clear glass than tinted.

[8] For the most part this description, with the exception of the part about scaling-off glass in order to introduce a variety in colour, corresponds closely with the technical directions which Theophilus gives so fully and clearly in his *Schedula Diversarum Artium* of about 1100 A.D. It is pretty clear that Vasari is telling us here what he learned from William of Marcillat who would have inherited the traditions of the great French glass-painters of the thirteenth century.

in white lead, and to each piece is assigned its number
in order to find it easily when joining them together;
when the work is finished the numbers are rubbed off.
When this is done, in order to cut the pieces to measure,
the workman, having first drawn an emery point over the
upper surface of the glass along the outline, which he
damps with saliva, takes a red-hot pointed tool and pro-
ceeds to pass the point along the outlines, keeping a little
within them; as he gradually moves the tool, the glass
cracks and snaps off from the sheet. Then with the emery
point he trims the said pieces, removing the superfluous
part, and with a tool called ' grisatoio ' or ' topo ' (grozing
iron) which nibbles the traced edges, he makes them exact
and ready to be joined all round.

In this manner then the bits of glass fitted together
are spread on a flat table above the cartoon, and the artist
begins to paint in the shadows over the draperies, using
for this the ground scales of iron and of another rust [9]
found in iron pits, which is red, or else hard red haematite
finely ground, and with these pigments he shades the
flesh, using alternately black and red, according to need.
To produce the flesh tints it is necessary to glaze all the
glasses with this red, and the draperies with the black,
the colours being tempered with gum, [10] and so gradually
to paint and shade the glasses to correspond with the
tints on the cartoon. When this process is finished, the
worker, desiring to put in the brightest lights, takes a
short thin brush of hog's bristles and with it scratches
the glass over the light, and removes some of that coat
of the first colour that had been given all over, and with

[9] The ' scaglia ' is the thin scale that comes off heated iron when cooling under
the hammer, and is collected from the floors of smithies. Vasari thinks of it as a
' rust ' ' ruggine,' because rusty iron scales off in much the same way, the cause in
both cases probably being oxidization. Hence the expression ' another rust.'

[10] The pigments or pastes that are to be fused on to the coloured glass, to
modify its hue or to indicate details, are powdered and mixed with gum for
convenience in application. The gum is not to serve as permanent binding
material as the pastes are subsequently fused and burnt in on the glass.

the handle of the brush picks out the lights on the hair, the beard, the drapery, the buildings, and the landscapes as he sees fit. There are great difficulties however in this work; and he who delights in it may put various colours on the glass, for example, if he trace a leaf or other minute object over a red colour, intending it to come out in the fire a different tint, he removes from the glass a scale the size of the leaf, with the point of a tool that pares away the upper surface of the glass. This must be the first layer and not more; by so doing, the glass remains white [11] and can be tinged afterwards with that red [12] made of many mixtures, which when fused by heat becomes yellow. This can be done with all the colours, but the yellow succeeds better on white than on other colours; when blue is used to paint in the ground, it becomes green in the firing, because yellow and blue mixed make a green colour. This yellow is never used unless at the back of the glass where it is not painted,[13] because if it were on the face it would mingle and run, so as to spoil and mix itself with the painting; when fired however the whole of the red remains on the surface, this, when scraped away by a tool leaves the yellow visible.[14]

[11] It will be understood that the glass subjected to this treatment is not coloured in the mass, or what is called 'pot-metal,' but has a film of colour 'flashed' or spread thinly on a clear sheet. This is done with certain colours, such as the admired ruby red, because a piece coloured in the mass would be too opaque for effect. Economy may also be a consideration, as the ruby stain is a product of gold.

[12] The composition, which when fused stains the glass yellow, may before fusion be of a red hue. As a rule the yellow stain on glass is produced by silver. Vasari does not say what his composition is.

[13] The red film is what Vasari understands by the 'painting.' This might fuse and run with the heat required to fuse the yellow.

[14] That is, the space where the yellow leaf is to come may be cleared of the red film *after* the yellow leaf has been painted on the back, as well as *before* that process. The process Vasari describes of introducing small details of a particular colour into a field of another hue is a good deal employed by modern workers in glass, but it was not known to Theophilus, or much used in the palmy days of the art, the twelfth and thirteenth centuries.

After the glasses are painted they must be put into an iron muffle with a layer of sifted cinders mixed with burnt lime, and arranged evenly, layer by layer, each layer covered with these ashes; they are then put into the furnace, in which at a slow fire they are gradually heated through till both cinders and glasses begin to glow, when the colours thereon become red hot and run and are incorporated with the glass. In this firing the greatest care must be taken, because a too violent heat would make the glasses crack and too little would not fix the colours. Nor must they be taken out till the pan, or muffle, in which they are placed is seen to be red hot, as well as the ashes, with some samples laid on the top to show when the pigment is liquefied.

After this the leads are cast in certain moulds of stone or iron. The leads have two grooves; that is one on either side, within which the glass is fitted and pressed tight.[15] The leads are then flattened and made straight and fastened together on a table. Bit by bit all the work is leaded in many squares and all the joinings of the lead soldered by means of tin soldering irons. Across it in parts are iron rods bearing copper wires leaded in to support and bind the work, which has an armature of irons that do not run straight across the figures, but are twisted according to the lines of the joinings, so as not to interrupt the view of the figures. These are rivetted into the irons that support the whole, and they are made not square but round that they may interfere less with the view. They are put on to the outside of the windows and leaded into holes in the walls, and are strongly bound together with copper wires, that are soldered by means of fire into the leads of the windows. And in order that boys and other nuisances should not spoil the windows, a fine network of copper-wire is placed

[15] In Theophilus's time these convenient leads grooved on both sides, which are still in use, were not invented. He directs the worker to bind strips of lead round each piece of glass and then solder together the leads when the pieces so bound are brought into juxtaposition.

behind them. These works, if it were not for the too fragile material, would last in the world an infinite time. But for all this it cannot be said that the art is not difficult, artistic, and most beautiful.

CHAPTER XIX. (XXXIII.)

Of Niello,[1] and how by means of this process we have Copper Prints ; and how Silver is engraved to make Enamels over bas-relief, and in like manner how Gold and Silver Plate is chased.[2]

§ 103. *Niello Work.*

NIELLO, which may be described as a design traced and painted on silver, as one paints and traces delicately with the pen, was discovered by the goldsmiths as far back as the time of the ancients, there having been seen in their gold and silver plates incisions made by tools and filled up with some mixture.[3] In niello the design is traced with the stylus on silver which has a smooth surface, and is engraved with the burin, a square tool cut on the slant like a spur from one of its angles to the other ; for sloping thus towards one of the corners makes it very

[1] 'Niello' is from the mediaeval Latin 'nigellum,' 'black,' and refers to the black composition with which engraved lines in metal plates were filled, according to the process detailed by Vasari.

[2] It is curious that the chapter ends without any discussion of the chasing of gold and silver plate.

[3] To some small extent the ancients do seem to have filled the engraved lines in their bronze or silver plates with colouring matter, and the known examples are described in Daremberg et Saglio, *Dictionnaire des Antiquités*, art. 'Chrysographia,' p. 1138. Pliny, *Hist. Nat.*, XXXIII, 46, gives a recipe, as used by the Egyptians, for a material for colouring silver that corresponds with the composition used for niello work, though the use he indicates seems rather that of an artificial *patina* than a filling for incisions. In any case the use of such a filling in antiquity was quite uncommon, for the innumerable incised designs on the backs of Greek and Etruscan mirrors and on caskets like the Ficeronian Cista show no indication of the process, though of course in the lapse of time the incisions have acquired a darker tinge than the smooth surfaces of the metal, and Vasari may have seen them filled with accidental impurities.

sharp and cutting on the two edges, and its point
glides over the metal and graves extremely finely.[4]　With
this tool is executed all graving on metal, whether the
lines are to be filled or are to be left open, according to
the pleasure of the artificer.　When therefore they have
finished their graving with the burin, they take silver and
lead and fuse them into one substance over the fire; and
this when completely amalgamated is black in colour,
very friable, and extremely fusible.[5]

The next process is to pound this substance and put
it over the engraved silver plaque which must be thor-
oughly clean, then to bring it near to a fire of green wood,
blowing with the bellows that the rays of the fire may
strike upon the niello, which by virtue of the heat melts
and flows filling up all incisions that the graver has
made.　Afterwards when the silver has cooled, the worker
proceeds to remove carefully the overplus with scrapers,
and with pumice stone to grind it away little by little,
rubbing it with the hands and with a leather till it is
reduced to the true flat and the whole is left polished.
The Florentine Maso Finiguerra worked most admirably
in this craft in which he was really extraordinary, as is
testified to by some paxes [6] of niello in San Giovanni of
Florence that are esteemed wonderful.

§ 104. *The Origin of Engraving.*

From this graving by the burin are derived the copper
plates from which we see to-day so many impressions

[4] A burin is shown in Fig. 2, D, ante, p. 48.

[5] Vasari makes no mention here of sulphur, which in the recipes given by
Pliny, Theophilus, and Cellini, is a constant constituent of the black amalgam.
Silver and lead alone would not give the black required.

[6] The ‘ Pax,’ Italian ‘ pace,’ was a little tablet of metal or some other material
used in churches to transmit the kiss of peace from the priest to the people.
Certain paxes once in the Baptistry of Florence have now found their way
through the Uffizi to the Museum in the Bargello, but experts are not agreed
as to the ascription of particular examples to Finiguerra.　See Milanesi’s note on
this artist at the close of Vasari’s Life of Marc Antonio Raimondi (*Opere*,
V, 443).

PLATE XIII

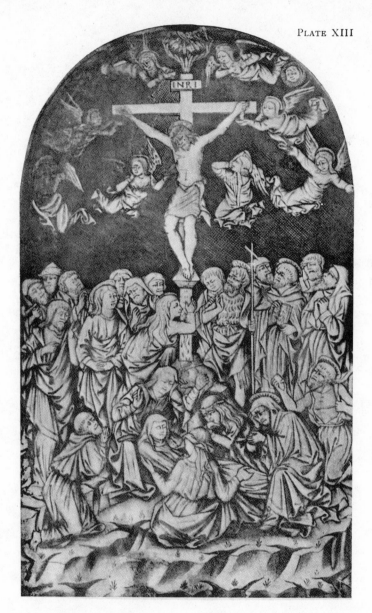

SPECIMEN OF NIELLO WORK

A 'Pax' formerly in the Baptistry, and now in the National Museum, Florence

throughout all Italy of both Italian and German origin. Just as impressions in clay were taken from silver plaques before they were filled with niello, and casts pulled from these in sulphur,[7] in the same manner the printers found out the method of striking off the sheets from the copper plates with the press, as we have seen printing done in our own days.

[7] In Vasari's first edition, of 1550, there is a notice of Finiguerra in the Life of Antonio Pollaiuolo (p. 498) and he there celebrates only the skill of Maso as a niellist, but in the edition of 1568 there is another notice of him in connection with Marc Antonio (*Opere*, ed. Milanesi, v, 395), and here Vasari claims for him the credit of being the first to make the advance from niello work to copper-plate engraving. This second passage is a famous one, and describes how Finiguerra moulded his silver plate, incised with a design, in clay, and then cast it in sulphur, and subsequently filled the hollow lines in the sulphur cast (which reproduced the incisions on the silver plate) with lamp-black, so that they showed up more clearly. He then seems, according to Vasari, to have pressed damp paper against the sulphur plaque so treated, and obtained a print by extracting the black from the lines. Benvenuto Cellini however, a better authority than Vasari on Finiguerra, praises him as the best niello worker of his time, but says nothing about this further development of his craft, and on the contrary ascribes the invention of copper-plate engraving to the Germans. Cellini tells us at the end of his 'Introduzione,' that in 1515, when fifteen years old, he began to learn the goldsmith's trade, and that then, though the art of niello-work had greatly declined, the older goldsmiths sang in his ears the praise of Maso Finiguerra, who had died in 1464. Hence, Cellini says, he gave special attention to niello work, and he describes the process, at rather greater length than Vasari, in the first chapter of his *Treatise* on Gold-work (*I Trattati, etc. di Benvenuto Cellini*, ed. Milanesi, Firenze, 1893).

The question of the origin of copper-plate engraving need not be here discussed. Any of the incised silver or bronze plaques of the ancients might have been printed from ; and as a fact some incised bronze discs that are placed at the bottoms of the towers in the great crown-light of the twelfth century in the Minster at Aachen have actually been put through the printing press and the impressions published, though no one at the time they were made can have thought of printing from them. In the same way wooden stamps in relief were used by Egyptians and Romans for impressing the damp clay of their bricks, though no one seems to have thought of multiplying impressions on papyrus or parchment. So trial impressions of niello plates, before the lines were filled in permanently, may often have been made, and not by Finiguerra alone. The idea of multiplying such impressions on their own account is now universally credited to the Germans, and this seems also to have been the opinion of Cellini. See his 'Introduzione.'

§ 105. *Enamels over Reliefs.*

See now another sort of work in silver and in gold, commonly called enamel, a kind of painting intermingled with sculpture, suitable for lining the bottom of pieces intended to hold water.[8] This when worked on gold, needs the very finest gold; and when on silver, the silver at least of the quality of the giulio.[9] The following method is necessary in order that the enamel may remain in its place and not run beyond its proper limits. The edges of the silver [10] must be left so fine that when looked at from above they escape the eye. In this way is made a flat relief contrary to the other kind,[11] in order that when the enamels are put over it, it may take its darks and lights from the height and depth of the intaglio. Then glass enamels of various colours are picked out and carefully fixed with the hammer; [12] they are kept in little bowls filled with clear water, separated and distinct one from

[8] That is to say, the bottoms of cups or chalices. There are notices of armorial insignia, enamelled at the bottom of cups of gold used by some of the French kings, in Labarte, *Histoire des Arts Industriels.*

[9] Giulio: a piece coined under Pope Julius II, of the same value as the 'paolo,' and equivalent to 56 centesimi, or about 5½d. of our money.

[10] That is, the outlines of the different figures, ornaments, or other objects executed in low relief on the metal. See the Note on 'Vasari's Description of Enamel Work' at the close of the 'Introduction' to Painting, postea, p. 311.

[11] 'The other kind.' probably refers to the incisions on the niello plates of which he has been speaking. These are hollow, or in intaglio, whereas the work he is here describing is in relief.

[12] 'Si fermino col martello.' The only practicable use of the hammer in connection with enamels is to pound the lumps of vitreous paste to a more or less fine powder, in which form they are placed over the metal. Theophilus, in chapter 53 of his third Book, 'de Electro,' 'on Enamel,' introduces the hammer in a similar connection: 'Accipiensque singulas probati vitri . . . quod mox confringas cum rotundo malleo donec subtile fiat;' 'take portions of the glass you have tested . . . and break up each lump with a round-headed hammer till it be finely powdered.' Cellini also says the pastes are to be pounded in a mortar 'con martello.' *Trattati,* p. 30. It is not easy however to see how any sense of 'pounding' can be extracted from the verb 'fermare' which Vasari uses.

the other. Those which are used with gold are different from those that serve for silver [13] and they are worked in the following manner. The enamels are lifted out separately with the most delicate little silver shovel and spread in their places with scrupulous cleanliness, and this is done over and over again, according as the enamel adheres properly, and so with all the quantity that is needed at the time. This done, an earthenware receptacle, made on purpose, is prepared; it must be perforated all over and have a mouthpiece in front, then the muffle, which is a little perforated earthenware cover that will prevent the charcoal falling from above, is introduced into this receptacle, and above the muffle the space is filled

[13] The difference in colour between gold and silver will naturally affect the choice of the transparent vitreous pastes that are to cover them, and there are also considerations of a chemical kind which prevent the use of certain pastes on certain metal grounds. For example tin has the property of rendering transparent enamels opaque, and transparent pastes cannot be used over metal grounds wherein tin enters into the composition. Cellini, who gives the same caution as Vasari, takes as an illustration transparent ruby coloured enamel, which he says cannot be used over silver, for a reason which has about it a reminiscence of the ancient alchemy, namely, that it is a product of gold and must be employed only over its kindred metal! On the other hand he forbids for use with gold yellow, white, and turquoise blue. We are indebted for some special information on this highly technical subject to the kindness of Mr. H. H. Cunynghame, C.B., who writes: 'There are two distinct reasons why different enamels are used on silver and gold respectively. The first is an artistic reason. Transparent reds do not show well over silver, the rays reflected from a silver surface not being well calculated to show off the colours of the gold. In fact silver absorbs those rays on the transmission of which the beauty of gold-red largely depends, whence then it follows that transparent blues and greens should be used on silver, and reds, browns, and the brighter yellows on gold. In addition to this, silver has its surface disturbed by the silicic acid in the enamel. The consequence is that ordinary enamels put on a silver surface are stained. To prevent this it is desirable to add some ingredient that dissolves and renders colourless the stain. For this purpose therefore special fluxes or clear enamels are made for silver. They usually contain manganese and arsenic. The first of these has such a property of "clarifying" enamels and glazes that it used to be called the potter's "soap," for it cleaned the glazes on china. The other is also used for the same purpose. . . . As silver alloy is more easy to melt than gold alloy, fluxes, i.e. clear enamels for silver, are much more fusible than those for gold.'

up to the top with oak charcoal kindled in the ordinary way. In the empty space which is left under the afore-named cover the enamelled object is placed on a very thin iron tray to feel the heat gradually and is kept there long enough to admit of the enamels melting, when they flow all over almost like water. Which done, it is allowed to cool, and then with a 'frassinella,' that is, a stone for sharpening iron tools, and with sand such as is used for drinking glasses moistened with clear water, it is rubbed till it becomes perfectly level. When the process of removing all superfluity is finished, the object is placed in the actual fire, to be melted a second time in order that the whole surface may become lustrous.[14] Another sort is made by hand, and polished with Tripoli plaster (powder) and a piece of leather, but of this there is no need to make mention.[15] I have however described the above because being, like the other processes, of the nature of painting it seemed to come into our subject.

[14] This is a practice of modern enamellers. Cellini however is against it, as if the enamels begin again to run there is a danger of losing the truth of the surface. He recommends polishing by hand alone (*Trattati*, ed. Milanesi, 35).

[15] This may have been the so-called Venetian enamel used in Vasari's time. This was a form of opaque painted enamel over copper, extremely decorative, but coarse as compared with the translucent enamel over reliefs. We owe this suggestion to Sir T. Gibson Carmichael.

CHAPTER XX. (XXXIV.)

Of Tausia,[1] that is, work called Damascening.

§ 106. *Metal Inlays.*

IN imitation of the ancients, the moderns have revived
a species of inlaying in metals, with sunk designs in
gold or silver, making surfaces either flat or in half or low
relief; and in that they have made great progress. Thus
we have seen works in steel sunk in the manner of tausia,
otherwise called damascening, because of its being excel-
lently well done in Damascus and in all the Levant.
Wherefore we have before us to-day many bronzes and
brasses and coppers inlaid in silver and gold with
arabesques, which have come from those countries; and
among the works of the ancients we have observed
rings of steel, with half figures and leafage very beautiful.
In our days, there is made in this kind of work armour
for fighting all worked with arabesques inlaid with
gold, also stirrups and saddle-bows and iron maces:
and now much in vogue are such furnishings of swords,

[1] The word 'Tausia,' and its connection with 'Tarsia,' the term used for
wood inlays, has given rise to some discussion. The explanation in Bucher's
Geschichte der Technischen Künste, III, 14, is probably correct, and according
to this the Italian 'Tausia' comes from the Spanish 'Tauscia' or 'Atauscia,'
which is derived from an Arabic root meaning 'to decorate.' The art of
inlaying one metal in another is one of great antiquity in the East, and was
no doubt brought to Spain by the Moors, from which country, perhaps by
way of Sicily, it spread to Italy. The word 'Tarsia,' applied as we have
already seen to inlays in wood, may have been derived by corruption from
'Tausia,' though, as the form 'Intarsia' is also common, a derivation
(unlikely) has been suggested from the Latin 'Interserere.' The 'in' is probably
only the preposition, that has become incorporated with the word it preceded.

of daggers, of knives and of every weapon that men
desire to have richly ornamented. Damascening is
done in this way. The worker makes undercut sinkings
in the iron [2] and beats in the gold by the force of a
hammer, having first made cuttings or little teeth like
those of a slender file underneath, so that the gold is
driven into these hollows and is fixed there.[3] Then by
means of tools, he enriches it with a pleasing design
of leaves or of whatever he fancies. All these designs
executed with threads of gold passed through the wire-
drawing plate [4] are twined over the surface of the iron
and beaten in with the hammer, so as to be fixed in the
method mentioned above. Let care however be taken
that the threads are thicker than the incised outlines so
as to fill these up and remain fixed into them. In this
craft numberless ingenious men have executed praise-
worthy things which have been esteemed marvellous; and
for this reason I have not wished to omit mention of it,
for it depends on inlaid work and so, partaking of the
nature of both sculpture and painting, is part of the
operations of the art of design.

[2] 'Cavasi il ferro in sotto squadra.'

[3] If the sinkings be undercut the further process of roughening the sunk
surfaces is hardly necessary, but the roughening or puncturing may suffice to
hold the inlaid metal when there is no actual undercutting of the sides
of the sinkings.

[4] The 'filiera,' or iron plate pierced with holes of various sizes for drawing
wires through, was known to Theophilus. See chapter 8 of Book III of the
Schedula, '*De ferris per quae fila trahuntur.*'

CHAPTER XXI. (XXXV.)

Of Wood Engraving and the method of executing it and concerning its first Inventor: how Sheets which appear to be drawn by hand and exhibit Lights and Half-tones and Shades are produced with three Blocks of Wood.

§ 107. *Chiaroscuro Wood Engravings.*

THE first inventor of engraving on wood in three pieces for showing not only the design but the shadows, half-tints, and lights also was Ugo da Carpi.[1] He invented the method of wood engraving in imitation of the engravings on copper, cutting them on the wood of the pear tree or the box which are excellent above all other kinds of wood for this work. He made his blocks

[1] Vasari does not attempt to deal with the art of wood engraving in general nor need this Note traverse the whole subject. In all these later chapters of the 'Introduction' to Painting he is dealing with forms of the decorative art in which various materials are put together so as to produce something of the effect of a picture. Hence all that he envisages in the department of wood engraving are what are called chiaroscuri, or engravings meant to produce the effect of shaded drawings by tints rather than by the lines which constitute engravings proper. It has been noticed that some writers on engraving, (ante, p. 20) have denied to these imitated light-and-shade drawings the character of true engravings.

As we have seen to be the case with copper-plate engraving (ante, p. 275) priority is now claimed in these chiaroscuri for Germany over Italy, and Ugo da Carpi, who was born about 1450, near Bologna, becomes rather the improver of a German process than the inventor of a new one. On July 24, 1516, when resident in Venice he petitions the Signoria of that city for privilege for his 'new method of printing in light and shade, a novel thing and not done before.' Lippmann (*The Art of Wood Engraving in Italy in the Fifteenth Century*, trans., London, 1888) thinks that this claim may be true 'in so far as he may have introduced further developments in the practice of colour printing with several blocks, which still survived in Venice,

then in three pieces,[2] placing on the first all that is contour and line; on the second all that is tinted near to the outline, putting in the shadow with water-colour; and on the third the lights and the ground leaving the white of the paper to give the light, and tingeing the rest for the ground. This third block containing the light and the ground, is executed in the following manner. A sheet printed by the first block, on which are all the contours

especially after the production of coloured wood-cuts by Burgkmair and Cranach in Germany had given fresh stimulus to a more artistic cultivation of that method' (p. 69), and that 'he gave the art an entirely new development based upon the principles which guided the profession of painting' (p. 136). This last phrase explains the interest that Vasari here manifests in his work. In the older wood engraving only lines had been left on the block to take the ink, the rest of the surface being cut away, and whatever was to be shown in the print was displayed in the lines alone. In the new method broad surfaces of the wood were left, on which was spread a film of ink or pigment, and these printed a corresponding tint upon the paper which took off the film thus laid. The pigment might be of any colour desired, or might only represent a lighter tint of the ink that had been used all along for the lines. Hence either an effect of colour or one merely of gradations of light-and-shade could equally well be produced by the process Vasari describes. The work he contemplates is of the latter kind, and his explanation of the process by which it was produced is fairly clear. Plate XIV, from a print by Ugo da Carpi in the British Museum, gives a specimen of the result.

Critics of Ugo da Carpi's work, which is sufficiently abundant, notice that he begins by merely adding tints of shading to outlines, which as in the earlier productions of the Germans, like those of Cranach or Dienecker, remained substantially responsible for the effect; but that he gives more and more importance to the tints, the pictorial element in the design, till the outlines end by merely reinforcing the chiaroscuro, like the touches 'a tempera' that give effect and decision to painting in fresco (Kristeller, *Kupferstich und Holzschnitt in vier Jahrhunderten*, Berlin, 1905, p. 300).

[2] That is, he made three blocks A, B, C, each the full size of the design, but each containing only a part of the work. A has engraved on it all the *lines* of the design, and a print from it would be an old-fashioned engraving proper. Such a print with the ink on it still wet is pressed down on a clean block of wood, on which it leaves indications of all these lines. The broad tints of shading, in which gradations may be introduced, are then laid on the block by hand, the outlines being a guide, and so is constituted block B, an impression from which printed on a sheet already printed from block A, and made to register accurately with this, would add shading to

PLATE XIV

CHIAROSCURO WOOD-ENGRAVING BY UGO DA CARPI

In the Print-Room, British Museum. Subject:—'Jacob's Dream,' after Raphael

and lines, is taken wet and placed on the plank of the pear tree and weighted down with other sheets which are not damp and so pressed upon that the wet sheet leaves on the board the impression of all the outlines of the figures. Then the painter takes white lead mixed with gum and puts in the lights on the pear-wood. After this is done the engraver cuts them all out with tools, according as they are marked. This block is that which, duly primed with oil colour,[3] is used for the first process, namely, to produce the lights and the ground, the whole surface, therefore, is left tinted except just where it is hollowed out, because there the paper remains white. The second block is that which gives shadows. It is quite flat and tinted with water-colour, except where the shadows are not to come, because there the wood is hollowed out. And the third, which is the first to be shaped, is that in which the whole outlined part is hollowed out all over, except where there are no profiles touched in with black by the pen.[4]

These are printed at the press and are put under it three times, i.e. once for each impression, so that they shall

the outlines. C would add by the same process a third tint, quite flat, for the background, and this might of course be of another colour. The high lights would be cut away in this block, C, and these parts come out white in the print, as is seen on Plate XIV. The uniform grey shade on the Plate is the background tint. In the actual process of printing this block, C, is first put into the press and produces an impression showing the tinted background but white spaces where the high lights are to come. B, with the shadows tinted but all the rest of the wood cut away, is printed over the impression from C, and lastly A comes to give the decided lines and sharpen up the whole effect.

[3] The 'oil colour' is the pigment which is transferred from the block to the paper. The 'water colour' and the 'white lead mixed with gum' mentioned above are only put on by the artist to guide the wood-cutter in his work of cutting the block.

[4] The text, in both the original editions, runs as follows: 'E la terza che è la prima a formarsi, è quella dove il profilato del tutto è incavato per tutto, salvo che dove e' non ha i profili tocchi dal nero della penna,' and the negative is puzzling, for obviously the wood must be cut away everywhere but in those places where the outlines do come.

severally have the same pressure. And certainly this was a most beautiful invention.

§ 108. *Dependence on Design of the Decorative Arts.*

All these lines of work and ingenious arts, as one sees, are derived from design, which is the necessary fount of all, for if they are lacking in design they have nothing.[5] Therefore although all processes and styles are good, that is best by which every lost thing is recovered and every difficult thing becomes easy : as we shall see in reading the Lives of the artists, who, aided by nature and by study have done superhuman things solely by means of design. And thus, making an end of the Introduction to the three Arts, treated perhaps at too great length, which in the beginning I did not intend, I pass on to write the Lives.

[5] But Theophilus says practically nothing about design, and yet the mediaeval epoch was for the decorative arts one of the most glorious the world has ever seen. See on this subject the last part of the Introductory Essay, ante, p. 20 f.

NOTES ON 'INTRODUCTION'
TO PAINTING

NOTES ON 'INTRODUCTION'
TO PAINTING

FRESCO PAINTING.

[§ 81, *The Fresco Process,* ante, p. 221.]

The fresco process is generally regarded as one of several methods for the production of pictures. It is better to consider it in the first place as a colour finish to plaster work. What it produces is a coloured surface of a certain quality of texture and a high degree of permanence, and it is a secondary matter that this coloured surface may be so diversified as to become a picture.

The history of the process is involved in obscurity, and it is not known who first observed the fact that colours mixed only with water when laid on a wet surface of lime plaster dried with the plaster and remained permanently attached to it. The technique was however known to the Romans, and we obtain the best idea of its essential character from the notice of it by Vitruvius in the third chapter of his seventh book. It is there treated in intimate connection with plaster work, as only the last stage in the technical treatment of a wall. The wall is constructed of stone or brick; it is then plastered; and the plaster is, or can be, finally finished with a wash of colour. Of the character of this antique plaster work something has already been said in a note to § 72, in connection with Sculpture (ante, p. 171). It could be finished either in a plain face of exquisite surface that might even be polished, or with stamped ornaments in relief or figures modelled by hand; but it could also be completed with colour in the form either of a plain tint

or a picture, and this colour would be applied by the fresco process.

Painting ' a fresco ' means painting on the freshly laid and still wet final coat of plaster. The pigments are mixed with nothing but pure water, and the palette of the artist is limited by the fact that practically speaking only the earth colours, such as the ochres, can be used with safety; even the white has to be made from lime—the Italians called it ' bianco San Giovanni '—as lead white, called ' biacca,' is inadmissible. Vegetable and metallic pigments are as a rule excluded from use. The reason why pigments mixed with water only, without any gum or similar binding material, adhere when dry to the plaster is a chemical one. The explanation of it was given by Otto Dönner in an Appendix to Helbig's *Campanische Wand-gemälde,* Leipzig, 1868, and is to be found also in Professor Church's *Chemistry of Paints and Painting.* When limestone is burnt into lime all the carbonic acid is driven out of it. The result of the slaking of the lime by water, which is preliminary to its use in plastering, is that the material becomes saturated with an aqueous solution of hydrate of lime. This hydrate of lime rises to the surface of the plaster, and when the pigment is laid on, to use Professor Church's phrasing, it ' diffuses into the paint, soaks it through and through, and gradually takes up carbonic acid from the air, thus producing carbonate of lime, which acts as the binding material.' To put the matter in simpler language, lime when burnt loses its carbonic acid, but gradually recovers it from the air, and incidentally this carbonic acid, as it is re-absorbed, serves to fix the colours used in the fresco process. It is a mistake to speak of the pigment ' sinking into the wet plaster.' It remains on the surface, but it is fixed there in a sort of crystalline skin of carbonate of lime which has formed on the surface of the plaster. This crystalline skin gives a certain metallic lustre to the surface of a fresco painting, and is sufficient to protect the colours from the action of external moisture, though on the other hand there are many causes chemical and physical that may contribute to their decay. If however proper care have been taken throughout, and atmospheric conditions remain favourable, the fresco painting is quite permanent.

The process of painting, it will be easily seen, must be a rapid one, for it must be completed before the plaster has time to dry, which it would do if left for a night. Hence only a certain portion of the work in hand is undertaken on each day and only so much of the final coat of plaster, called by the Italians ' intonaco,' is laid by the plasterer as will correspond to the amount the artist expects to cover before nightfall. At the end of the day's work, the plaster not painted on is cut away round the outline of the work actually finished, and the next morning a fresh patch is laid on and joined up as neatly as possible to that of yesterday. In the making of these joints the ancient plasterer seems to have been more expert than the Italians of the Renaissance, and the seams are often pretty apparent in frescoes of the fifteenth and sixteenth centuries, so that they can be discerned in a good photograph. When they can be followed, they furnish information, which it is often interesting to possess, as to the amount that has been executed in a single day.

To prevent loss of time it is necessary to have a full-sized cartoon in readiness so that the drawing can be at once transferred to the coat of wet plaster as soon as it has been laid. Vasari speaks of these cartoons in § 77, in the second chapter on Painting, ante, p. 213. The use of the iron stylus for impressing the lines of the drawing on the wet plaster is to be traced in some of the later Italian frescoes. Another process for carrying out the transfer was called ' pouncing.' For this the lines of the cartoon were pricked and dabbed with a muslin bag filled with powdered black, so as to show in dotted contours upon the wall.

Vasari is eloquent, both here and in a passage in his ' Proemio ' to his whole work, on the judgement, skill, and decision necessary to paint successfully in fresco under these conditions and within these limits of time. The ideal of the process was to complete each portion absolutely at the one sitting. When the wall is once dry, any retouching, reinforcement of shadows, and the like, must be done ' a secco,' ' on the dry,' that is with pigments mixed with size, egg, or some other tempera, which will bind them to the surface. These after-touches lack the quality of texture and permanence

of the true fresco (buon fresco). If size or gum have been used, they can be washed off the wall, and having been laid on a dry surface by a kind of hatching process they are harsh and 'liney.' It is often possible in good large-scale photographs to distinguish between the broad soft touches of the frescoist laid on while the ground was wet, and the hard dry hatchings of the subsequent retouching.

The illustration, Plate XV, has been chosen as a good example of the fresco technique. It shows the head of Mary from Luini's fresco of the 'Marriage of the Virgin' at Saronno. The painting is executed in a broad and facile manner, the tints and tones which give the colour and the modelling being deftly fused while the whole is wet, and the darker details, such as the locks of the hair, are struck over the moist ground so that the touches seem soft and have no appearance of hatching. The light-coloured leaves of the garland round the head show the same softness, and they are laid in with a full brush in thick pigment. On the other hand there are marks of retouching where the shadows round the eyes, the corner of the mouth, etc., have been reinforced 'a secco,' perhaps by a restorer. These show as thin, hard, wiry lines, and have quite a different appearance from the work on the wet plaster.

It was only in the palmy days of Italian painting, from the latter part of the fifteenth century onwards, that artists were able to dispense almost entirely with retouching. In the earlier period of Giotto and his successors much more was left to be done 'a secco,' but the Giottesques fully understood the importance of doing all they could on the wet plaster, and Cennini in the 67th chapter of his *Trattato* insists that 'to paint on the fresh, that is a fixed portion on each day, is the best and most permanent way of laying on the colour, and the pleasantest method of painting.' The truth is that the technique of 'buon fresco,' while apparently understood by the Romans, was lost in the west during the early middle ages, though it may have been maintained in the Byzantine cloisters. In the course of the progressive improvements in the art of painting in the fourteenth and fifteenth centuries the old technique was gradually recovered. Recently Ernst Berger, in his *Beiträge zur Entwicklungs-Geschichte der Maltechnik,* I and II, München,

PLATE XV

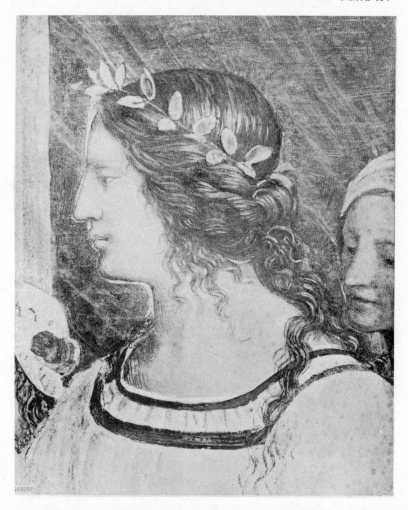

HEAD OF MARY, FROM LUINI'S FRESCO OF THE 'MARRIAGE
OF THE VIRGIN' AT SARONNO

(From a photograph by Giacomo Brogi)

2nd ed., 1904, has denied that the Romans used the fresco technique, and has evolved an ingenious theory of a derivation of fresco painting from the mural work in mosaic which flourished in the Early Christian centuries. See note, ante, p. 255. Into the question thus raised it is not necessary to enter, because no reader of Vitruvius or Pliny can have the shadow of a doubt that they knew and were referring to the fresco process. The words of Vitruvius (vii, iii) ' Colores autem, udo tectorio cum diligenter sunt inducti, ideo non remittunt sed sunt per- petuo permanentes, quod calx,' etc., and those of Pliny (xxxv, 49) ' udo inlini recusant ' employed of certain colours which are known not to be admissible in fresco are quite conclusive on this point, and it does not advance science to build up elaborate theories on a denial of obvious facts.

TEMPERA PAINTING.

[§ 82, *Painting in Tempera*, ante, p. 223.]

In his appreciation of technical processes Vasari, it will be seen, reserves his enthusiasm for fresco painting, but gives oil the advantage over tempera (ante, p. 230) in that it (1) 'kindles the colours,' i.e., gives them greater brilliancy ; (2) enables the artist to blend his pigments on the panel or canvas so as to secure a melting, or as the Italians say a ' sfumato ' or ' misty ' effect; (3) admits of a force and liveliness in execution which makes the figures seem in relief upon the surface, and finally (4), as he says at the beginning of chapter vii, is a great con- venience, ' una gran comodità all' arte della pittura.' The only corresponding advantages on the side of tempera, as detailed in § 82, ante, p. 223 f., are the facts that all pigments can be used in it, and that the same media serve for work on grounded or ungrounded panels or on the dry plaster of walls; and that paintings in tempera are very lasting. When Vasari came to write of his own works at the end of the *Lives* in the second edition, his conscience seems a little to have smitten him, and he gives the process a word of special commendation. He speaks of using it for some mural paintings in his private house which he had just built at Arezzo, and says, ' I have always reverenced the memory and the works of the ancients, and

seeing that this method of colouring " a tempera " has fallen
out of use, I conceived the desire of rescuing it from oblivion.
Hence I did all this work in tempera, a process that certainly
does not merit to be despised or neglected ' (*Opere,* vii, 686).

If antiquity and wide diffusion be criteria of rank among
painting processes, then tempera may claim the first place of
all. The Spaniard Pacheco, the father-in-law and teacher of
Velasquez, remarks on the veneration due to it because it
had its birthday with art itself. As a fact all the wall paint-
ings in ancient Egypt and Babylonia and Mycenaean Greece,
all the mummy cases and papyrus rolls in the first-named
country, are executed in tempera, and the same is probably true
of all the wall paintings in Italian tombs, as well as of the lost
mural work of Polygnotus and his school, and the panel paint-
ings of all the Greek artists save those who, in the later period
after Alexander, adopted encaustic. Though fresco was known
as a mural process to the Romans it was not used in the Early
Christian catacomb paintings, nor in the mediaeval wall
paintings north of the Alps, for all these were in tempera. For
panel painting, both in the East and the West, save for a
doubtful and in any case limited use of oil, tempera was in
constant employment till in the fifteenth century it began to be
superseded by the new oil media popularized by the van Eycks.
Even then tempera maintained its ground, and it is not always
realized that artists like Mantegna, Botticelli and Dürer were
as a rule in their panel work tempera painters. In the case
of mural work at any period fresco can really never have wholly
superseded tempera, for fresco can only be worked on fresh
plaster, while the artist must often have to decorate walls
already plastered and long ago dry. In this case there would
be a choice between replastering for fresco and the more
economical alternative of employing some form of tempera.

It is however with tempera painting on panels rather than
with mural work that we are here concerned. Vasari's sum-
mary treatment of the process in § 82 ante, p. 223, contrasts
with Cennini's far more elaborate directions, and is a measure
of the destructive effect of the inroad of oil painting on the
more venerable system. At the outset of his *Trattato* Cennini
gives a list of the processes the panel painter has to go

through. The preliminary ones, before painting actually begins, will take him six years to learn and Cennini needs about a hundred chapters to describe them. The artificer must know how to grind colours, to use glue, to fasten the linen on the panel, to prime with gesso, to scrape and smooth the gesso, to make reliefs in gesso, to put on bole, to gild, to burnish, to mix temperas, to lay on grounding colours, to transfer by pouncing through pricked lines, to sharpen lines with the stylus, to indent with little patterns, to carve, to colour, to ornament the panel, and finally to varnish it! All this suggests, what was actually the case, that the process of tempera painting was a very precise and methodical one, proceeding by regular stages according to traditional methods and recipes. The result was from the point of view of modern painting something very limited, but within its range, and in the hands of artists of the fifteenth century, it was a very finished and exquisite artistic product, one indeed to which we return with ever-renewed delight after our yearly visits to the Salon or to Burlington House. A certain natural reaction, that some artists of to-day have felt against the slashing impressionistic style, has led to a revival of the old precise technique, which is now cultivated in London in a Society of Painters in Tempera. It should be remembered that it is perfectly possible to paint ' a tempera ' in a free and loose fashion with a full impasto and individualistic handling. If dry powdered colours be mixed with the yolk or whole inside of an egg without dilution, the resulting pigment is as full of body as oil paint and can be manipulated in the same fashion. What is generally understood however by the tempera style is the painting of the fifteenth century on panel, in which, as Cennini indicates, the egg would be diluted with about its own bulk of water. This rendered the pigment comparatively thin and as a result transparent, and allowed coat to be laid over coat, so that Cennini contemplates seven or eight or even ten coats of colour tempered with egg yolk diluted with water. These are laid over an underpainting in a monochrome of terra verte, and are so transparent that even at the end the ground will remain slightly visible (c. 147) and so help the modelling. It is however a difficulty in tempera that it dries very quickly, too quickly

to admit of that fusing of the tints while the impasto is wet, which Vasari mentions as an advantage in the oil process, § 83, ante, p. 230. Hence the usual ways to model in tempera are (1) to superimpose coats varying in tone, and (2), to use hatching, a process very observable in early Italian temperas, such as some ascribed to Botticelli in the National Gallery. Another drawback, not so marked however in egg tempera as in the size tempera with a basis of whitening used by scenic artists, is that the colours dry lighter than they appear when wet. Those who in the present day are enamoured of the tempera process say that these inconveniences do not trouble them, while they delight in the purity of the tints, the precision of the forms, which it enables them to preserve, and in a certainty and reposefulness which seem to belong to it. One of these writes as the result of her experience ' In tempera you work with solid paints, and blending must be extremely rapid, or a substitute for this must be found in thin washes or in hatching. Crisp work is again a great beauty, but from the rapid drying of the paint in the brush, and its un-tenacious quality, it is a difficulty. Vasari is right in saying oil is a great *convenience,* but its introduction does not seem to have been in all respects a gain.'

OIL PAINTING.

[§ 83, *Oil Painting, its Discovery and Early History,*
ante, p. 226.]

The bare fact of the invention of oil painting by John of Bruges, recorded by Vasari in 1550 in chapter VII of his ' Introduction ' to Painting, is in the Life of Antonello da Messina, in the same edition, retold in the personal anecdotic vein that accords with Vasari's literary methods. Here the ' invention ' followed on the splitting of a particular tempera panel, varnished in oil, that according to traditional practice van Eyck had put out in the sun to dry. The said artist then turned his attention to devising some means for avoiding such mischances for the future, and, in Vasari's words, ' being not less dissatisfied with the varnish than with the process of tempera painting, he began to devise means for preparing a

kind of varnish which should dry in the shade, so as to avoid
having to place the pictures in the sun. Having made experi-
ments with many things both pure and in compounds, he at
last found that linseed and nut oil, among the many which he
had tested, were more drying than all the rest. These there-
fore, boiled with other mixtures of his, made him the varnish
which he had long desired.' This varnish, Vasari goes on to
say, he mixed with the colours and found that it ' lit up the
colours so powerfully that it gave a gloss of itself,' without
any after-coat of varnish.

If we ask What is the truth about this ' invention ' of van
Eyck, or of the brothers van Eyck (see ante, p. 226, note 1), the
first answer of any one knowing alike the earlier history of the
oil medium and Vasari's anecdotal predilections would be ' there
was no invention at all.' The drying properties of linseed and
nut oil, and the way to increase these, had been known for
hundreds of years, as had also the preparation of an oil varnish
with sandarac resin. There is question too of a colourless spirit
varnish, and of the process of mixing varnish with oil for a
painting medium, in documents prior to the fifteenth century.
The technique of oil painting is described by Theophilus, about
1100 A.D. ; in the *Hermeneia* or Mount Athos Handbook; and
in the *Trattato* of Cennini, while numerous accounts and records
of the thirteenth and fourteenth centuries establish incontestably,
at any rate for the lands north of the Alps, the employment of
oils and varnishes for artistic wall and panel painting. The
epitaphs for the tombs of the two van Eycks make no mention
of such a feat as Vasari ascribes to them, and it is quite open
to any one to argue, as is the case with M. Dalbon in his
recent *Origines de la Peinture à l'Huile,* Paris, 1904, that it
was no special improvement in technique that brought the van
Eycks their fame in connection with oil painting, but rather
an artistic improvement that consisted in using a traditional
process to execute pictures which in design, finish, beauty, and
glow of colour, far surpassed anything previously produced in
the northern schools. There is a good deal of force in this
view, but at the same time it is impossible to deny to the van
Eycks the credit of technical improvements. They had a
reputation for this long before the time of Vasari. In 1456,

fifteen years after the death of the younger brother Jan, Bar-
tolomeo Facio of Spezia wrote a tract *De Viris Illustribus* in
which he spoke of John van Eyck as specially ' learned in those
arts which contributed to the making of a picture, and on that
account credited with the discovery of many things in the pro-
perties of colours, which he had learned from ancient traditions
recorded by Pliny and other writers.' The Florentine Filarete,
c. 1464, knew of the repute of Jan van Eyck in connection
with the oil technique. Hence we may credit the van Eycks
with certain technical improvements on traditional practices
and preparations in the oil technique, though these can hardly
be termed the ' invention of oil painting,' while their artistic
achievement was great enough to force into prominence what-
ever in the technical department they had actually accomplished.

The question of the exact technique of the van Eycks, in its
relation to the oil practice before their time, is one that has
occupied many minds, and is not yet satisfactorily settled.
Most of those who have enunciated theories on the subject have
proceeded by guess-work, and have suggested media and pro-
cesses that may possibly have been used, but for the employ-
ment of which there is no direct evidence. The most recent
suggestion is that of Principal Laurie of Edinburgh, and this
is founded on scientific analysis. The experiments with oils
and varnishes and other media, which this investigator has
been carrying on for many years, have taught him that the
most secure substance for ' locking-up ' pigments as the phrase
goes, that is for shielding them from the access of moisture or
deleterious gases, is a resin, like our Canada balsam, that
may be used as a varnish or painting medium when dissolved
in an essential oil. As he believes he can detect in the van
Eycks' extant pictures pigments that would only have lasted
had they been shielded by a preparation of the kind, he
conjectures that the use of a natural pine balsam, with probably
a small proportion of drying oil and rendered more workable
by emulsifying with egg, may be the real secret of which so
many investigators have been in search. For example, the
green used for the robe of John Baptist and other figures in
the ' Adoration of the Lamb ' at Ghent can be matched, as
we lately found by experiment, with verdigris (dissolved in

pine balsam which is a much finer green than verdigris ground in oil) and yellow ochre or orpiment, and the only known way of rendering verdigris stable is to dissolve it in these pine balsams, according to a recipe that is actually preserved in the de Mayerne MS., which Berger has lately printed in full in the fourth Part of his *Beiträge*.

Be this as it may, one thing is certain, that the oil painting of the van Eycks and other painters of the early Flemish school did not differ greatly if at all in its artistic effect from the tempera that had preceded it, and that is described in the last note. Oil painting, in the sense that we attach to the term, is really the creation not of the Flemings, nor of the Florentines and other Italians who were the first to try experiments with the new Flemish process, but of Giovanni Bellini and the other Venetians who adopted the oil medium in the last quarter of the fifteenth century. According to Vasari, ante, p. 229, and *Life* of Antonello da Messina, *Opere*, ii, 563 f., it was the last named artist who acquired the secret of the invention of van Eyck through a visit to Flanders, and brought it to Venice. Vasari has been proved to be wrong in the chronology he gives of the life of Antonello, who was born about 1444 and was therefore much younger than Vasari makes him, and many critics have been disposed to relegate his whole account of the Sicilian painter to the realm of myth. The most recent authority on the subject however, Dr von Wurtzbach, in his *Niederländisches Künstler-Lexicon,* vindicates Vasari's accuracy in the main points of the visit to Flanders and the introduction of the new process at Venice, which event may be fixed about 1475. It was taken up with avidity by the Bellini and by other Venetians of the time, and it is to the younger Bellini more than to any other painter that is due the apprehension of the possibilities latent in the oil medium. Giovanni Bellini began to manipulate the oil pigments with a freedom and a feeling for their varied qualities of which earlier oil painters had possessed little idea, and the way was prepared for the splendid unfolding of the technique in the hands of Giorgione, Palma, and Titian.

ENRICHED FAÇADES.

[§§ 90-92, ante, p. 240 f.]

The external decorations, of which Vasari writes in chapters XI, XII, and XIII of his ' Introduction ' to Painting, have come down to us in a very dilapidated condition, but there are still to be seen specimens of all the work he there describes, as well as of the decorative carvings in stone noticed in the ' Introduction ' to Architecture, under the head of Travertine (at Rome) § 12, Istrian stone (at Venice) § 15, and Pietra forte (at Florence) § 17; ante, pp. 51, 56, 60. The most common technique is monochrome painting ' a fresco ' on the plaster, and a good deal that passes as sgraffito is really only painted work in which there is no relief. One of the best existing displays is that on the façade of the Palazzo Ricci, at Rome, a little to the west of the Palazzo Farnese. Here on the top floor are painted trophies of armour in bronze colour (ante, p. 241) with grotesques (ante, p. 244) in yellow and brown on the story below. On the *piano nobile* there is a frieze of figures in grisaille monochrome, with some single figures on a larger scale between the windows. Above the door is another frieze of figures on a black ground. More extensive, but less varied and not so well preserved, are the figure compositions on the back of the Palazzo Massimi, in the Piazza dei Massimi, at Rome, where the whole wall is covered with figure monochromes on a large scale on dark grounds. There are many more fragmentary specimens, as in the Via Maschera d' Oro, No. 7; the Via Pellegrino, No. 66, etc. The work of Maccari, *Roma, Graffiti e Chiaroscuri, Secolo XV, XVI,* gives a large collection of reproductions of work that has now to a great extent perished.

Sgraffito work, in which the effect is produced by differences of plane in the plaster itself (see ante, p. 243), resists the weather much better than mere painting, but it takes longer to execute and was not so much used as the more rapidly wrought fresco. The Palazzo Montalvo, in the Borgo degli Albizzi at Florence, offers a good example of a compromise. The work, at any rate in the lower part, is not true sgraffito as the plaster in the backgrounds is not scraped away, but the outlines of the

figures and ornaments are marked by lines incised in the plaster, the brush, with light and dark tints, accomplishing the rest. On the other hand the house of Bianca Capello, 26 in the Via Maggio, is decorated in the true sgraffito technique as described by Vasari, ante, p. 243. The same may be said of a house in Rome, Via Maschera d' Oro, No. 9, where the difference of the two planes of plaster is about an eighth of an inch. This work is clogged up with buff lime-wash and would be worth cleaning, as it seems in fair preservation.

Of modelled stucco figure-designs and grotesques the Cortile of the Palazzo Spada, near the Campo di Fiore at Rome, presents the most extensive display. A more interesting piece of work will however be found not far away in the Via de' Banchi Vecchi, Nos. 22-24, the house of the goldsmith Pietro Crivelli of Milan, of the first half of the sixteenth century. Here between the windows of the first floor are boldly designed trophies of arms carved in travertine, while between and above the windows of the second floor there are figures and grotesques effectively modelled in stucco. These are outlined with an incised line in the stucco and there is no colour. For free but not over-florid Renaissance enrichment the façade is noteworthy. The abundant stone carving at Florence in the form of the ' stemmi ' has been already referred to, ante, p. 61.

STUCCO 'GROTESQUES.'

[§ 92, *Grotesques or fanciful devices painted or modelled on walls, ante,* p. 244.]

Vasari touches on the subject of plaster work in all three ' Introductions,' to Architecture (§ 29), to Sculpture (§ 73) and to Painting (§ 92). In the former passages he deals with the material itself and with what may be called its utilitarian employment; in the last he has in view the artistic forms into which the material can be moulded, and which he calls by the curious name ' grotesques.' What these ' grotesques ' are will presently be seen, but it is worth while first casting a glance back on the artistic use of plaster in its historical aspects.

It is not a little remarkable that although all the great ancient nations were familiar with this material, it was not till

the late Greek and Greco-Roman periods that any general use was made of it as an independent vehicle of artistic effect. The Egyptians coated their walls with plaster of exquisite quality, which they brought to a fine, almost a polished, surface for their tempera paintings. The inhabitants of Mesopotamia protected their mud-brick walls with thin coats of lime plaster, sometimes only about a quarter of an inch in thickness but perfect in durability and weather-resisting properties. The Phoenicians at Carthage plastered the interior walls of their tombs, and the expression ' whited sepulchres ' shows that Jewish tombs were coated in the same fashion. All through the historical period of Greek art plaster was at the command of the architect, to cover, and fill up inequalities in, the rough stone of which so many of the Hellenic temples were built, and fragments of the pre-Persian buildings of the Athenian Acropolis, still preserved on the rock, show how finely finished and how adhesive was this stucco film. So far as we know however none of the peoples just named seem to have modelled in the material, or used it for any of the decorative purposes for which the Greeks at any rate employed so largely the material of burnt clay. The exception is in the case of the older Aegean peoples, for the Cretans of Knossos made, as all the world now knows, a most effective artistic use of modelled stucco. This Aegean work may be connected technically with Egypt, for in the latest Egyptian period a considerable use was made of modelled plaster for sepulchral purposes, in the form of mummy-cases in which the features of the deceased, with headdress, jewels, etc., were represented in this material. The technique may go back in Egypt to the remoter times and may have been carried thence to the Aegean lands. The process however was apparently not inherited by the historical Greeks, who did not begin to use plaster freely and artistically till the later Hellenistic or Greco-Roman period.

Some late Greek private houses of the second or first century B.C., on Delos, show a beginning of modelled plaster work in the form of drafted ashlar stones imitated in the material, and it may be conjectured that the technique was developed at Alexandria, for the earliest existing mature works in the style, the famous stucco reliefs and mouldings found near the

Villa Farnesina at Rome, resemble in many respects the so-called ' Hellenistic ' reliefs, with landscape motives, that are ascribed to the school of Alexandria. In these stuccoes, now preserved in the Terme Museum at Rome, there are bands of enrichment stamped with wooden moulds, after the fashion described by Vasari in the ' Introduction ' to Sculpture, § 73, that enclose fields wherein figure compositions with landscape adjuncts, or single figures, have been modelled by hand. Many of these last are of great beauty of form, and the whole have been executed with the lightest but firmest touch and the most delightful freedom. Some ceiling decorations in two tombs on the Via Latina, of the second century A.D., are almost as good in execution, and are interesting as giving in typical form ancient models that have been much copied at the Renaissance and in more modern times.

Early Christian artists, both in the West and in the East kept up the artistic use of stamped or modelled stucco. The Arabs inherited the technique, and at Cairo, and in the East and in Spain, they made a very extensive and tasteful use of the tractable material in their own style of artistic decoration. This style, like that of Byzantium, from which in great part it was derived; and that of the familiar Indian work in the exquisite marble-dust plaster or chunam, is chiefly surface decoration, without much plastic feeling, and relying mainly on geometrical, or at any rate inorganic, motives and forms. Bold modelling of forms accentuated by light and shade, as we are kindly informed by Dr James Burgess, does occur in old Buddhist work in northern India, and some excellent examples have recently been published in *Ancient Khotan* (Chinese Turkistan) Oxford, 1907, vol. I, p. 587 and pl. liii ff. The work however belongs essentially to the West rather than to the East, and the middle-ages in Western Europe produced some remarkable works in this style. There is some modelled stucco-work of early date in the Baptistry at Ravenna, but the most interesting examples of the period in Italy are the large figures of saints and the archivolt enriched with very bold and effective vine scrolls, that are to be seen in the interior of the little oratory of S. Maria in Valle (or Peltrude's chapel) at Cividale in Friuli. These very remarkable works, with which may be

connected the stuccoes of the altar ciborium at S. Ambrogio, Milan, date about 1100, and may be paralleled by similar figures, equally plastic in treatment, and of about the same period, north of the Alps, in St Michael's at Hildesheim. Signor Cattaneo calls the Cividale work 'Byzantine,' but life-sized plastically-treated figures in high relief represent a form of decorative art that was not practised at Byzantium, and the work, like a good deal else that is too lightly dubbed 'Byzantine,' is no doubt of western origin, and is a proof that the tradition of modelling in plaster was handed down without a break through the mediaeval period.

At the Renaissance the tradition was revived, and this style of decoration was developed in Tuscany and North Italy, while one of its most conspicuous triumphs was the adornment by Italian artists in the first half of the sixteenth century of the Galerie François Premier and Escalier du Roi at Fontainebleau in France. It spread also to our own country, where artists of the Italian school carried out work in the same thoroughly plastic style in the now destroyed palace of Nonsuch, under the patronage of Henry VIII.

This is not however the style that Vasari has in view when he speaks of 'stucco grotesques.' What he means is an imitation of ancient stamped and modelled plaster decoration, of the type of that represented in the tombs on the Via Latina just referred to. Here the scale is small, though the work may cover large spaces, and the design is on the whole of a light and fanciful kind. The impulse to it dates from the early years of the sixteenth century when considerable discoveries were made at Rome, in the Baths of Titus and elsewhere, of antique apartments or sepulchral chambers decorated in this fashion. As these interiors, when discovered, were all underground they were called 'caves' or 'grottoes,' and for this reason, as Benvenuto Cellini informs us in the 6th chapter of his *Autobiography,* the decoration characteristic of them was called 'grottesque.' The fact that the designs were so commonly of the fantastic or so-called 'Pompeian' order has given to the word 'grotesque' its modern meaning of bizarre or semi-ludicrous.

According to Vasari, the painter Morto da Feltro (c. 1474-

c. 1519) was the first to study these antique decorations. ' Our first thanks and commendations ' he says (*Opere,* ed. Milanesi, v, 205 f.) ' are due to Morto, who was the first to discover and restore the kind of painting called " arabesques " and " grottesques," seeing that they were for the most part hidden among the subterraneous portions of the ruins of Rome, whence he brought them, devoting all his study to this branch of art.' He spent many months also, Vasari tells us, at Tivoli among the ruins of Hadrian's Villa, and made a journey to Pozzuoli near Naples, all on the same quest. Stucco reliefs in this revived antique style were used at the beginning of the sixteenth century by Pinturicchio in the Appartamenti Borgia in the Vatican, and from that time onwards they become exceedingly common.

TARSIA WORK, OR WOOD INLAYS.

[§ 100, *Inlays in Wood,* ante, p. 262.]

The covering of one kind of material by another, for reasons of a constructive or an aesthetic kind, is so primitive and so universal that Gottfried Semper made it the fundamental principle of decoration in general, and developed this view in his famous ' Bekleidungstheorie,' which dominates *der Stil.* Semper's philosophy of art was sufficiently profound for him to see that this process is not to be accused of insincerity because the more costly or beautiful material appears only on the outside, while the mass of the structure may be of commoner fabric. The materials in question are as a rule limited in quantity and it would be bad economy to employ them in positions where their beauty would not be seen. To build a thick wall of rare finely-veined and coloured marble in solid blocks would be to behave like degenerate Roman Emperors. Such material is far more suitably treated when it is exposed in thin layers over as large a superficial area as possible. Hence though there is nothing in the world to equal the fine ' isodomon ' masonry of the earlier Greeks, which is the same throughout, there is much to be said in justification of the late Greek and Roman technique, so largely used in mediaeval

Italy, of incrusting a common material with one of finer grain and colour.

In the case of wood inlays, it may be claimed for the craft that it originates in material need and not in any aesthetic considerations. Wood, of which the grain always runs one way, needs sometimes to be overlaid, braced, and prevented from warping by a slip of the same material placed with the grain at right angles to the first, after the fashion seen in our common drawing-boards. The great variety in colours and markings shown by different woods must however at a very early date have led to the employment of inlays and veneers for reasons of artistic effect, and in this craft the old Oriental peoples were proficient. It is worthy of notice that some Greek wood inlays have survived, and may be seen in the Kertch room at the Hermitage in St Petersburg. The motives of all early inlays are either geometrical patterns or simple conventional ornament, like the olive sprays which are represented in the Greek work just mentioned. In these forms the craft was preserved through the mediaeval period, and though in the West, at any rate north of the Alps, the mediaeval epoch was one in which ornamentation was plastic rather than graphic, that is to say, in carving more often than in inlay, yet in Moorish lands, and in parts of Italy, inlays, both in stone and wood, were freely developed.

The history of Italian tarsia work takes a new start with the beginning of the Renaissance, and it became as Bode has termed it ' a true child of the art of the Quattrocento ' or fifteenth century. The earliest examples seem to be in geometrical schemes, influenced by the so-called ' Cosmati ' work, or inlays of small pieces of coloured stones and gilded pastes, so common in Italy from the twelfth to the fourteenth century. The painted borders to the frescoes of Giotto and other pre-Renaissance masters imitate this kind of work and show how familiar it must have been. Next come conventional ornaments in the so-called ' Italian ' manner, consisting in acanthus scrolls, swags of fruit and flowers, with classical motives such as horns of plenty and candelabra, among which are soon introduced ' putti ' or Cupids, terminal figures, etc. As the fifteenth century advanced there was developed the curious *penchant,* noticed ante, p. 264,

for introducing perspective delineations of buildings and articles of furniture into the tarsia designs. Vasari in his Life of Filippo Brunelleschi *Opere,* ed. Milanesi, II, 333 (see also the text ante, p. 262), distinctly intimates that this was due to the influence of this artist, whose enthusiasm for perspective studies is well known. The only existing works in wood inlay which might claim to be designed or inspired by Brunelleschi are those in the old sacristy of S. Lorenzo at Florence, but these do not display perspectives, and the subjects comprise only ' putti ' with candelabra, rosettes, and other simple ornaments. The influence of Brunelleschi on the advancement of the study of perspective was however so great, that Vasari's view of his general responsibility for the perspectives is credible.

With the perspective designs of the latter part of the fifteenth and beginning of the sixteenth century, was developed the elaborate delineation of objects of still life, as well as more ambitious work in the representation of the human figure, alone or in groups. These inlays were abundantly displayed in wall panelling and on the doors of presses, and more especially on the backs and frames of choir stalls in the churches. It is characteristic of Italian decoration as opposed to that prevailing at an earlier date north of the Alps, to find choir stalls, which in northern churches are made the occasion of the most splendid display of wood carving in the boldest architectural and plastic styles which the world has to show, decorated in Italy for the most part in a pictorial style with flat inlays.

The number of extant examples, both in the case of presses and of choir stalls, is so great that no enumeration is possible, and the reader is referred for a critical account of the chief monuments of the art to the small book by Dr Scherer, *Technik und Geschichte der Intarsia,* Leipzig, 1891. The artists who fostered the work were also very numerous, and represent many centres in the northern parts of Italy. We learn for instance that in Florence alone in the year 1478 there were no fewer than 84 *botteghe* where tarsia work was in full practice. The names actually mentioned by Vasari will suffice to represent the chief phases of the craft. If Brunelleschi may have started the idea of perspective designs, these were carried out to great perfection by Fra Giovanni da Verona, whose master-works, the

stalls and presses in S. Maria in Organo at Verona, dating from about 1500 onwards, are among the most famous examples of the kind. Here are perspectives of buildings and furniture, objects of still-life, and the like, with geometrical patterns in the framings and on the dado. In figure work Benedetto da Majano, whom Vasari mentions, and more especially his brother Giuliano da Majano, were masters of the very first rank, and the examples left by the latter on the presses of the sacristy of the Duomo at Florence, and on the door leading to the Sala d' Udienza in the Palazzo Vecchio, are masterpieces of technique and style. At a later date near the middle of the century, the artist mentioned by Vasari towards the end of his chapter XVII, Fra Damiano of Bergamo, a pupil of the same Venetian school from which proceeded Fra Giovanni of Verona, executed at S. Domenico in Bologna a series of works in tarsia that represent the furthest development in a pictorial direction that the craft ever attained.

Of this display however Dr Scherer aptly writes (p. 80) that, 'whoever demands from wood an effect similar to that of a picture, sets it in ignorance of its nature to tasks that are beyond its capabilities, and constrains material and technique to exaggerated efforts which are contradictory to their character. This is the fundamental error that clings to all the works of the much-belauded Fra Damiano and is calculated seriously to obscure his greatness.' The development of tarsia work was in the direction of pictorial effects. Though purely decorative patterns of a geometrical or conventional kind were always used, they tended as the art advanced to be confined to borders and subsidiary parts of a design, while the principal fields were pictorially treated. The introduction of perspectives naturally led to the accentuation of the third dimension of objects, and in still-life compositions modelling and shading were deemed essential. The human figure, the use of which increased greatly as the fifteenth century advanced, was given its plastic roundness which it was assuming in the contemporary frescoes. Conventional leafage, etc., was no longer treated for the effect of a mere flat pattern. In the latter part of the century the figure work of Giuliano da Majano shows how far in this direction the art could be carried while still preserving

PLATE XVI

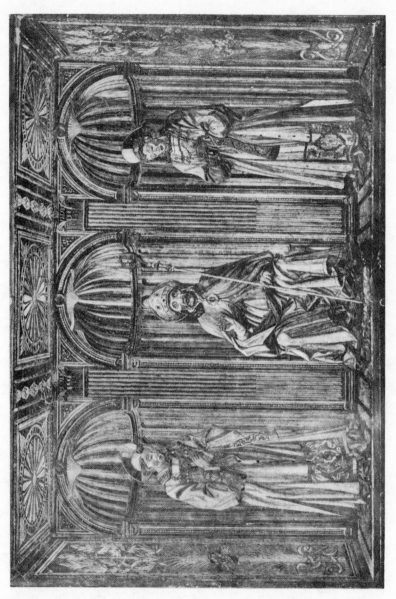

EXAMPLE OF TARSIA WORK

S. Zenobi, by Giuliano da Majano, in Opera del Duomo, Florence

its sincerity as a mosaic of natural woods. In this work the utmost advantage is taken of the varieties shown by woods in colour and texture, without dependence on artificial colouring matters, and those pictorial refinements over which Vasari sings his usual paean, but which really prefigure the decline of the art. A close examination of a specimen of Giuliano's inlays of about 1470-80, such as the S. Zenobi now in the Opera del Duomo at Florence (see Plate XVI), shows extraordinary skill and patience in the laborious work. The outlines are marked by thin strips of black wood; the staff which the Saint holds in his hand, though it is not half-an-inch broad, is modelled in light and shade with no fewer than six parallel strips of wood varying in light and dark. The hands are carefully modelled in inlays. The mouth of the figure on the right of the Saint has one piece for the upper lip and a lighter piece for the lower in which the two lights on the lobes are let in with separate pieces. The shadow between the lips and the light on the lower edge of the lower lip are inserted with strips of dark and light tinted wood. In one of the most interesting works of the da Majano brothers, the two portrait figures of Dante and Petrarch, on the door leading into the Sala d' Udienza in the Palazzo Vecchio at Florence, the face of the older poet is deeply furrowed, and in order to prevent the inlaid streaks appearing too hard and ' liney ' they are made up of an infinite number of little morsels of wood the size and shape of millet grains, each one glued down into its place. Such work impresses the spectator by its sincerity and earnestness as well as by its technical mastery.

The use of artificial colouring matters, over and above the burning which was the first device employed to give an effect of shading in special places, destroys for us this aspect of sincerity. The material is no longer allowed to express itself in its own character, and taste revolts from the work as it does from tapestry in which pigments have been used to give details for which stitches should in the theory of the work suffice. The case is different from that of the coloured wax medallions noticed ante, p. 188 f., where the scale is so small, and the detailed representation of nature so essential a part of the work, that waxes coloured in the piece could hardly be made to avail.

THE STAINED GLASS WINDOW.

[§ 101, *Stained Glass Windows, their Origin and History,*
ante, p. 265.]

This is not a specially Italian form of the decorative art, but belongs rather to France and north-western Europe. A proof of this may be found in the fact that in 1436 the Florentines have to send for a worker in glass from Lübeck in Germany to make windows for their Duomo (Gaye, *Carteggio,* ii, 441 f.), while at the beginning of the next century Pope Julius II summons French *verriers* to supply coloured windows for the Vatican (see ante, p. 266, note). The art was differently regarded north and south of the Alps, and Vasari in his account of it gives, in § 102, the tradition of the northern schools, but lets us see at the same time, in § 101, how the Italians were accustomed to envisage the craft.

There is accordingly in his treatment a confusion between two distinct ideals of the art, one traditional and northern, the other congenial to an Italian painter of the sixteenth century. According to the first ideal of the art, that on which it was founded and nurtured north of the Alps, it depended for its effect upon coloured glass, that is upon the varied tints of pieces of glass stained in the mass with metallic oxides, and called by the moderns 'pot metal.' These different coloured pieces were so arranged and so treated as to give the appearance of figures or ornaments, and to this extent the effect was pictorial, but such a window would depend for its beauty far more on the sumptuous display of coloured light than on any delineation of figures or objects.

The sort of window which would present itself to the Italian of the Renaissance, as representing his ideal of the art, is rather a transparent picture painted on glass, in which delineation is the chief part of the effect. This is the view that Vasari has in mind, when, in § 101, he insists on transparency in the glass employed. The old glass worker of Chartres or the Sainte Chapelle would hardly have known what to do with transparent uncoloured glass, for this, save in pearl borders, was not an element with which he worked. Vasari however starts with the

idea of clear glass and imagines it coloured in such a way as to produce a transparent picture. There were two methods for this colouring. The only satisfactory one was to paint in transparent enamel colours which were afterwards burnt in on to the glass. This was a process specially developed in the fifteenth and sixteenth centuries in Flanders, whence it was probably introduced into Italy.

The other method was to employ transparent pigments, such as were used for ordinary painting, and to fix them on the glass by means of gum or varnish. This method is of course a mere *pis aller* to which no self-respecting worker in glass would like to have recourse, and must be regarded as merely a cheap imitation of true glass painting in enamel colours. That is to say, it did not *precede,* as Vasari suggests in § 101, but followed as an imitation, the development of true enamel painting. That the two processes were in use in Italy in Vasari's time is shown by a contract printed by Gaye, *Carteggio,* II, 446, in which certain windows to be executed at Arezzo in 1478 are to be ' *cotte al fuoco,*' ' burned in the fire,' and not merely to have the colours ' *messi a olio,*' ' laid on in oil-paint.'

The earlier glass workers of the palmy days of the craft, from the twelfth to the fourteenth century, in France, England, Flanders, or Germany, aimed at different effects altogether, and their technique is explained by Vasari in § 102, (ante, p. 268), where the whole character of the work envisaged differs from the painted work previously in contemplation. As is indicated in a foot-note to the text, the description of the work, which starts it will be noticed with ' bits of red, yellow, blue, and white glass,' not with a clear pane, is almost exactly what we find in Theophilus, though a little less simple, and represents the early tradition of the mediaeval masters. Their work was the development of an Early Christian technique. Coloured glass, which it must be remembered is really easier to procure than glass perfectly clear, was first used in little rounds or squares for insertion in the holes pierced in marble or plaster slabs that filled window openings. Such window fillings are to be seen in mosques and Byzantine churches. The next stage was a mosaic of pieces of coloured glass arranged on a certain scheme and perhaps displaying geometrical patterns. No speci-

mens of early windows of this kind seem to have survived, but they are referred to in contemporary documents, as in the *Liber Pontificalis,* where it is said that Leo III, 795-816, in Old St. Peter's, ' fenestras de apsida ex vitro diversis coloribus conclusit.' It is not clear whether such mosaics, or something more pictorial, is referred to by Abbot Gozbert of Tegernsee about the year 1000 A.D. as ' *discoloria picturarum vitra,*' but about this same epoch we find it stated of Archbishop Adalberon of Reims, who died in 989 A.D., that he supplied his church with ' *fenestris diversas continentibus historias,*' which certainly implies something more than the kaleidoscope effect of a mere conjunction of coloured pieces. Theophilus, whose treatment of the process shows that it was fully established at the time of his writing, say about 1100 A.D., makes it clear wherein the innovation consisted. The new invention was that of a pigment, of a brown colour when fused, with which could be painted any details or shading required for representing the forms of objects. A mere patch of pale flesh-coloured glass the shape of a face would tell nothing, but when the features, the locks of the hair, and the like, were painted in with this pigment then the patch became a human countenance. In the same way a piece of red or blue glass with some lines and shading on it became a garment, and so on with the representation in a simple and summary fashion of the objects necessary to constitute the sort of pictorial representation suitable to the technique. The coloured glass remained throughout the essential element in the effect. All the finest glass windows of the twelfth and thirteenth centuries were executed with these simple media. The later history of the art shows as usual a progressive advance in the importance of the pictorial element, till by the sixteenth century coloured glass is scarcely needed, and the pictorial effect desired may be gained by fusing pigments on to clear glass, in the way Vasari contemplates in § 101 (ante, p. 267).

Of this Italian stained glass of the Renaissance period very good examples are to be seen in the Laurentian Library at Florence, and a specimen is shown on Plate XVII.

Chapter XIII of Charles Heath Wilson's *Life and Works of Michelangelo* contains a good critical notice of the decorative

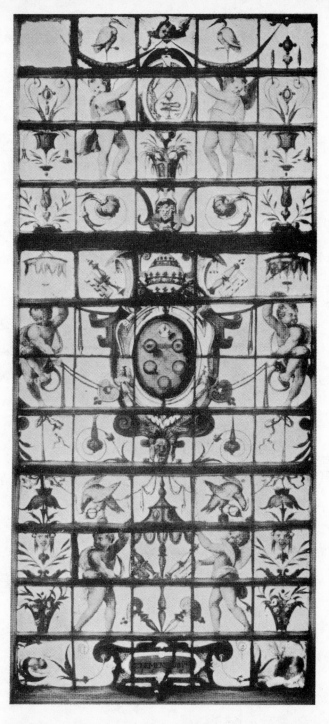

PAINTED
GLASS
WINDOW
IN THE
LAURENTIAN
LIBRARY,
FLORENCE

work at the Laurentian Library. The windows, which were not executed till long after the death of Clement VII whose name appears on the glass, he thinks may be mainly from the designs of Vasari's friend Francesco Salviati, a pupil of the glass painter Guglielmo da Marcillat. He writes of them :—
' These windows both in design and colour are admirably suited to Italian architecture, and offer useful lessons at the present time. Introduced into a Library where plenty of light was indispensable, white glass prevails. There is much yellow (silver) stain, and where colour is wanted in some parts, pot metal is introduced, but there is not much of it. The shadows are vigorously painted in enamel brown of a rich tone. Unlike modern painted glass, the figures and ornaments are drawn with all the skill of an educated artist, and it is a pleasure to look at them.'

The Victoria and Albert Museum in London affords the opportunity for a comparison of all these different styles. There is some original glass of the thirteenth century from the Sainte Chapelle at Paris, made of small pieces of very richly tinted glass, coloured in the mass, the effect being more that of a very rich and beautiful diaper pattern than a picture; while close by may be seen a Flemish window of 1542, in which the pieces of glass are of large size and in many cases are white, the necessary colouring being added in different enamel pigments. The subject is the Last Supper, and a purely pictorial result is aimed at, the effect of colour being as a fact extremely poor.

VASARI'S DESCRIPTION OF ENAMEL WORK.

[§ 105, *Enamels over Reliefs,* ante, p. 276.]

Coloured vitreous pastes are among the most valuable materials at the command of the decorative artist, and are employed in numerous crafts, as for example for the glazes of keramic products including floor or wall tiles, for painted glass windows, for glass mosaic, and for enamel work. The glass is tinged in the mass with various metallic oxides, one of the finest colours being a ruby red gained from gold. Silver gives yellow, copper a blue-green, cobalt blue, manganese violet, and so on. Tin in any form has the property of making the vitreous

paste opaque. The material is generally lustrous, and it admits of a great variety in colours some of which are highly saturated and beautiful. It is on the lustre and colour of the substance, more than on the pictorial designs that can be produced by its aid, that its artistic value depends.

The difference between opaque and transparent coloured glass is the basis of a division that can be made among the crafts which employ the material. If the glass be kept transparent the finest possible effect is obtained from it in the stained glass window where the colours are seen by transmitted light. A similar effect is secured on a minute scale in that form of enamel work called by Labarte ' emaux à plique à jour,' or ' transparent cloisonné enamel,' in which transparent coloured pastes are fused into small apertures in metal plates. Old examples in this kind are very rare, but modern workers seem to reproduce it without difficulty. On the other hand transparent or more usually opaque vitreous pastes in thin films form many of the so-called ' glazes ' which give the charm of lustre and colour to so many products of the potter's art. The most effective use of opaque coloured glass is in wall mosaic, where it is seen by reflected light, and owes its beauty to its lustrousness as well as to the richness and variety of its hues. Between these two crafts of the stained-glass window and mosaic comes that of the enameller, who makes use of vitreous pastes both in an opaque and a transparent condition. The identity of the materials in these different uses is shown by the fact that Theophilus, Bk. ii, ch. 12, directs the enameller to pound up and melt for his incrustations the very cubes used in old mosaics, or as he puts it ' in antiquis aedificiis paganorum in musivo opere diversa genera vitri.' Enamel work consists in fusing these coloured pastes over surfaces that are generally of metal, the different tints being either distinctly separated by divisions, or else running beside each other, or again interpenetrating like the colours in a picture. Hence there are two main divisions of the enameller's craft, the painted enamel where the colours are fused on to the metal but produce an effect similar to that of a painting executed with the brush, the special advantage of the enamel being its lustre; and the encrusted enamel, where the effect is more like that of mosaic. Vasari would have

thoroughly appreciated the painted enamels, known generally as enamels of Limoges, which are complete pictures, but, though Cellini mentions them, they originated north of the Alps and only came into general vogue after Vasari's time. The incrusted enamels are earlier, and of these he only describes one particular kind that had its home specially in Italy.

The earliest known enamels, whether Western or Byzantine or Oriental in origin, have the different colours separated in compartments divided from each other by ridges of metal which give the lines of the design. These so-called ' champlevé ' and ' cloisonné ' enamels there is no need to discuss, but it may be noted that the pastes used in them, though highly lustrous, are opaque, and cover completely the metal over which they are laid. The enamel described by Vasari differs from these earlier enamels in compartments in that the pastes are transparent, so that the ground shows through. The divisions between the colours also are not so marked. In this kind of work transparent vitreous pastes are fused over a metal ground that has been chased in low relief, so that the light and shade of the relief shows through the transparent coloured film. The work is very delicate and on a small scale, and the ground is nearly always gold or silver. A slight sinking is made in a plate of one of these metals where the enamel is to come, and at the bottom of this sinking the subject is carved or chased in very low relief, so low indeed that Cellini compares the height of it to the thickness of two sheets of paper (*Dell' Oreficeria*, c. 111). The transparent enamels are then fused over the different parts of the design, the contours of the figures or objects being just allowed to show as fine lines of metal between the different colours.

Examples of this work are rare, but the Victoria and Albert Museum and the British Museum have some good specimens. Transparent enamels are used also in other ways, and are sometimes arranged in apertures (see above) so as to show by transmitted light. Labarte's *Histoire des Arts Industriels* is still indispensable as an authority on various kinds of enamel work, though there is a whole literature on the theme.

INDEX

Potters' ; clay, 240 ; 'soap,' *277.*
Pouncing, as method of transfer, *289.*
Pozzuoli, Pozzuolo, 66, *303.*
Prato, 42, *127.*
Praxiteles ; 180 ; his 'Hermes,' *44.*
Presses, decorated, *305.*
Primaticcio, *171, 183.*
Priming, directions for, 230 ff.
'Prisoners,' porphyry figures in Boboli Gardens, 29.
Probert, *History of Miniature Art, 190.*
Proceedings of Huguenot Society, *189.*
Proportions of the human figure, 146, *180* f.
Pulvinated frieze, 79.
Pumice stone, for polishing ; bronze, 165 ; marble, 49, 152 ; niellos, 274.
'Puntelli,' for measuring statues, *194.*

Quellenschriften, the Vienna, *2, 6, 92.*

Rabelais, his Abbey of Theleme, *139.*
Raffaello da Urbino, see 'Raphael.'
Ragionamenti, see 'Vasari, his writings.'
Rags covered with clay, for drapery, 150, 208.
Raimondi, Marc Antonio, *274, 275.*
Raphael ; *14, 15, 134, 188,* 220, 230, 260 ; the *Report* on Roman Monuments, *134.*
Ravello, *111.*
Ravenna ; mosaics, 252 ; stuccoes in Baptistry, *301.*
Recipes : *6, 20* :
 black ; filling for marble monochromes, 260 ; for niellos, 274 ;
 for transferring, 215 :
 bronzes and metal alloys, 163 :
 keeping clay soft, 150 :
 core for a bronze casting, 159 :
 'egg-shell' mosaic, *137* :
 enamels, fluxes for, *277* :
 envelope for a bronze casting, 161, 166 :

gesso, 'grosso' and 'sottile,' *249* :
gilding, 248 f. :
glass ; gilding, 254 ; painting on (burnt in), 269, *310,* (unburnt), 267 ; yellow stain for, 270, *311* :
 ink, drawing, 213 :
 preparing mosaic cubes, *254* :
 mucilages, 173, 213 :
 oil paint, mixing, 230, *295* f. :
 patina, artificial ; for bronze, 166 ; for silver, *273* :
 priming, 230 ff. :
 polishing, see 'Polishing' :
 sgraffito, 243 f. :
 retouching media for fresco, 222, *289* :
 stone, painting on, 238 :
 stucco ; for enriched vaults and 'grotesques,' 86, 170 ; for setting glass mosaic, 255 f., *256* ; for setting mosaic pavements, 92 ; for preparing a wall for oil painting, 232 f. ; retarding its setting, *150* :
 temperas, for painting, 224, *293* f. ; for decorative painting, etc., 240 f. :
 tempering baths for steel, 30, 32, *112* :
 tiles, variegated, 260 :
 'verdaccio,' *242* :
 vitreous pastes, coloured, *311* :
 preparing walls for oil painting, 232 f. :
 wax ; for bronze-casting, 160 ; for coloured effigies, *189* ; for modelling, 148 :
 white, lime, (bianco Sangiovanni) *221* :
 colouring woods for tarsia work, 262 f.
Reliefs ; origin of, 154 ; influence of painting and perspective on, *196* f. ; terminology of, *154* ;
 antique, 154, *196* ; flat (stiacciati), 156 f. ; low (bassi), 156 ; pictorial or perspective, 154 f., *196* f. ;
 in cast bronze, *197* f. ; in baked clay, *197* f. ; in marble, *197* f. ; in metal repoussé, *198* ;
 Andrea Pisano's, *199* ; Dona-

**A CATALOGUE OF SELECTED DOVER BOOKS
IN ALL FIELDS OF INTEREST**

A CATALOGUE OF SELECTED DOVER
BOOKS IN ALL FIELDS OF INTEREST

RACKHAM'S COLOR ILLUSTRATIONS FOR WAGNER'S RING. Rackham's finest mature work—all 64 full-color watercolors in a faithful and lush interpretation of the *Ring*. Full-sized plates on coated stock of the paintings used by opera companies for authentic staging of Wagner. Captions aid in following complete Ring cycle. Introduction. 64 illustrations plus vignettes. 72pp. 8⅝ x 11¼. 23779-6 Pa. $6.00

CONTEMPORARY POLISH POSTERS IN FULL COLOR, edited by Joseph Czestochowski. 46 full-color examples of brilliant school of Polish graphic design, selected from world's first museum (near Warsaw) dedicated to poster art. Posters on circuses, films, plays, concerts all show cosmopolitan influences, free imagination. Introduction. 48pp. 9⅜ x 12¼.
23780-X Pa. $6.00

GRAPHIC WORKS OF EDVARD MUNCH, Edvard Munch. 90 haunting, evocative prints by first major Expressionist artist and one of the greatest graphic artists of his time: *The Scream, Anxiety, Death Chamber, The Kiss, Madonna*, etc. Introduction by Alfred Werner. 90pp. 9 x 12.
23765-6 Pa. $5.00

THE GOLDEN AGE OF THE POSTER, Hayward and Blanche Cirker. 70 extraordinary posters in full colors, from Maitres de l'Affiche, Mucha, Lautrec, Bradley, Cheret, Beardsley, many others. Total of 78pp. 9⅜ x 12¼. 22753-7 Pa. $5.95

THE NOTEBOOKS OF LEONARDO DA VINCI, edited by J. P. Richter. Extracts from manuscripts reveal great genius; on painting, sculpture, anatomy, sciences, geography, etc. Both Italian and English. 186 ms. pages reproduced, plus 500 additional drawings, including studies for *Last Supper*, Sforza monument, etc. 860pp. 7⅞ x 10¾. (Available in U.S. only)
22572-0, 22573-9 Pa., Two-vol. set $15.90

THE CODEX NUTTALL, as first edited by Zelia Nuttall. Only inexpensive edition, in full color, of a pre-Columbian Mexican (Mixtec) book. 88 color plates show kings, gods, heroes, temples, sacrifices. New explanatory, historical introduction by Arthur G. Miller. 96pp. 11⅜ x 8½. (Available in U.S. only) 23168-2 Pa. $7.95

UNE SEMAINE DE BONTÉ, A SURREALISTIC NOVEL IN COLLAGE, Max Ernst. Masterpiece created out of 19th-century periodical illustrations, explores worlds of terror and surprise. Some consider this Ernst's greatest work. 208pp. 8⅛ x 11. 23252-2 Pa. $6.00

DRAWINGS OF WILLIAM BLAKE, William Blake. 92 plates from Book of Job, *Divine Comedy, Paradise Lost,* visionary heads, mythological figures, Laocoon, etc. Selection, introduction, commentary by Sir Geoffrey Keynes. 178pp. 8⅛ x 11. 22303-5 Pa. $4.00

ENGRAVINGS OF HOGARTH, William Hogarth. 101 of Hogarth's greatest works: *Rake's Progress, Harlot's Progress, Illustrations for Hudibras, Before and After, Beer Street and Gin Lane,* many more. Full commentary. 256pp. 11 x 13¾. 22479-1 Pa. $12.95

DAUMIER: 120 GREAT LITHOGRAPHS, Honore Daumier. Wide-ranging collection of lithographs by the greatest caricaturist of the 19th century. Concentrates on eternally popular series on lawyers, on married life, on liberated women, etc. Selection, introduction, and notes on plates by Charles F. Ramus. Total of 158pp. 9⅜ x 12¼. 23512-2 Pa. $6.00

DRAWINGS OF MUCHA, Alphonse Maria Mucha. Work reveals drafts-man of highest caliber: studies for famous posters and paintings, render-ings for book illustrations and ads, etc. 70 works, 9 in color; including 6 items not drawings. Introduction. List of illustrations. 72pp. 9⅜ x 12¼. (Available in U.S. only) 23672-2 Pa. $4.00

GIOVANNI BATTISTA PIRANESI: DRAWINGS IN THE PIERPONT MORGAN LIBRARY, Giovanni Battista Piranesi. For first time ever all of Morgan Library's collection, world's largest. 167 illustrations of rare Piranesi drawings—archeological, architectural, decorative and visionary. Essay, detailed list of drawings, chronology, captions. Edited by Felice Stampfle. 144pp. 9⅜ x 12¼. 23714-1 Pa. $7.50

NEW YORK ETCHINGS (1905-1949), John Sloan. All of important American artist's N.Y. life etchings. 67 works include some of his best art; also lively historical record—Greenwich Village, tenement scenes. Edited by Sloan's widow. Introduction and captions. 79pp. 8⅜ x 11¼. 23651-X Pa. $4.00

CHINESE PAINTING AND CALLIGRAPHY: A PICTORIAL SURVEY, Wan-go Weng. 69 fine examples from John M. Crawford's matchless private collection: landscapes, birds, flowers, human figures, etc., plus calligraphy. Every basic form included: hanging scrolls, handscrolls, album leaves, fans, etc. 109 illustrations. Introduction. Captions. 192pp. 8⅞ x 11¾. 23707-9 Pa. $7.95

DRAWINGS OF REMBRANDT, edited by Seymour Slive. Updated Lipp-mann, Hofstede de Groot edition, with definitive scholarly apparatus. All portraits, biblical sketches, landscapes, nudes, Oriental figures, classical studies, together with selection of work by followers. 550 illustrations. Total of 630pp. 9⅛ x 12¼. 21485-0, 21486-9 Pa., Two-vol. set $15.00

THE DISASTERS OF WAR, Francisco Goya. 83 etchings record horrors of Napoleonic wars in Spain and war in general. Reprint of 1st edition, plus 3 additional plates. Introduction by Philip Hofer. 97pp. 9⅜ x 8¼. 21872-4 Pa. $4.00

THE SENSE OF BEAUTY, George Santayana. Masterfully written discussion of nature of beauty, materials of beauty, form, expression; art, literature, social sciences all involved. 168pp. 5⅜ x 8½. 20238-0 Pa. $3.00

ON THE IMPROVEMENT OF THE UNDERSTANDING, Benedict Spinoza. Also contains *Ethics, Correspondence,* all in excellent R. Elwes translation. Basic works on entry to philosophy, pantheism, exchange of ideas with great contemporaries. 402pp. 5⅜ x 8½. 20250-X Pa. $4.50

THE TRAGIC SENSE OF LIFE, Miguel de Unamuno. Acknowledged masterpiece of existential literature, one of most important books of 20th century. Introduction by Madariaga. 367pp. 5⅜ x 8½.
20257-7 Pa. $4.50

THE GUIDE FOR THE PERPLEXED, Moses Maimonides. Great classic of medieval Judaism attempts to reconcile revealed religion (Pentateuch, commentaries) with Aristotelian philosophy. Important historically, still relevant in problems. Unabridged Friedlander translation. Total of 473pp. 5⅜ x 8½. 20351-4 Pa. $6.00

THE I CHING (THE BOOK OF CHANGES), translated by James Legge. Complete translation of basic text plus appendices by Confucius, and Chinese commentary of most penetrating divination manual ever prepared. Indispensable to study of early Oriental civilizations, to modern inquiring reader. 448pp. 5⅜ x 8½. 21062-6 Pa. $5.00

THE EGYPTIAN BOOK OF THE DEAD, E. A. Wallis Budge. Complete reproduction of Ani's papyrus, finest ever found. Full hieroglyphic text, interlinear transliteration, word for word translation, smooth translation. Basic work, for Egyptology, for modern study of psychic matters. Total of 533pp. 6½ x 9¼. (Available in U.S. only) 21866-X Pa. $5.95

THE GODS OF THE EGYPTIANS, E. A. Wallis Budge. Never excelled for richness, fullness: all gods, goddesses, demons, mythical figures of Ancient Egypt; their legends, rites, incarnations, variations, powers, etc. Many hieroglyphic texts cited. Over 225 illustrations, plus 6 color plates. Total of 988pp. 6⅛ x 9¼. (Available in U.S. only)
22055-9, 22056-7 Pa., Two-vol. set $16.00

THE STANDARD BOOK OF QUILT MAKING AND COLLECTING, Marguerite Ickis. Full information, full-sized patterns for making 46 traditional quilts, also 150 other patterns. Quilted cloths, lame, satin quilts, etc. 483 illustrations. 273pp. 6⅞ x 9⅝. 20582-7 Pa. $4.95

CORAL GARDENS AND THEIR MAGIC, Bronsilaw Malinowski. Classic study of the methods of tilling the soil and of agricultural rites in the Trobriand Islands of Melanesia. Author is one of the most important figures in the field of modern social anthropology. 143 illustrations. Indexes. Total of 911pp. of text. 5⅝ x 8¼. (Available in U.S. only)
23597-1 Pa. $12.95

THE PHILOSOPHY OF HISTORY, Georg W. Hegel. Great classic of Western thought develops concept that history is not chance but a rational process, the evolution of freedom. 457pp. 5⅜ x 8½. 20112-0 Pa. $4.50

LANGUAGE, TRUTH AND LOGIC, Alfred J. Ayer. Famous, clear introduction to Vienna, Cambridge schools of Logical Positivism. Role of philosophy, elimination of metaphysics, nature of analysis, etc. 160pp. 5⅜ x 8½. (Available in U.S. only) 20010-8 Pa. $2.00

A PREFACE TO LOGIC, Morris R. Cohen. Great City College teacher in renowned, easily followed exposition of formal logic, probability, values, logic and world order and similar topics; no previous background needed. 209pp. 5⅜ x 8½. 23517-3 Pa. $3.50

REASON AND NATURE, Morris R. Cohen. Brilliant analysis of reason and its multitudinous ramifications by charismatic teacher. Interdisciplinary, synthesizing work widely praised when it first appeared in 1931. Second (1953) edition. Indexes. 496pp. 5⅜ x 8½. 23633-1 Pa. $6.50

AN ESSAY CONCERNING HUMAN UNDERSTANDING, John Locke. The only complete edition of enormously important classic, with authoritative editorial material by A. C. Fraser. Total of 1176pp. 5⅜ x 8½.
20530-4, 20531-2 Pa., Two-vol. set $16.00

HANDBOOK OF MATHEMATICAL FUNCTIONS WITH FORMULAS, GRAPHS, AND MATHEMATICAL TABLES, edited by Milton Abramowitz and Irene A. Stegun. Vast compendium: 29 sets of tables, some to as high as 20 places. 1,046pp. 8 x 10½. 61272-4 Pa. $14.95

MATHEMATICS FOR THE PHYSICAL SCIENCES, Herbert S. Wilf. Highly acclaimed work offers clear presentations of vector spaces and matrices, orthogonal functions, roots of polynomial equations, conformal mapping, calculus of variations, etc. Knowledge of theory of functions of real and complex variables is assumed. Exercises and solutions. Index. 284pp. 5⅝ x 8¼. 63635-6 Pa. $5.00

THE PRINCIPLE OF RELATIVITY, Albert Einstein et al. Eleven most important original papers on special and general theories. Seven by Einstein, two by Lorentz, one each by Minkowski and Weyl. All translated, unabridged. 216pp. 5⅜ x 8½. 60081-5 Pa. $3.50

THERMODYNAMICS, Enrico Fermi. A classic of modern science. Clear, organized treatment of systems, first and second laws, entropy, thermodynamic potentials, gaseous reactions, dilute solutions, entropy constant. No math beyond calculus required. Problems. 160pp. 5⅜ x 8½.
60361-X Pa. $3.00

ELEMENTARY MECHANICS OF FLUIDS, Hunter Rouse. Classic undergraduate text widely considered to be far better than many later books. Ranges from fluid velocity and acceleration to role of compressibility in fluid motion. Numerous examples, questions, problems. 224 illustrations. 376pp. 5⅝ x 8¼. 63699-2 Pa. $5.00

THE COMPLETE BOOK OF DOLL MAKING AND COLLECTING, Catherine Christopher. Instructions, patterns for dozens of dolls, from rag doll on up to elaborate, historically accurate figures. Mould faces, sew clothing, make doll houses, etc. Also collecting information. Many illustrations. 288pp. 6 x 9. 22066-4 Pa. $4.50

THE DAGUERREOTYPE IN AMERICA, Beaumont Newhall. Wonderful portraits, 1850's townscapes landscapes; full text plus 104 photographs. The basic book. Enlarged 1976 edition. 272pp. 8¼ x 11¼. 23322-7 Pa. $7.95

CRAFTSMAN HOMES, Gustav Stickley. 296 architectural drawings, floor plans, and photographs illustrate 40 different kinds of "Mission-style" homes from *The Craftsman* (1901-16), voice of American style of simplicity and organic harmony. Thorough coverage of Craftsman idea in text and picture, now collector's item. 224pp. 8⅛ x 11. 23791-5 Pa. $6.00

PEWTER-WORKING: INSTRUCTIONS AND PROJECTS, Burl N. Osborn. & Gordon O. Wilber. Introduction to pewter-working for amateur craftsman. History and characteristics of pewter; tools, materials, step-by-step instructions. Photos, line drawings, diagrams. Total of 160pp. 7⅞ x 10¾. 23786-9 Pa. $3.50

THE GREAT CHICAGO FIRE, edited by David Lowe. 10 dramatic, eyewitness accounts of the 1871 disaster, including one of the aftermath and rebuilding, plus 70 contemporary photographs and illustrations of the ruins—courthouse, Palmer House, Great Central Depot, etc. Introduction by David Lowe. 87pp. 8¼ x 11. 23771-0 Pa. $4.00

SILHOUETTES: A PICTORIAL ARCHIVE OF VARIED ILLUSTRATIONS, edited by Carol Belanger Grafton. Over 600 silhouettes from the 18th to 20th centuries include profiles and full figures of men and women, children, birds and animals, groups and scenes, nature, ships, an alphabet. Dozens of uses for commercial artists and craftspeople. 144pp. 8⅜ x 11¼. 23781-8 Pa. $4.50

ANIMALS: 1,419 COPYRIGHT-FREE ILLUSTRATIONS OF MAMMALS, BIRDS, FISH, INSECTS, ETC., edited by Jim Harter. Clear wood engravings present, in extremely lifelike poses, over 1,000 species of animals. One of the most extensive copyright-free pictorial sourcebooks of its kind. Captions. Index. 284pp. 9 x 12. 23766-4 Pa. $8.95

INDIAN DESIGNS FROM ANCIENT ECUADOR, Frederick W. Shaffer. 282 original designs by pre-Columbian Indians of Ecuador (500-1500 A.D.). Designs include people, mammals, birds, reptiles, fish, plants, heads, geometric designs. Use as is or alter for advertising, textiles, leathercraft, etc. Introduction. 95pp. 8¾ x 11¼. 23764-8 Pa. $3.50

SZIGETI ON THE VIOLIN, Joseph Szigeti. Genial, loosely structured tour by premier violinist, featuring a pleasant mixture of reminiscenes, insights into great music and musicians, innumerable tips for practicing violinists. 385 musical passages. 256pp. 5⅝ x 8¼. 23763-X Pa. $4.00

TONE POEMS, SERIES II: TILL EULENSPIEGELS LUSTIGE STREICHE, ALSO SPRACH ZARATHUSTRA, AND EIN HELDEN-LEBEN, Richard Strauss. Three important orchestral works, including very popular *Till Eulenspiegel's Marry Pranks,* reproduced in full score from original editions. Study score. 315pp. 9⅜ x 12¼. (Available in U.S. only) 23755-9 Pa. $8.95

TONE POEMS, SERIES I: DON JUAN, TOD UND VERKLARUNG AND DON QUIXOTE, Richard Strauss. Three of the most often performed and recorded works in entire orchestral repertoire, reproduced in full score from original editions. Study score. 286pp. 9⅜ x 12¼. (Available in U.S. only) 23754-0 Pa. $7.50

11 LATE STRING QUARTETS, Franz Joseph Haydn. The form which Haydn defined and "brought to perfection." (*Grove's*). 11 string quartets in complete score, his last and his best. The first in a projected series of the complete Haydn string quartets. Reliable modern Eulenberg edition, otherwise difficult to obtain. 320pp. 8⅜ x 11¼. (Available in U.S. only) 23753-2 Pa. $7.50

FOURTH, FIFTH AND SIXTH SYMPHONIES IN FULL SCORE, Peter Ilyitch Tchaikovsky. Complete orchestral scores of Symphony No. 4 in F Minor, Op. 36; Symphony No. 5 in E Minor, Op. 64; Symphony No. 6 in B Minor, "Pathetique," Op. 74. Bretikopf & Hartel eds. Study score. 480pp. 9⅜ x 12¼. 23861-X Pa. $10.95

THE MARRIAGE OF FIGARO: COMPLETE SCORE, Wolfgang A. Mozart. Finest comic opera ever written. Full score, not to be confused with piano renderings. Peters edition. Study score. 448pp. 9⅜ x 12¼. (Available in U.S. only) 23751-6 Pa. $11.95

"IMAGE" ON THE ART AND EVOLUTION OF THE FILM, edited by Marshall Deutelbaum. Pioneering book brings together for first time 38 groundbreaking articles on early silent films from *Image* and 263 illustrations newly shot from rare prints in the collection of the International Museum of Photography. A landmark work. Index. 256pp. 8¼ x 11. 23777-X Pa. $8.95

AROUND-THE-WORLD COOKY BOOK, Lois Lintner Sumption and Marguerite Lintner Ashbrook. 373 cooky and frosting recipes from 28 countries (America, Austria, China, Russia, Italy, etc.) include Viennese kisses, rice wafers, London strips, lady fingers, hony, sugar spice, maple cookies, etc. Clear instructions. All tested. 38 drawings. 182pp. 5⅜ x 8. 23802-4 Pa. $2.50

THE ART NOUVEAU STYLE, edited by Roberta Waddell. 579 rare photographs, not available elsewhere, of works in jewelry, metalwork, glass, ceramics, textiles, architecture and furniture by 175 artists—Mucha, Seguy, Lalique, Tiffany, Gaudin, Hohlwein, Saarinen, and many others. 288pp. 8⅜ x 11¼. 23515-7 Pa. $6.95

THE AMERICAN SENATOR, Anthony Trollope. Little known, long un-available Trollope novel on a grand scale. Here are humorous comment on American vs. English culture, and stunning portrayal of a heroine/villainess. Superb evocation of Victorian village life. 561pp. 5⅜ x 8½.
23801-6 Pa. $6.00

WAS IT MURDER? James Hilton. The author of *Lost Horizon* and *Goodbye, Mr. Chips* wrote one detective novel (under a pen-name) which was quickly forgotten and virtually lost, even at the height of Hilton's fame. This edition brings it back—a finely crafted public school puzzle resplendent with Hilton's stylish atmosphere. A thoroughly English thriller by the creator of Shangri-la. 252pp. 5⅜ x 8. (Available in U.S. only)
23774-5 Pa. $3.00

CENTRAL PARK: A PHOTOGRAPHIC GUIDE, Victor Laredo and Henry Hope Reed. 121 superb photographs show dramatic views of Central Park: Bethesda Fountain, Cleopatra's Needle, Sheep Meadow, the Blockhouse, plus people engaged in many park activities: ice skating, bike riding, etc. Captions by former Curator of Central Park, Henry Hope Reed, provide historical view, changes, etc. Also photos of N.Y. landmarks on park's periphery. 96pp. 8½ x 11. 23750-8 Pa. $4.50

NANTUCKET IN THE NINETEENTH CENTURY, Clay Lancaster. 180 rare photographs, stereographs, maps, drawings and floor plans recreate unique American island society. Authentic scenes of shipwreck, light-houses, streets, homes are arranged in geographic sequence to provide walking-tour guide to old Nantucket existing today. Introduction, captions. 160pp. 8⅞ x 11¾. 23747-8 Pa. $6.95

STONE AND MAN: A PHOTOGRAPHIC EXPLORATION, Andreas Feininger. 106 photographs by *Life* photographer Feininger portray man's deep passion for stone through the ages. Stonehenge-like megaliths, forti-fied towns, sculpted marble and crumbling tenements show textures, beau-ties, fascination. 128pp. 9¼ x 10¾. 23756-7 Pa. $5.95

CIRCLES, A MATHEMATICAL VIEW, D. Pedoe. Fundamental aspects of college geometry, non-Euclidean geometry, and other branches of mathe-matics: representing circle by point. Poincare model, isoperimetric prop-erty, etc. Stimulating recreational reading. 66 figures. 96pp. 5⅝ x 8¼.
63698-4 Pa. $2.75

THE DISCOVERY OF NEPTUNE, Morton Grosser. Dramatic scientific history of the investigations leading up to the actual discovery of the eighth planet of our solar system. Lucid, well-researched book by well-known historian of science. 172pp. 5⅜ x 8½. 23726-5 Pa. $3.50

THE DEVIL'S DICTIONARY. Ambrose Bierce. Barbed, bitter, brilliant witticisms in the form of a dictionary. Best, most ferocious satire America has produced. 145pp. 5⅜ x 8½. 20487-1 Pa. $2.25

HISTORY OF BACTERIOLOGY, William Bulloch. The only comprehensive history of bacteriology from the beginnings through the 19th century. Special emphasis is given to biography-Leeuwenhoek, etc. Brief accounts of 350 bacteriologists form a separate section. No clearer, fuller study, suitable to scientists and general readers, has yet been written. 52 illustrations. 448pp. 5⅝ x 8¼. 23761-3 Pa. $6.50

THE COMPLETE NONSENSE OF EDWARD LEAR, Edward Lear. All nonsense limericks, zany alphabets, Owl and Pussycat, songs, nonsense botany, etc., illustrated by Lear. Total of 321pp. 5⅜ x 8½. (Available in U.S. only) 20167-8 Pa. $3.95

INGENIOUS MATHEMATICAL PROBLEMS AND METHODS, Louis A. Graham. Sophisticated material from Graham *Dial*, applied and pure; stresses solution methods. Logic, number theory, networks, inversions, etc. 237pp. 5⅜ x 8½. 20545-2 Pa. $4.50

BEST MATHEMATICAL PUZZLES OF SAM LOYD, edited by Martin Gardner. Bizarre, original, whimsical puzzles by America's greatest puzzler. From fabulously rare *Cyclopedia*, including famous 14-15 puzzles, the Horse of a Different Color, 115 more. Elementary math. 150 illustrations. 167pp. 5⅜ x 8½. 20498-7 Pa. $2.75

THE BASIS OF COMBINATION IN CHESS, J. du Mont. Easy-to-follow, instructive book on elements of combination play, with chapters on each piece and every powerful combination team—two knights, bishop and knight, rook and bishop, etc. 250 diagrams. 218pp. 5⅜ x 8½. (Available in U.S. only) 23644-7 Pa. $3.50

MODERN CHESS STRATEGY, Ludek Pachman. The use of the queen, the active king, exchanges, pawn play, the center, weak squares, etc. Section on rook alone worth price of the book. Stress on the moderns. Often considered the most important book on strategy. 314pp. 5⅜ x 8½. 20290-9 Pa. $4.50

LASKER'S MANUAL OF CHESS, Dr. Emanuel Lasker. Great world champion offers very thorough coverage of all aspects of chess. Combinations, position play, openings, end game, aesthetics of chess, philosophy of struggle, much more. Filled with analyzed games. 390pp. 5⅜ x 8½. 20640-8 Pa. $5.00

500 MASTER GAMES OF CHESS, S. Tartakower, J. du Mont. Vast collection of great chess games from 1798-1938, with much material nowhere else readily available. Fully annotated, arranged by opening for easier study. 664pp. 5⅜ x 8½. 23208-5 Pa. $7.50

A GUIDE TO CHESS ENDINGS, Dr. Max Euwe, David Hooper. One of the finest modern works on chess endings. Thorough analysis of the most frequently encountered endings by former world champion. 331 examples, each with diagram. 248pp. 5⅜ x 8½. 23332-4 Pa. $3.75

SECOND PIATIGORSKY CUP, edited by Isaac Kashdan. One of the greatest tournament books ever produced in the English language. All 90 games of the 1966 tournament, annotated by players, most annotated by both players. Features Petrosian, Spassky, Fischer, Larsen, six others. 228pp. 5⅜ x 8½. 23572-6 Pa. $3.50

ENCYCLOPEDIA OF CARD TRICKS, revised and edited by Jean Hugard. How to perform over 600 card tricks, devised by the world's greatest magicians: impromptus, spelling tricks, key cards, using special packs, much, much more. Additional chapter on card technique. 66 illustrations. 402pp. 5⅜ x 8½. (Available in U.S. only) 21252-1 Pa. $4.95

MAGIC: STAGE ILLUSIONS, SPECIAL EFFECTS AND TRICK PHO-TOGRAPHY, Albert A. Hopkins, Henry R. Evans. One of the great classics; fullest, most authorative explanation of vanishing lady, levitations, scores of other great stage effects. Also small magic, automata, stunts. 446 illus-trations. 556pp. 5⅜ x 8½. 23344-8 Pa. $6.95

THE SECRETS OF HOUDINI, J. C. Cannell. Classic study of Houdini's incredible magic, exposing closely-kept professional secrets and revealing, in general terms, the whole art of stage magic. 67 illustrations. 279pp. 5⅜ x 8½. 22913-0 Pa. $4.00

HOFFMANN'S MODERN MAGIC, Professor Hoffmann. One of the best, and best-known, magicians' manuals of the past century. Hundreds of tricks from card tricks and simple sleight of hand to elaborate illusions involving construction of complicated machinery. 332 illustrations. 563pp. 5⅜ x 8½. 23623-4 Pa. $6.00

MADAME PRUNIER'S FISH COOKERY BOOK, Mme. S. B. Prunier. More than 1000 recipes from world famous Prunier's of Paris and London, specially adapted here for American kitchen. Grilled tournedos with anchovy butter, Lobster a la Bordelaise, Prunier's prized desserts, more. Glossary. 340pp. 5⅜ x 8½. (Available in U.S. only) 22679-4 Pa. $3.00

FRENCH COUNTRY COOKING FOR AMERICANS, Louis Diat. 500 easy-to-make, authentic provincial recipes compiled by former head chef at New York's Fitz-Carlton Hotel: onion soup, lamb stew, potato pie, more. 309pp. 5⅜ x 8½. 23665-X Pa. $3.95

SAUCES, FRENCH AND FAMOUS, Louis Diat. Complete book gives over 200 specific recipes: bechamel, Bordelaise, hollandaise, Cumberland, apri-cot, etc. Author was one of this century's finest chefs, originator of vichyssoise and many other dishes. Index. 156pp. 5⅜ x 8. 23663-3 Pa. $2.75

TOLL HOUSE TRIED AND TRUE RECIPES, Ruth Graves Wakefield. Authentic recipes from the famous Mass. restaurant: popovers, veal and ham loaf, Toll House baked beans, chocolate cake crumb pudding, much more. Many helpful hints. Nearly 700 recipes. Index. 376pp. 5⅜ x 8½. 23560-2 Pa. $4.50

"OSCAR" OF THE WALDORF'S COOKBOOK, Oscar Tschirky. Famous American chef reveals 3455 recipes that made Waldorf great; cream of French, German, American cooking, in all categories. Full instructions, easy home use. 1896 edition. 907pp. 6⅝ x 9⅜. 20790-0 Clothbd. $15.00

COOKING WITH BEER, Carole Fahy. Beer has as superb an effect on food as wine, and at fraction of cost. Over 250 recipes for appetizers, soups, main dishes, desserts, breads, etc. Index. 144pp. 5⅜ x 8½. (Available in U.S. only) 23661-7 Pa. $2.50

STEWS AND RAGOUTS, Kay Shaw Nelson. This international cookbook offers wide range of 108 recipes perfect for everyday, special occasions, meals-in-themselves, main dishes. Economical, nutritious, easy-to-prepare: goulash, Irish stew, boeuf bourguignon, etc. Index. 134pp. 5⅜ x 8½.
23662-5 Pa. $2.50

DELICIOUS MAIN COURSE DISHES, Marian Tracy. Main courses are the most important part of any meal. These 200 nutritious, economical recipes from around the world make every meal a delight. "I . . . have found it so useful in my own household,"—*N.Y. Times.* Index. 219pp. 5⅜ x 8½. 23664-1 Pa. $3.00

FIVE ACRES AND INDEPENDENCE, Maurice G. Kains. Great back-to-the-land classic explains basics of self-sufficient farming: economics, plants, crops, animals, orchards, soils, land selection, host of other necessary things. Do not confuse with skimpy faddist literature; Kains was one of America's greatest agriculturalists. 95 illustrations. 397pp. 5⅜ x 8½.
20974-1 Pa.$3.95

A PRACTICAL GUIDE FOR THE BEGINNING FARMER, Herbert Jacobs. Basic, extremely useful first book for anyone thinking about moving to the country and starting a farm. Simpler than Kains, with greater emphasis on country living in general. 246pp. 5⅜ x 8½.
23675-7 Pa. $3.50

PAPERMAKING, Dard Hunter. Definitive book on the subject by the foremost authority in the field. Chapters dealing with every aspect of history of craft in every part of the world. Over 320 illustrations. 2nd, revised and enlarged (1947) edition. 672pp. 5⅜ x 8½. 23619-6 Pa. $7.95

THE ART DECO STYLE, edited by Theodore Menten. Furniture, jewelry, metalwork, ceramics, fabrics, lighting fixtures, interior decors, exteriors, graphics from pure French sources. Best sampling around. Over 400 photographs. 183pp. 8⅜ x 11¼. 22824-X Pa. $6.00

ACKERMANN'S COSTUME PLATES, Rudolph Ackermann. Selection of 96 plates from the *Repository of Arts,* best published source of costume for English fashion during the early 19th century. 12 plates also in color. Captions, glossary and introduction by editor Stella Blum. Total of 120pp. 8⅜ x 11¼. 23690-0 Pa. $4.50

THE CURVES OF LIFE, Theodore A. Cook. Examination of shells, leaves, horns, human body, art, etc., in *"the* classic reference on how the golden ratio applies to spirals and helices in nature "—Martin Gardner. 426 illustrations. Total of 512pp. 5⅜ x 8½. 23701-X Pa. $5.95

AN ILLUSTRATED FLORA OF THE NORTHERN UNITED STATES AND CANADA, Nathaniel L. Britton, Addison Brown. Encyclopedic work covers 4666 species, ferns on up. Everything. Full botanical information, illustration for each. This earlier edition is preferred by many to more recent revisions. 1913 edition. Over 4000 illustrations, total of 2087pp. 6⅛ x 9¼. 22642-5, 22643-3, 22644-1 Pa., Three-vol. set $25.50

MANUAL OF THE GRASSES OF THE UNITED STATES, A. S. Hitchcock, U.S. Dept. of Agriculture. The basic study of American grasses, both indigenous and escapes, cultivated and wild. Over 1400 species. Full descriptions, information. Over 1100 maps, illustrations. Total of 1051pp. 5⅜ x 8½. 22717-0, 22718-9 Pa., Two-vol. set $15.00

THE CACTACEAE,, Nathaniel L. Britton, John N. Rose. Exhaustive, definitive. Every cactus in the world. Full botanical descriptions. Thorough statement of nomenclatures, habitat, detailed finding keys. The one book needed by every cactus enthusiast. Over 1275 illustrations. Total of 1080pp. 8 x 10¼. 21191-6, 21192-4 Clothbd., Two-vol. set $35.00

AMERICAN MEDICINAL PLANTS, Charles F. Millspaugh. Full descriptions, 180 plants covered: history; physical description; methods of preparation with all chemical constituents extracted; all claimed curative or adverse effects. 180 full-page plates. Classification table. 804pp. 6½ x 9¼.
 23034-1 Pa. $12.95

A MODERN HERBAL, Margaret Grieve. Much the fullest, most exact, most useful compilation of herbal material. Gigantic alphabetical encyclopedia, from aconite to zedoary, gives botanical information, medical properties, folklore, economic uses, and much else. Indispensable to serious reader. 161 illustrations. 888pp. 6½ x 9¼. (Available in U.S. only)
 22798-7, 22799-5 Pa., Two-vol. set $13.00

THE HERBAL or GENERAL HISTORY OF PLANTS, John Gerard. The 1633 edition revised and enlarged by Thomas Johnson. Containing almost 2850 plant descriptions and 2705 superb illustrations, Gerard's *Herbal* is a monumental work, the book all modern English herbals are derived from, the one herbal every serious enthusiast should have in its entirety. Original editions are worth perhaps $750. 1678pp. 8½ x 12¼.
 23147-X Clothbd. $50.00

MANUAL OF THE TREES OF NORTH AMERICA, Charles S. Sargent. The basic survey of every native tree and tree-like shrub, 717 species in all. Extremely full descriptions, information on habitat, growth, locales, economics, etc. Necessary to every serious tree lover. Over 100 finding keys. 783 illustrations. Total of 986pp. 5⅜ x 8½.
 20277-1, 20278-X Pa., Two-vol. set $11.00

AMERICAN BIRD ENGRAVINGS, Alexander Wilson et al. All 76 plates. from Wilson's *American Ornithology* (1808-14), most important ornithological work before Audubon, plus 27 plates from the supplement (1825-33) by Charles Bonaparte. Over 250 birds portrayed. 8 plates also reproduced in full color. 111pp. 9⅜ x 12½. 23195-X Pa. $6.00

CRUICKSHANK'S PHOTOGRAPHS OF BIRDS OF AMERICA, Allan D. Cruickshank. Great ornithologist, photographer presents 177 closeups, groupings, panoramas, flightings, etc., of about 150 different birds. Expanded *Wings in the Wilderness*. Introduction by Helen G. Cruickshank. 191pp. 8¼ x 11. 23497-5 Pa. $6.00

AMERICAN WILDLIFE AND PLANTS, A. C. Martin, et al. Describes food habits of more than 1000 species of mammals, birds, fish. Special treatment of important food plants. Over 300 illustrations. 500pp. 5⅜ x 8½.
20793-5 Pa. $4.95

THE PEOPLE CALLED SHAKERS, Edward D. Andrews. Lifetime of research, definitive study of Shakers: origins, beliefs, practices, dances, social organization, furniture and crafts, impact on 19th-century USA, present heritage. Indispensable to student of American history, collector. 33 illustrations. 351pp. 5⅜ x 8½. 21081-2 Pa. $4.50

OLD NEW YORK IN EARLY PHOTOGRAPHS, Mary Black. New York City as it was in 1853-1901, through 196 wonderful photographs from N.-Y. Historical Society. Great Blizzard, Lincoln's funeral procession, great buildings. 228pp. 9 x 12. 22907-6 Pa. $8.95

MR. LINCOLN'S CAMERA MAN: MATHEW BRADY, Roy Meredith. Over 300 Brady photos reproduced directly from original negatives, photos. Jackson, Webster, Grant, Lee, Carnegie, Barnum; Lincoln; Battle Smoke, Death of Rebel Sniper, Atlanta Just After Capture. Lively commentary. 368pp. 8⅜ x 11¼. 23021-X Pa. $8.95

TRAVELS OF WILLIAM BARTRAM, William Bartram. From 1773-8, Bartram explored Northern Florida, Georgia, Carolinas, and reported on wild life, plants, Indians, early settlers. Basic account for period, entertaining reading. Edited by Mark Van Doren. 13 illustrations. 141pp. 5⅜ x 8½. 20013-2 Pa. $5.00

THE GENTLEMAN AND CABINET MAKER'S DIRECTOR, Thomas Chippendale. Full reprint, 1762 style book, most influential of all time; chairs, tables, sofas, mirrors, cabinets, etc. 200 plates, plus 24 photographs of surviving pieces. 249pp. 9⅞ x 12¾. 21601-2 Pa. $7.95

AMERICAN CARRIAGES, SLEIGHS, SULKIES AND CARTS, edited by Don H. Berkebile. 168 Victorian illustrations from catalogues, trade journals, fully captioned. Useful for artists. Author is Assoc. Curator, Div. of Transportation of Smithsonian Institution. 168pp. 8½ x 9½.
23328-6 Pa. $5.00

YUCATAN BEFORE AND AFTER THE CONQUEST, Diego de Landa. First English translation of basic book in Maya studies, the only significant account of Yucatan written in the early post-Conquest era. Translated by distinguished Maya scholar William Gates. Appendices, introduction, 4 maps and over 120 illustrations added by translator. 162pp. 5⅜ x 8½.
23622-6 Pa. $3.00

THE MALAY ARCHIPELAGO, Alfred R. Wallace. Spirited travel account by one of founders of modern biology. Touches on zoology, botany, ethnography, geography, and geology. 62 illustrations, maps. 515pp. 5⅜ x 8½.
20187-2 Pa. $6.95

THE DISCOVERY OF THE TOMB OF TUTANKHAMEN, Howard Carter, A. C. Mace. Accompany Carter in the thrill of discovery, as ruined passage suddenly reveals unique, untouched, fabulously rich tomb. Fascinating account, with 106 illustrations. New introduction by J. M. White. Total of 382pp. 5⅜ x 8½. (Available in U.S. only) 23500-9 Pa. $4.00

THE WORLD'S GREATEST SPEECHES, edited by Lewis Copeland and Lawrence W. Lamm. Vast collection of 278 speeches from Greeks up to present. Powerful and effective models; unique look at history. Revised to 1970. Indices. 842pp. 5⅜ x 8½. 20468-5 Pa. $8.95

THE 100 GREATEST ADVERTISEMENTS, Julian Watkins. The priceless ingredient; His master's voice; 99 44/100% pure; over 100 others. How they were written, their impact, etc. Remarkable record. 130 illustrations. 233pp. 7⅞ x 10 3/5. 20540-1 Pa. $5.95

CRUICKSHANK PRINTS FOR HAND COLORING, George Cruickshank. 18 illustrations, one side of a page, on fine-quality paper suitable for watercolors. Caricatures of people in society (c. 1820) full of trenchant wit. Very large format. 32pp. 11 x 16. 23684-6 Pa. $5.00

THIRTY-TWO COLOR POSTCARDS OF TWENTIETH-CENTURY AMERICAN ART, Whitney Museum of American Art. Reproduced in full color in postcard form are 31 art works and one shot of the museum. Calder, Hopper, Rauschenberg, others. Detachable. 16pp. 8¼ x 11.
23629-3 Pa. $3.00

MUSIC OF THE SPHERES: THE MATERIAL UNIVERSE FROM ATOM TO QUASAR SIMPLY EXPLAINED, Guy Murchie. Planets, stars, geology, atoms, radiation, relativity, quantum theory, light, antimatter, similar topics. 319 figures. 664pp. 5⅜ x 8½.
21809-0, 21810-4 Pa., Two-vol. set $11.00

EINSTEIN'S THEORY OF RELATIVITY, Max Born. Finest semi-technical account; covers Einstein, Lorentz, Minkowski, and others, with much detail, much explanation of ideas and math not readily available elsewhere on this level. For student, non-specialist. 376pp. 5⅜ x 8½.
60769-0 Pa. $4.50

THE EARLY WORK OF AUBREY BEARDSLEY, Aubrey Beardsley. 157 plates, 2 in color: *Manon Lescaut, Madame Bovary, Morte Darthur, Salome,* other. Introduction by H. Marillier. 182pp. 8⅛ x 11. 21816-3 Pa. $4.50

THE LATER WORK OF AUBREY BEARDSLEY, Aubrey Beardsley. Exotic masterpieces of full maturity: *Venus and Tannhauser, Lysistrata, Rape of the Lock, Volpone,* Savoy material, etc. 174 plates, 2 in color. 186pp. 8⅛ x 11. 21817-1 Pa. $5.95

THOMAS NAST'S CHRISTMAS DRAWINGS, Thomas Nast. Almost all Christmas drawings by creator of image of Santa Claus as we know it, and one of America's foremost illustrators and political cartoonists. 66 illustrations. 3 illustrations in color on covers. 96pp. 8⅜ x 11¼. 23660-9 Pa. $3.50

THE DORÉ ILLUSTRATIONS FOR DANTE'S DIVINE COMEDY, Gustave Doré. All 135 plates from Inferno, Purgatory, Paradise; fantastic tortures, infernal landscapes, celestial wonders. Each plate with appropriate (translated) verses. 141pp. 9 x 12. 23231-X Pa. $4.50

DORÉ'S ILLUSTRATIONS FOR RABELAIS, Gustave Doré. 252 striking illustrations of *Gargantua and Pantagruel* books by foremost 19th-century illustrator. Including 60 plates, 192 delightful smaller illustrations. 153pp. 9 x 12. 23656-0 Pa. $5.00

LONDON: A PILGRIMAGE, Gustave Doré, Blanchard Jerrold. Squalor, riches, misery, beauty of mid-Victorian metropolis; 55 wonderful plates, 125 other illustrations, full social, cultural text by Jerrold. 191pp. of text. 9⅜ x 12¼. 22306-X Pa. $7.00

THE RIME OF THE ANCIENT MARINER, Gustave Doré, S. T. Coleridge. Dore's finest work, 34 plates capture moods, subtleties of poem. Full text. Introduction by Millicent Rose. 77pp. 9¼ x 12. 22305-1 Pa. $3.50

THE DORE BIBLE ILLUSTRATIONS, Gustave Doré. All wonderful, detailed plates: Adam and Eve, Flood, Babylon, Life of Jesus, etc. Brief King James text with each plate. Introduction by Millicent Rose. 241 plates. 241pp. 9 x 12. 23004-X Pa. $6.00

THE COMPLETE ENGRAVINGS, ETCHINGS AND DRYPOINTS OF ALBRECHT DURER. "Knight, Death and Devil"; "Melencolia," and more—all Dürer's known works in all three media, including 6 works formerly attributed to him. 120 plates. 235pp. 8⅜ x 11¼. 22851-7 Pa. $6.50

MECHANICK EXERCISES ON THE WHOLE ART OF PRINTING, Joseph Moxon. First complete book (1683-4) ever written about typography, a compendium of everything known about printing at the latter part of 17th century. Reprint of 2nd (1962) Oxford Univ. Press edition. 74 illustrations. Total of 550pp. 6⅛ x 9¼. 23617-X Pa. $7.95

THE COMPLETE WOODCUTS OF ALBRECHT DURER, edited by Dr. W. Kurth. 346 in all: "Old Testament," "St. Jerome," "Passion," "Life of Virgin," Apocalypse," many others. Introduction by Campbell Dodgson. 285pp. 8½ x 12¼. 21097-9 Pa. $7.50

DRAWINGS OF ALBRECHT DURER, edited by Heinrich Wolfflin. 81 plates show development from youth to full style. Many favorites; many new. Introduction by Alfred Werner. 96pp. 8⅛ x 11. 22352-3 Pa. $5.00

THE HUMAN FIGURE, Albrecht Dürer. Experiments in various techniques—stereometric, progressive proportional, and others. Also life studies that rank among finest ever done. Complete reprinting of Dresden Sketchbook. 170 plates. 355pp. 8⅜ x 11¼. 21042-1 Pa. $7.95

OF THE JUST SHAPING OF LETTERS, Albrecht Dürer. Renaissance artist explains design of Roman majuscules by geometry, also Gothic lower and capitals. Grolier Club edition. 43pp. 7⅞ x 10¾ 21306-4 Pa. $3.00

TEN BOOKS ON ARCHITECTURE, Vitruvius. The most important book ever written on architecture. Early Roman aesthetics, technology, classical orders, site selection, all other aspects. Stands behind everything since. Morgan translation. 331pp. 5⅜ x 8½. 20645-9 Pa. $4.50

THE FOUR BOOKS OF ARCHITECTURE, Andrea Palladio. 16th-century classic responsible for Palladian movement and style. Covers classical architectural remains, Renaissance revivals, classical orders, etc. 1738 Ware English edition. Introduction by A. Placzek. 216 plates. 110pp. of text. 9½ x 12¾. 21308-0 Pa. $10.00

HORIZONS, Norman Bel Geddes. Great industrialist stage designer, "father of streamlining," on application of aesthetics to transportation, amusement, architecture, etc. 1932 prophetic account; function, theory, specific projects. 222 illustrations. 312pp. 7⅞ x 10¾. 23514-9 Pa. $6.95

FRANK LLOYD WRIGHT'S FALLINGWATER, Donald Hoffmann. Full, illustrated story of conception and building of Wright's masterwork at Bear Run, Pa. 100 photographs of site, construction, and details of completed structure. 112pp. 9¼ x 10. 23671-4 Pa. $5.50

THE ELEMENTS OF DRAWING, John Ruskin. Timeless classic by great Viltorian; starts with basic ideas, works through more difficult. Many practical exercises. 48 illustrations. Introduction by Lawrence Campbell. 228pp. 5⅜ x 8½. 22730-8 Pa. $3.75

GIST OF ART, John Sloan. Greatest modern American teacher, Art Students League, offers innumerable hints, instructions, guided comments to help you in painting. Not a formal course. 46 illustrations. Introduction by Helen Sloan. 200pp. 5⅜ x 8½. 23435-5 Pa. $4.00

THE ANATOMY OF THE HORSE, George Stubbs. Often considered the great masterpiece of animal anatomy. Full reproduction of 1766 edition, plus prospectus; original text and modernized text. 36 plates. Introduction by Eleanor Garvey. 121pp. 11 x 14¾. 23402-9 Pa. $6.00

BRIDGMAN'S LIFE DRAWING, George B. Bridgman. More than 500 illustrative drawings and text teach you to abstract the body into its major masses, use light and shade, proportion; as well as specific areas of anatomy, of which Bridgman is master. 192pp. 6½ x 9¼. (Available in U.S. only) 22710-3 Pa. $3.50

ART NOUVEAU DESIGNS IN COLOR, Alphonse Mucha, Maurice Verneuil, Georges Auriol. Full-color reproduction of *Combinaisons ornementales* (c. 1900) by Art Nouveau masters. Floral, animal, geometric, interlacings, swashes—borders, frames, spots—all incredibly beautiful. 60 plates, hundreds of designs. 9⅜ x 8-1/16. 22885-1 Pa. $4.00

FULL-COLOR FLORAL DESIGNS IN THE ART NOUVEAU STYLE, E. A. Seguy. 166 motifs, on 40 plates, from *Les fleurs et leurs applications decoratives* (1902): borders, circular designs, repeats, allovers, "spots." All in authentic Art Nouveau colors. 48pp. 9⅜ x 12¼. 23439-8 Pa. $5.00

A DIDEROT PICTORIAL ENCYCLOPEDIA OF TRADES AND IN-DUSTRY, edited by Charles C. Gillispie. 485 most interesting plates from the great French Encyclopedia of the 18th century show hundreds of working figures, artifacts, process, land and cityscapes; glassmaking, paper-making, metal extraction, construction, weaving, making furniture, clothing, wigs, dozens of other activities. Plates fully explained. 920pp. 9 x 12. 22284-5, 22285-3 Clothbd., Two-vol. set $40.00

HANDBOOK OF EARLY ADVERTISING ART, Clarence P. Hornung. Largest collection of copyright-free early and antique advertising art ever compiled. Over 6,000 illustrations, from Franklin's time to the 1890's for special effects, novelty. Valuable source, almost inexhaustible.
Pictorial Volume. Agriculture, the zodiac, animals, autos, birds, Christmas, fire engines, flowers, trees, musical instruments, ships, games and sports, much more. Arranged by subject matter and use. 237 plates. 288pp. 9 x 12. 20122-8 Clothbd. $14.50

Typographical Volume. Roman and Gothic faces ranging from 10 point to 300 point, "Barnum," German and Old English faces, script, logotypes, scrolls and flourishes, 1115 ornamental initials, 67 complete alphabets, more. 310 plates. 320pp. 9 x 12. 20123-6 Clothbd. $15.00

CALLIGRAPHY (CALLIGRAPHIA LATINA), J. G. Schwandner. High point of 18th-century ornamental calligraphy. Very ornate initials, scrolls, borders, cherubs, birds, lettered examples. 172pp. 9 x 13. 20475-8 Pa. $7.00

ART FORMS IN NATURE, Ernst Haeckel. Multitude of strangely beautiful natural forms: Radiolaria, Foraminifera, jellyfishes, fungi, turtles, bats, etc. All 100 plates of the 19th-century evolutionist's *Kunstformen der Natur* (1904). 100pp. 9⅜ x 12¼. 22987-4 Pa. $5.00

CHILDREN: A PICTORIAL ARCHIVE FROM NINETEENTH-CENTURY SOURCES, edited by Carol Belanger Grafton. 242 rare, copyright-free wood engravings for artists and designers. Widest such selection available. All illustrations in line. 119pp. 8⅜ x 11¼. 23694-3 Pa. $4.00

WOMEN: A PICTORIAL ARCHIVE FROM NINETEENTH-CENTURY SOURCES, edited by Jim Harter. 391 copyright-free wood engravings for artists and designers selected from rare periodicals. Most extensive such collection available. All illustrations in line. 128pp. 9 x 12. 23703-6 Pa. $4.50

ARABIC ART IN COLOR, Prisse d'Avennes. From the greatest ornamentalists of all time—50 plates in color, rarely seen outside the Near East, rich in suggestion and stimulus. Includes 4 plates on covers. 46pp. 9⅜ x 12¼. 23658-7 Pa. $6.00

AUTHENTIC ALGERIAN CARPET DESIGNS AND MOTIFS, edited by June Beveridge. Algerian carpets are world famous. Dozens of geometrical motifs are charted on grids, color-coded, for weavers, needleworkers, craftsmen, designers. 53 illustrations plus 4 in color. 48pp. 8¼ x 11. (Available in U.S. only) 23650-1 Pa. $1.75

DICTIONARY OF AMERICAN PORTRAITS, edited by Hayward and Blanche Cirker. 4000 important Americans, earliest times to 1905, mostly in clear line. Politicians, writers, soldiers, scientists, inventors, industrialists, Indians, Blacks, women, outlaws, etc. Identificatory information. 756pp. 9¼ x 12¾. 21823-6 Clothbd. $40.00

HOW THE OTHER HALF LIVES, Jacob A. Riis. Journalistic record of filth, degradation, upward drive in New York immigrant slums, shops, around 1900. New edition includes 100 original Riis photos, monuments of early photography. 233pp. 10 x 7⅞. 22012-5 Pa. $7.00

NEW YORK IN THE THIRTIES, Berenice Abbott. Noted photographer's fascinating study of city shows new buildings that have become famous and old sights that have disappeared forever. Insightful commentary. 97 photographs. 97pp. 11⅜ x 10. 22967-X Pa. $5.00

MEN AT WORK, Lewis W. Hine. Famous photographic studies of construction workers, railroad men, factory workers and coal miners. New supplement of 18 photos on Empire State building construction. New introduction by Jonathan L. Doherty. Total of 69 photos. 63pp. 8 x 10¾. 23475-4 Pa. $3.00

THE DEPRESSION YEARS AS PHOTOGRAPHED BY ARTHUR ROTH-STEIN, Arthur Rothstein. First collection devoted entirely to the work of outstanding 1930s photographer: famous dust storm photo, ragged children, unemployed, etc. 120 photographs. Captions. 119pp. 9¼ x 10¾.
23590-4 Pa. $5.00

CAMERA WORK: A PICTORIAL GUIDE, Alfred Stieglitz. All 559 illustrations and plates from the most important periodical in the history of art photography, Camera Work (1903-17). Presented four to a page, reduced in size but still clear, in strict chronological order, with complete captions. Three indexes. Glossary. Bibliography. 176pp. 8⅜ x 11¼.
23591-2 Pa. $6.95

ALVIN LANGDON COBURN, PHOTOGRAPHER, Alvin L. Coburn. Revealing autobiography by one of greatest photographers of 20th century gives insider's version of Photo-Secession, plus comments on his own work. 77 photographs by Coburn. Edited by Helmut and Alison Gernsheim. 160pp. 8⅛ x 11.
23685-4 Pa. $6.00

NEW YORK IN THE FORTIES, Andreas Feininger. 162 brilliant photographs by the well-known photographer, formerly with Life magazine, show commuters, shoppers, Times Square at night, Harlem nightclub, Lower East Side, etc. Introduction and full captions by John von Hartz. 181pp. 9¼ x 10¾.
23585-8 Pa. $6.95

GREAT NEWS PHOTOS AND THE STORIES BEHIND THEM, John Faber. Dramatic volume of 140 great news photos, 1855 through 1976, and revealing stories behind them, with both historical and technical information. Hindenburg disaster, shooting of Oswald, nomination of Jimmy Carter, etc. 160pp. 8¼ x 11.
23667-6 Pa. $5.00

THE ART OF THE CINEMATOGRAPHER, Leonard Maltin. Survey of American cinematography history and anecdotal interviews with 5 masters—Arthur Miller, Hal Mohr, Hal Rosson, Lucien Ballard, and Conrad Hall. Very large selection of behind-the-scenes production photos. 105 photographs. Filmographies. Index. Originally Behind the Camera. 144pp. 8¼ x 11.
23686-2 Pa. $5.00

DESIGNS FOR THE THREE-CORNERED HAT (LE TRICORNE), Pablo Picasso. 32 fabulously rare drawings—including 31 color illustrations of costumes and accessories—for 1919 production of famous ballet. Edited by Parmenia Migel, who has written new introduction. 48pp. 9⅜ x 12¼. (Available in U.S. only)
23709-5 Pa. $5.00

NOTES OF A FILM DIRECTOR, Sergei Eisenstein. Greatest Russian filmmaker explains montage, making of Alexander Nevsky, aesthetics; comments on self, associates, great rivals (Chaplin), similar material. 78 illustrations. 240pp. 5⅜ x 8½.
22392-2 Pa. $4.50

HOLLYWOOD GLAMOUR PORTRAITS, edited by John Kobal. 145 photos capture the stars from 1926-49, the high point in portrait photography. Gable, Harlow, Bogart, Bacall, Hedy Lamarr, Marlene Dietrich, Robert Montgomery, Marlon Brando, Veronica Lake; 94 stars in all. Full background on photographers, technical aspects, much more. Total of 160pp. 8⅜ x 11¼. 23352-9 Pa. $6.00

THE NEW YORK STAGE: FAMOUS PRODUCTIONS IN PHOTO-GRAPHS, edited by Stanley Appelbaum. 148 photographs from Museum of City of New York show 142 plays, 1883-1939. *Peter Pan, The Front Page, Dead End, Our Town,* O'Neill, hundreds of actors and actresses, etc. Full indexes. 154pp. 9½ x 10. 23241-7 Pa. $6.00

DIALOGUES CONCERNING TWO NEW SCIENCES, Galileo Galilei. Encompassing 30 years of experiment and thought, these dialogues deal with geometric demonstrations of fracture of solid bodies, cohesion, lever-age, speed of light and sound, pendulums, falling bodies, accelerated motion, etc. 300pp. 5⅜ x 8½. 60099-8 Pa. $4.00

THE GREAT OPERA STARS IN HISTORIC PHOTOGRAPHS, edited by James Camner. 343 portraits from the 1850s to the 1940s: Tamburini, Mario, Caliapin, Jeritza, Melchior, Melba, Patti, Pinza, Schipa, Caruso, Farrar, Steber, Gobbi, and many more—270 performers in all. Index. 199pp. 8⅜ x 11¼. 23575-0 Pa. $7.50

J. S. BACH, Albert Schweitzer. Great full-length study of Bach, life, background to music, music, by foremost modern scholar. Ernest Newman translation. 650 musical examples. Total of 928pp. 5⅜ x 8½. (Available in U.S. only) 21631-4, 21632-2 Pa., Two-vol. set $11.00

COMPLETE PIANO SONATAS, Ludwig van Beethoven. All sonatas in the fine Schenker edition, with fingering, analytical material. One of best modern editions. Total of 615pp. 9 x 12. (Available in U.S. only)
 23134-8, 23135-6 Pa., Two-vol. set $15.50

KEYBOARD MUSIC, J. S. Bach. Bach-Gesellschaft edition. For harpsi-chord, piano, other keyboard instruments. English Suites, French Suites, Six Partitas, Goldberg Variations, Two-Part Inventions, Three-Part Sin-fonias. 312pp. 8⅛ x 11. (Available in U.S. only) 22360-4 Pa. $6.95

FOUR SYMPHONIES IN FULL SCORE, Franz Schubert. Schubert's four most popular symphonies: No. 4 in C Minor ("Tragic"); No. 5 in B-flat Major; No. 8 in B Minor ("Unfinished"); No. 9 in C Major ("Great"). Breitkopf & Hartel edition. Study score. 261pp. 9⅜ x 12¼.
 23681-1 Pa. $6.50

THE AUTHENTIC GILBERT & SULLIVAN SONGBOOK, W. S. Gilbert, A. S. Sullivan. Largest selection available; 92 songs, uncut, original keys, in piano rendering approved by Sullivan. Favorites and lesser-known fine numbers. Edited with plot synopses by James Spero. 3 illustrations. 399pp. 9 x 12. 23482-7 Pa. $9.95

PRINCIPLES OF ORCHESTRATION, Nikolay Rimsky-Korsakov. Great classical orchestrator provides fundamentals of tonal resonance, progression of parts, voice and orchestra, tutti effects, much else in major document. 330pp. of musical excerpts. 489pp. 6½ x 9¼. 21266-1 Pa. $7.50

TRISTAN UND ISOLDE, Richard Wagner. Full orchestral score with complete instrumentation. Do not confuse with piano reduction. Commentary by Felix Mottl, great Wagnerian conductor and scholar. Study score. 655pp. 8⅛ x 11. 22915-7 Pa. $13.95

REQUIEM IN FULL SCORE, Giuseppe Verdi. Immensely popular with choral groups and music lovers. Republication of edition published by C. F. Peters, Leipzig, n. d. German frontmaker in English translation. Glossary. Text in Latin. Study score. 204pp. 9⅜ x 12¼.
23682-X Pa. $6.00

COMPLETE CHAMBER MUSIC FOR STRINGS, Felix Mendelssohn. All of Mendelssohn's chamber music: Octet, 2 Quintets, 6 Quartets, and Four Pieces for String Quartet. (Nothing with piano is included). Complete works edition (1874-7). Study score. 283 pp. 9⅜ x 12¼.
23679-X Pa. $7.50

POPULAR SONGS OF NINETEENTH-CENTURY AMERICA, edited by Richard Jackson. 64 most important songs: "Old Oaken Bucket," "Arkansas Traveler," "Yellow Rose of Texas," etc. Authentic original sheet music, full introduction and commentaries. 290pp. 9 x 12. 23270-0 Pa. $7.95

COLLECTED PIANO WORKS, Scott Joplin. Edited by Vera Brodsky Lawrence. Practically all of Joplin's piano works—rags, two-steps, marches, waltzes, etc., 51 works in all. Extensive introduction by Rudi Blesh. Total of 345pp. 9 x 12. 23106-2 Pa. $14.95

BASIC PRINCIPLES OF CLASSICAL BALLET, Agrippina Vaganova. Great Russian theoretician, teacher explains methods for teaching classical ballet; incorporates best from French, Italian, Russian schools. 118 illustrations. 175pp. 5⅜ x 8½. 22036-2 Pa. $2.50

CHINESE CHARACTERS, L. Wieger. Rich analysis of 2300 characters according to traditional systems into primitives. Historical-semantic analysis to phonetics (Classical Mandarin) and radicals. 820pp. 6⅛ x 9¼.
21321-8 Pa. $10.00

EGYPTIAN LANGUAGE: EASY LESSONS IN EGYPTIAN HIERO-GLYPHICS, E. A. Wallis Budge. Foremost Egyptologist offers Egyptian grammar, explanation of hieroglyphics, many reading texts, dictionary of symbols. 246pp. 5 x 7½. (Available in U.S. only)
21394-3 Clothbd. $7.50

AN ETYMOLOGICAL DICTIONARY OF MODERN ENGLISH, Ernest Weekley. Richest, fullest work, by foremost British lexicographer. Detailed word histories. Inexhaustible. Do not confuse this with *Concise Etymological Dictionary*, which is abridged. Total of 856pp. 6½ x 9¼.
21873-2, 21874-0 Pa., Two-vol. set $12.00

A MAYA GRAMMAR, Alfred M. Tozzer. Practical, useful English-language grammar by the Harvard anthropologist who was one of the three greatest American scholars in the area of Maya culture. Phonetics, grammatical processes, syntax, more. 301pp. 5⅜ x 8½. 23465-7 Pa. $4.00

THE JOURNAL OF HENRY D. THOREAU, edited by Bradford Torrey, F. H. Allen. Complete reprinting of 14 volumes, 1837-61, over two million words; the sourcebooks for *Walden*, etc. Definitive. All original sketches, plus 75 photographs. Introduction by Walter Harding. Total of 1804pp. 8½ x 12¼. 20312-3, 20313-1 Clothbd., Two-vol. set $70.00

CLASSIC GHOST STORIES, Charles Dickens and others. 18 wonderful stories you've wanted to reread: "The Monkey's Paw," "The House and the Brain," "The Upper Berth," "The Signalman," "Dracula's Guest," "The Tapestried Chamber," etc. Dickens, Scott, Mary Shelley, Stoker, etc. 330pp. 5⅜ x 8½. 20735-8 Pa. **$4.50**

SEVEN SCIENCE FICTION NOVELS, H. G. Wells. Full novels. *First Men in the Moon, Island of Dr. Moreau, War of the Worlds, Food of the Gods, Invisible Man, Time Machine, In the Days of the Comet.* A basic science-fiction library. 1015pp. 5⅜ x 8½. (Available in U.S. only)
 20264-X Clothbd. $8.95

ARMADALE, Wilkie Collins. Third great mystery novel by the author of *The Woman in White* and *The Moonstone.* Ingeniously plotted narrative shows an exceptional command of character, incident and mood. Original magazine version with 40 illustrations. 597pp. 5⅜ x 8½.
 23429-0 Pa. $6.00

MASTERS OF MYSTERY, H. Douglas Thomson. The first book in English (1931) devoted to history and aesthetics of detective story. Poe, Doyle, LeFanu, Dickens, many others, up to 1930. New introduction and notes by E. F. Bleiler. 288pp. 5⅜ x 8½. (Available in U.S. only)
 23606-4 Pa. $4.00

FLATLAND, E. A. Abbott. Science-fiction classic explores life of 2-D being in 3-D world. Read also as introduction to thought about hyperspace. Introduction by Banesh Hoffmann. 16 illustrations. 103pp. 5⅜ x 8½.
 20001-9 Pa. $2.00

THREE SUPERNATURAL NOVELS OF THE VICTORIAN PERIOD, edited, with an introduction, by E. F. Bleiler. Reprinted complete and unabridged, three great classics of the supernatural: *The Haunted Hotel* by Wilkie Collins, *The Haunted House at Latchford* by Mrs. J. H. Riddell, and *The Lost Stradivarius* by J. Meade Falkner. 325pp. 5⅜ x 8½.
 22571-2 Pa. $4.00

AYESHA: THE RETURN OF "SHE," H. Rider Haggard. Virtuoso sequel featuring the great mythic creation, Ayesha, in an adventure that is fully as good as the first book, *She.* Original magazine version, with 47 original illustrations by Maurice Greiffenhagen. 189pp. 6½ x 9¼.
 23649-8 Pa. $3.50

UNCLE SILAS, J. Sheridan LeFanu. Victorian Gothic mystery novel, considered by many best of period, even better than Collins or Dickens. Wonderful psychological terror. Introduction by Frederick Shroyer. 436pp. 5⅜ x 8½. 21715-9 Pa. $6.00

JURGEN, James Branch Cabell. The great erotic fantasy of the 1920's that delighted thousands, shocked thousands more. Full final text, Lane edition with 13 plates by Frank Pape. 346pp. 5⅜ x 8½. 23507-6 Pa. $4.50

THE CLAVERINGS, Anthony Trollope. Major novel, chronicling aspects of British Victorian society, personalities. Reprint of Cornhill serialization, 16 plates by M. Edwards; first reprint of full text. Introduction by Norman Donaldson. 412pp. 5⅜ x 8½. 23464-9 Pa. $5.00

KEPT IN THE DARK, Anthony Trollope. Unusual short novel about Victorian morality and abnormal psychology by the great English author. Probably the first American publication. Frontispiece by Sir John Millais. 92pp. 6½ x 9¼. 23609-9 Pa. $2.50

RALPH THE HEIR, Anthony Trollope. Forgotten tale of illegitimacy, inheritance. Master novel of Trollope's later years. Victorian country estates, clubs, Parliament, fox hunting, world of fully realized characters. Reprint of 1871 edition. 12 illustrations by F. A. Faser. 434pp. of text. 5⅜ x 8½. 23642-0 Pa. $5.00

YEKL and THE IMPORTED BRIDEGROOM AND OTHER STORIES OF THE NEW YORK GHETTO, Abraham Cahan. Film *Hester Street* based on *Yekl* (1896). Novel, other stories among first about Jewish immigrants of N.Y.'s East Side. Highly praised by W. D. Howells—Cahan "a new star of realism." New introduction by Bernard G. Richards. 240pp. 5⅜ x 8½. 22427-9 Pa. $3.50

THE HIGH PLACE, James Branch Cabell. Great fantasy writer's enchanting comedy of disenchantment set in 18th-century France. Considered by some critics to be even better than his famous *Jurgen*. 10 illustrations and numerous vignettes by noted fantasy artist Frank C. Pape. 320pp. 5⅜ x 8½. 23670-6 Pa. $4.00

ALICE'S ADVENTURES UNDER GROUND, Lewis Carroll. Facsimile of ms. Carroll gave Alice Liddell in 1864. Different in many ways from final Alice. Handlettered, illustrated by Carroll. Introduction by Martin Gardner. 128pp. 5⅜ x 8½. 21482-6 Pa. $2.50

FAVORITE ANDREW LANG FAIRY TALE BOOKS IN MANY COLORS, Andrew Lang. The four Lang favorites in a boxed set—the complete *Red, Green, Yellow* and *Blue* Fairy Books. 164 stories; 439 illustrations by Lancelot Speed, Henry Ford and G. P. Jacomb Hood. Total of about 1500pp. 5⅜ x 8½. 23407-X Boxed set, Pa. $15.95

HOUSEHOLD STORIES BY THE BROTHERS GRIMM. All the great Grimm stories: "Rumpelstiltskin," "Snow White," "Hansel and Gretel," etc., with 114 illustrations by Walter Crane. 269pp. 5⅜ x 8½.
21080-4 Pa. $3.50

SLEEPING BEAUTY, illustrated by Arthur Rackham. Perhaps the fullest, most delightful version ever, told by C. S. Evans. Rackham's best work. 49 illustrations. 110pp. 7⅞ x 10¾.
22756-1 Pa. $2.50

AMERICAN FAIRY TALES, L. Frank Baum. Young cowboy lassoes Father Time; dummy in Mr. Floman's department store window comes to life; and 10 other fairy tales. 41 illustrations by N. P. Hall, Harry Kennedy, Ike Morgan, and Ralph Gardner. 209pp. 5⅜ x 8½.
23643-9 Pa. $3.00

THE WONDERFUL WIZARD OF OZ, L. Frank Baum. Facsimile in full color of America's finest children's classic. Introduction by Martin Gardner. 143 illustrations by W. W. Denslow. 267pp. 5⅜ x 8½.
20691-2 Pa. $3.50

THE TALE OF PETER RABBIT, Beatrix Potter. The inimitable Peter's terrifying adventure in Mr. McGregor's garden, with all 27 wonderful, full-color Potter illustrations. 55pp. 4¼ x 5½. (Available in U.S. only)
22827-4 Pa. $1.25

THE STORY OF KING ARTHUR AND HIS KNIGHTS, Howard Pyle. Finest children's version of life of King Arthur. 48 illustrations by Pyle. 131pp. 6⅛ x 9¼.
21445-1 Pa. $4.95

CARUSO'S CARICATURES, Enrico Caruso. Great tenor's remarkable caricatures of self, fellow musicians, composers, others. Toscanini, Puccini, Farrar, etc. Impish, cutting, insightful. 473 illustrations. Preface by M. Sisca. 217pp. 8⅜ x 11¼.
23528-9 Pa. $6.95

PERSONAL NARRATIVE OF A PILGRIMAGE TO ALMADINAH AND MECCAH, Richard Burton. Great travel classic by remarkably colorful personality. Burton, disguised as a Moroccan, visited sacred shrines of Islam, narrowly escaping death. Wonderful observations of Islamic life, customs, personalities. 47 illustrations. Total of 959pp. 5⅜ x 8½.
21217-3, 21218-1 Pa., Two-vol. set $12.00

INCIDENTS OF TRAVEL IN YUCATAN, John L. Stephens. Classic (1843) exploration of jungles of Yucatan, looking for evidences of Maya civilization. Travel adventures, Mexican and Indian culture, etc. Total of 669pp. 5⅜ x 8½.
20926-1, 20927-X Pa., Two-vol. set $7.90

AMERICAN LITERARY AUTOGRAPHS FROM WASHINGTON IRVING TO HENRY JAMES, Herbert Cahoon, et al. Letters, poems, manuscripts of Hawthorne, Thoreau, Twain, Alcott, Whitman, 67 other prominent American authors. Reproductions, full transcripts and commentary. Plus checklist of all American Literary Autographs in The Pierpont Morgan Library. Printed on exceptionally high-quality paper. 136 illustrations. 212pp. 9⅛ x 12¼.
23548-3 Pa. $12.50

GEOMETRY, RELATIVITY AND THE FOURTH DIMENSION, Rudolf Rucker. Exposition of fourth dimension, means of visualization, concepts of relativity as Flatland characters continue adventures. Popular, easily followed yet accurate, profound. 141 illustrations. 133pp. 5⅜ x 8½.
23400-2 Pa. $2.75

THE ORIGIN OF LIFE, A. I. Oparin. Modern classic in biochemistry, the first rigorous examination of possible evolution of life from nitrocarbon compounds. Non-technical, easily followed. Total of 295pp. 5⅜ x 8½.
60213-3 Pa. $4.00

PLANETS, STARS AND GALAXIES, A. E. Fanning. Comprehensive introductory survey: the sun, solar system, stars, galaxies, universe, cosmology; quasars, radio stars, etc. 24pp. of photographs. 189pp. 5⅜ x 8½. (Available in U.S. only)
21680-2 Pa. $3.75

THE THIRTEEN BOOKS OF EUCLID'S ELEMENTS, translated with introduction and commentary by Sir Thomas L. Heath. Definitive edition. Textual and linguistic notes, mathematical analysis, 2500 years of critical commentary. Do not confuse with abridged school editions. Total of 1414pp. 5⅜ x 8½.
60088-2, 60089-0, 60090-4 Pa., Three-vol. set $18.50

Prices subject to change without notice.

Available at your book dealer or write for free catalogue to Dept. GI, Dover Publications, Inc., 180 Varick St., N.Y., N.Y. 10014. Dover publishes more than 175 books each year on science, elementary and advanced mathematics, biology, music, art, literary history, social sciences and other areas.